The Hellenistic Origins
of Byzantine Art

D. V. AINALOV

The Hellenistic Origins of Byzantine Art

Translated from the Russian by
ELIZABETH SOBOLEVITCH
and
SERGE SOBOLEVITCH

Edited by
CYRIL MANGO

RUTGERS UNIVERSITY PRESS
New Brunswick New Jersey

Foreword

We are happy to present to the English reading public this English version of D. V. Ainalov's *The Hellenistic Origins of Byzantine Art*. The significance of this book lies in the fact that it gave a new orientation to the study of Byzantine art and so transformed our knowledge of it. Dr. Mango in his Preface makes this very clear. Equally clear are the reasons which he gives why this English version, although by no means a new edition, now supersedes the Russian original. The translation rendered by Elizabeth Sobolevitch and her son, Professor Sobolevitch of Rutgers, The State University, was carefully checked by Dr. Mango.

The publication of an English translation of Ainalov's work was first suggested to us by the late Professor Albert Mathias Friend, Jr., of Princeton University. We regret profoundly that Professor Friend has not lived to see the realization of his suggestion. The Advisory Council and the Director of the Rutgers University Press, the general editor of this series, the translators, and the editor of this volume join together in dedicating this book to his memory. Αἰωνία αὐτοῦ ἡ μνήμη.

PETER CHARANIS
General Editor,
The Rutgers Byzantine Series

November, 1960

Editor's Preface

There exists at this time enough serious interest in the study of Byzantine art to justify the republication of a work that is generally regarded as a classic in this field. D. V. Ainalov's *Hellenistic Origins of Byzantine Art* (*Ellinisticheskie osnovy vizantiiskogo iskusstva*) was published, for the first and only time, in 1900-1901 in the *Bulletin of the Imperial Russian Archaeological Society* [1] and, until now, has never been translated. Its influence upon subsequent research has been very great, although most Western scholars did not take the trouble of consulting the original, but were content with a German resumé of it. [2] In the following pages I shall attempt to define the importance of Ainalov's work and to explain why, in spite of the enormous advances made by Byzantine studies in the past sixty years, it can still be read with profit and stimulation.

In the nineteenth century, the study of Byzantine art in western Europe was as yet in its infancy. Interest in this art, stimulated by the Romantic movement, was at first mostly confined to France. Even there, it was only in the last three decades of the century that this exotic interest assumed a scholarly form in the works of Charles Bayet, followed somewhat later by those of Charles Diehl and Gabriel Millet. It was during this period that art history was beginning to emerge as a professional discipline in the German universities and museums; and if the taste of the time was not yet receptive to Byzantine art in its mature, fully developed form, the problem of how Byzantine art arose, or rather, how antique art decayed, came under systematic discussion. It is not surprising that the scholars who took an interest in this problem should have, in the first instance, turned their attention to Italy. Italy was the recognized training ground for art historians and was much easier of access than the Orient;

furthermore, it had an abundance of well-preserved early Christian monuments. One could follow the development of Christian art from its presumed origin in the Roman catacombs, through the Roman basilicas of the fourth and fifth centuries, to the Byzantine churches of Ravenna—a downward curve showing the gradual debasement of imperial Roman art under Oriental and barbarian influence. To quote Josef Strzygowski, writing some forty years ago, "The earliest research in the field of Christian art discovered its origins in Rome. It is thus easy to understand how even as late as 1880 the recognized horizon hardly extended beyond Rome and Italy. This was about the period when the seniors of the present generation began their work. It was a time in which our teachers kept us puzzling by the month together over the origin of the basilica, and we lived trustfully in the belief that the catacombs—above all, of course, those of Rome—were the birthplace of Christian art." [3] This attitude became crystallized in the works of Wickhoff, Kraus, Riegl, and Rivoira, and it still claims many adherents and even converts. [4] But it is no longer the prevailing orthodoxy. The frontal attack on the "Roman school" was launched simultaneously by two scholars, Ainalov in Russia and Strzygowski in Austria. It is largely thanks to their work that our knowledge of early Byzantine art has been completely transformed.

In Russia, interest in Byzantine antiquities was both natural and patriotic. In the nineteenth century this took two courses: the "clerical-archaeological" and the "scientific." The latter owes its origin to F. I. Buslaev who passed it on to N. P. Kondakov. Kondakov was the teacher of Ainalov who, in turn, taught V. Lazarev. Thus an uninterrupted teacher-to-pupil tradition extends for a whole century down to our day, and it is this continuity that has given the Russian school much of its strength. The interests of this school have also remained uniform: They have embraced classical antiquity, Byzantium and early Russia (the one as the necessary prelude to the other), and the Italian Renaissance. If this program was already elaborated by Buslaev, it was Kondakov who established the study of Byzantine and early Russian art on a secure scientific basis. Kondakov's scholarly activity covers almost sixty years (he was born in 1844 and died at Prague in 1925) and includes almost every aspect of Byzantine art. One of

his principal contributions was the accumulation of a vast body of material which he collected on a number of expeditions: to Georgia and the Caucasus (1873, 1889), Mount Sinai (1881), Constantinople (1884), Syria and Palestine (1891), Mount Athos and Macedonia (1898). Each of these expeditions was followed by a substantial publication; thus the body of material available to Russian scholarship was not only much more vast than it was at that time in western Europe, but it was also focused on the Orient rather than on Italy. Kondakov's approach may be described as factual, iconographic, and cultural; he considered works of art not under their aesthetic aspect (in fact, he professed the utmost contempt for "aesthetes"), but in the context of literature, religion, and social life.[5] His attitude to Byzantine art is best expressed in his own words: "Russian scholarship ought to construct the scientific foundation of its subject on Byzantium. We believe that the investigation of the antiquities and art of the East is obligatory for Russian archaeology, not only because these are akin and therefore understandable to us, but also because they form our historical inheritance; hence, this represents today the only means towards the establishment in Russian archaeology of a comparative scientific method."[6]

Dmitrii Vlas'evich Ainalov was born in 1862 at Mariupol in southern Russia and attended the University of Odessa, where Kondakov was teaching at that time. While still an undergraduate, he wrote, in collaboration with E. K. Redin, a study on the mosaics and frescoes of the church of St. Sophia at Kiev. This was published in 1890 and still remains the best investigation of that famous monument.[7] Having graduated in 1888 (the same year that Kondakov moved from Odessa to St. Petersburg), he was appointed in 1891 *Privatdozent* at the University of Kazan. In 1895 he defended his master's dissertation on the Italian mosaics of the fourth and fifth centuries, a study that had the privilege of being published the same year in the *Journal of the Ministry of Public Instruction*.[8] *The Hellenistic Origins of Byzantine Art* was Ainalov's doctoral dissertation. This won him not only international repute, but also an appointment in 1903 as a professor at the University of St. Petersburg. His subsequent career was devoted entirely to teaching and research. Of his later publications, the ones of greatest interest to Byzantinists

are his substantial study of the encaustic icons of Mount Sinai,[9] his book on the early Christian churches of the Crimea,[10] and, finally, his book on Byzantine painting of the fourteenth century.[11] The last, published during the First World War, has not received all the attention it deserves. In it Ainalov has attempted to demonstrate that the last creative phase of Byzantine art, the so-called "Palaeologian Renaissance" of the fourteenth century, was a by-product of the Italian Dugento, and that the only originality shown by Byzantine artists was "in the choice and adaptation of the new forms of Renaissance art to the highly complex and rich inheritance of Byzantine art." [12] This conclusion, diametrically opposed as it is to the better known iconographic analysis of fourteenth-century Byzantine painting by Gabriel Millet, has not won wide acceptance. Nevertheless, Ainalov's book is full of acute observations and well repays study.

Simultaneously with his Byzantine interests, Ainalov was devoting increasing attention to early Russian and Renaissance art. His views on the former are succinctly stated in two slender volumes that he published much later in German.[13] His principal works on the Renaissance are two studies he published in 1908, the one on the influence exerted by the mosaics of Sta. Maria Maggiore on Raphael, the other on the lower church of St. Francis at Assisi,[14] as well as a monograph on Leonardo da Vinci, part of a larger work that he never completed.[15] Ainalov died in 1939.

It may be apparent from the foregoing remarks that *The Hellenistic Origins of Byzantine Art* stands directly in the tradition of the Russian school of art history and is, in fact, an outgrowth of Kondakov's diverse investigations. In 1901, a year after the publication of Ainalov's work, there appeared Strzygowski's famous *Orient oder Rom*, in which roughly the same views were set forth with greater belligerence and missionary fervor. In reviewing this book, Ainalov expressed some well-founded reservations concerning the Austrian scholar's method and remarked that "the whole direction of his thinking, with the addition of much more to which he has not yet paid adequate attention, is already contained *in extenso* in Russian scholarship." [16] It is to Ainalov's credit that he was content to rest on the conclusion that Byzantine art owed its origin to the great Hellenistic em-

poria of the Near East, such as Alexandria and Antioch, whereas Strzygowski, after reaching substantially the same results, started on a wild-goose chase that led him successively to northern Mesopotamia, Iran, and Armenia, and finally to a vague territory, somewhere between the Oxus and China, where the nomadic Aryans were alleged to have attained the noblest expression of abstract art. The uninterrupted series of polemical books and pamphlets which Strzygowski continued to pour forth for half a century led to a fracas that has hardly yet subsided, and while everyone concerned had a highly stimulating time, the serious task of studying and dating individual early Christian monuments has been somewhat impeded by the discussion of all sorts of irrelevancies, like the "Hvarenah-Landschaft" and the nonexistent Mazdean art. Strzygowski's later theories have now, for the most part, been relegated to the trash basket. Ainalov's views, on the other hand, as well as the "early Strzygowski," form the basis of all the standard textbooks of Byzantine and early Christian art, such as those of Diehl, Wulff, Dalton, and Morey.

Apart from focusing attention on Alexandria, Antioch, and Jerusalem as the sources of Byzantine art, Ainalov also deserves our attention for his method of investigation. This method, which he owed to Kondakov, is essentially philological, i.e., artifacts are used as intermediary links in a chain of transmission leading up to some lost original. Especially interesting in this connection is Ainalov's treatment of the Monza ampullae which he regards as copies of lost monumental compositions in Palestinian churches. This belief in the normative influence of the Palestinian monuments—the great shrines erected by Constantine and his successors on the spots hallowed by biblical events—was also shared by other Russian scholars such as Redin and Smirnov. In the absence of the early decoration of these monuments and of any detailed description of the mosaics and paintings that they contained, this theory is basically unprovable and has, in fact, been abandoned in the latest study devoted to the ampullae of Monza and Bobbio;[17] yet it possesses an undeniable attraction. As Ainalov stressed in a later article,[18] the unprecedented movement of pilgrims to the Holy Land and the dissemination of Palestinian mementos, such as ampullae, rings, and icons, all over Christendom must have certainly exerted a profound influ-

ence upon East and West alike. On the other hand, the Palestinian originals, far from being local products, were works of a composite, cosmopolitan character, which in many cases owed their origin to imperial initiative and were created by masters imported to Palestine from various parts of the Empire. This hypothesis, though admittedly tentative, has the merit of explaining the repetition of the same compositions in widely scattered works of Christian art and the inclusion in these compositions of specific local features such as the rotunda of the Holy Sepulcher, the jewel-studded cross of Golgotha, the flight of stairs leading to the altar of Isaac's sacrifice, etc.

Ainalov's method was "philological" also in its broader application. Just as the classical scholar is able, on the basis of a few medieval manuscripts, to reconstruct the text of an ancient author and to define the characteristics of textual recensions of which not one scrap has survived, so the Alexandrian, Antiochene, and Palestinian "schools" to which Ainalov ascribed the decisive role in the formation of Byzantine art were—in his time —no more than abstract postulates, almost completely unsupported by any significant works of art that were known to have come from those regions. The Alexandrian school of illumination was reconstructed entirely from Byzantine, i.e., Constantinopolitan copies. The chapter on sculpture is devoted exclusively to monuments that are found in Italy. In monumental painting Ainalov did not have before him a single work from Egypt, Syria, Palestine, or Asia Minor that was earlier than the sixth century. Now that Ainalov's positions are accepted, and indeed taken for granted, it is well to remember on how shaky a basis they were first built.

Today, the body of material at our disposal is immeasurably greater than it was in 1900. The smallest expansion has been in the field of illuminated manuscripts, where the only significant addition has been the Sinope fragment, now in the Bibliothèque Nationale.[19] Our knowledge of early Byzantine sculpture has been greatly enlarged: It is sufficient to mention the series of "Asiatic" sarcophagi, classified by C. R. Morey, and the Constantinopolitan sculpture of the fourth and early fifth centuries so thoroughly studied by J. Kollwitz. In monumental painting a great number of relevant works have come to light, such as the

synagogue of Dura, the frescoes of Bawit and Saqqara, of Sta. Maria Antiqua in Rome and Castelseprio, the mosaics of St. Demetrius and Hosios David at Salonica. In the minor arts, various finds of silver plate have opened a new chapter in the continuity of the classical tradition in the early Byzantine period. Even the Palestinian ampullae have been greatly increased in number by the discovery, in 1920, of the Bobbio series. But perhaps most spectacular of all has been the discovery of acres of floor mosaics all over the Mediterranean world, especially those of Antioch, the Great Palace of Constantinople, and Piazza Armerina, so that the development of this genre can now be traced in detail, from Gaul to Transjordan, for the entire formative period of Byzantine art, i.e., from the fourth to the sixth centuries.

As the archaeological material has grown, so has scholarly literature. Consequently, the problems of the origin of Byzantine art appear to us today in an infinitely more complex form than they did in 1900. The choice is no longer only between East and West, the former represented by the Hellenistic cities, the latter by Rome. I do not mean merely that other centers of artistic production, such as Milan or Roman North Africa or Constantinople itself, have entered the debate, or that, thanks to Strzygowski, we have become more aware of the Oriental hinterland whose immemorial traditions asserted themselves more and more as Hellenism declined. The problem is not primarily one of regional schools, a concept that has led to a tedious game of musical chairs in which the same crucial but "homeless" works of art, such as illuminated manuscripts and ivories, have been successively assigned to different geographical areas. If we are to argue whether, say, the Vienna Genesis was produced in Italy, Constantinople, Asia Minor, Antioch, or Mesopotamia, we should have a clear conception of the artistic distinctions between these various regions; but the very fact that such a choice can be entertained is proof enough that no clear distinctions can at present be drawn. It may be more fruitful to approach the problem from a historical and cultural point of view. This approach can offer a more adequate explanation of the artistic fashions that recent scholarship has discovered in late antiquity, such as the abstract, "pneumatic" fashion in Roman portraiture of the late third century that has been so acutely analyzed by H. P. L'Orange,

the deliberate provincialism and barbarity of official Constantinian art, the neo-Augustan style cultivated by the pagan Roman aristocracy of the fourth century, the elegant revival of the Theodosian period, and especially that phenomenon which surprises every student of the period, namely the preservation of a thin veneer of classical art well into the seventh century in works intended for the sophisticated upper classes. It may not be too much of an oversimplification to say that the transition from Greco-Roman to Byzantine art was parallel to the infiltration of paganism by the Oriental religions. In this process the Greek and Semitic East was in the lead over the Latin West. But it would be a mistake to assume an opposition between the Hellenized aristocracy of the East and that of Rome. Artistically as well as religiously, the two were really on the same side of the fence. Hence the distinction between East and West, between Rome and Alexandria, is far too simple. The same cosmopolitan center was capable of producing works in the pure classical tradition as well as crude artifacts in the Oriental folk style. The dichotomy in late antique art and culture which gave rise to the Byzantine synthesis cannot be expressed simply in terms of geography.

❉ ❉ ❉

In editing Ainalov's book, I have made little attempt to "bring it up to date." This would have been impossible, not only because so much new material and scholarly literature have been added since 1900, but also, as I have tried to explain, because the problems are no longer quite the same, and many of the conclusions which Ainalov had to demonstrate at great length are now accepted without question. Nevertheless, this book differs in many important respects from the Russian edition and, indeed, ought to supersede the latter. In the first place, I have had the good fortune of having before me Ainalov's own working copy of his book, which was formerly in the possession of the late Thomas Whittemore and is now at the Dumbarton Oaks Research Library and Collection. In this copy Ainalov has made a great number of alterations and additions which, for the most part, have been incorporated in the English translation. It is evident that Ainalov continued to annotate his text until about

Editor's Preface

1920 (see below, p. 7), and if he has not taken into account all the Western scholarship prior to that date, that was probably due to the isolation imposed upon him by the First World War and the Revolution. With the exception of a few tacit corrections and omissions which I have taken the liberty of making, all the other departures from the printed Russian edition are thus due to Ainalov himself.

As regards the footnotes, I have checked the bibliographic references that were directly accessible to me and have on occasion corrected Ainalov's inadvertent mistakes. For the sake of the student I have also added within square brackets a few references to more recent investigations. These references, which could have easily been multiplied tenfold, are, for the most part, to publications of specific objects, and not to discussions of broader issues. I have refrained from registering disagreement with any of Ainalov's statements even when I felt that they required some modification, except on a few specific details such as dates of objects.

An effort has been made to illustrate every significant object that is discussed by Ainalov so that the number of illustrations is about triple that of the Russian edition. Some of the figures are reproduced from the original photographs that were in Ainalov's possession. A few others have been kindly supplied by Prof. K. Weitzmann, to whom I should like to express my sincerest thanks.

The student who wishes to consult a more recent discussion of most of the material contained in this book may be advised to read C. R. Morey's *Early Christian Art* (2nd ed., Princeton, 1953). This will not only acquaint him with the monuments that have come to light in the past half century, but also show him how great a debt is owed to Ainalov by all scholars of this field.

CYRIL MANGO

Dumbarton Oaks
Washington, D. C.
August, 1960

Contents

The Hellenistic Origins
of Byzantine Art

Introduction

The two major factors involved in the formation of Byzantine art have been recognized long ago. It is generally acknowledged, first, that Byzantine art is founded upon the art of antiquity, and second, that this antique foundation underwent a gradual modification under the influence of Oriental arts; in fact, this very process of modification constitutes the actual formation of Byzantine art. According to N. P. Kondakov, "in the fourth and fifth centuries, Byzantine art, growing out of the art of antiquity, also acquired the latter's ornamentation. This antique foundation was Roman only in the beginning; in the fifth century it already bears obvious signs of Greek character, which seems to indicate a temporary revival of art both in Greece proper and in those Eastern countries that had adopted the Greek style." In another passage he describes the transformation thus: "The modification of the Roman foundation [of Byzantine art] consisted in the fact that borrowings from Egyptian, Persian, and central Asian art gave the decorative elements of Byzantine art their characteristic aspect." [1]

Elsewhere he defines more closely the essential nature of this change: "The combination of disparate styles and techniques in Byzantine art caused its first steps to be uncertain, a fact that forbids us to define its character in the fourth and fifth centuries. At present it would be utterly impossible to divide Byzantine art according to the various nations and provinces of the Empire. The only way to examine it is chronologically." [2]

Indeed, the earliest signs of the formation of Byzantine art emerge in the fourth and fifth centuries A.D. At that time there appears in various Eastern and Western regions the so-called "early Christian" art, "which is very similar to antique art," to quote J. Strzygowski, who characterizes it as "naïvely symbolical." [3] Only a few local variations modify its standard general characteristics.

According to the same scholar, early Byzantine art "is not very similar to the art of antiquity, whose traditions it adopted only to develop them further, so that it might even be considered to be the final flowering of antique art. It united within itself all local variations and flourished in the very places where early Christian art had existed. Its character was historico-dogmatic, and it was born on the day of the foundation of Constantinople. Constantinople played the same role in the Byzantine period as Alexandria did in the Hellenistic era. In the fourth century it was the meeting place of antique and Byzantine art. The arts of the various parts of the Empire were reflected in the art of Constantinople. Romans, Greeks, Alexandrians, Syrians, and the natives of Asia Minor lived and worked here together." [4]

Such statements of a general nature, concerning the formation of Byzantine art, its place of origin, and its character, are of course important, but they represent insights rather than a full examination of the facts.

It is therefore interesting to compare the above quotations from Strzygowski with equally sweeping assertions by a well-known authority on Oriental styles, A. Riegl, who writes: "Byzantine art is nothing but the late antique art of the eastern Roman Empire. There is no good reason to consider that the elevation of Byzantium by Constantine the Great marks a new era in art history. . . . We may praise the high technical execution of Byzantine works; we may shower our thanks upon Byzantine artists for having preserved established Roman techniques, but we will not add the Byzantine to our list of creative artistic styles, since even in its most mature creation (St. Sophia) we find not the original work of Byzantines, but the heritage of the rich and creatively productive art of another period—the Hellenistic era." [5]

The only important thing in this quotation is the indication that Hellenistic art is to be found at the roots of Byzantine art.

Introduction

If Riegl does not acknowledge the historic role of Constantinople in the formation of the Byzantine style, and if he does not feel inclined to recognize a creative spirit in this style, it is because his outlook lacks historical perspective. Kondakov has recently restated the historical point of view with great forcefulness: "A scientific examination of the history of art proves that every art begins by what is known as borrowing from a higher culture, or, more accurately, by communing with it." [6] Riegl forgets that Hellenistic art once found itself in the same position with respect to Hellenic art, which was then fully developed, and that there, too, the same decline of creative genius could be observed.

Thus the antique origins of Byzantine art appear to be sometimes Roman, sometimes Greek, sometimes Hellenistic. Essentially there is no difference between all these names: In all cases they refer to the Greco-Roman art of the imperial period. [7] However, a closer examination of the use of these terms will reveal a radical difference. In the first case, the origins of Byzantine art are credited to Roman art, or even to Rome itself; in the second, they are credited to the Hellenistic East.

Testimonials in favor of Rome have been brought forward by a group of Catholic scholars. F. X. Kraus can be considered the spokesman for those who maintain that Byzantine art is Roman in its origins. He attributes to Rome, inasmuch as it was the capital of the Empire, the creation not only of the art of the catacombs, but also of all early Christian iconography. He attributes an Alexandrian origin to only a few of the symbols and subjects of catacomb paintings, such as the fish, the anchor, Daniel among the lions, and scenes from the life of Jonah. Generally speaking his position is that "early Christian art is a creation of the Greco-Roman spirit." The art of Egypt, Syria, and Greece, as well as that of Sicily and Gaul, appear to him as provincial variations of Roman art, so that he considers Egyptian textiles with Christian motifs to be representative of late Roman work. [8] R. Forrer, who has published the textiles discovered at Achmim-Panopolis, generally agrees with this "Roman" school of historians. It is therefore not surprising to find him asserting that one of these vestments, although it shows clear indications of Arab style, was a gift sent by the Pope from Rome; he simi-

larly attributes a Roman origin to numerous other textiles, which he considers to have been imported from Rome.[9]

This tendency towards proclaiming the superiority of Rome in artistic matters is not too sharply or openly displayed as long as early Christian art is considered fundamentally Greco-Roman. But it does come out with particular vehemence when Kraus insists upon the Roman origin of Byzantine art. He considers that from the foundation of Constantinople to the eighth century one cannot speak of a Byzantine Empire, and that everything in it—government, law, and language—was Roman. He sees the art of Constantinople as Roman art in a provincial or barbarous form.[10] His basic error is his assumption that the Christian art of the Empire—eastern as well as western—is Roman. It is true that he also calls it Greco-Roman or even Hellenistic,[11] but this does not prevent him from seeing in it, at every point, Rome and the Roman school.[12] Nowhere does he explain in any detail what should be understood by "Hellenistic-Roman" Christian art.

There is at present general agreement among scholars concerning the Hellenistic character of ancient Roman art. It is also clear that the frescoes and sarcophagi of the Roman catacombs should be examined in the same light as the Pompeian frescoes and Roman sculpture of the first to the third centuries A.D. But it is equally true that Christianity, and the first forms of Christian art, came to Rome from the East. The advent of the Christian era does not alter this process. Does it not follow from this that the painting and sculpture of Roman catacombs were related to the Hellenistic art of Eastern Christians? Kondakov's Palestinian report gives an affirmative answer to this question.[13] In the present study we shall have occasion to demonstrate at length that compositions of Alexandrian, Syrian, and Palestinian origin were incorporated into the early Christian art of Rome. The Roman catacombs should be considered as monuments which preserve most completely and comprehensively the forms of Christian art received from the East. This view of Roman art does not deny the high, metropolitan standing of painting and sculpture in Christian Rome or the purity of its antique style; but it does establish the true character of this art and explain the meaning of the terms that are applied to it: Greco-Roman and Hellenistic. Before assuming that Rome, as the capital of the Empire, created

Introduction

early Christian art, we should turn our attention to Eastern art, if only because the forms of this art are illustrated primarily in Greek written sources.

When we study the antique foundations of Byzantine art, the Christian East assumes even greater importance, for it is there, and there only, that we can find more or less clear answers to the questions that have already arisen, namely, what this antique foundation is, what are its general character, its fundamental traits, and its peculiarities.

The foundation of Constantinople drew the center of the Empire nearer to Eastern lands that had a long tradition of Hellenistic culture. Christian art was formed in these countries on Hellenistic foundations, modified under the influence of the various popular styles of the East. Syria, Palestine, Asia Minor, Africa (with Alexandria as its center) found themselves in continuous and intimate contact with Constantinople.

Among the monuments of so-called early Christian art we can now distinguish whole groups which are of Alexandrian and Coptic, or of Syrian and Palestinian origin. Finally, one can point to an important group of monuments of Arab style with representations from Byzantine iconography. Only future research can show in what relation these groups stand to the later, mature Byzantine style. However, it can be confidently asserted even now that Alexandria, Syria, and Palestine were of extreme importance in the formation of this art, its style, and iconography. Hellenistic art, which is the foundation of the Christian art of the East, is also the foundation of Byzantine art.

The reader will find in this work the confirmation of these general theses, based on the examination of extant monuments.

❋ ❋ ❋

Today, twenty years after the publication of the first edition of this book, I hold the same views. After several investigations of a specialized character, such as those of the paintings of El-Bagawat, the study and description of the encaustic icons from the monastery of Mount Sinai (now belonging to the Ecclesiastic-Archaeological Museum at Kiev), the study of the Christian monuments of the Crimea (Chersonesus) and other works, these views have gained in depth and conviction. It may properly be

said that the Christian monuments of Egypt, Asia Minor, Palestine, Persarmenia, and Arabia constitute the main branches of that tree, the crown of which is called Byzantine art. The trunk of this tree is that same antique art which clothed with its own style the local forms of Oriental art and thereby was itself transformed.

The last great stage of Byzantine art is observed in the thirteenth and fourteenth centuries when it was illuminated with the reflection of the European Renaissance. This last chapter was investigated by me in a study entitled *Byzantine Painting of the Fourteenth Century* (Petrograd, 1917), in which I examined the so-called *question byzantine* in its widest context. Even for this late period I was compelled to recognize that the early groups of monuments constitute "schools" of immense importance not only in the formation but also in the further development of Byzantine art.

I. Miniatures of Alexandrian and Syrian Manuscripts

1. It may seem strange that the history of Hellenism in Byzantine art should begin by the examination of a work of the eleventh century.[1] But this will not appear so odd as we become more familiar with the work in question. Nicander's Greek manuscript (Νικάνδρου Θηριακά, Par. suppl. gr. 247) contains a poem about poisonous snakes and the herbs that counteract their bite. The manuscript is written in 8°, in a fine, clear eleventh-century script. F. Lenormant, who has studied it thoroughly, praises its illustrations very highly and perceptively remarks that they "diffuse an aroma of classical antiquity." [2] This χνοῦς ἀρχαιοπινής is apparent in the Byzantine copy of Nicander, indeed more so than in any other manuscript. Even the Latin copies of Virgil or Terence in the Vatican Library, which go back to the much earlier period of the sixth and seventh centuries, cannot compare with this eleventh-century Byzantine manuscript, which has preserved for us wonderful examples of Alexandrian painting, contemporary with the author himself. Nicander, who is numbered among the scholars of Alexandria, was born in the second century B.C.; he came from Colophon in Ionia.[3] His poems were popular among the Byzantines and were used as a school textbook.[4]

The style of the drawings in the Paris manuscript of Nicander, which so impressed Lenormant, caused him to ascribe to the third or fourth century A.D. the original from which this eleventh-century copy was made. But Lenormant did not know that illustrations to Nicander's text existed as early as the second century

A.D. Tertullian of Carthage saw these drawings and attributed them to the author himself: "Magnum de modico malum scorpios terra suppurat; tot venena, quot genera; tot pernicies, quot et species; tot dolores, quot et colores Nicander scribit et pingit." [5] The eleventh-century copy gives, of course, no clear indication of the number of drawings in the original. Nonetheless, this passage of Tertullian clearly establishes the existence, in the second century A.D., of an illustrated copy of Nicander, and the original itself may be dated to Nicander's lifetime.

However, although the Alexandrian original is reproduced with such remarkable freshness in the Byzantine copy, we cannot conclude that the copy is as masterful as the original. The execution of the figures bespeaks a decline of art; the faces lack the *joie de vivre* of antiquity; mouths often droop at the corners; legs and arms are slightly angular; lights and shadows are flat and cannot convey their antique vividness. Nevertheless, the rendering of muscles, copied line by line, the modeling of figures and the colors themselves are visibly refreshed and strengthened by the very process of copying. The most widely used color for depicting flesh is a brick yellow tinged with carmine, or sometimes a plain yellowish shade. Purple shadows are laid over a red ground. In general, purple plays the same role here as in the Joshua Roll, i.e., it is often used not only for clothing, but also for shadows. The use of browns and dark greens for trees should also be related to the antique practice of polychromy.

The opening section of the poem, relating how snakes were engendered from the blood of giants and how the goddess Titania created the scorpion, is illustrated by a miniature of Orion as a shepherd, wearing an *exomis* and high boots (fol. 2ᵛ). He is depicted walking towards the left, raising and swinging his crook. A scorpion lies at his feet. Another drawing (fol. 3) represents a shepherd, clad in a fleece and holding a staff (Fig. 1). The shepherd's right shoulder is bare; the fleece, whose ends hang down, is secured at the waist by a belt. A similar figure of a shepherd occurs at a later date in another Alexandrian manuscript, that of Cosmas Indicopleustes, whence it passes into the Vatican Octateuch, No. 746, fol. 45, where it represents Abel. The shepherd is burning a deer's antler over an altar. Three snakes, one green, one blue, and one red, drawn with remarkable realism, crawl

Fig. 1

around the altar, the pedestal of which is represented in reverse perspective. Next are depicted a peasant pressing grapes in a vat and a youth fleeing from two snakes (fols. 5 and 6). The youth wears a beltless tunic of a light violet color, with two black stripes or clavi.

Another interesting illustration is that of Gyges' tomb, shown in order to depict a plant that grew by his grave (fol. 18). The tomb is in the shape of the edicule of Lazarus, with five steps leading to its locked door. A trident drawn in ink on the gable of the edicule is a later addition. No less interesting is the representation of the plateau of Cilbis and the Cayster spring (fol. 18v: Fig. 2). Here we see a temple with four small columns, and over it a branch of a sacred tree which represents a grove, *pars pro toto*. A rock on the right conceals the steps and the lower part of the temple. A youth clad in a brown cloak and a light blue chiton is seated near the temple. Opposite him is a seated woman who leans her elbow on a rock and pensively rests her head on the palm of her hand. A kind of little house, apparently imitating a mural crown, rests on the woman's head; she is the personification of Cilbis. The two figures extend their arms to each other. There is a small pool at the youth's feet.

Particularly curious is the miniature (fol. 47) showing the birth of snakes from the blood of the giants (Fig. 3).[6] Its composition is very "painterly." The figures of the giants are placed in superimposed tiers over light blue water, which extends to the top of the picture. Two folios are appended at the end of the manuscript. On these are represented two scenes, both being independent full-page pictures. The first (fol. 47v) shows a peasant behind whom are a kneeling woman and a boy; the second (fol. 48: Fig. 4) shows a shepherd walking among the trees of a garden, holding a bent crook over his shoulder.

The miniatures of this manuscript, with the exception of the last three, have no background other than the plain parchment. They also lack frames, ground, and sky.

The content of these pictures, taken in conjunction with the text, points to Hellenistic scholarship and art. Everything suggests in a distant manner the diversity of forms and techniques of Alexandrian painting: the accurate observation of the shapes and colors of snakes and of various kinds of trees and grasses,

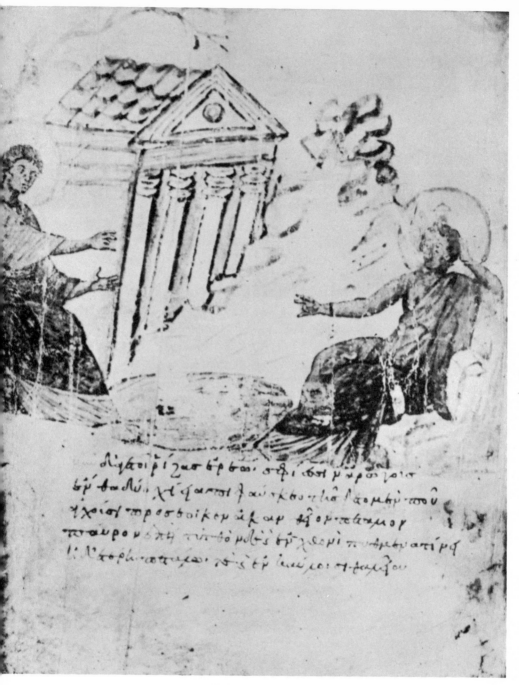

Fig. 2

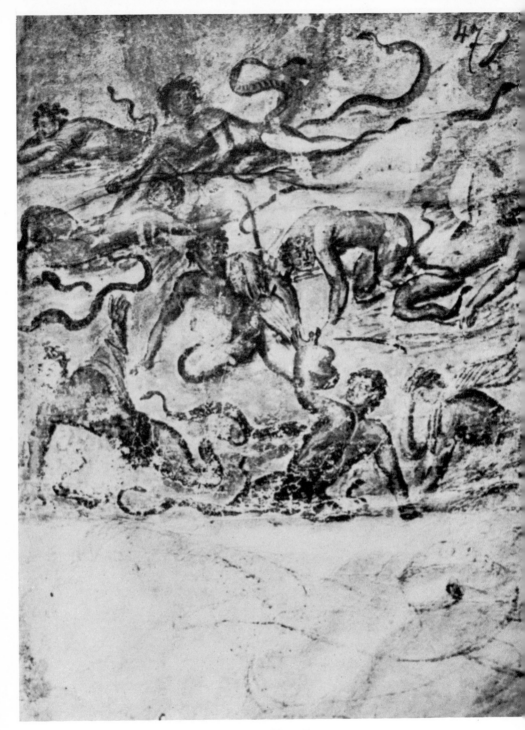

Fig. 3

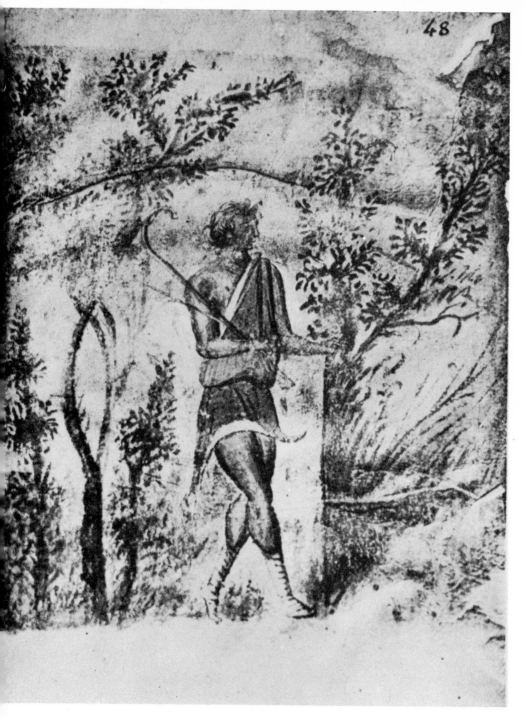

Fig. 4

shown flattened out, in linear drawing; a conventional type of composition in which buildings are smaller than human figures; the use of personifications with halos; the two types of miniatures, one showing figures directly on the parchment, the other being an independent, full-page picture on a separate folio.

2. Another equally instructive specimen of Alexandrian painting on Byzantine soil is provided by the manuscript of the physician Apollonius of Citium (Laurentian Library, Plut. LXXIV, 7), containing a treatise on the reduction of dislocations.[7] Apollonius lived before 60 B.C. and was either a disciple or an assistant of the Alexandrian physician Zopyrus. He wrote his work (*Commentaries*) not in Alexandria but elsewhere. One may suppose that the author lived in Cyprus, since the Ptolemy mentioned in the text may have been Ptolemy Auletes, who ruled Cyprus from 81 to 58 B.C. Verses 5 to 10 of the second dedicatory poem indicate that this manuscript is a copy of an ancient original. Schöne concludes from these verses that the Byzantine scribe, whom Dobbert identifies with the protospatharius Nicetas, must have had before him illuminated manuscripts of both Apollonius and Soranus.[8] But, we may ask, what was the date of these manuscripts?

The copy shows all the traits of eleventh-century Byzantine style. Only in a few cases does it reproduce the freshness of the earliest originals. These cases are most instructive.

The compositions are framed by an arch supported by two small Corinthian columns (Figs. 5 and 6). The lunette of each arch consists of a series of bands filled with ornaments of various shapes, such as a rainbow composed of little cubes, vegetal rinceaux, zigzags, lilies, and cruciform flowers (as on twelfth-century enamels). Along with these we find white dots, small rhombi, a twisted braid, a curling ribbon folded in accordion pleats, i.e., forms encountered in the ornamentation of sixth-century mosaics and manuscripts.

The figures are drawn inside the arcades: They are the physician, his assistants, and the patient, shown at various stages of operations. In most cases the figures are nude, but they are sexless. Sometimes the physician is clothed, and in one case (Fig. 6)[9] his tunic and cloak—in fact his entire figure—have been cop-

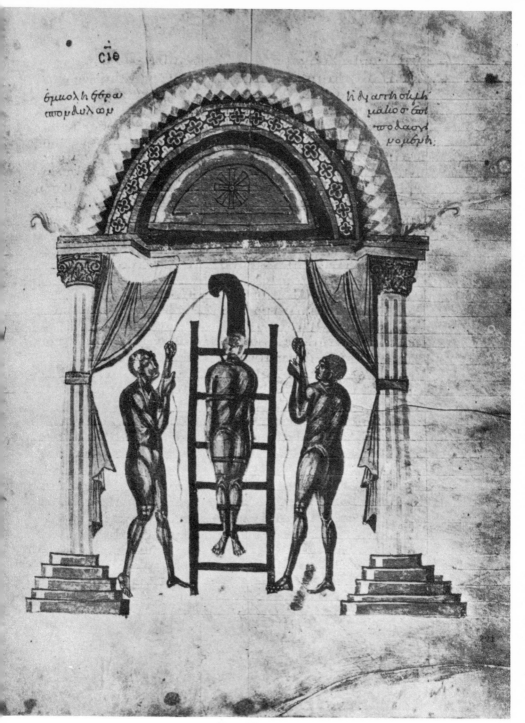

Fig. 5

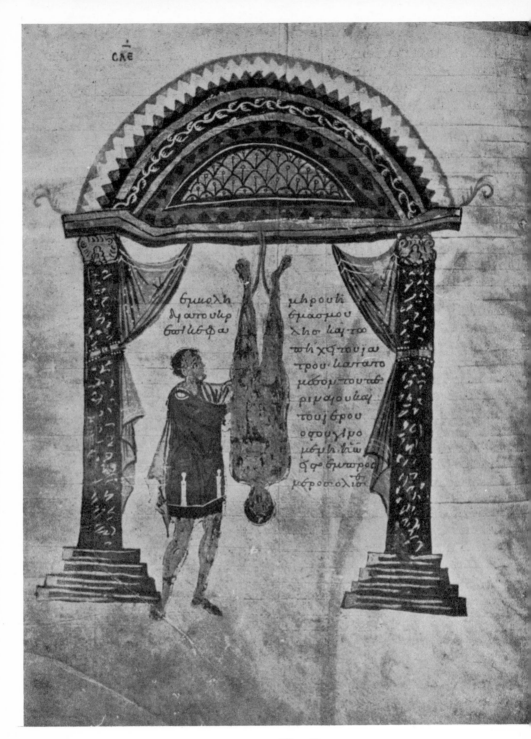

Fig. 6

ied with such exactitude that this could be mistaken for the fourth-century original. The correct foreshortening of the right foot, the white appliqué patches of the tunic in the form of a strip with a rounded head, the circular patch on the shoulder, the wide, regular folds of the tunic—all of these point to a fourth-century original.

Schöne calls attention to the late Byzantine characteristics of these drawings, such as the bearded physician [10] and the fact that some of the representations, such as the couch of Hippocrates, have been misunderstood. But we think it is a mistake to attribute the arcades to the scribe Nicetas. For in that case he should be credited with the symmetrical arrangement of the figures within the arcades, and with the execution of the columns, and more particularly of the hangings, in the style of the fourth century. The folds of these hangings are drawn with such elegant simplicity that they bear comparison with those of the Calendar of 354. The columns (Fig. 5) [11] faithfully express the structure of classical fluted columns; the stripes, resembling clavi, which decorate the hangings are faithful to the spirit of antiquity.

All the drawings of the original were likewise colored, as is indicated by the expression ζωγραφικὴ σκιαγραφία used by Apollonius himself when he mentions these illustrations.[12] Schöne finds it impossible to admit that the essential quality and the traditions of this form of painting could have been preserved in Byzantine copies. He does not, however, undertake to state positively whether Apollonius meant by these words the type of shading invented by Apollodorus of Athens or some similar type of painting.

Such doubts bring out the paucity of available data for the study of Byzantine painting. The characteristics of *skiagraphia* are found not only in the manuscript we are now considering, but in almost all the other works of Byzantine painting. The features which Byzantine painting inherited from the *skiagraphia* of antiquity can be clearly ascertained by comparing the flat, even-toned paintings of the Orient (Egypt, Assyria, archaic Greece) with this Byzantine copy of Apollonius with its shadows and highlights.

The terms most frequently used by Byzantine writers to designate painting are γραφή and ζωγραφία. The term σκιαγραφία is

also frequently found in authors of the fourth to the eighth centuries. St. Cyril of Alexandria and St. John Chrysostom use it to designate the initial design or outline of a picture, whether on a panel or on a wall, on which the colors are subsequently applied.[13] Moreover, St. Clement of Alexandria often uses this term to describe the paintings of Egyptian temples and the coloring of the body with various kinds of make-up.[14] Eusebius, on the other hand, uses it to designate entire paintings and the elaborate art of encaustic portraiture. Thus he had seen portraits of Constantine the Great and of private individuals done in encaustic painting, σκιαγραφίας κηροχύτου γραφῆς.[15] Eusebius also applies the same term (μιμήματα τῇ σκιαγραφίᾳ) to a representation of Constantine the Great and his sons in the act of defeating the dragon.[16] This picture was also executed in colored encaustic (διὰ κηροχύτου γραφῆς).

The miniatures in the manuscript of Apollonius of Citium are copies of ancient illustrations, which must have actually been contained in Apollonius' treatise on the reduction of dislocations and fully deserve the name given them in the dedicatory inscription, ζωγραφικὴ σκιαγραφία. The presence of modeling, of strong and soft shadows, of highlights—all these are traditional traits of ancient chiaroscuro, so that there is no reason to postulate here any other type of painting. On the contrary, the traditions of antique *skiagraphia* are as apparent in Apollonius' manuscript as is the survival of antique architectonic forms, hangings, and sometimes, figures.

Thus the main features of Alexandrian painting stand out in Apollonius' manuscript. If the splendor of the ancient model has not been equaled, its traditions and tendencies have been preserved. Here, just as in the Nicander manuscript, art has been called upon to serve a science—in this case practical surgery—which explains why such painstaking care has been lavished upon anatomical representation and why muscles are shown in such salient form, no matter how ugly this might make the figures. All these are features of the original redaction.

3. Other similar manuscripts, such as treatises on astronomy, geography, and military science (with representations of machines) present somewhat the same interest. Among such trea-

tises a conspicuous place is occupied by cod. Vat. gr. 1291 containing Ptolemy's astronomical tables.[17] This parchment manuscript decorated with magnificent miniatures shows how long-lived were the principles of Alexandrian astronomy in the Byzantine Empire. The place of origin of this manuscript is unknown, but as Usener supposes with good reason, all the indications tend to show that it was written at Constantinople, at the instigation either of an emperor or a person occupying high military office. The astronomical data of the manuscript allow us to suppose that the original of the Byzantine copy of Ptolemy, written between 813 and 820, went back to the third or fourth century.

The extremely refined and artistic execution of the miniatures shows that this manuscript represents, as it were, a revival of Alexandrian art on Byzantine soil. On the one hand, this manuscript reminds us of the existence of similar astronomical charts of Serapion and Hipparchus, on the other, it makes us recollect the astronomical theories of an emperor like Leo the Wise.

The tables are framed with a double red line after the manner of independent illustrations. On fols. 2ᵛ and 4ᵛ are the well-known representations of the heavenly hemispheres, the northern and the southern (Fig. 7). These hemispheres are painted blue. The colures and parallels are blue and gold; the constellations, represented as usual in the form of animals, are colored a darker shade than the spheres and have white hatching. Some of the animals are represented by means of white dots. The words in which Ptolemy explains the coloring of his diagrams deserve our attention. "We shall give," he says, "a somewhat darker color to our sphere in order to show it not in daylight, but by night, when the stars appear. . . . We shall represent each constellation in as simple a form as possible by means of simple lines of a color that does not differ greatly from that of the sphere." [18] This explanation proves that the pictures of the Vatican manuscript copy the illustrations that were due to the pen of Ptolemy himself, and at the same time enable us to bring out an essential trait of Alexandrian art, namely, the ability to render the illumination of objects both by day and by night, a technique that was admittedly conventional but nevertheless formed part of an artist's stock-in-trade. It is interesting that as a result of the representation in perspective of the band with the signs of the zodiac, the sphere

assumes a three-dimensional appearance. This sphere closely resembles the well-known Farnese globe and may be compared to the blue sphere in the manuscript of Gregory Nazianzen, Paris gr. 510, in the representation of St. Cyprian in his study. The latter sphere is likewise girded with a gold zodiacal belt represented in perspective.

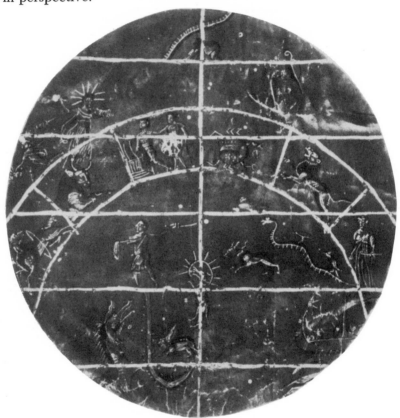

Fig. 7

On fol. 9 we have a diagram of the yearly revolution of the sun and its passage through the signs of the zodiac (Fig. 8). Within a big circle girded by a band with the twelve signs of the zodiac are placed two more concentric bands. In the outer one, under each sign of the zodiac, is a deity, while in the inner one are twelve nude female figures, six of a light color and six of a dark color: These represent days and nights. In the center, in a

medallion with a gold background, is the sun in the form of a youthful charioteer driving a quadriga. He holds a whip in his left hand and extends his right hand with open palm. On his head is a radiate crown.

The constellations are represented once more on fols. 22-37 in semicircular lunettes. On the first two folios they are placed on

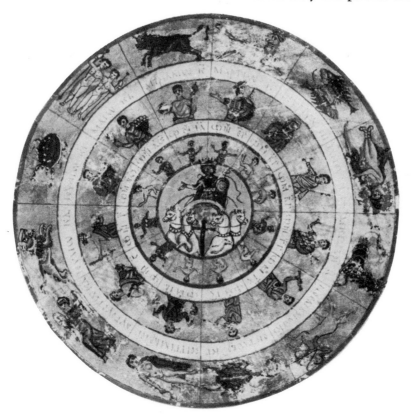

Fig. 8

a blue background, whereas on the other folios the background is uncolored. On fols. 45 and 46 are twice represented Selene and the four winds. On fol. 47, within a circle inscribed in a square, is another figure of Selene with a torch in each hand, in a chariot drawn by two horses. In the corners of the square are four medallions containing personifications of the day and night, of a type frequently found in Byzantine painting. There is hardly

another Byzantine manuscript that preserves with so much freshness and purity the elegance of antique figure drawing.

Cod. 655 of Vatopedi, a manuscript of the twelfth or thirteenth century, contains an illustrated text of Ptolemy's *Geography,* in addition to Strabo and the *Periplus* of Arrian. Bishop Porphirii Uspenskii has pointed out some defects due to faulty workmanship in this Byzantine copy: Longitude and latitude are confused and inaccurately shown; the colors have been improperly applied.[19] Nevertheless each map is set in a rectangular frame, with latitude and longitude numbers marked on the sides. All maps are colored: Rivers and seas are bluish-green, and various areas are tinted in different colors—pink, yellow, and yellowish-green. These drawings constitute valuable specimens of Byzantine cartography. Here are preserved such curious features as the representation of cities and villages in the form of rectangles outlined in red, which imitates the familiar type of the walled city. Walls of fortified cities are shown with crenelations.[20] However, the maps in this manuscript are considerably simpler than the famous map of Palestine discovered in Madaba; they have no human figures, animals, or trees, no fish or ships in the rivers and seas. The representation of cities is the only remnant of the landscape character of ancient maps. A few geometrical drawings are to be found in the text.

We may briefly mention here Athenaeus' treatise on engines of war (Par. gr. 2442). The various machines and ballistic weapons pictured in it represent one more facet of the Hellenistic heritage which Byzantine art has preserved for us.[21] The treatises of Athenaeus and Hero of Alexandria,[22] whose manuscripts contain also the drawings of Posidonius or Praxidamus, combine for practical use the scientific data of mechanics. In Constantinople the depot of military engines was at the Mangana, said to have been built by Constantine the Great.[23] In the invention of engines great fame was won by Anthemius of Tralles, one of the two architects of St. Sophia, who is said to have applied the force of steam to shake the house of his enemy, the orator Zeno.[24]

4. The most important monument of Alexandrian art, which enables us to obtain a clear picture of the Hellenistic tendencies in Byzantine art, is the celebrated manuscript of the *Christian*

Topography by Cosmas Indicopleustes (Vat. gr. 699).[25] Kondakov, basing himself on stylistic and paleographic evidence, has ascribed it to the seventh or eighth century.[26] There is no doubt that it is a copy of the author's own original manuscript, which was composed in Alexandria. Cosmas Indicopleustes, a scholar, astronomer, traveler, and theologian, was born in Alexandria. His *Christian Topography* dates from between 536 and 547, that is to say, from the reign of Justinian.[27] The drawings accompanying the manuscript are contemporary with the text, since the author frequently refers to them.

Cosmas' work is most typical of the Alexandrian scholarship of the Christian period. The author displays a purely Hellenistic erudition and a complete knowledge of astronomical systems and other branches of the learning of his time: botany, zoology, pagan philosophical systems, and Christian philosophy. The many-sidedness of his *Topography* is reflected in its drawings, the character of which varies according to the needs of the treatise. In some places these drawings are geometrical diagrams and terrestrial maps (as in Ptolemy's *Geography*); in other places they are independent tableaux, framed by a red line, representing scenes from the Old and New Testaments that are mentioned in the text; elsewhere there are pictures of various types of animals and plants, of Ptolemy's throne, or the Tabernacle of the Witness. The Vatican Codex does not include pictures of animals and plants, but these are found in the later copies (eleventh–twelfth century) in the Mount Sinai and Laurentian libraries (Sinait. gr. 1186; Laur. Plut. IX, 28).

Not only do the drawings of Cosmas Indicopleustes' manuscript present a full analogy to those of the Alexandrian manuscripts described above, but they are, as a whole, representative of Alexandrian art.

Among these illustrations we find Abel as a young shepherd, clad in a sheepskin and leaning on a long bent crook (fol. 55). This figure bears a close resemblance to a similar one in Nicander's manuscript. The bonds with Hellenistic art can be even more sharply perceived in the group representing a horse devoured by a lion (Fig. 9). Its composition is so true to the spirit of its ancient model that it can be used as a guide for a more correct restoration of the mutilated marble copies of this same

group in the Vatican Museum and especially the one in the Palazzo dei Conservatori in Rome (Fig. 10). The lion and the horse are completely covered with aquamarine tint, which indicates that the original group was of green marble. The shadows

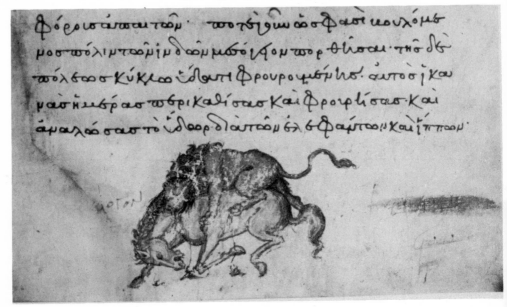

Fig. 9

are deep green and the gushing blood is red. This drawing is found on the last folio of the Laurentian Codex.

In the representation of Ptolemy's throne (Vat. gr. 699, fol. 15ᵛ), we see black Ethiopians, whose dark bodies faithfully portray the coloring of their race. Similarly, we find on an Egyptian textile a representation of the Ishmaelite merchant carrying off Joseph; the merchant's body is dark gray.[28]

In the representation of the resurrection of the dead, the bodies resting in the earth have the appearance of Egyptian mummies: They are wrapped in shrouds and tied with bandages. The mummies are depicted with particular clarity in the Laurentian copy. Such features in the drawings of Cosmas' manuscript must be considered characteristic of Alexandrian art, which, since early times, had introduced Egyptian motifs into the imagery of antiquity. The same traits appear in the representation of Gyges' tomb in the form of a *heroon* in the Nicander manuscript. W. M.

Miniatures of Alexandrian and Syrian Manuscripts

Flinders Petrie has discovered in Egypt a terra cotta representing such a *heroon,* its doors open, with one figure shown standing inside and another in front of the doors.[29] These data confirm the Alexandrian origin of the edicule and mummy of Lazarus in Roman catacomb paintings and sarcophagi. The edicule of Lazarus is also depicted as a *heroon* with a mummy on an Egyptian comb found in Antinoë that has been published by J. Strzygowski.[30] One should take particular notice of the mummies with portrait masks now being discovered in Egypt.[31] This explains why the mummy of Lazarus is shown with its face uncovered and the features marked on it.

It should be noted that Cosmas shows great fondness for personifications. In the illustration of Elijah's ascent to heaven (fol. 66ᵛ: Fig. 11), the river Jordan is depicted as a figure reclining on the ground. This faithfully reproduces the personification of

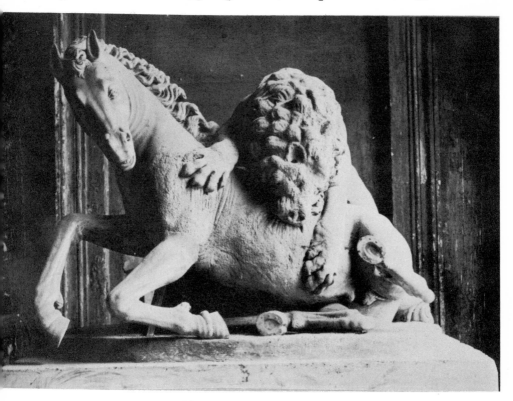

Fig. 10

rivers that was common in antiquity. The bearded Jordan is lean-
ing with his left elbow on an urn; the middle part of his body
is covered with a garment. In the diagram showing how the rays
of the sun fall on various parts of the earth (Fig. 12), the sun
is depicted as a bust, with a youthful head painted red, enclosed

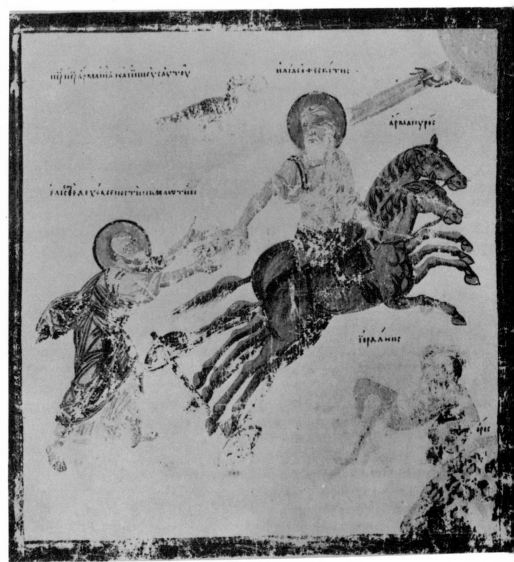

Fig. 11

in a solar disc. From the head, whose hair is tied with a band, stream golden rays. The last of these personifications is a bare-chested youth representing Death, the lower part of his body covered by a himation (fol. 56: Fig. 13). This figure sits on a rectangular box, probably a sarcophagus. Its face and body are

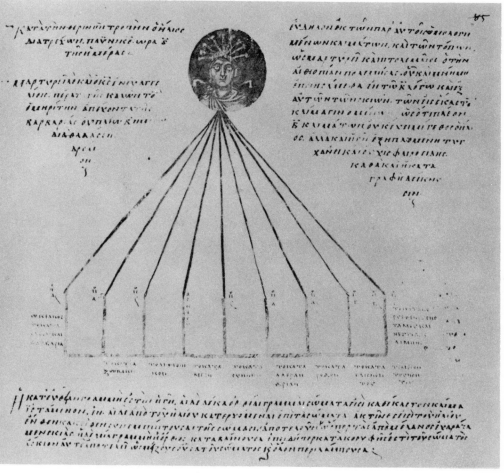

Fig. 12

of a light green color, to indicate deathly pallor.

A curious detail in Cosmas' manuscript is a vessel containing fire. It is depicted twice, in the scene of Moses and the burning bush and in that of the sacrifice of Isaac (Figs. 14 and 15). In both instances the vessel is depicted in the same manner: It is a

Fig. 13

squat vase on a short base, containing tongues of flame. It represents the burning bush in one case, the altar in the other. Vessels of this shape may be seen in a few crude fifth- and sixth-century terra-cotta reliefs that have been discovered in Africa,[32] depicting the sacrifice of Isaac. This similarity points to the fact that the drawings of Cosmas are certainly related to the local art of the fifth and sixth centuries.

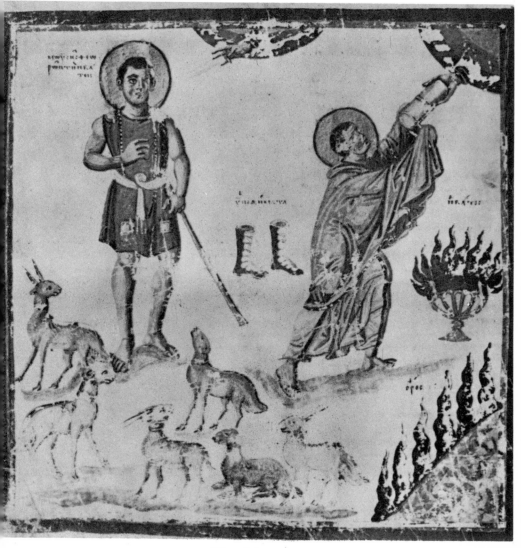

Fig. 14

Some of the compositions in Cosmas' manuscript bear a fairly close resemblance to those in the Roman catacombs, and, in the light of the above considerations, they take on great interest. Such are the scenes from the life of Jonah (fol. 69ᵛ) which remind us of catacomb paintings, but are especially close to the

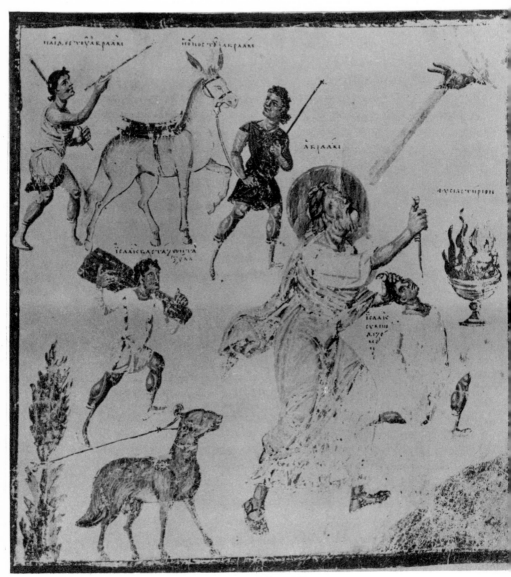

Fig. 15

same scenes on the famous sarcophagus in the Lateran Museum (Fig. 66). Cosmas' drawing reproduces *in toto* the composition on the right side of the sarcophagus. It shows a ship with sailors; two monsters swim alongside, their tails pointing up. The monster on the left is swallowing Jonah; the one on the right spews him forth and casts him on the shore. Jonah is shown lying on a raised shore under the gourd vine. All the figures are nude and remind us of antique *putti*, whose use is so widespread in Hellenistic art. It was in this genre that the earliest scenes from the life of Jonah were composed. Considering the general resemblance in the figures and in the arrangement of the composition in these two monuments, the few differences are not very important. The manuscript differs from the sarcophagus in these respects: There are two sailors instead of three; hind legs have been added to the monsters; Jonah holds his hand on his hip instead of behind his head. In both monuments fish are as usual shown in the water. The relatively late date of the manuscript copy probably explains a certain crudeness and angularity of forms in its drawings.

The composition depicting Elijah's ascent to heaven (Fig. 11) similarly reminds us of catacomb painting. In both cases we find the chariot moving to the right, the figure of Jordan with an urn, and that of Elisha behind the chariot. The most important difference lies in the fact that in the manuscript of Cosmas, we see a biga, with Elijah astride the second horse, instead of a quadriga with Elijah standing in the chariot. Moreover, a raven carrying bread in its beak and the hand of God, with a green ray, emerging from a semicircle have been added at the top of the picture.

A miniature in Cosmas' manuscript depicts the Babylonian envoys coming to Hezekiah. One should note here that they wear caps, tunics, cloaks, trousers, and footwear identical to those worn by the so-called Judean guards on Roman sarcophagi (Fig. 16).

Any theory to the effect that the work of Cosmas reproduced models of Roman origin does not stand up to a closer examination of the Vatican manuscript. The fact is that the "historical" compositions of the Last Judgment, the descent of the Holy Ghost, and others found in later Byzantine manuscripts originated in the art of Alexandria. The first attempt at such a representa-

tion of the Last Judgment was made by the Alexandrian scholar;
the drawings and the text of Cosmas offer irrefutable proof of
this.

The singularity of representations of the Last Judgment lies in
the fact that its component elements are arranged either in super-

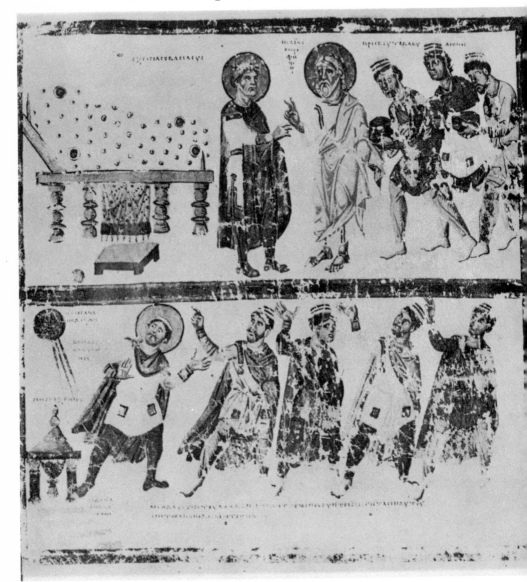

Fig. 16

imposed layers or in separate groups set out in rows, without any landscape setting that might have united these elements. In manuscripts as in murals, the parchment or the wall supplies the background for these layers or groups.

Kondakov has already pointed out the unmistakable relation-

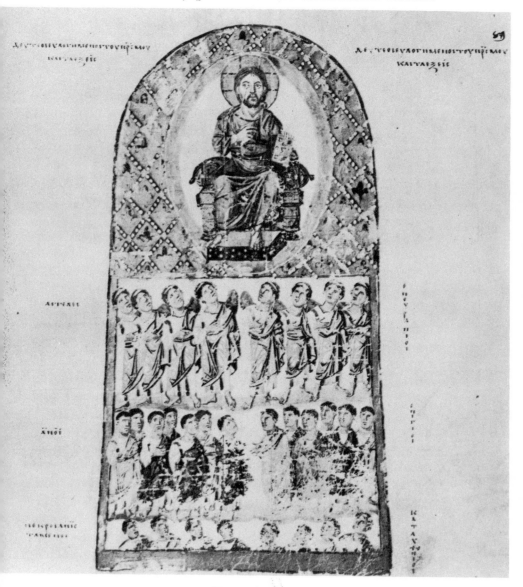

Fig. 17

ship between the representation of the Last Judgment and one of the miniatures in the Vatican manuscript of Cosmas.[33] This miniature, like several other illustrations of this manuscript, is executed in the form of a diagram. Its upper part is a semicircular arch surmounting a rectangle divided by two strips into three layers or friezes, each of which is filled with figures (Fig. 17). To understand this design we should study some of Cosmas' other drawings, which represent the structure of the earth and of the universe. The author himself gives these diagrams the general appellation of σχήματα. In some cases he calls them διαγραφή in his text. In the margins of the Laurentian manuscript next to some drawings of this type there are annotations by a later scholiast, who calls them διαγραμμή [sic]. The use of such terms proves that Cosmas himself, as well as his later Byzantine commentators, attributed to these drawings the meaning of linear diagrams.[34] All of the three types of diagrams known to antiquity are found in Cosmas: (1) ground plans, (2) elevations, and (3) perspectives (ἰχνογραφία, ὀρθογραφία and σκηνογραφία).[35] Instead of cross sections he employs side elevations. The diagram mentioned above, representing the resurrection of the dead, is based upon Cosmas' general conceptions concerning the structure of the universe. Cosmas teaches that a Christian must not accept the Hellenic doctrine of a spherical earth and universe, for it would make it impossible to explain either how the rain falls or how people walk upon the surface of the earth. He draws the antipodes, and by means of a graphic sketch that was to have wide currency in Psalters, he proves the impossibility of walking on the curved surface of the earth. In a polemic against those who maintain the older views, he exclaims: "How was it possible for the earth, which according to you is placed in the very middle of the universe, to have been submerged by the Deluge in the time of Noah? Or how can it be believed that on the first and the second day it was covered by the waters, and on the third, when the waters were gathered together, that it made its appearance, as is recorded in Genesis? But with even greater wisdom you suppose that there are men walking all the earth over with their feet opposite the feet of other men. We therefore depict (διαγράφομεν) according to your view the earth and the antipodes, and let each one of you who has sound vision and the power

of reasoning turn the earth around whatever way he pleases, and let him say whether the antipodes can all be standing upright in the same sense of the expression."[36] Elsewhere he says: "If then all the spheres lie in a continuous series and are solid, how is it possible to conceive that in such a configuration there can be a resurrection of the dead, and that men can ascend into heaven, that is in the second Tabernacle, whereinto Christ also, saith scripture, hath already entered the first of all? . . . Therefore

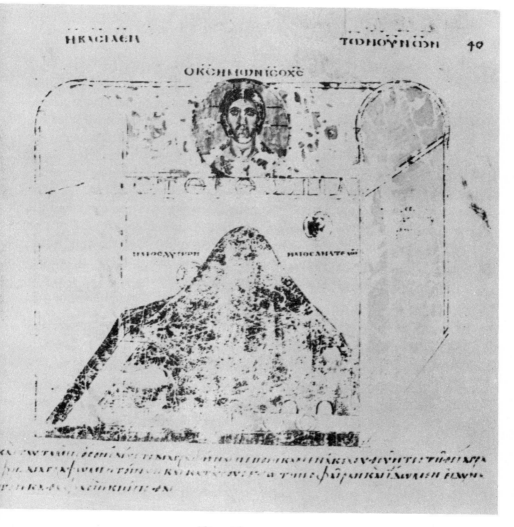

Fig. 18

the pagans who think that there is a sphere must deny the resurrection of the dead, their ascent into heaven, and the presence of waters above the firmament." [37] Denying the sphericity of the earth and of the universe, Cosmas argues that the earth is flat, that the heavens are supported above it by four walls and that the shape of the universe must be represented by that of Moses' Tabernacle, since Moses, the wisest of men, built his Tabernacle according to the shape of the universe. Cosmas therefore pictures the universe as a rectangular box with blue walls, the top of which is barrel-vaulted. Within the vault (Fig. 18) is placed a medallion with a bust of Christ. This is the first heaven (πρῶτος οὐρανός), as is stated in the inscription. The firmament (στερέωμα) is under the first heaven. According to the diagrams it must be represented as a ceiling, while the vault over it serves as a kind of roof. The waters are above the firmament; Cosmas represents them graphically by means of indentations or bulges over the line indicating the ceiling. This detail (i.e., the waters above the firmament) is represented by Cosmas in a drawing that shows the side view of the first diagram and which indicates the dimension of width: γῆ συνδεδεμένη τῷ πρώτῳ οὐρανῷ κατὰ τὸ πλάτος (Fig. 19).

The rectangular bottom of the box represents the earth and the seas, with the ocean surrounding a mountain around which moves the sun. An interesting schematic drawing showing a side view of the universe (fol. 39ᵛ) proves that Cosmas delineates the universe as a scholar and a geometrician, and that he presents his diagrams in the form of normal geometrical figures; hence his linear drawings should be regarded not as the work of an artist but as diagrams by means of which he explains his theory. In the diagram we are discussing showing the universe seen along its length (γῆ συνδεδεμένη τῷ πρώτῳ οὐρανῷ κατὰ τὸ μῆκος), there appears a division in the form of a line between the earth and the first heaven. This is the firmament or second heaven, στερέωμα τοῦ δευτέρου οὐρανοῦ, where, as is explained on fol. 108, are the angels and archangels.

All of this makes the delineation of the universe and its structure quite clear. But what is even more interesting is that Cosmas uses the side view of the universe seen along its width in order to present graphically the resurrection of the dead. He fills the latter drawing with numerous figures and adds a further parti-

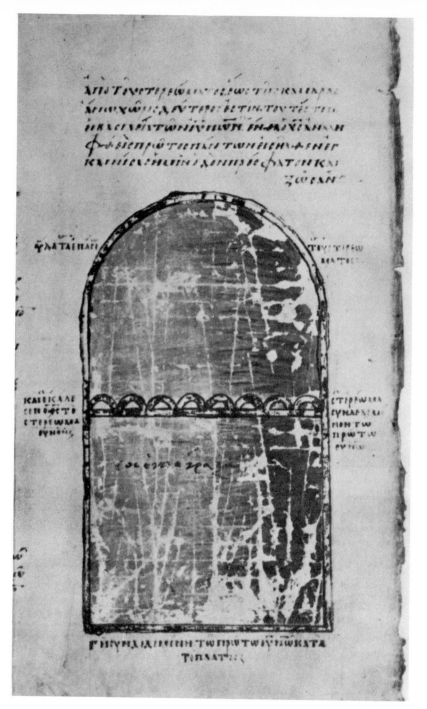

Fig. 19

tion to it, namely, the underground abode of the dead. In its general features, this diagram is basic to later Byzantine compositions representing the Last Judgment. The first version of this composition, due to the pen of Cosmas Indicopleustes, is therefore worthy of our particular attention (Fig. 17). In its upper part, i.e., inside the barrel vault, is shown Christ enthroned within an aureole. The blue background of the sky is crisscrossed by intersecting bands, forming lozenges; each of these contains a golden lily. The bands are ornamented with white dots, imitating pearls. These are the adornments of the mansions of the first heaven. Under the boundary line of the first heaven are shown the angels who stand upon the firmament (ἄγγελοι ἐπουράνιοι). Below, on the line representing the earth, stand the living people (ἄνθρωποι ἐπίγιοι). Under this line are pictured the dead, with shrouds and bandages, arising and looking upward (νεκροὶ ἀνιστάμενοι, καταχθόνιοι). Thus each layer of this composition has a definite meaning, and is disposed according to a definite plan, which eliminates any possibility of a picturesque treatment of the composition as a whole.

The only compositional element possible in such a diagram is a symmetrical arrangement of groups within each layer according to the rules of high relief: The heads of the figures do not emerge above a given level and their feet are placed upon the band which represents the ground. The group on the right faces the one on the left. The vault at the top, with its blue background, its golden lilies, and its pearls, does indicate some attempt at a picturesque treatment, but this element is employed only to provide a decorative background; it does not display any other characteristic of a picturesque style. Besides, the schematic presentation is frozen within the bounds of its structure, since each zone is assigned a definite position, from top to bottom. These zones differ from the friezes of antique painting in that they cannot be unrolled in a continuous form.

The subsequent history of the representation of the Last Judgment proves that many of the peculiarities we have just described became an integral part of it; they have been retained, for instance, in the Last Judgment contained in a ninth-century manuscript of the *Sacra Parallela* (Par. gr. 923, fol. 67ᵛ). The latter miniature (Fig. 20) is placed in the margin of the manuscript. At

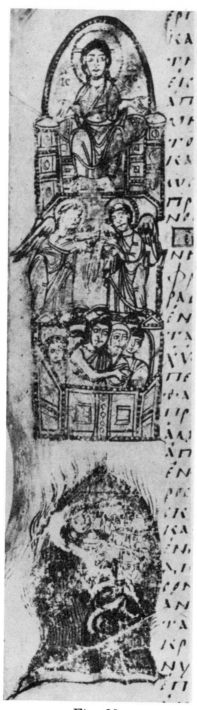

Fig. 20

the top is pictured Christ on a gold throne, displaying the palms of both His hands, i.e., showing the stigmata. Above Him a semi-circle reproduces the vault of Cosmas' diagram. Below this, above the throne, are shown two angels bowing down (προσκυνοῦντες). At their feet can be seen the walls of a city, the heavenly Jerusalem, within which are depicted the blessed, both old and young. Lower still, hell is pictured as a cave surrounded by tongues of flame, containing sinners who are encoiled by snakes. Above hell flows a river of fire, represented by a golden band called in the text ἡ πηγὴ τοῦ πυρός. This representation of the Last Judgment, perhaps the earliest extant, is rather different from Cosmas', but does maintain the first and second heaven of his diagram. Paradise, hell, and the fiery river belong to the later iconography of this subject, but are disposed according to Cosmas' general scheme, as Kondakov has already pointed out. The same structure of this subject may also be observed in early Psalters.[38] In the eleventh-century Psalter of the Vatican Library (No. 752, fol. 44[v]), Christ is portrayed at the top, enthroned under the semicircle of the vault of heaven. Before Him the earth is represented, as by Cosmas, in the form of a mountain; two figures, Adam and Eve, stand on either side of it. Under the mountain are two sinners lying in a cavern whose significance is elucidated by the inscription ᾅδης.[39] Further down the dead are shown arising, the men at the reader's left and the women at the right. Here, too, the miniature is in the margin of the manuscript.

Whatever changes may occur in the composition of subsequent representations of the Last Judgment, they always contain the most important feature of Cosmas' original version, namely the diagrammatic, as opposed to the picturesque, distribution of the component elements, which are arranged in superimposed layers. This division into friezes is particularly apparent in monumental compositions, as in the churches of S. Angelo in Formis, Torcello, Reichenau, and Oberzell.[40] Being normally placed on the western wall of the church, this picture keeps both its rectangular shape and its division into zones. This structure has been maintained even in Michelangelo's "Last Judgment" in the Sistine Chapel, although here we find no lines dividing it into layers.

In representations of the descent of the Holy Ghost we may also point out one feature that originates in the *Topography* of Cosmas Indicopleustes. These representations show twelve rays of light falling upon the heads of the apostles. Such a depiction of rays repeats a diagram of Cosmas, giving a visual representation of the sun's rays illuminating various parts of the world (fol. 93: Fig. 12). Cosmas' drawing presents the sun in the manner of an antique personification, a radiate bust with a red face, set in a medallion. The rays, in a bundle which broadens at its base, emanate from a point in the lower part of the medallion. Cosmas divides the earth, according to the intensity of the sun's rays, into ten regions only; the longer rays represent the lesser intensity of irradiation, the shorter ones the greater intensity. In pictures of the descent of the Holy Ghost, these rays emanate either from a half circle, if the scene is contained in a rectangular frame, or from a full circle, enclosing an *Etimasia* with the Holy Ghost under the traits of a dove, if the scene is set inside a dome.

It is most important to note the presence of these rays in a composition dating from the period of Justinian or perhaps a little later. This composition is found in St. Sophia at Constantinople, in a dome which represents the vault of heaven. It has neither the enclosed room nor the sigma-shaped seat, which normally constitute an important part of this composition when it is used as an illustration to the Gospels. Instead, the twelve apostles are shown standing on the lower rim of the dome, looking up. In the center of the dome is a blue medallion, enclosing an image of Christ seated on a throne from which emanate rays of light which fall on the apostles' heads. The blue medallion is surrounded by a wide golden band; the apostles are shown against a gray background. In the pendentives are shown groups of people, among them the figure of an angel.[41] No less interesting is another representation of the Pentecost in one of the lesser domes of the church of St. Luke in Phocis (early eleventh century). Here, too, the rays fall on the apostles' heads, while in the four pendentives are shown the "nations" (φυλαί and γλῶσσαι). In the center of the dome, however, in a blue medallion, is pictured a throne supporting the book of Gospels, a feature that regularly occurs in later representations of this subject.[42]

The use of Cosmas' diagram of falling sunbeams becomes even clearer in the similar composition in one of the domes of S. Marco in Venice (Fig. 21).[43] Here, under each apostle, are two figures representing the nation to which that particular apostle brought the Gospel. Compositions of this kind retain the following gen-

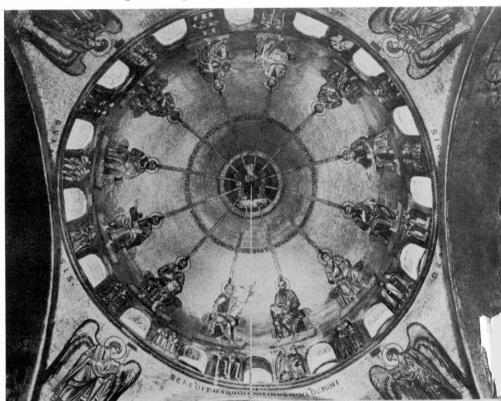

Fig. 21

eral characteristics of Cosmas' scheme: the long rays of light falling upon the heads of the apostles who represent various nations; the form of these rays, which have preserved the appearance of slim lines diverging downwards from a common center or circle substituted for the solar disc of Cosmas. This similarity is especially striking when the descent of the Holy Ghost forms a rectangular picture, as it usually does in manuscripts and frescoes.

But the significance of the manuscript of Cosmas Indico-

pleustes for the history of Byzantine iconography is not confined to these two diagrams. In addition to the representation of the antipodes that we have already mentioned, which is frequently found in Byzantine Psalters, we find here for the first time other compositions that owe their origin to the *Christian Topography*, such as the rising and setting of the sun behind a mountain representing the earth, and the rectangular map of the earth surrounded by the ocean. In this map the earth, too, is in the form of a rectangular island; on its sides are pictured four winds, blowing into horns. In Cosmas' manuscript these winds are contained in medallions set against the blue ocean that surrounds the earth like a frame (Fig. 22). This map, then,

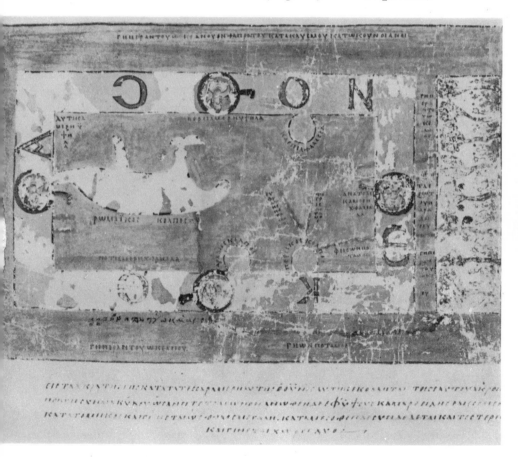

Fig. 22

was introduced into the canon of Christian iconography by Cosmas, the Alexandrian scholar.[44] Finally, the representation of the earth as a mountain surrounded by the ocean,[45] rare as this may be, can be regarded as a clear reflection of the geographical conceptions of Cosmas that became part of the illustra-

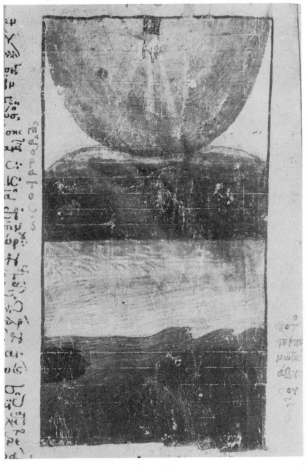

Fig. 23

tion of Byzantine Psalters. In the Vatican Octateuch No. 746, a number of miniatures have been appended to the text concerning the days of creation. These show the divisions of the universe and are related to the diagrams of Cosmas Indicopleustes. The miniature on fol. 19ᵛ is rectangular. At the top is a semicircle containing the hand of God; this is the sky (οὐρανός) (Fig. 23).

Below is the earth in the form of a hill (γῆ), and further down is a band of water, i.e., the ocean encircling the earth. At the very bottom is a wide brown band that stands for the kingdom of darkness (σκότος τὸ ἐπάνω τῆς ἀβύσσου). On another drawing, also rectangular (fol. 22ʳ: Fig. 24), a semicircle, i.e., the sky, is

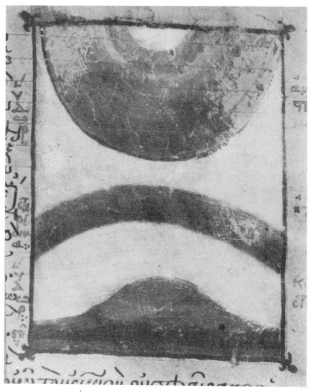

Fig. 24

once more shown at the top. Under this is a blue arc with the inscription στερέωμα ἤτοι οὐρανός ("the firmament, that is, the heaven"). The space between this arc and the upper semicircle stands for the waters that are upon the firmament (ὕδωρ ἄνω τοῦ στερεώματος). Below the firmament is shown a yellow mountain, which represents the earth (γῆ) and closely resembles the mountain in Cosmas' manuscript. These drawings are repeated in the Vatican Octateuch No. 747, which was copied from No. 746. In these miniatures only a few traits of Cosmas' cosmography have remained, namely the rectangular diagrams, showing the disposi-

tion of the celestial, earthly, and subterranean regions, and the earth in the shape of a mountain. The blue segment of heaven—a late motif—is also found in the Vatican manuscript of Cosmas, not among the schematic diagrams, but in iconic compositions. The same two Octateuchs also contain images of the Tabernacle of Witness, modeled after those of Cosmas.

The Smyrna manuscript of the *Physiologus* contains at the end a description of the universe accompanied by many drawings that are either borrowed from Cosmas' *Topography* or else are new compositions based on his diagrams.[46] These include animals, the Tabernacle, Moses and the burning bush, Israel's wanderings in the desert, the sacrifice of Isaac, a diagram of the universe (shown as an ark containing the earth in the shape of a mountain, the ocean, the sun, the moon, the stars, the first and second heavens with a bust of Christ under the semicircle of the first heaven), and others.

The manuscript of Cosmas also contains several New Testament scenes that shed light on other aspects of Alexandrian art during the century of Justinian.

In his analysis of the miniatures of the Vienna Genesis, Wickhoff has pointed out two peculiarities in the organization of their composition. The first is that the same composition combines several successive moments of an action. For this he coined a special term, *continuirende Darstellungsart* ("the method of continuous representation"), to distinguish it from the other, "the method of separate representation" (*distinguirende Darstellungsart*), where each separate moment of the action constitutes an independent composition. Wickhoff was not the first to discover these two types of composition: They have long been known to Russian as well as to foreign scholars. Wickhoff must be credited, however, with having indicated the supposedly Roman origin of the first of these two types. He points out its widespread use not only in ancient Roman art, but also in Christian art before Michelangelo, who himself used this kind of composition in his works. He sees the first emergence of this method on Roman sarcophagi, then in the paintings of the Roman period, and mentions the description of a few such paintings by Philostratus the Elder, who had seen them in Naples. Wickhoff believes that this method

of representation was foreign to Greek art at its peak.[47] But is this really so?

Before Wickhoff, Bertrand had arrived at quite a different deduction. He also pointed out compositions embodying the simultaneous representation of successive scenes on sarcophagi and in Pompeian painting, but he traced their origin to an earlier time, namely to the painting of Polygnotus and to ancient vase painting. He also gave a late example of it in the Renaissance, in Fra Angelico's "Coronation of the Virgin." [48]

Indeed, the paintings of Polygnotus united several episodes of one action into a single composition. Moreover, the figures were disposed in superimposed tiers on a predominantly monochrome background, and the landscape was reduced to a minimum. In compensation, the action of the figures was very developed, as in vase painting. Schöne admits that under the feet of Polygnotus' figures, the ground was represented otherwise than by the line used in vase paintings, but still assumes a sculptural development of the composition and not a pictorial one, as in late Hellenistic painting. Robert assumes that Polygnotus used a line for the ground.[49]

Traditions of Greek painting dating to high antiquity were inherited by Hellenistic art. They maintained themselves on Alexandrian soil as late as the reign of Justinian and were then taken over by Byzantine art. The big iconic compositions in the manuscript of Cosmas Indicopleustes, which preserve the ancient Greek traditions in their purest form, bear witness to this fact. Among them we may mention the sacrifice of Isaac, the conversion of St. Paul, Daniel in the lion's den, Moses and the burning bush, Elijah's ascension to heaven, etc.

The miniatures just mentioned, as well as all the others, i.e., the schematic drawings, the images of saints, and so forth, have the untinted parchment of the manuscript for background. But to distinguish them from the other illustrations, they are enclosed by a red strip or frame to form independent pictures. The structure of their composition displays certain traits indicative of the particular type of this painting. In the scene of the sacrifice of Isaac there is no ground under the figures' feet, which are placed in mid-air, but in such a manner that they give the im-

pression of stepping on the ground. The lamb is walking on the rim of the frame (Fig. 15). In the scene of the conversion of St. Paul (Fig. 25), two cities, Jerusalem and Damascus, are placed in the upper corners of the composition in order to fill

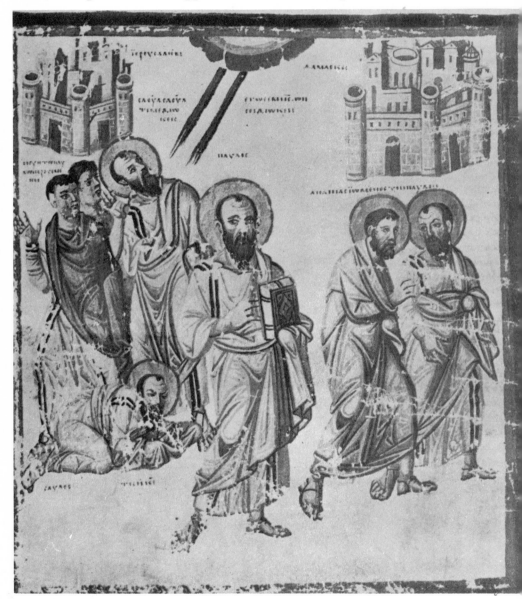

Fig. 25

the available space. The Apostle Paul, on his way to deliver a sermon, is the central figure of the composition; on either side of him are disposed scenes of his vision, his blinding, and his conversation with Ananias, i.e., his conversion. Most of the other miniatures are of the same type. Only rarely does a strip of land appear as it does under the feet of Moses, the river Jordan, and Habakkuk in the miniatures showing Moses and the burning bush (Fig. 14), the ascension of Elijah (Fig. 11) and Daniel in the lion's den (fol. 75), respectively. In these same compositions there is no ground under the feet of the other figures. This abbreviation of the pictorial element, and especially the disposition of figures and objects in superimposed tiers over a plain parchment background so as to fill a rectangular space, prove that Cosmas' miniatures represent a legacy from antique art, originating in that very ancient kind of painting we have mentioned.

The sacrifice of Isaac deserves special attention. In its upper part are pictured Abraham's slaves, two youths wearing chitons. One of them leads a donkey, the other urges it forward with a stick. Below, Isaac is walking with firewood on his shoulders (Fig. 15). To the right, Abraham, having seized Isaac by the hair and pulled his head back, points a knife at his throat. In front of Abraham, on a level with Isaac's head, is a sacrificial vessel containing fire. Below the figure of Isaac carrying firewood, a lamb is leashed to a tree. In the right-hand corner an elevation represents Mount Moriah. In the upper right corner appears the blessing hand of God, which emits a long ray that falls on Abraham's face. No other representation of this scene from the fourth to the sixth century has such a complex iconography.

The naturalistic traits of this scene which so impressed St. Gregory of Nyssa are particularly noticeable here. In his description of this subject, St. Gregory of Nyssa notes a whole series of particulars which may be observed in Cosmas' miniature. He mentions the position of Abraham behind his son and the kneeling posture of Isaac: These characteristics are common to all known representations of this scene except in the Syro-Palestinian school. But he also describes certain other details: Isaac's hair pulled back by Abraham's left hand, the knife pointed to the throat, and the "voice from above." [50] There are differences in only two respects: St. Gregory of Nyssa says that Abraham's

head was bent down towards Isaac, whereas in Cosmas' miniature Abraham gazes up at the ray issuing from God's hand; nor does Abraham place his foot upon the tied body of Isaac. This miniature of Cosmas is also interesting in that it relates the event in three successive scenes. Neither in catacomb painting nor on sarcophagi does one find this subject depicted with such wealth of detail. This scene, in its usual type, represents only one moment of the action, that of the raising of the knife and of the voice from above, i.e., the hand of God pointing to the lamb, which usually stands to the right. Sometimes, though rarely, another scene—Isaac carrying firewood—is depicted on sarcophagi.[51] Another version of this scene is found on a patera from Trier.[52] Abraham and Isaac are standing on either side of a tall altar behind which can be seen a building shaped like a rotunda, with a door ajar. This composition is found again on a sarcophagus in Madrid, but without the building.[53] In the catacomb of Callixtus, Abraham and Isaac are standing side-by-side with their arms raised. Schultze is probably right in interpreting this representation as the last scene of the action, i.e., the prayer of thanksgiving for Isaac's deliverance.[54]

That such intricate representations of the sacrifice of Isaac were known in Alexandria is proved by the words of St. Cyril of Alexandria in his epistle to Acacius, Bishop of Scythopolis, which was read at the Seventh Oecumenical Council: "So, if any of us should wish to see the story of Abraham pictured on a board, how would this be represented by the painter? Will Abraham be doing all his actions at once, or separately and in different forms? I mean something like this: he might be riding his donkey, accompanied by his son and followed by his servants; or, having left behind the donkey together with the servants and loaded the wood on Isaac, he might have the knife and the fire in his hands; and then further, in a different aspect, having bound the boy and placed him upon the firewood, he might be grasping the knife in his right hand in order to slay him. Yet, it is not a different Abraham who is seen in different parts of the painting under differing aspects, but the same person, since the painter's art always conforms to the requirements of the subject. For it would be impossible to show Abraham accomplishing at once all the above actions."[55] No such complex representations as those

described by St. Cyril of Alexandria have been preserved, but Cosmas' miniature is without doubt a monument of this type. On a Caucasian relief in the Moscow Historical Museum, Abraham is shown brandishing his knife over Isaac; below, a servant is shown with a donkey, but the figure of Isaac laden with firewood is missing. This relief dates from the seventh or eighth century.[56]

The conversion of St. Paul is shown in four combined episodes, as mentioned above; Moses receiving the Commandments is shown in two. This method of representation is in general characteristic of Cosmas' manuscript. The scenes depicting Hezekiah receiving the Babylonian envoys and Merodach's fright upon seeing the motion of the sun are also shown as a sequence of successive episodes.

In the two other codices, one in the Laurentian Library (Plut. IX, 28), the other in the monastery of Mount Sinai (No. 1186), we find representations of plants and animals in addition to the group of a horse devoured by a lion which has already been mentioned.[57] Cosmas himself speaks of his drawing of a unicorn, taken from a statue, and that of a rhinoceros. He probably drew other animals from life as well.[58] It is only natural to assume that these images were included in the original recension of the manuscript. Garrucci has already noted that the Vatican Codex omits some of the subjects to which Cosmas himself refers, among them a picture of the people of Israel in the desert, covered by a cloud by day and illuminated by a pillar of fire by night.[59] This drawing is found on fol. 75 of the Sinai Codex and on fol. 17 of the Laurentian. This leads us to assume that there may be other omissions in our oldest manuscript. The *Chronicle* of Theophanes notes briefly that in the year 450, those very animals which are depicted in the two late codices of the *Christian Topography* were brought to Alexandria.[60] The drawings of animals in the Laurentian Codex are notable for their incorrect proportions, but nevertheless reproduce ancient models. The animals are sometimes shown in motion, sometimes motionless in profile, as specimens of their species; the plants are shown flattened out as in a herbal. The latter are in the same style as the specimens of plants in the manuscript of Dioscorides.

In the manuscript of Cosmas Indicopleustes we find a fully

developed iconography of the saints, prophets, angels, cherubim, the Virgin, Christ, John the Baptist, Joachim, and Anna (Fig. 26). The elderly type of prophet, with long gray hair and a long beard (Isaiah, Zechariah), as well as that of John the Baptist, with long wavy black hair, a black beard, and a cross in his hand, but without a sheepskin, became firmly entrenched in Byzantine art. The "historical" type of Christ is worthy of our particular attention. Its appearance in Cosmas' manuscript might possibly be connected with the *mandylia* and holy images that were greatly revered in Egypt. One such *mandylion* was seen in Memphis by Antoninus of Piacenza.[61] A holy image, not made by human hands, was brought to Constantinople from Africa by Heraclius.[62]

The images of six-winged cherubim with long wings and blue feathers belong to the same type as the mosaics of St. Sophia. There the cherubim are depicted in the pendentives and therefore differ somewhat from Cosmas' figures. Being set in triangular spaces, they are wider than the latter and consequently have shorter wings and no hands or feet. The close resemblance of these mosaics to the drawings of Cosmas consists in the fact that the faces of the cherubim are framed by blue feathers.[63] This resemblance has also been pointed out by O. Wulff. In the relief from Khoja Kalessi in Isauria two six-winged Victories carry a medallion enclosing a bust of Christ. Wulff considers them to be seraphim.[64] The type of these creatures, with their hands and feet and six wings, indicates their kinship to the deities and genii of Assyria. They may be traced back to the cherubim known in antiquity, e.g., those that were removed by Titus from the temple of Jerusalem and placed by Vespasian on the gates of Antioch, an event that is recorded in the *Chronicle* of Malalas.[65]

The freshness of the original manuscript of Cosmas is to some extent lost in its Byzantine copy. In a few cases carelessness is noticeable in the execution of details. For instance, in the schematic drawing representing the resurrection of the dead, the mummies are shown in bust, whereas in the Laurentian Codex they are shown in their entirety. Another instance of the decline of painting is that the feet of figures are small when clad in shoes, whereas they are large when bare. Eyes and brows are drawn at an angle. Often the stance of figures lacks freedom and

reminds us of icon painting. Furthermore, we may assume that there are omissions. But whatever departures from the original codex one might postulate, Cosmas' manuscript is nonetheless an extremely close copy of the Alexandrian original. A whole

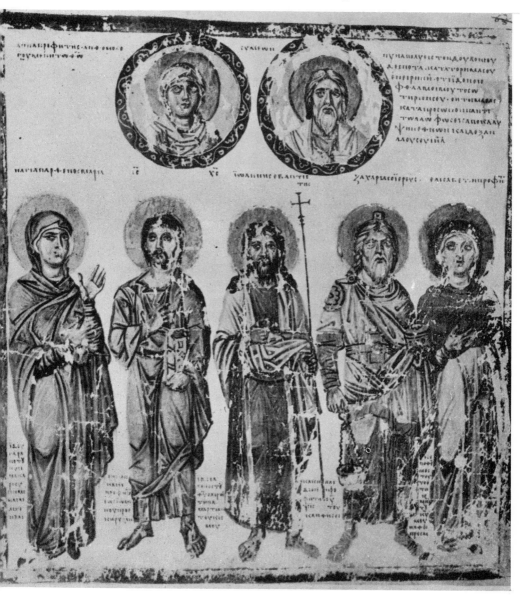

Fig. 26

series of new and heretofore unknown compositions and types enters subsequent iconography through Cosmas' *Christian Topography*. The importance of this manuscript consists precisely in that it unites the peculiarities of Alexandrian art with the creative genius of Christian art. There can be no doubt about the independence of this art we are considering, even through a late copy of a lost original.

The antique characteristics of the human figure as depicted in Cosmas' manuscript acquire therefore a special importance. This type of figure, distinguished, as Kondakov has noted, by the vitality and strength of ancient art, appears in manuscripts of Alexandrian origin. It is sharply differentiated from the figure types of other manuscripts, such as the Vienna Genesis and the Rossano Codex, and acquires significance in the study of certain monuments of unknown origin. We shall encounter again in sixth-century art these strong, wide-shouldered figures, with heavy hands and big feet, powerfully muscled and clad in loose garments.

It is not known when and for whom the manuscripts of Nicander, Apollonius of Citium, and Cosmas' *Topography* were copied. All that can be said about them is that they belong to Byzantium. In many respects they define the Alexandrian trend in Byzantine art prior to the eleventh century, since these copies belong to the period between the seventh [66] and the eleventh centuries.

5. The manuscript of Dioscorides (Vind. med. gr. 1) provides a brilliant example of Alexandrian art in Constantinople itself.[67] This manuscript was written for the Byzantine princess Juliana, who died in the year 528. In it are depicted various medicinal plants in a manner proper to a scientific herbal, a manner that we have already noted in other manuscripts of Alexandrian origin.[68] In the Dioscorides manuscript we find pictures of branches, roots, flowers, and fruits, and of all the other peculiarities of plants, as a visual aid for the study of their distinctive characteristics. This herbal is related to the existence of botanical gardens in Alexandria and Pergamum, just as the drawings of Apollonius of Citium are related to Alexandrian clinics and to their practical surgery. This category of drawing should be credited to very ancient man-

uscripts, unknown to us, which Dioscorides used in his work. A contemporary of Pliny the Elder, the physician Dioscorides was born in the city of Anazarbus, in Cilicia. He lived during the first half of the first century A.D.[69] Although he is not listed among the scholars of Alexandria, the whole character of his work distinctly indicates that it belongs to the Alexandrian school. We should therefore ascribe the first illustrated manuscript of his work to the first century A.D. We may also assume that among the miniatures of the earliest recensions were the two frontispieces showing the school of ancient physicians, followed by the two miniatures depicting Dioscorides himself in the midst of his scientific labors, although admittedly we cannot claim this with complete assurance for lack of positive proof. The second miniature shows Nicander and Dioscorides himself among the seven famous physicians of antiquity (fol. 3ᵛ). The mosaic of the Villa Albani, which originally came from the Baths of Caracalla, also depicts the seven physicians, and is more ancient than the Byzantine miniature; this seems to prove that pictures of these physicians could have decorated an illustrated codex of Dioscorides prior to the year 500, that is to say, before the execution of the Byzantine copy, but after the appearance of the first recension of Dioscorides' works, for at that time he could not yet have acquired his world-wide reputation. Visconti has rightly suggested that the physicians' pictures in the Byzantine manuscript must be considered copies of older portraits as well as of conventional representations (e.g., Chiron with a horse's body, fol. 2ᵛ). On the other hand, he believed, without adequate evidence, that the Dioscorides shown among the other physicians was not the author of this work, who is depicted in the other miniatures, and this in spite of the positive resemblance in the type of head, hair, and beard and the absence of any indication that two different persons named Dioscorides might have been represented here.[70]

As for the other two miniatures, representing the studies of Dioscorides himself (fols. 4ᵛ, 5ᵛ), nothing prevents us from considering that they first appeared in one of the original manuscript recensions of his works, since it was common in the time of the Ptolemies to have books luxuriously illuminated and ornamented with the portraits of their authors. Seneca describes this

kind of book, with lavish decoration and portraits. Thus only the one miniature that represents Princess Juliana can be considered contemporaneous with the manuscript copy. It therefore deserves our particular attention.

On the first folio is the image of a peacock with its tail spread out and covered with little golden "eyes." The book thus opens with the apotheosis of the princess, symbolized by this bird. Such was the opinion of Lambecius, who furthermore attempted to establish a relationship between this bird and the blossoming of trees. He thought that a peacock's image on the first dedicatory folio represented, on the one hand, the *consecratio* of the princess (as on the coins of Roman empresses) and, on the other hand, was connected with the botany of Dioscorides. Montfaucon proved by quotations from ancient writers that the peacock was considered a μηδικὸς ὄρνις, and assumed that its presence on the first folio was called for by the medicinal properties of the plants described in Dioscorides' treatise.[71] A peacock is also depicted in a later manuscript of Dioscorides in the Vienna Library.[72]

On the second folio are represented physicians seated in a circle. The miniature has a gold background and is enclosed by a beautiful frame of purely antique character, consisting of a garland around which is twined a ribbon. Here we find Chiron, Machaon, Pamphilus, Xenocrates, Niger, Heraclitus of Tarentum, and Mantias. On the third folio we find Galen, Crateuas, Apollonius, Andreas, Dioscorides, Nicander, and Rufus (Fig. 27). The picturesque traits of the mosaic from the Villa Albani have disappeared here. There is no ground, no portico or buildings, and there are no seats to be seen.

On fol. 4ᵛ Dioscorides is shown sitting in a folding armchair, holding a scroll, and wearing a blue himation (Fig. 28). A female figure, symbolizing Invention (εὕρεσις), clad in a golden sleeveless chiton and a purple palla, shows him a mandrake root. A dog that has been given a dose of this drug is writhing in front of Dioscorides' golden footstool. The background is light blue.

On fol. 5ᵛ, this same female figure of *Heuresis* holds the mandrake root in front of a painter who copies it on an easel (Fig. 29). Dioscorides is seated on the right, holding in his lap an open book over which he leans slightly as he is writing. The background of the miniature is occupied by an apse with a scallop shell under

its gable. Columns with Corinthian capitals extend to the right and to the left of the apse; garlands are hung over the entablature. The two personifications of Invention may be compared to the figure of Urania in a twelfth-century Latin copy of the

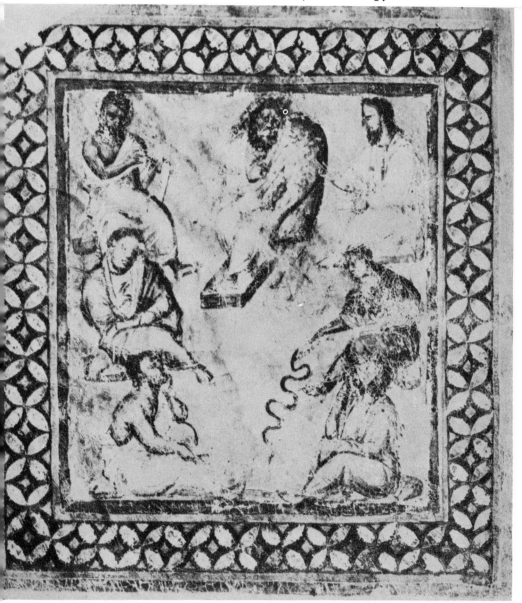

Fig. 27

The Hellenistic Origins of Byzantine Art

Astronomy of Aratus. Urania stands at the right and touches with her scepter a globe supported on a stand, while Aratus is seated at the left.[73] This is a suggestive analogy. Ultimately, there must have been a common source of the sixth-century Greek manuscript and the twelfth-century Latin manuscript.

The miniature representing Juliana herself (Fig. 30), is even

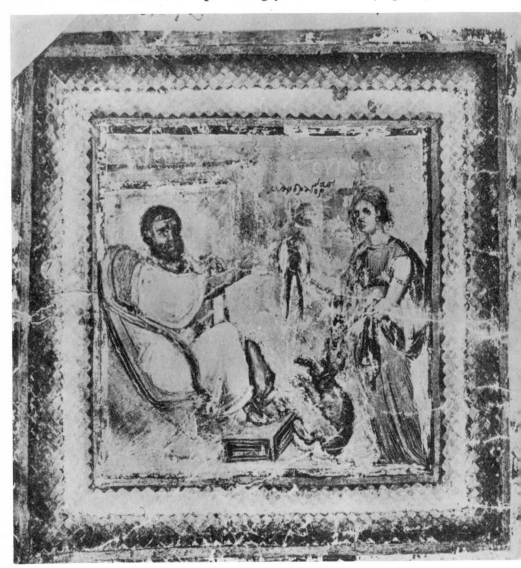

Fig. 28

more interesting (fol. 6ᵛ). It belongs, without doubt, to the time when the codex was made, i.e., to the beginning of the sixth century. Instead of the usual square picture we have here a round medallion divided into several compartments by a twisted braid. Two superimposed squares are inscribed in the medallion, so that the corners of one are laid over the sides of the other, form-

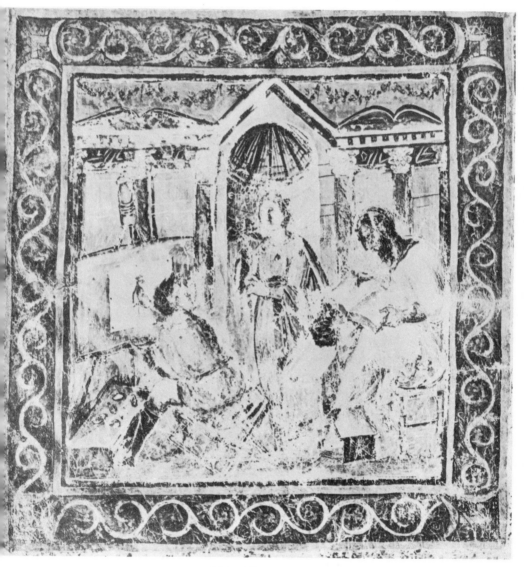

Fig. 29

ing an eight-pointed star. The princess is shown in the center, clad in luxurious imperial vestments, on a throne with a golden footstool.⁷⁴ Two female figures symbolizing Wisdom and Magnanimity (φρόνησις, μεγαλοψυχία) stand on her right and left. The

Fig. 30

former points to one side with the index finger of her right hand; the latter stands motionless. A nude winged *putto* (πόϑος τῆς σοφίας κτίστου)⁷⁵ offers to the princess an open book towards which she extends her hand. At her feet is a prostrated figure representing some other personification. The accompanying in-

scription has been read in various manners. Only so much is clear: εὐχαριστία τε. . . . Further on Kondakov has read φιλ . . . ; Gardthausen gives τεχνῶν.[76] Two round boxes containing scrolls stand below the footstool. Around the central representation, in

Fig. 31

separate angular segments, are pictured winged *putti* or genii, engaged in different tasks. It is no longer possible to distinguish their occupations because the paint has peeled off. It would seem that one of the *putti* paints a picture, standing at an easel; others are putting together the model of a house. Another *putto* bends

over a row of vessels. One of his companions sits beneath him on a long bench, holding an object that he has placed upon the bench. Four others, in a segment at the lower right, are rotating a pole by means of four beams inserted into it. These little scenes from the life of the *putti* are pictured on a dark gray background, while Juliana's image is shown on a bright blue background.

Fol. 7ᵛ bears the title of the work inscribed within a circular laurel wreath, with an eight-pointed star at the top (Fig. 31). The inscription reads: Τάδε ἔνεστιν Πεδανίου Διοσκουρίδου ᾿Αναζαρβέως περὶ βοτανῶν καὶ ῥιζῶν καὶ χυλισμάτων καὶ σπερμάτων συνφυλλῶν τε καὶ φαρμακωδῶν. ἀρξώμεθα τοίνυν ἀκολούθως ἀπὸ τοῦ ἄλφα. There is, as usual, a small cross over the inscription.

On fol. 391ᵛ, under the plant *enhaliadrys*, is represented a rocky shore, with the parchment itself for background; the sea is an even bright blue color (Fig. 32). A dolphin and another fish are seen jumping out of the water. A half-nude female figure, with an oar on her shoulder, is sitting on the shore. Her left elbow rests on the body of a monster with a large coiled tail, resembling the whale in the story of Jonah. The monster's head has long whiskers. Long strands of hair made of seaweed fall on the shoulders of the sea-goddess, who may be Thetis or Amphitrite. Two crab's claws can be seen projecting above her forehead. From the waist down the goddess is clad in a light blue chlamys, of the same color as the sea, edged in gold. Redin has noted the existence in Constantinople of a similar bronze statue of Thetis with claws on her head.[77] An ivory in the museum of Sens also reproduces the type of this goddess.[78]

In this manuscript produced in Constantinople we should note the same characteristics that we have already found in such abundance in Alexandrian manuscripts. We observe here a fondness for personifying virtues and natural elements, which calls to mind the personifications found in the manuscripts of Cosmas (Death, the Sun, the river Jordan) and of Nicander (rivers and cities). In addition, we find represented here a winged *putto* (πόθος τῆς σοφίας) and a whole series of scenes from the lives of *putti*. Dioscorides' manuscript gives us the first example of this genre in Constantinople.[79] It was just as common in the art of Egypt as in that of Rome, and in the Christian era became one of the most popular types of church decoration. The representa-

tions from the life of Jonah are particularly interesting because of their kinship to this Hellenistic genre. The *putti* are represented in Dioscorides' manuscript alongside personifications, drawings of various kinds of plants and trees, and portraits of physicians. Therefore they must be considered as a heritage of Alexandrian art on Byzantine soil.

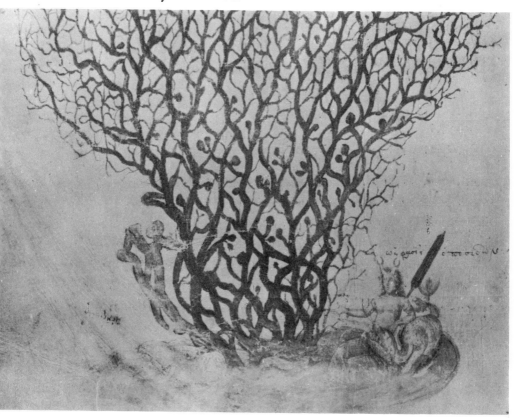

Fig. 32

This genre also appears in the Orient, presumably under direct Alexandrian influence. In the Dioscorides manuscript it appears in only one of its many forms. In church painting the *putti* are usually shown fishing from the banks of the Nile, in an Egyptian landscape. This distinction does not affect the general character of the images in the Dioscorides manuscript. All these small genre scenes must be classed together, whether found in Christian and Byzantine art or in Pompeian art and on various Egyp-

tian monuments. Later on we shall have an opportunity to examine this kind of painting more closely when we analyze characteristics of church decoration in the fifth and sixth centuries.[80]

The light blue, gold, and gray backgrounds in the Dioscorides manuscript are also of interest, as well as the use of gold for clothes or furniture, as, for instance, on the footstool of the throne. We can obviously recognize in these features the taste that is to become characteristic of the Byzantine style. The same three colors are used to cover large areas in Salzenberg's colored drawings of a cupola decoration representing the descent of the Holy Ghost: The central medallion is light blue, while the two bands below it are gold and dark gray respectively.[81]

All the manuscripts we have considered are copies made at different times either in Constantinople itself (as in the case of the Dioscorides manuscript) or in other parts of the Byzantine Empire, and provide us therefore with a clear insight into the traces of Hellenistic art that lie at the base of Byzantine art. To explain the appearance on Byzantine soil of manuscripts such as the ones we have been examining, it is most important to remember that Constantine the Great called Alexandrian scholars to Constantinople and founded a library there. The scholars were lodged in the Octagon, and it is there also that the library was established.[82] We can evidently assume the presence in this library of the original manuscripts, copies of which have been preserved to this day. This is proved most clearly by the Dioscorides manuscript.

No other sixth-century manuscript that is still extant contains such a clear indication of its origin. The Vienna Genesis, the Rossano Gospel, and the Joshua Roll in the Vatican Library have given rise to conflicting theories concerning the time and place of their manufacture. It will therefore be more convenient to describe them after a survey of a few Coptic and Syrian manuscripts.

6. The Coptic fragment of the Book of Job in the Naples Library (I, B, 18) should be ascribed to the seventh century, judging by the character of its only drawing, which is similar in style to the miniatures of Cosmas Indicopleustes.[83] The drawing is a pen and ink outline intended for coloring; its execution is rapid,

free, and skillful (Fig. 33). Only four figures are represented. The emperor at the left has a stemma of precious stones and a nimbus. His attractive youthful face is framed by a short beard. He is clad in a belted tunic with appliqué patches, two round ones near the hem and a long one terminating with a little circle on the shoulder. The lines of his chlamys are drawn over the

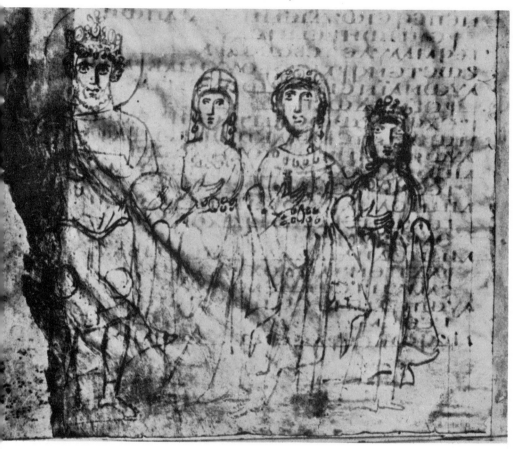

Fig. 33

tunic, on the right. The chlamys is fastened over his right shoulder and falls over his left hand in which he holds an orb, while his right hand grasps a scepter. At the right stands an empress, with a daughter on each side. The women wear royal headdresses and earrings. Their garments are girded with broad belts studded with gems. Over their robes, they wear chlamydes

draped over their left arms. Each of them holds her right hand on her breast. The daughters are shorter than the empress. The folds of the garments are drawn swiftly and naturally. The figure of the first daughter is particularly well drawn. The folds of her dress fall obliquely, outlining her right knee and her right leg which is set back. The figure of the empress is the least successful: Her head is not proportioned to her body; her neck is long and scrawny.

This portrait of an imperial family obviously belongs to those group portraits mentioned by St. John Chrysostom, who had seen them on title pages.[84] Representations of emperors in books duplicated imperial portraits painted on boards. Such details as the absence of the emperor's sons, the representation of two daughters only, the emperor's distinctive features, his nimbus, scepter, and orb, all these lead us to think of a specific historical ruler rather than of Job. The lack of inscriptions might be explained by the fact that these persons were universally known. On the other hand, the inscriptions could have been omitted in the preliminary tracing, to be inserted after the drawing had been colored.

This drawing from a Coptic fragment reminds us very much of the famous mosaics in S. Vitale in Ravenna depicting Justinian and Theodora. The royal garments, the crowns, and mantles of Justinian and Theodora are very similar to those depicted on the fragment. The difference consists in that the mosaic of S. Vitale represents the groups in motion, whereas the Coptic fragment shows the imperial family standing still, facing the onlooker, as in group portraits. The latter representation should be related to the imperial portraits that were officially sent from the capital to the provinces.

We have an excellent example of the ornamentation of Coptic manuscripts in the parchment manuscript of the Acts of the Apostles brought from Egypt by V. S. Golenishchev.[85] This manuscript is written in two columns. The margins and the space between the columns are filled with ornaments. Here are used the big initials that are so well known in Greek manuscripts from the ninth to the eleventh centuries. Various birds—merlins, ibises, storks, with their heads lifted up, red and yellow wings, gray bodies, and red bills—appear to be pecking at the letters, resting

Fig. 34

one leg either on the end of a letter or on a bar. Their feet are red. Three lines, used to mark the number of verses, are a characteristic trait of Egyptian calligraphy. The Egyptian manner of depicting birds is seen in their strict profile and stereotyped stance.

In the vertical margins we find an ornament similar to the appliqué patches we have seen on Coptic tunics: It is decorated with plant forms. We also find here the shape of a censer such as one sees in other Coptic manuscripts and in the Syrian Gospel of 586. Furthermore, arabesques also occur at the bottom of pages. A lion killing a gazelle reminds us of the lions of Sassanian art (Fig. 34). The arched hindquarters of the lion, its widely parted hind legs, the slenderness of its groin and the serrated appearance of its mane have a clearly Sassanian character. The drawing of the bodies is, on the other hand, weak. The same traits of Sassanian art are seen in the figures of griffins (Fig. 35). Their hind legs are as wide apart as those of the lions; their tails are turned up in a wide curve, which combines with the line of the rear legs to form an ornamental design. The position of the two confronted griffins is that of the antique motif of fighting griffins, but they are executed here in the Sassanian style. Their heads are black, their wings green, their bodies brown, their chins red, and they have yellow ornamental curls on their shoulders. On one of the following pages (Fig. 36) a bird is pecking at the outstretched muzzle of a fox, while a wolf attacks the fox from the rear and is biting its neck. The bird looks somewhat like a stork. Possibly this is a variant of one of the many well-known fables of the animal epos. The preacher Shanudah makes use of the animal epos in his sermons, which are composed in the style of Oriental oratory. In one of his sermons he describes a vision in which a bird fights a wild beast; victory goes to the beast, whom Shanudah compares to a sinner. In the same sermon he mentions a peacock and a partridge.[86]

Among the Christian symbols we may mention a simple cross with a long arm, used to represent the middle bar of the letter E, and a cross with two tendrils emerging from its base, i.e., a flowering cross. Both forms distantly imitate the cross called *nikos* that stood in the Forum of Constantinople and had globes at its extremities which in our manuscript are imitated by dots.[87]

Fig. 35

H. Hyvernat has published three specimens of liturgical manuscripts written in both Greek and Coptic.[88] These contain ornaments of a Coptic character like the ones in the Golenishchev manuscript and other Coptic manuscripts the ornamentation of which has been published by V. V. Stasov, namely little birds perched on a bough or on a letter, amphorae out of which birds are drinking water,[89] plaits, and arabesques.

7. The most important monument of Syrian art is a manuscript dating from A.D. 586, now in the Laurentian Library of Florence. It was written by the priest John and ornamented by the monk Rabula, a calligrapher, in the city of Zagba in Mesopotamia. The exact indication of the date and place of origin of this manuscript are given by the monk Rabula himself in the colophon. Consequently, this codex has long been considered a primary source for the study of Christian art in Syria.[90]

The majority of the miniatures in this manuscript consist of arcades designed for the purpose of framing the canons of Eusebius and sometimes the figures of the Evangelists. These arcades, bowers, and ciboria imitate the curious architectonic forms of antique mural painting. This particular type of arcade (καμάραι, as it is called in an Armenian manuscript of 955, now in the St. Petersburg Public Library)[91] will be examined below when we survey the wall paintings that have preserved the same architectonic types. But we may note at this point that the Pompeian murals furnish us with highly developed and varied prototypes of these architectonic forms. The Calendar of 354 proves that these forms had been adapted to the ornamentation of books.[92] As in the Syrian manuscript, the text of the calendar, prophecies, as well as representations of the months, busts of various figures, and full-length portraits of emperors are placed within the arcades. In describing the baths he erected, Sidonius Apollinaris compares the walls of the *caldarium* to the pages (*paginae*) of a book. The ceiling was painted but there were no images of histrios or other undignified subjects. He adds: "There will not be found traced on those pages anything which it would be more proper not to look at."[93]

In the Calendar of 354 one may distinguish five different forms of architecture, some simple, others more complex, but all marked

Fig. 36

by the fantastic character of the architectonic representations on antique murals. There are up to seven or eight such variants in the Syrian Gospel; they differ in the complexity of their structure but not in their fantastic character. The constructions consist of columns with arches, lunettes, apses, and conical roofs. All parts of these constructions are executed in a flat, linear design with many instances of reverse perspective. In one case only is an arch replaced by the domical roof of a pavilion, showing the lower zone of the dome in perspective, and the cassettes inside (fol. 9v). The basic form of structure adopted here is an arch with a lunette or an apse resting upon several small columns. The simplest form consists of three small columns connected by two small arches. The most complex and most characteristic type preserves the apse and the small columns, but instead of lateral columns there are two more apses each supported on two columns. Thus the whole structure resembles the light architectural motifs of Pompeii which usually consist of three or five bays. In the mosaic frieze of St. George in Salonica the fantastic structures consist of one central and two or four lateral elements.[94] In other instances this structure becomes a kind of ciborium on three small columns, or a pavilion on two columns, with a pointed roof (fols. 2r, 14r). These structures are furnished with vases, as in ancient murals. Birds are perched on various parts of the roof. However, the plants and flowers that are appended directly to the sloping sides of the roofs are unknown in antique painting.

On either side of the colonnades, in the upper part of the margins, are placed Old Testament scenes and individual images of saints and prophets. Scenes from the Gospel usually occur in front of the canon tables; below these, at the base of the little columns, are various plants and animals.

Surrounded in this manner, the architectural forms lose their antique character. The style of antiquity survives only in the slender, elegant little columns, in the conches, the Corinthian capitals, the dome, and in the fantastic conglomeration of these various forms suspended in mid-air. In addition to these forms there appear entirely new ones, unknown to the painting of antiquity, such as capitals ornamented with figures, either two heads in profile facing in opposite directions (fol. 3v), or two little birds (fol. 7r), or birds' heads (fols. 7v, 8v), or two fishes

(fol. 10ᵛ).⁹⁵ The columns are often replaced by a plain pilaster, covered with ornaments of flat, linear design. A new kind of ciborium, with curved sides and a conical top, seems to be a special feature of Syrian manuscripts. At the top of such cones there grow plants and flowers, and birds are aligned in rows. The same birds, plants, and flowers are also placed over apses or lunettes. The Cross of Calvary appears on a sphere or on a pedestal, placed at the summit of the cone; there are also crosses in circles within lunettes. The structures begin to show a strong resemblance to real Byzantine ciboria, or church apses on columns and arches. A whole series of new ornaments increase the difference between this type of structure and its prototypes in classical antiquity. This new ornamentation bears a close relationship to Coptic art; such are the rows of hearts (fol. 10ᵛ),⁹⁶ the wavy ribbon with a flower or a leaflet in each curve,⁹⁷ the lozenges with serrated sides (which play so prominent a rôle in the history of Byzantine ornament),⁹⁸ the zigzags, rhombi, squares,⁹⁹ and finally the rainbow strip composed of little cubes, also found in the mosaics of S. Vitale, and the rose. The general resemblance of these motifs to certain ornaments of Coptic textiles cannot be doubted. This points to a connection between Egyptian and Syrian ornamentation in the sixth century.

The curious frontispiece is placed at the end of the manuscript, since the Syrian text must be read backwards. Two wide pilasters, decorated with linear ornaments and surmounted by Corinthian capitals, support a vault with a conical top capped by vegetation. Within this Christ sits upon a throne with a footstool; on either side is represented a saint, possibly St. Ephraem and the Apostle James. Each of them holds the Gospel in his hand, which is covered by his himation, just like the Apostle Paul in the Cosmas manuscript. On the left is a hooded monk, probably Rabula himself, who places both his hands on the shoulders of one of the saints. On the right is represented another monk, possibly John, the abbot of the monastery (fol. 14ʳ: Fig. 37).¹⁰⁰

This miniature is composed in the same spirit as the frontispiece of the Dioscorides manuscript which represents Juliana surrounded by personifications, but its meaning is different. This manuscript is dedicated to Christ. In another miniature, depict-

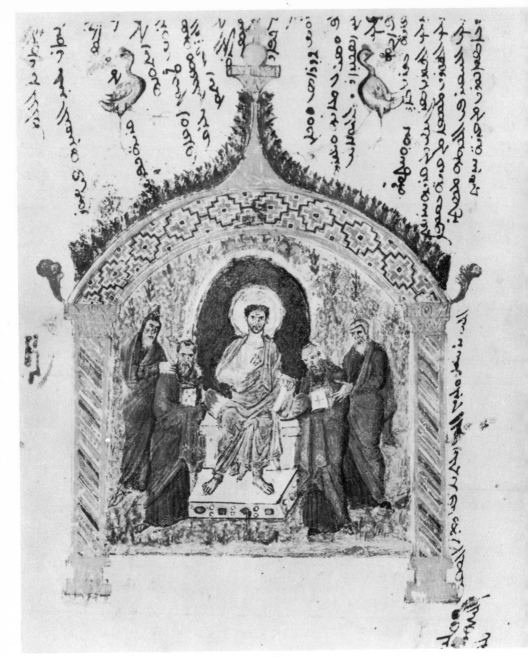

Fig. 37

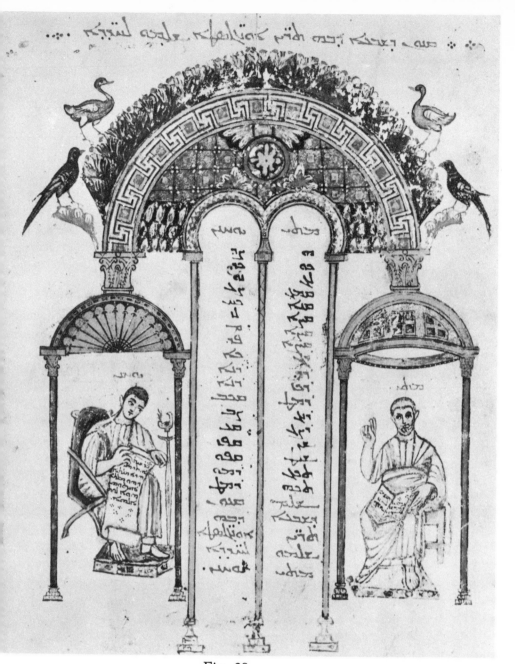

Fig. 38

ing the election of the twelfth apostle (fol. 1ʳ), the figures are arranged in a semicircle and are seated in the same manner as the physicians in the Dioscorides manuscript.

The Syrian manuscript contains the earliest known representation of an Evangelist writing his Gospel (Fig. 38). He is shown seated under an arch of fantastic construction; a tall lampstand with a small light is in front of him. This representation of a writing Evangelist may be compared to the image of Dioscorides writing his treatise. An open scroll is spread on the Evangelist's knees. In the next arch sits another Evangelist, holding an open book on his knees; his right hand is lifted with two fingers extended.

Many of the peculiarities that we have already singled out in Alexandrian manuscripts are combined here in an organic whole. Various species of birds, animals, plants, and fruits remind us of the elaborate ornamentation of Coptic textiles and of the illustrations of the works of Nicander, Dioscorides, and Cosmas Indicopleustes. For instance one may compare the small goat, scratching its head with its hoof, to a similar representation in the Mount Sinai Cosmas, in the picture illustrating Indian palms. Other miniatures, however, present large picturesque compositions. It is rare to find in the art of the sixth century landscapes that have better preserved the character of antique painting.

The first miniature (Fig. 39) is divided into two parts by a strip. Above is represented the Crucifixion; below, the women at the Sepulcher. In the scene of the Crucifixion, there are mountains, one on each side of the cross; they are light blue with delicate lilac shadows. The band of sky is light lilac above, shading to pale pink below. The ground is green with yellow highlights, and the legs of the figures cast green shadows on the earth.

The landscape of the lower scene is more complex. The sky above it is also lilac, shading into light pink. The Holy Sepulcher is pictured in the center, completely surrounded by a dense garden. The trees and bushes are colored in airy hues: Those that are closest are green, those that are farther away are light or even dark blue. The earth is light green, in places turning to yellow. The Holy Sepulcher is represented as a rotunda with a roof of fantastic character, like the pavilions in those Pompeian murals that depict gardens.

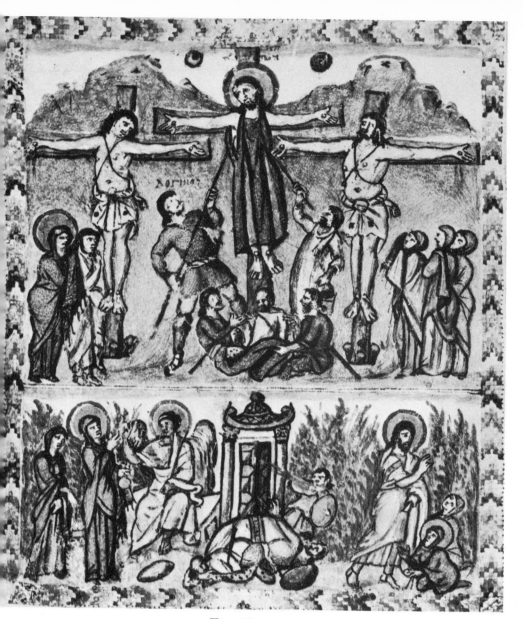

Fig. 39

Finally, in the miniature of the Ascension (Fig. 40), bands of purple cloud are seen in the sky, which is of the same pinkish color. It is particularly interesting to note that the upper portions of these clouds are highlighted in two colors. The clouds beneath the sun are flushed with vermilion red, those on the side of the moon are shot with blue. This can be explained by the fact that the sun is shown red, while the moon is gray-blue. The cherub under the *mandorla* in which Christ is carried upwards by angels is also vermilion, and the clouds under the cherub are likewise shot with red. The mountains visible behind the apostles' heads are greenish and light blue, shading into lilac.

In all these miniatures the garments of the figures are executed in strong, bright colors. The faces, hands, and clothes are sharply highlighted. The shadows are as vividly delineated as in those Pompeian paintings that have bright daylight illumination.

Thus, the antique landscape with its traditional techniques appears on Syrian soil. Wickhoff has made an observation that is important for the history of Byzantine painting: He pointed out that the sun's rays and their reflection from rocks and clothes in one of the miniatures of the Vienna Genesis is a heritage from the illusionistic painting of antiquity. These rays, and the highlights that result from them, he connected with the attempts to reproduce various effects of illumination in Alexandrian painting. Examples of this type of painting are described by Philostratus the Elder.[101] Having pointed this out, Wickhoff concluded that the Vienna Genesis (which he dates to the fourth century) is the last example of the illusionistic style in the history of painting. This, however, is contradicted by our Syrian manuscript. Not only are the distant mountains and trees executed in the colors of aerial perspective, i.e., lilac and light blue, but even the clouds are highlighted by the sun and the moon. Shadows cast by figures on yellow ground become green. One cannot therefore deny the Hellenistic heritage even in this work of a Syrian illuminator. We must consider as a simple misunderstanding the theory that ascribes a later date to the miniature of the Crucifixion. This miniature shows no trace of retouching; the antique character of its colors and types and the peculiarities of its composition prove beyond doubt that it is contemporary with the other miniatures.[102] The Greek inscription ΛΟΓΙΝΟϹ

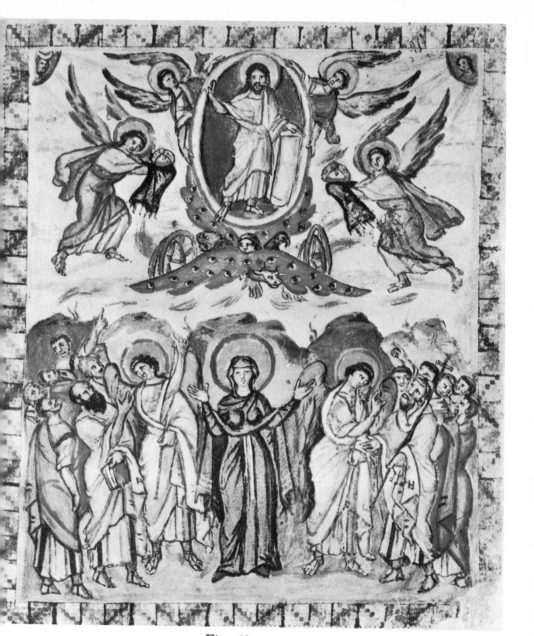

Fig. 40

above the centurion's head shows that the original copied by Rabula was Greek.

The antique traits of the architecture and landscape of the Syrian manuscript connect it with late Alexandrian painting. On the other hand, indubitable links with the art of Palestine are an equally important feature of this manuscript. The miniatures placed in the margins with no frames and no ground under the feet of the figures, alongside plants and animals, may be considered as a crude form of painting, essentially decorative in character and execution. Such scenes are often split into two parts in order to decorate the canon tables. One part is then represented to the left of the arcades, the other to the right, in order to form a symmetrical arrangement or fill the available space. These compositions are nothing but distant copies of fully-developed and widely-used originals. The big, full-page miniatures fall into a quite different category: They represent, with adequate detail, originals unknown to us, and therefore are of primary historical importance. The resemblance of both groups to the Palestinian ampullae of Monza proves the close tie between the arts of Syria and Palestine. In spite of the small number of subjects depicted on the ampullae, one can point to many common traits. Both the Syrian manuscript and the big ampulla (Figs. 41 and 107) represent the Annunciation with a spindle and with the Virgin standing. In the Nativity there appears behind the manger the same kind of building that we see in front of the manger on the same ampulla. This resemblance is particularly striking in the representation of the Crucifixion, with the two thieves on either side. The figures of the thieves are shown in almost exactly the same manner in the manuscript and on the ampullae: They hang above the ground wearing loincloths, their feet fastened to the pole of the cross. However, the thieves' arms are bent at the elbow on the ampullae, whereas in the manuscript they are stretched out on the cross beams. This probably resulted from the fact that the composition could not be fully developed within the circular dies of the ampullae, whereas the miniature had space enough for the purpose. At the foot of the cross in both instances, soldiers are casting lots for the clothing, but there are usually two of them on the ampullae and four on the miniature. The sun and the moon are also depicted in both cases.

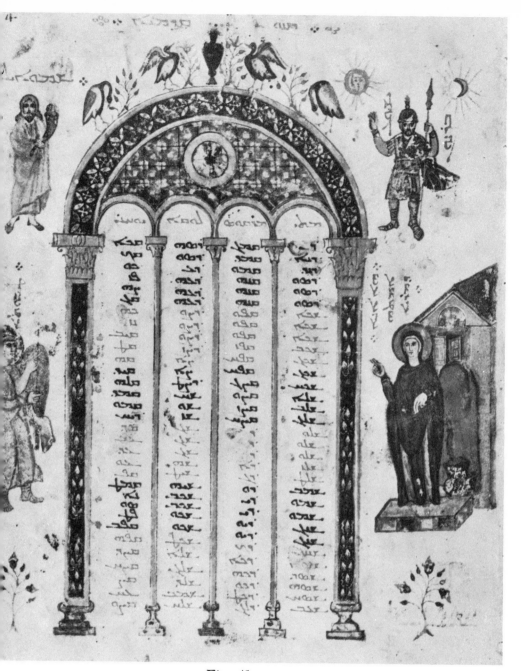

Fig. 41

A close resemblance may also be found in the scene of the Ascension (Fig. 40). The *mandorla* in which Christ is ascending and the four angels occur in both instances. The two angels who are shown in half figure holding the upper portion of the aureole and bending back in opposite directions, are copied from those on the ampullae. The two lower angels are different in the miniature and on the ampullae. In the former case they are holding crowns, while in the latter they are flying in the manner of Victories and upholding the *mandorla*. Beneath the *mandorla*, the open hand of God and the group of apostles, set in two rows of figures, are repeated in both cases.[103]

The number of images taken from the New Testament in the Syrian manuscript of 586 is remarkably large: No other known document of that period possesses so many of them. The miracles and the Passion of Christ predominate, whereas the parables are absent. The historical character of these representations suggests a Palestinian origin. The veneration of the holy places of Palestine and in particular of Jerusalem, and the establishment of churches, monasteries, and communities of cenobites in the very places hallowed by the birth, sufferings, and death of Christ—all of this must have prompted the representation of the various events described in the Gospels and imparted to them a historical character. We shall have to refer frequently to these representations in examining other documents that are related to the Syrian Gospel of Rabula.

The change that occurred in the antique architectural forms corresponds to a change in the antique type of human figure. It is true that the heads of figures are still encircled by nimbi of various colors—light blue, yellow, and gold; but the very type of the figures—their size, bodily shape, facial character—is very different from the ideal type of antiquity. The lean, elongated oval of the Virgin's face (Fig. 42), her big, dark eyes, her narrow, long nose, her small, thin lips are so indicative when compared to the full, florid faces of antiquity, even those of Cosmas Indicopleustes, that we can use the type of the Virgin in the Syrian Gospel as a point of reference in our studies of the feminine type in the mosaics of Ravenna and other monuments of unknown origin.[104] The same change can be noted in the type of Christ (Fig. 39). The heavy black hair that falls down on his shoulders

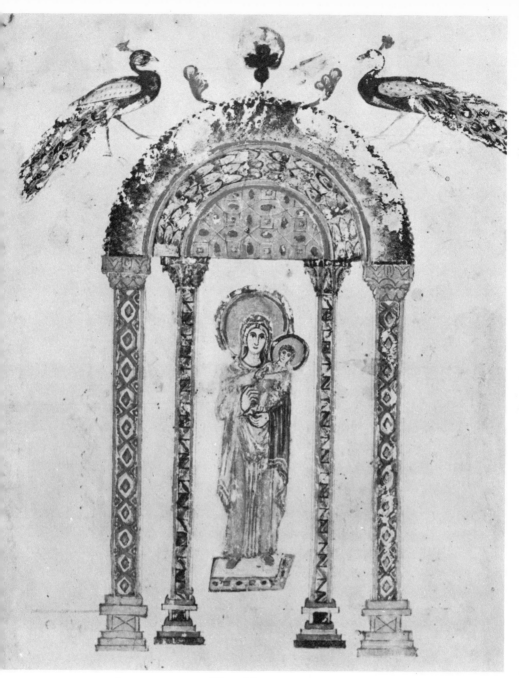

Fig. 42

is doubtlessly a racial characteristic of the Syrian nation, which is noted for the abundance and thickness of its hair. It stands up over the forehead, partly covering it and thus making it appear narrow. Other racial characteristics are the black eyes and the heavy black beard covering the chin and the cheeks. It is also interesting to note that the Syrian legends concerning the *acheiropoietos* image of Christ ascribe to it black eyes and beard.[105]

The types of the Evangelists and prophets, although they conform in general to the antique, are also distinguished by their black eyes, beard, and hair. At the same time, however, the youthful type of Christ preserves, probably through tradition, its antique traits, namely the light auburn hair and the short beard.

Full-length figures are marked by their angular, almost clumsy appearance. Their shoulders are drooping, the folds of their garments are overly elaborate, their motions are unbalanced. The toes of one foot often point slightly towards the heel of the other. In many cases the figures are noticeably elongated. The immediate cause for the appearance of this last trait cannot always be accounted for, as, for instance, in the case of certain carved ivories. Sometimes the elongation of the figures results from their arrangement under a high vault or arch; their normal appearance is restored when they are placed on a long frieze.

8. Another Syrian Gospel (Paris, Bibliothèque Nationale, Syr. 33) also presents considerable interest.[106] It probably dates from the sixth century and belonged to the monastery of Mar-Anania at Mardin. In this manuscript, as in the Gospel of 586, separate figures, scenes, and ornaments are disposed alongside the canon tables. There are no colored backgrounds. The figures are placed in the margins, the background being provided by the parchment which has been beautifully treated with whiting and polished. Some scenes are therefore divided into two parts as in the Rabula Gospel. The canon tables display the simplest architectonic forms, consisting of five small arches resting on even, flat columns colored blue and yellow and surmounted by capitals that imitate the Corinthian order in outline, but differ from it in that they lack acanthus leaves and are pierced through.

On fol. 2ᵛ is a woven basket, with flowers and fruit, of a type

often found on the Coptic textiles of the Hermitage Museum. On fol. 3 is a stork standing over a basket filled with flowers and greenery. The stork is bluish gray with light blue and yellow feathers in its wings.

On fol. 3ᵛ the Virgin is represented standing on a simple yellow pedestal and wearing a purple maphorion. Her light blue robe is adorned with two stripes, one reddish, the other brown. She holds in her left hand two skeins of purple yarn, one of which is wound on a spindle surmounted by a little blue bird, the other on a spindle with a small flower. Forrer has published some long ivory needles from Achmim-Panopolis, which he took to be either pens or styli. These needles are decorated at the top with little birds resembling cockerels.[107] The Virgin's face is round and full but the Oriental cast of her features can be discerned in her dark eyes, elongated nose, and thin lips. The fingers of her right hand are held in a gesture of blessing. She stretches her hand out towards the angel who is depicted in the margin of the next folio. The angel holds in his left hand a red staff terminating in a knob, while his blessing right hand is extended towards the Virgin. His youthful face is framed by red hair; he wears no headband, and is clad in a white tunic and himation. In spite of the fact that the figures are disposed on different folios, the over-all composition of this scene is very close to that on one of the Monza ampullae.[108]

On fols. 4ᵛ and 5, Christ, with particularly abundant light auburn hair and a forked beard, clad in a purple himation and a white tunic, is walking toward an infirm woman, who wears a yellow paenula. Her spine is bent like a bow. She stretches forth one hand, palm outwards, while holding the other on her breast (Luke XIII: 11-13). This miniature can also be found in the Syrian Gospel of 586 (fol. 6ʳ): The infirm woman is shown leaning on a staff and opening the palm of her hand on her breast. The nimbus of Christ shows traces of a cross.

On fol. 5ᵛ is depicted the healing of the woman with an issue of blood (Fig. 43). Christ stands to the right, facing forward; to the left the small figure of the bleeding woman has fallen down on one knee and grasps the hem of Christ's purple himation. Christ's face is distinguished by the gentleness of its features and by the fact that His eyes are not black. We find the same subject

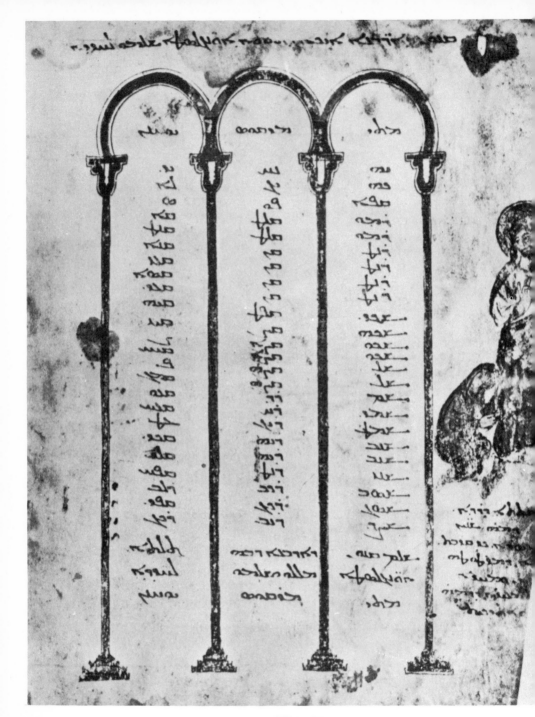

Fig. 43

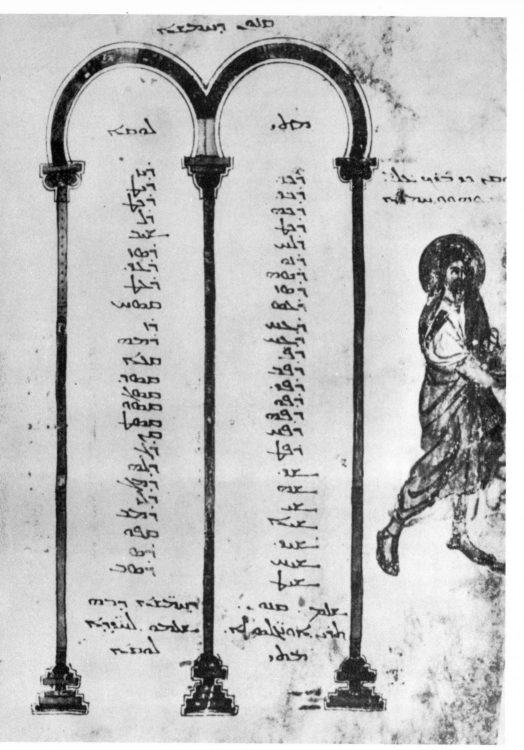

Fig. 44

in the Syrian Gospel of 586 (fol. 5ᵛ), treated in almost the same manner, except that here a disciple stands next to Christ.

All that remains on fol. 6 are traces of a sheep, a nimbus without a head and, further down, the head of another sheep. We must assume that this represented the separation of the sheep from the goats, and that the nimbus was that of Christ. Half of this miniature has been cut off.

On the reverse side of the same folio is represented Christ walking to the right, holding a scroll in His left hand and extending His right hand. A fish and two loaves of bread are depicted at His feet (Fig. 44).

On fol. 7 is represented a rooster, perhaps a remnant of Peter's denial, as in the Syrian Gospel of 586 (fol. 12). On fol. 7ᵛ is a peacock, on fol. 8 a pheasant; the same birds are depicted above the arcades in the Syrian Gospel of 586 (fols. 2ʳ, 3ᵛ, 8ʳ, 8ᵛ). Further on we see the curious image of a basin shaped like a shell, out of which a stream of water shoots up. On fol. 9 is an ibis pecking a serpent.[109]

Finally, on fol. 10 is depicted the arrival of the women at the Sepulcher. At the right, near a little house part of which is cut off, is seated an angel—a youthful, curly-haired figure with a pink nimbus, white tunic, and greenish-blue wings. He holds a staff in his left hand and blesses the two women with his right. The first woman carries in her right hand a vessel containing ointments, suspended on a cord. One of the women has a yellow nimbus, the other a light-brown one. The whole composition repeats almost to the last detail scenes on the Monza ampullae, where the Holy Sepulcher is represented as an aedicula and one of the two women carries a *balsamarion* suspended on a cord.[110] It is also similar to a miniature in the Syrian Gospel of 586 (Fig. 39).

It is interesting to note in the Paris Gospel the combination of antique characteristics, such as colored nimbi, birds of beautiful hues, and the antique type of angels, with the "historical" type of Christ having a short parted beard and full, light auburn hair falling behind the shoulders. In most cases the drawing is very careless, but free and lively. It lacks the excessive finish that is a distinguishing feature of ninth-century miniatures. In this carelessness we can discern the work of a skilled artist,

trained in the traditions of antique painting. These traditions may be observed, mainly, in the correct structure of feet, in the natural movement of the figures, in the correct folds of antique garments, and, above all, in the lifelike representation of birds. At the same time, one must point out that the figures represented in the margins of this manuscript are much too big for the text. There is no background and no soil under the feet. The figures apparently imitate originals created not as miniatures but as mosaics. It is as though the traditions of miniature painting had disappeared here under the influence of monumental painting. The kinship with compositions on the ampullae bears witness to close contact with the art of Palestine. One should also observe here a preference for ornamental forms, as in Egyptian textiles or in the Syrian Gospel of 586, but to a lesser degree.

9. It is with full justification that we can add to the two manuscripts we have just examined—those of the Laurentian and Paris Libraries—a third one, the Armenian Gospel from the monastery of Etschmiadzin (No. 229). The miniatures that decorate this document were copied in the year 989 by the calligrapher John from "authentic and ancient" drawings, and have the same character as the miniatures in the two preceding manuscripts. The copies reproduce the ancient originals in a rather clumsy and incompetent manner, but, in general, seem to follow them closely. The four drawings appended to the end of the manuscript are, as has already been pointed out by Strzygowski, who published them for the first time, considerably more ancient than the drawings at the beginning of the manuscript, which may be attributed to John. On the basis of their style and composition, the former should be ascribed to the sixth century.[111]

Nothing, it seems to me, prevents us from regarding these miniatures as some of the originals that John himself had in his hands. Indeed, we can prove this. In the body of the text, the scribe made a small-scale copy of one of the most interesting of the miniatures appended to the manuscript, namely, the adoration of the Magi (fol. 10). The copy is in many ways inferior to the original (Figs. 45 and 46). The figures are disproportionately small and squat. There is no edifice depicted behind the Virgin's throne, although there is one on the miniature appended to the

manuscript. The other characteristics, however, are preserved. The Magi approach from two sides; the angel is shown at the right; the shape of the throne is the same. The abbreviated form of the copy results from its place in the lower margin of the manuscript, beneath the text: This is why the figures are so

Fig. 45

squat. The copy thus proves that the scribe had in his hands the miniature appended to the manuscript, that the latter is by far the more ancient, and that it was appended to the manuscript by John himself.

The similarity between the miniatures of the Etschmiadzin Gospel and those of the Paris and Laurentian Gospels may be observed, first of all, in the repetition of the architecture of the canon tables and their disposition with regard both to the text inside them and to the figures. The colonnades are closer to the Syrian Gospel of 586. We find here the same kind of ciborium surmounted by a cone instead of an arch (fol. 5ᵛ), the flowers,

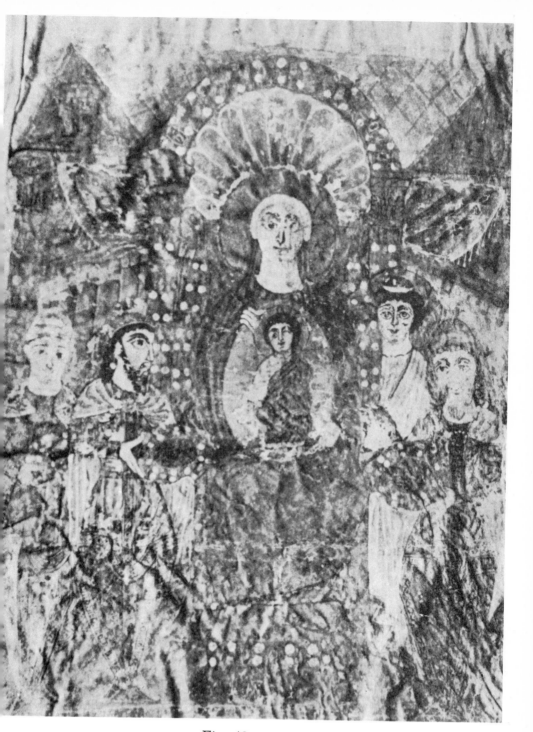

Fig. 46

plants, and birds above the arches, the ornamentation of the arches, and lunettes with crosses set in medallions. Nevertheless, the light and elegant character of the architecture of the Laurentian Gospel is absent. The columns, instead of being slender, are thick and heavy. They are topped by Corinthian capitals. Under the bases of the columns is drawn a line, upon which stand the apostles.

The other miniatures confirm the connection between the Etschmiadzin manuscript and the two previously considered by virtue of their being closely linked with the art of Palestine. We find here the sacrifice of Isaac and the adoration of the Magi, which, according to all the features of their iconography, belong to Palestine.

The sacrifice of Isaac (fol. 8) is represented on a separate folio, as an independent picture, framed by a wide, dark band (Fig. 47). The general type of composition with which we are already acquainted from Cosmas Indicopleustes is preserved here; this type is also found on Roman sarcophagi. Abraham stands in the middle, holding a knife; the ram is tied to a tree at the left, as in Cosmas' manuscript. The essential difference consists in that the altar here stands at the top of a tall stairway with small treads. Isaac is not shown kneeling, but is standing on the steps. This composition is repeated exactly on two pyxides, one in the Berlin Museum [112] (Fig. 48) and the other in the Bologna Museum [113] (Fig. 49).

All three of these scenes are remarkably alike. The ram stands to the left; above it is seen the hand of God. Abraham, with curly hair and a wide beard, turns his head toward the hand. A tall stairway is shown at the right with an altar above it. We find the same details in all three cases: the serrated top of the altar; Abraham's posture, the weight of his body resting on his left leg while the right one is thrust aside; his hand touching Isaac's head; Isaac's position on the steps with his hands tied behind his back. But there are also a few differences. On the Bologna pyxis and in the Etschmiadzin miniature, the tree is shown to the left, but is to the right on the Berlin pyxis, as the space on the left is here occupied by an angel. On both pyxides Abraham is shown with his long knife pointing up, but on the Bologna pyxis he holds it near his left shoulder, whereas on the

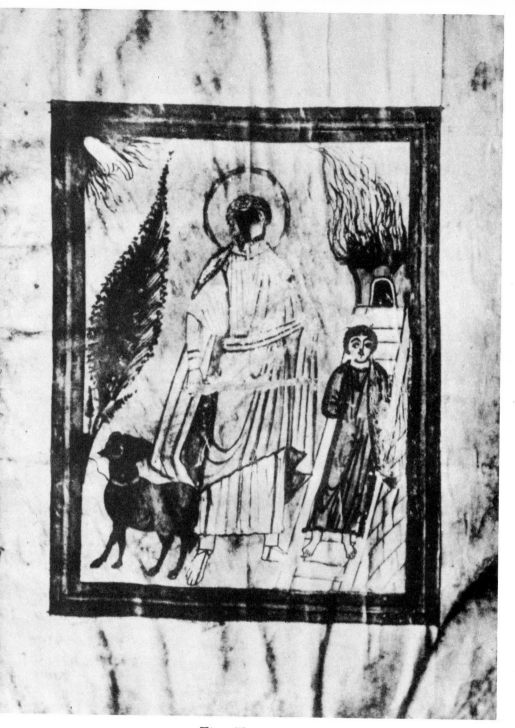

Fig. 47

Berlin pyxis he holds it near his right shoulder. In the Etschmiadzin miniature, on the other hand, Abraham points the sharp end of the knife at Isaac, as if he were ready to stab him. Moreover, in the Armenian miniature Isaac is clad in a tunic and a himation; Abraham has a nimbus; the hand of God appears amid flames; there is a fire burning upon the altar, and the stairway is shown obliquely so that one sees its side, constructed of well-dressed stones; there is a collar on the ram's neck; Abraham's himation hangs loosely behind his back.

The dissimilarities in some of the details do not destroy, however, the essential resemblance in the structure of these compositions. This is particularly important because we are dealing with three monuments, two of which are usually attributed to the West while the third one is Eastern, probably of Syrian origin

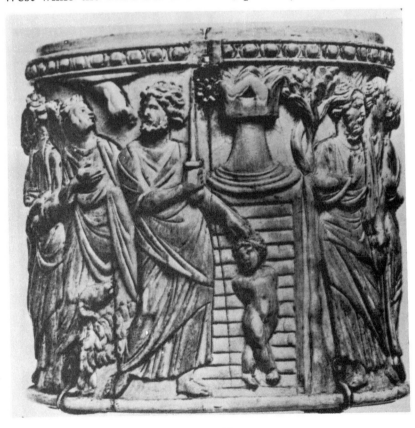

Fig. 48

and much later in date. We cannot assume that the miniature was directly copied from the Berlin or the Bologna pyxis. The Berlin pyxis is distinguished by the perfection of its relief, which

Fig. 49

harks back to the reliefs of antiquity. Isaac is represented as a graceful antique *putto*, his legs crossed, his head slightly bowed, the forms of his body rounded. The Bologna pyxis, although it possesses the same antique characteristics, is carved in a cruder technique; its execution is hurried and unartistic, so that this work takes second place after the Berlin pyxis. In the Armenian miniature, on the other hand, the elongated proportions of Abraham's and Isaac's bodies, the small tree in the shape of a leaf of Oriental type, the weakness of the drawing, the flat modeling, and the black color of the eyes bespeak an altogether different style and artistic technique which we have already encountered in other monuments of Syrian origin. To account for so many similarities in these compositions and for the transmission of such peculiarities as the stairway under the altar (very rarely represented in early Christian monuments), we have to presuppose the existence of a common original which contained this element and which served as a basis for the composition of the two pyxides and of the Syrian miniature.

The stairway is shown on the Armenian miniature as an independent structure with a wall of cut stone, the height of which is indicated, on the pyxides, by the large number of steps. In fact, it was the deliberate intention to reproduce the height of this stairway that led to a change of the composition, since Isaac's position on the stairs, below the altar (and not on the altar itself, as in other instances), is a direct indication of the height of the stairs. The significance of this detail is elucidated by the statements of pilgrims to the Holy Land. Already Jerome

in his commentary on the fifteenth chapter of Mark repeats the Jewish legend according to which Abraham intended to sacrifice his son on Golgotha or Calvary, i.e., on the very spot where Christ was later crucified.[114] The interesting point about this tradition, as Jerome relates it, is that he attributes it to the Jews, whereas it is well known from the works of Jewish authors that Mount Moriah, and not Golgotha, was the scene of the sacrifice of Isaac. The small rock, on which the sacrifice took place, was included inside the Holy of Holies of Solomon's temple, built on Mount Moriah.[115] However, Christian pilgrims indicate that Golgotha had indeed been the place of the sacrifice of Isaac and describe the stairway leading to that spot, as well as the altar that Abraham had built. The pilgrim Theodosius (*ca.* A.D. 530) describes it as follows: "There is the mount of Calvary, where Abraham brought his son to make a burnt offering of him (it is there that men were executed). The hill is stony and is ascended by means of steps. Abraham made his altar at the foot of this mountain which towers over the altar."[116]

The Anonymous Breviary (*ca.* A.D. 530), repeats the same account more briefly: "There [i.e., on Golgotha] Abraham brought his son Isaac to be sacrificed on the very spot where Jesus Christ, Our Lord, was crucified."[117] Antoninus of Piacenza defines the position of the stairway even more precisely: "From one side one ascends [Golgotha] by means of steps at the place where Our Lord went up to be crucified. On the very spot where Christ was crucified blood is visible in the stone itself. On the side of that stone is Abraham's altar, where he intended to sacrifice Isaac."[118]

Thus, according to Antoninus of Piacenza, Abraham's altar was on the slope of Golgotha. The other sources we have quoted indicate that Mount Calvary rose above the altar. The pilgrims disagree on the number of steps in the staircase.[119] On the Berlin pyxis there are fourteen steps; on the Bologna pyxis and the Armenian miniature their number is indeterminate. Obviously no significance was attached on pictorial representations to the number of the steps, provided they were numerous so as to form a high flight of stairs. Arculf places the altar (*locus altaris Abraham*) between the church of the Resurrection and the Martyrion, and describes the altar as a large wooden table on which

in his time alms were placed for the poor.[120] On his map, which shows the buildings erected by Constantine, Abraham's altar (*mensa lignea* as it is designated by the inscription) is located near the basilica of Constantine, in a corner on the southwest side, i.e., in the same place where other pilgrims had seen it (*a parte occidentis*). Likewise according to the pilgrim Daniel, Abraham's altar was near Golgotha and the path leading to it the same one that Christ had ascended on His way to the Crucifixion,[121] as was already stated by Antoninus of Piacenza.

Thus the image of a stairway with an altar in representations of the sacrifice of Isaac can be related to the stairs and Abraham's altar that existed in Jerusalem. The Jewish legend concerning the sacrifice of Isaac on Mount Moriah was replaced by the Christian legend of the sacrifice on Mount Golgotha. This substitution found its immediate expression in the indication of the existence near Golgotha of the very altar erected by Abraham. Theodosius states this directly and unequivocally. It is therefore natural that a tall stairway with an altar at the top of it should have appeared in representations of the sacrifice of Isaac. It was by this stairway that Abraham and Isaac went up to the altar erected on the mountain; both the stairs and the altar were shown in Jerusalem in connection with the biblical story of the sacrifice. In view of this evidence, as well as that furnished by the monuments, namely the height of the stairs and the altar above them, we must regard these details as being historical. They must have entered the representation of the sacrifice of Isaac at the time when the altar and the stairs appeared in Jerusalem and were connected with the legend of Isaac's sacrifice on Golgotha.

One can consequently solve the important iconographical problem concerning the original prototype from which derive the various representations of this scene on monuments of different periods and provenance. This prototype must have originated in Jerusalem where the altar and the stairs were to be seen; from this source analogous reproductions of it could have appeared both in the East and in the West. Similar compositions were apparently not uncommon in Christian art. In the *Biblia Pauperum* the representation of the stairs—but without the altar—occurs precisely in the scene of the sacrifice of Isaac.[122] We find here a

close correspondence in the arrangement of the whole composition: the position of the ram with its head turned to the right and the figures of Abraham and Isaac. The late recensions of the *Biblia Pauperum* must obviously be considered copies of more ancient ones. Between 678 and 684, the Venerable Bede acquired in Rome a great number of images (*concordia veteris et novi Testamenti*) and mentions, among them, representations of Christ bearing the Cross and Isaac carrying faggots.[123]

More important still are the four older miniatures appended at the end of the Etschmiadzin Gospel: The Annunciation to Zacharias, the Annunciation to the Virgin, the adoration of the Magi, and the baptism of Christ.

Of the four, only the baptism of Christ is a true miniature, executed as an independent tableau (Fig. 50). The scene is enclosed in a wide frame, decorated with medallions of Evangelists in the corners and with birds. The other three are devoid of miniature style. The figures are too large and out of proportion to the parchment sheet. The buildings have the unpainted parchment for background, and the figures do not project beyond their outlines. None of the three scenes is framed. This proves that these three miniatures were copied from an original of a type that included these characteristics. They reproduce the architecture of edifices, the big figures, and the compositional structure inherent in monumental painting, with its ample backgrounds, its complete symmetry, and its fantastic architectural motifs. We must assume that the originals of these compositions were mosaics of the fifth or sixth century.

Indeed, two of these compositions—the Annunciation to the Virgin and that to Zacharias (Figs. 51 and 52)—are completely symmetrical to each other. The buildings are so similar in both cases that the only difference between the Virgin's house and Zacharias' temple consists in the curtain of the latter. The buildings are of the same size; both have high gables supported by four small columns or pilasters with Corinthian capitals. Two columns stand on either side of the entrance, supporting an arch decorated with jewels. A window opens above the arch. What is even more important is that the roof is cut off vertically in line with the back columns. In this particular case one might be inclined to ascribe this to incompetent

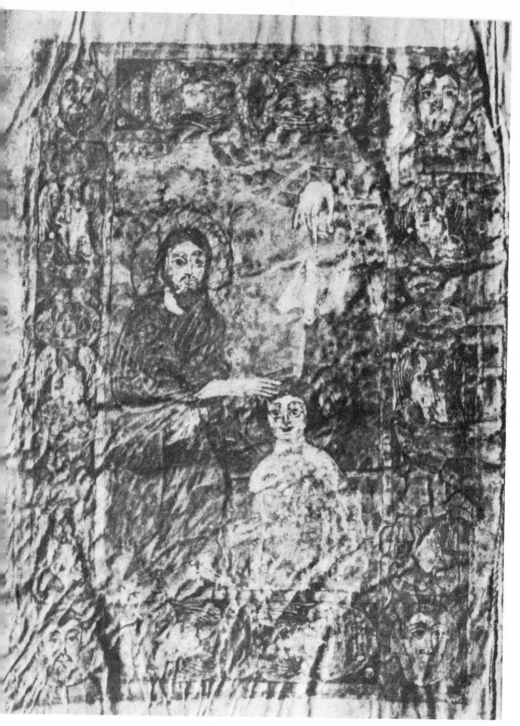

Fig. 50

Fig. 51

Fig. 52

draughtsmanship or to the use of reverse perspective, were it not for the following facts: The two buildings are almost perfect copies of each other and furthermore, other examples are known in monuments exhibiting correct perspective where the roof is cut off in the same fashion. In both miniatures two figures are represented with these buildings behind them: On one, the angel stands before the Virgin; on the other, the angel appears to Zacharias. The exact correspondence of the forms of the two structures is complemented by the number, the postures, and the symmetry of the figures. Such detailed resemblance in the structure of these two scenes is totally inexplicable in the field of miniature painting where every composition is completely independent of the others. The disposition of the figures in both scenes is reminiscent of the Syrian Gospel of 586 and of the Coptic textiles published by Forrer. In the Annunciation, the Virgin is shown standing with a spindle in her hand, as on one of the Monza ampullae, but here she has a footstool. This scene is closest to the one in the Syrian Gospel of 586, where the Virgin stands on a footstool and there is a building behind her representing Joseph's house with a gable and a roof (fol. 42). In the second scene Zacharias stands to the right, in front of an altar in the shape of a table on thick legs; the angel stands to the left. This scene is represented in the same manner in the Syrian Gospel (fol. 3ᵛ) and on a vestment from Achmim-Panopolis.[124] The Annunciation to Zacharias on the carved doors of Sta. Sabina in Rome and the presumed representation of the same subject on the triumphal arch of Sta. Maria Maggiore differ considerably from the Syrian compositions: Zacharias does not wear the vestments of a high priest, nor does he hold a censer.[125]

The composition showing the adoration of the Magi (Fig. 46) has many traits common to the first two miniatures. The building behind the Virgin's throne has two gables, one to the left and one to the right, each resting on two small columns or pilasters with Corinthian capitals, similar to those of the first two edifices. Both gables are covered by a single roof. In the middle of this building is a conch or apse, within which the Virgin is seated with the Child. Fringed hangings, suspended under the gables, are drawn back into the building. The pilasters and the arch are studded with bands of precious stones. The character of this edi-

fice and its ornamentation are repeated in monumental painting of the fourth to the sixth century. The most typical and splendid example of this architecture is found in the dome of St. George's church in Salonica. Here we see the same kind of conch as in the miniature, rising over an entablature and flanked by a pair of small columns of the Corinthian order; the conch has the same wide frame, and the hangings are drawn back in a similar fashion. The closest approximation of these features can be seen in the central part of one of the edifices published by Texier.[126] This is distinguished from the building in the miniature in that it has no roof, and that the gables are replaced by broken pediments. The roof and pediments are repeated in another mosaic of the same church.[127] Here the two pediments belong to separate projecting wings flanking the central element of the building. It is thus easy to account for the appearance of the two gables under one roof, shown in the miniature almost *en face*. This roof represents, as it does in the mosaic, the roof of both gables, united by a straight line. The sixth-century mosaics of Ravenna often display the same architectural forms but in a disconnected way, scattered among various compositions. For instance, the mosaics in the dome of the Orthodox Baptistery in Ravenna depict structures similar in form to those of Salonica and to the building in the Armenian manuscript. The fluted conches, the pilasters with Corinthian capitals, the gathered hangings, the rows of precious stones and pearls are found in the mosaics of S. Vitale, of S. Apollinare Nuovo, of S. Apollinare in Classe, and of the Orthodox Baptistery. The Syrian Gospel of 586 also contains such forms as the conch with an arch, the pilasters, the hangings, and the rows of precious stones. Once created, this sumptuous type of architecture became a common iconographical element. On a thirteenth-century enamel of Western origin one may see the same kind of edifice, representing the temple of Jerusalem in the scene of the Presentation. It has two gables with a shell between them, one common roof, small columns with Corinthian capitals, and an arch in the shape of a wide band.[128]

Thus the close relationship of the Etschmiadzin miniatures to mosaics would seem to prove that they derive from originals created in the sumptuous style of monumental art.

This is also shown by the pyramidal construction of the adoration of the Magi. The Virgin and Child are seated in the center on a high throne with a footstool; her figure is higher than all the others. One of the Magi approaches her from the right. Next to him stands an angel with a nimbus. The other two Magi approach with gifts from the left. This kind of composition is usually found in apses, niches, and pediments. These locations require absolute symmetry in the arrangement of the figures and do not allow the principal subject to be placed on one side. Such compositions are common in church apses in Rome, Ravenna, Mount Sinai, and Cyprus.[129] There can hardly be any doubt that such solemn compositions in apses are related to the painting of earlier times. Eusebius describes a picture in which Constantine the Great was represented with vanquished nations bringing him gifts from both sides.[130] The mosaics of a house in Rome on the Caelian Hill,[131] as well as a painting at Ephesus [132]—the former of which depicted the two Tetrici and the latter the proconsul Theodore, receiving from the emperor or from an angel the insignia of their office—may be considered the prototypes of such compositions.

The Crawford ivory, which formed the central part of the second leaf of the Murano diptych, is closely connected to the Etschmiadzin miniature. It has the same composition of the adoration of the Magi, but in reverse (Fig. 122). Both monuments are copies from the same unknown original.[133] The Syrian origin of the Ravenna diptych seems indisputable. Its iconographic peculiarities and the Oriental character of its style (see below, p. 264 ff.) take on decisive importance when considered in conjunction with its derivation from the same prototypal composition of the adoration of the Magi that is also transmitted by the Etschmiadzin miniature.

Graeven has recently published a silver pyxis, found in Milan during excavations in the church of S. Nazaro. On one of its sides is represented the adoration of the Magi in a monumental composition, with the Magi approaching the Virgin from right and left.[134] Generally speaking, the composition is the same as in the Ravenna diptych and the Etschmiadzin miniatures, but there is an important difference in the garments, in the resemblance of the figures to antique types, and in the greater number of Magi

whose heads and torsos can be discerned behind the figures in the foreground. These characteristics remind us of the earlier art of the catacombs and of the composition on the famous vase of the Museo Kircheriano, with its six Magi approaching the Virgin.[135] Another monument, an ivory which is unfortunately fragmentary, repeats a part of this composition: This is a tablet in the British Museum which on stylistic criteria should be ascribed to the Carolingian era.[136] It formed part of a diptych or a Gospel binding. Two Magi are depicted moving from right to left. They are garbed in tunics and high boots and do not wear cloaks. These figures correspond to those of the two Magi on the right side of the Ravenna diptych. Above their heads is represented part of an edifice with a gable and a tiled roof, supported by two small columns. There is a window in the triangle of the gable. These details bear a strong resemblance to the right side of the edifice in the Etschmiadzin miniature. Obviously, the ivory tablet represents a part of the same composition as in the two previous monuments.

The resemblance of the compositions depicting the adoration of the Magi in Eastern and Western monuments has made it impossible, until now, to determine where the original prototype first appeared. Nonetheless, the famous conciliar epistle of 836 makes it clear that compositions representing the Nativity and the adoration of the Magi adorned the façade of the basilica in Bethlehem; consequently, these must have been executed in a monumental style. The Syrian miniature and the Crawford ivory evidently reproduce a well-known Palestinian type of this composition.

The Baptism of Christ repeats, almost to the last detail, the composition in the Rabula Gospel and on the Egyptian tablet from the Golenishchev collection which I have published (Fig. 50). The resemblance of these three monuments as regards the type of John the Baptist and the half-length representation of Christ sets them apart from other known examples of this composition. John the Baptist is pictured on all three monuments with a big black beard and long black hair falling on his shoulders; he wears a tunic and a himation instead of a sheepskin. There is some difference, however, in the type of Christ, who in the Etschmiadzin miniature is beardless and has short hair.

The antique element underwent even more drastic changes in this manuscript than in the Syrian Gospel of 586. We are struck here by the awkwardness of the figures, their sloping shoulders, shapeless bodies, clumsy position of the feet, as well as by the intensely black color of their hair and eyes and the Oriental type of their faces. Particular attention should be paid to the faces of the Virgin and of angels who have completely lost their antique beauty. The face of the Virgin is very similar in type to that of the Rabula Gospel, but is far inferior in execution. On the other hand, the monumental character of the compositions, the architecture of the buildings which repeats the main features of the edifices in the Salonica mosaics, the symmetry of the figures, as well as the vestments of the Virgin and of the angels, are sufficient indications of that antique foundation, which in Syria acquired an Oriental character.

10. A number of sixth- and seventh-century manuscripts that are written in Greek and therefore belong, properly speaking, to Byzantine art, exhibit some important peculiarities when compared to the two groups of manuscripts, Alexandrian and Syrian, that we have examined.

The purple codex of the New Testament, preserved in the city of Rossano in Calabria, is the most important and characteristic document in this respect. Now that A. Haseloff has published his monograph containing excellent reproductions of the miniatures of this manuscript, it has become possible to study them more thoroughly than before.[137] In spite of the numerous studies occasioned by Harnack's discovery of this manuscript, its date and place of origin have not been definitely established.[138]

As in the case of the Syrian manuscripts, its compositions do not have a miniature style. Indeed, the traditions of miniature painting are totally lacking here. This is the first and foremost characteristic of the drawings of this Gospel. All the images bear the imprint of monumental style. The purple color of the parchment replaces here in the best possible manner the flat, gold or blue backgrounds of mural painting.

The majority of the compositions unfold as a long frieze, in several successive scenes. Two of these compositions, namely Pilate's judgment and the Jewish people before Pilate (fols. 8,

8ᵛ), are set inside an arched frame which repeats the shape of a lunette. In both compositions, groups of people are placed on either side of the throne on which Pilate sits high above everyone else. The pyramidal structure of the compositions was clearly required by the form of a lunette. All the other scenes are with-

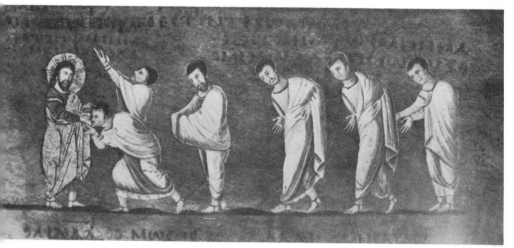

Fig. 53

out frames and are stretched out to the full width of the folios. One may observe in them a strong tendency toward isocephaly. The ground is represented by a narrow strip with hillocks. There is no landscape behind the figures. The relief-like quality displayed in the disposition of figures in rows seems to indicate that the illuminations of this manuscript were direct copies from monumental painted friezes. This is particularly clear in the composition depicting the Communion of the apostles (Fig. 53). This is broken into two parts and represented on two folios. On one folio Christ is shown standing, turning to the right, and offering bread to six apostles who approach Him in single file; on the other folio the figure of Christ is repeated, turning to the left and offering wine to six apostles. The long frieze required for purposes of mural painting (later we find it in the apses of Byzantine churches) was here broken into two parts, as it could not fit in its entirety on one folio. The heads of Christ and the apostles do not rise above a given level. The figure of the first apostle, who bends down to receive Communion, breaks the rule

of isocephaly. In order to balance this imperfection, the torso of another figure is placed above it. The same structure may be observed in the composition illustrating the Parable of the Wise and Foolish Virgins, which is divided into two parts by the gates of Paradise; but this last miniature is contained on one folio (Fig. 54).

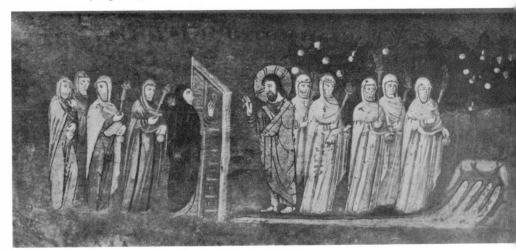

Fig. 54

The greater part of the illuminated pages of the Rossanensis have the following disposition: A scene is placed at the top of the folio in the form of a long frieze; underneath is a row of prophets. The latter are half-length figures holding rectangular scrolls and pointing upward with their hands. This is reminiscent of a convention of Byzantine wall paintings where, around or next to a New Testament scene, are depicted the prophets who predicted that particular event.

Another instructive characteristic of the Rossano Codex is the repetition of certain scenes whose only other known representation is in the Syrian Gospel of Rabula. Such is the scene of Christ before Pilate (Figs. 55 and 56). The latter manuscript shows a table covered with a cloth; Pilate is seated high above it; at his left stands, not a scribe as in the Rossano Gospel, but a youth with a basin and a ewer for the washing of hands (Fig. 57). On the other side of the arcade containing the canons is the standing figure of Christ. The people and the banners depicted in the

Fig. 55

Fig. 56

Fig. 57

Rossano Codex are absent. The most obvious traits of resemblance are the high table, Pilate's figure seated on an eminence, and Christ's movement from left to right. The same scene, iconographically closer to the Rossano than to the Rabula Gospel, is depicted on a column of the ciborium of S. Marco in Venice. It includes two standard-bearers, each one holding a labarum.[139] Haseloff has erroneously indicated another example of this subject in the Milan diptych. The scene represented there is, however, not the judgment of Pilate, but the apocryphal one of Christ confounding the elders in the Temple.[140]

The first appearance, in the Rossano Codex, of a modified iconography of the judgment of Pilate may be connected, in general, to the art of Palestine and Syria. Both compositions, the judgment of Pilate and the crowd demanding the execution, are based upon the apocryphal Acts of Pilate and the Gospel of Nicodemus.[141] The veneration of the holy places of Palestine, especially of Jerusalem, could have evoked interest in subjects of this kind, drawn from Palestinian apocrypha. Antoninus of Piacenza saw in Pilate's Praetorium, at Jerusalem, the stone on which Christ had stood during the judgment and on a wall a portrait of Christ supposedly drawn from life on Pilate's orders.[142] Nor should one discount the possibility that apocryphal Gospels could have been illustrated just as well as the canonical ones. One of these apocryphal Gospels, the Protevangelium of James, has been preserved in the Laurentian Library and dates from the twelfth or thirteenth century. It is written in Arabic.[143] Illuminated manuscripts of the Acts of Pilate could also have existed, and several scenes could have passed from these into current iconography. The Gospel of Nicodemus recently discovered in Madrid, with drawings dating from the thirteenth century, indirectly points to the same conclusion.[144]

Another subject of the Rossano Codex, the Communion of the Apostles, is repeated in the Rabula Gospel, but it is presented in a different composition. In the Syrian Gospel all the apostles stand before Christ who holds a vessel in His left hand and with His right gives bread to the first of the apostles. In all, there are eleven apostles. It follows that the twelfth figure was either omitted through carelessness or that it has disappeared. This is quite possible since only the first three apostles are represented

full-length; the heads of the others appear in rows above the heads of the first three. In this manner, both scenes of the Rossano Gospel are here united into one, a fact that reveals a more independent redaction of the Syrian composition, not influenced as yet by monumental painting. This scene is also often found in Psalters, in a composition similar to that of the Rossano Gospel.[145]

The Entrance into Jerusalem (Fig. 58) is also repeated in a similar form in both manuscripts. In the Syrian Gospel, a little boy is shown to the right spreading out his garments; three others with branches constitute the beginning of the group represented in the Rossano Gospel. In both cases the donkey walks to the right, left hoof forward; Christ rides it sidesaddle. There is only one figure behind the donkey in the Syrian manuscript, whereas there are two in the Rossano Gospel. One of them bears a close resemblance to the type of Peter found elsewhere in the same manuscript. It thus forms the prototype for the representation of Peter, in the same scene, in the Palatine Chapel at Palermo.[146] The Acts of Pilate tell of a *cursor* who asked a question of one of the disciples. This may explain the conversation between an apostle and a youth in the Rossano Gospel, as has already been pointed out by Usov.[147] On the cover of a pyxis discovered in the Ozerukov mound (Fig. 123), the donkey is followed by a bald man with a large beard, holding a long book, who may be the *cursor* or an evangelist. His head resembles the type of evangelist who occurs several times on Maximian's chair.

One should especially note the complete similarity of the type of Christ in both these manuscripts. Kondakov has attributed an Oriental origin to this image and has drawn attention to its occurrence in the mosaics of SS. Cosma e Damiano in Rome, S. Apollinare Nuovo in Ravenna and on the carved doors of Sta. Sabina in Rome.[148] The image of Christ in the Rossano Gospel is the closest and most direct reproduction of the Syrian type. The long, black hair, broad beard, and dark eyes are characteristically Syrian traits. The oval of the face is elongated. The wide distribution of this type on Eastern and Western monuments should be attributed to the Veronica images known to have existed in Edessa, Jerusalem, and Memphis. It is interesting to note that on the doors of Sta. Sabina in Rome we find the cross-nimbus

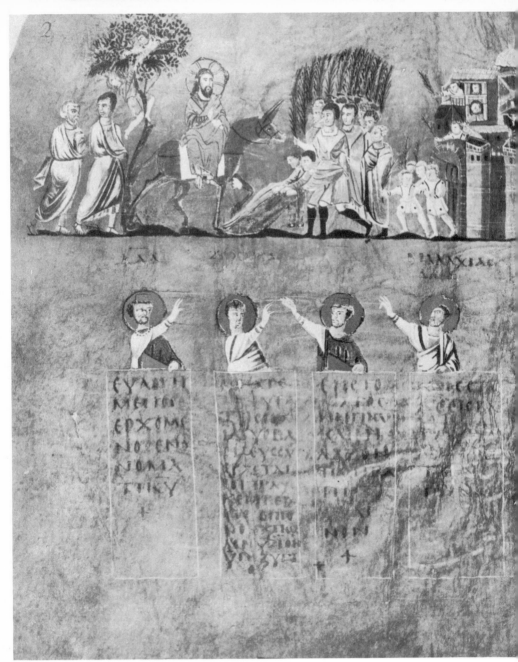

Fig. 58

with flaring arms. This kind of nimbus encircles the head of Christ that is of the same "historical" type on Italian, and in particular Ravennate, sarcophagi.[149]

We may mention two more scenes from the Rossano Gospel that are also found in the Syrian Gospel of Rabula, namely the death of Judas (Fig. 55) and the healing of the blind man. The death of Judas is repeated, in a similar composition, on the Lipsanoteca of Brescia, on the London casket, and on the Milan diptych, all of which are monuments of unknown origin dating from the fourth or fifth centuries. The healing of the blind man in the Syrian manuscript of 586 resembles the simplest two-figure compositions found on sarcophagi, whereas in the Rossano Gospel it consists of two scenes. To the left, Christ, accompanied by Peter and John, heals the blind man who reverently extends his hands; to the right, the Pool of Siloam is represented as a rectangular tank, surrounded by people who are amazed to see the blind man recovering his sight as he washes his eyes.

The raising of Lazarus (fol. 1) shows, to the left, a group of apostles standing symmetrically behind Christ; among them we recognize Andrew, John, and Mark. A hillock with a cave is shown on the right. A young man, covering the lower part of his face with his tunic, leads Lazarus, wrapped like a mummy, out of the cave. Two other young men throw themselves back away from the cave, lifting up their arms in fear. Martha and Mary have fallen at the feet of Christ. Behind them stands a crowd of people, occupying the central part of the composition. One man turns towards Christ and opens in astonishment the palm of his right hand; the others look in the direction of Lazarus. Two men have headgear resembling that of a Bedouin. The paenulae worn by the disciples of Christ may also be seen in the mosaics of Sta. Maria Maggiore, of S. Apollinare Nuovo in Ravenna, and in the Vienna Genesis.[150] The figure of Christ and His facial features closely resemble the Syrian type and that of S. Apollinare Nuovo in Ravenna.

The scene of the expulsion of the money lenders from the Temple (Fig. 59) is interesting in that its representation of the Temple in Jerusalem is very similar to the one found in the mosaics of the triumphal arch of Sta. Maria Maggiore. A long portico abuts on a small temple with a gable roof and a hanging

over the entrance. In spite of certain differences (there are fewer columns, the temple has no lamp and no columns at the entrance, and the portico is covered by a tiled roof), there is a general resemblance which points to a common original. At the left, near the temple, Christ converses with two of the chief priests, one of

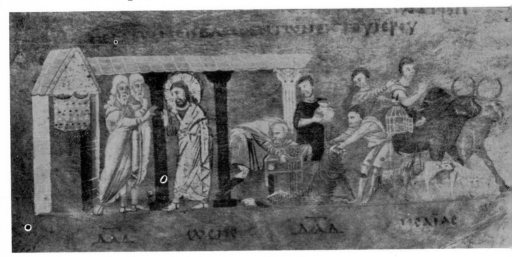

Fig. 59

whom extends his hand, while the other pensively pulls at his beard. To the right a money changer removes his table and all the objects that were flung down from it. Merchants drive out their cattle and carry away a cage with a bird. The money changer and three of the merchants turn their heads towards Christ, evidently to listen to His prophecy concerning the Temple. The heads of the chief priests and the nimbus of Christ touch the edge of the roof. The heads of the cattle merchants are represented on the same level as the roof.

The Parable of the Wise and Foolish Virgins (Fig. 54) is interesting in that it represents Paradise as a row of fruit trees, as in the Vienna Genesis. Under the trees is a rocky hillock from which flow the four rivers of Paradise, converging into a common stream which, represented as a narrow strip, extends to the feet of Christ and five of the virgins. In front of Christ is a door drawn in perspective, but not joined to anything. There is a similar representation in the Vienna Genesis, in the expulsion from Eden. In both miniatures the door is in the middle and the

figures are placed on either side; this emphasizes the resemblance of the two compositions. To the left, beyond the door, stand the other five virgins, one of whom knocks on the door. The four rivers of Paradise are repeated in a similar fashion on the diptych of the Carrand collection.[151]

The Last Supper (fol. 3) is repeated in the mosaics of S. Apollinare Nuovo and subsequently becomes widespread in the art of the eleventh to the thirteenth centuries.[152] The apostles recline around a semicircular table shaped like a sigma. Christ, represented full length, reclines on the left, leaning on His right elbow; to the right is Peter. The latter's figure is foreshortened. Matthew and Andrew are discernible among the youthful faces of the other apostles. Judas stretches out his hand toward the chalice placed upon the table. A rug hangs over the lower part of the sigma; birds, with ribbons around their necks, are depicted on it.

The Washing of the Feet reminds one of late Byzantine compositions. Christ bends down towards Peter's feet, placed in a basin of water. The apostles crowd behind Peter and Christ. This composition was designed for a rectangular space, but here it forms the continuation of the Last Supper. Peter's stool and the feet of Christ are placed at the same level as the sigma. The heads of the apostles are level in both compositions.

The representation of the Agony in the Garden (fol. 4ᵛ) is also composed as a frieze. The sky is represented in the form of two stripes, a blue one above and a black one below. The sun and the stars are pictured on the blue stripe. The sky is likewise represented by two long stripes in the scene of the Deluge, in the Vienna Genesis.[153] To the right, Christ is shown praying, prostrated on the ground; to the left, He is awakening three disciples who are asleep inside a cave.

In the Parable of the Good Samaritan (fol. 7ᵛ), the Samaritan is represented by Christ Himself, as in later Byzantine manuscripts.[154] There is a city on the left; next to it stands Christ, bending over the naked, outstretched body of the wounded wayfarer. An angel with covered hands holds forth ,a vessel filled with water. In the next scene Christ is shown leading the mule on which the wayfarer is seated sidesaddle. Christ approaches the innkeeper and gives him money.

Beneath the representation of the judgment of Pilate (Fig. 55) is pictured a ciborium, under which sit two high priests. Judas approaches them from the right. He holds money in his himation and offers it to them. One of the priests makes a gesture of refusal, stretching out his hands, palm forward, and turning his head to the right. The vault of the ciborium is shown in correct perspective, but the two front columns are depicted behind the figures of the high priests in order not to mask them. This imperfection is often encountered in mature Byzantine art, as for example in the mosaics of St. Sophia in Kiev.[155]

Beneath the scene showing the populace demanding Christ's execution (Fig. 56) are depicted the arrest of Christ and the freeing of Barabbas. To the left stands a lictor carrying a bundle of rods, which he points at Christ. The lictor is dressed in a blue tunic and a long chlamys with a *tablion.* Another official, also dressed in a chlamys, stands with his back to the spectator and looks at Christ. Two men lead Barabbas, who bows to Christ. The clothes of these two men are interesting: One is dressed in a red tunic, the other has a black garment.

Kondakov has already pointed out the close similarity of two of these representations, namely, the raising of Lazarus and the entrance into Jerusalem, with the mosaics of the Palatine Chapel in Palermo.[156]

In general, the body of monuments adduced by Haseloff for comparison with the Rossano Gospel shows that many of its compositions (e.g., the raising of Lazarus, the Communion of the apostles, the Good Samaritan, the entrance into Jerusalem, the Agony in the Garden, the wise and foolish virgins) provide the prototypes for these subjects in Byzantine iconography from the ninth to the thirteenth centuries. This increases even further the importance of the miniatures in the Rossano Gospel. They occupy an almost isolated position in the iconography of the sixth and seventh centuries, to which, in all probability, this manuscript belongs. It is not known when and where the Rossano Gospel was written, in spite of the various hypotheses that have been put forward. Haseloff leaves the question open. This much is beyond doubt: the manuscript is in some way connected with the art of Syria and Palestine; it does, however, exhibit certain characteristics that relate it to Alexandrian manuscripts. Its representation of an Evangelist in the act of writing (Fig. 60) is

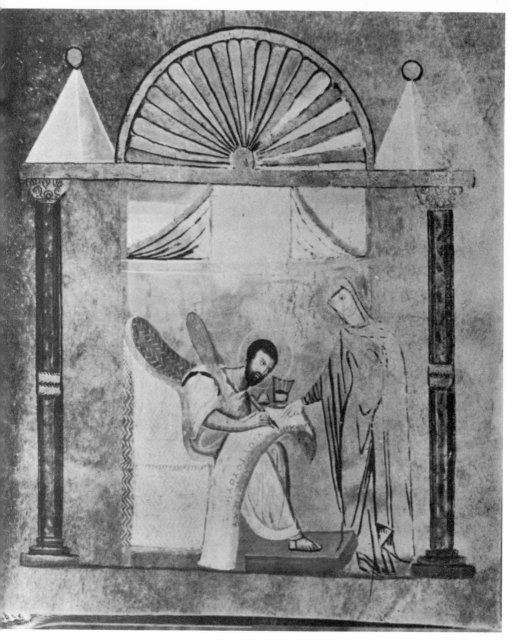

Fig. 60

very close to that of Dioscorides performing the same action. Little attention has been paid up to now to the origin of this type. However, the very fact that these representations always appear as frontispieces to the Gospels proves that they are derived from prototypes of the Hellenistic period. I have already indicated the existence of author-portraits used as frontispieces in Greek and Roman art. It will suffice to note here that the two miniatures in Dioscorides' manuscript, representing the author writing his treatise, and the representation of Aratus in a twelfth-century Latin manuscript, can be considered copies of antique originals. Bethe has pointed out quite correctly this resemblance between antique and Christian manuscripts.[157] The Evangelists are usually shown at their desks, absorbed in their work, just as scholars, philosophers, and poets had been represented on antique memorial reliefs, mosaics, and manuscripts.

The Evangelist Mark is shown seated inside an edifice of fantastic form (Fig. 60). Two small columns girded with bands and topped by capitals that remotely imitate the Corinthian order support an entablature surmounted by an arch containing a sea shell. A white pyramid is placed on each side of the arch. Under the entablature can be seen two windows with hangings gathered sideways. Mark sits on a wicker armchair with a high back; his feet rest on a footstool. Next to his left shoulder can be seen a standish with three styluses. On his lap lies an open scroll on which he is writing the words of the Gospel. A tall female figure stands on his right, stretching out her hand toward the scroll with index and middle fingers extended. This figure is completely enveloped in voluminous garments. Kondakov, having rejected the view that she represents the Virgin Mary, has compared her to the personification of *Heuresis* in the Dioscorides manuscript and to other similar allegorical personifications in later Byzantine manuscripts.[158] In addition to the Dioscorides miniature and the portrait of Aratus, who is accompanied by Urania, we may mention a similar composition on a mosaic discovered at Trier. The Muse Urania is also represented in this manner in the well-known fresco of the house of the Vettii at Pompeii. Similarly, Virgil appears on a mosaic seated between two Muses.[159] Bethe has also adduced several reliefs in the Lateran Museum, portraying poets and their Muse in attitudes that

closely resemble the one under discussion. He has traced this kind of composition to antique memorial reliefs dating from the best period of Greek plastic art. In antique representations of this kind, however, we do not find such fantastic edifices having columns and a roof but no entrance. A structure of this kind, ap-

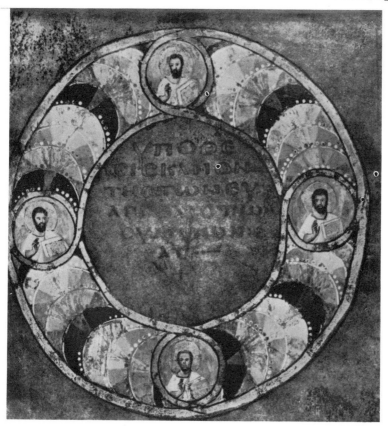

Fig. 61

parently placed at a distance, is shown in the Aratus miniature. The Dioscorides manuscript shows the interior colonnade of a building; there is no roof. This fantastic type of edifice with a roof and an exposed interior—a type that became a permanent feature of Byzantine art—has a history of its own that is connected to the fantastic architecture of the Calendar of 354, to mural paintings, and to Syrian manuscripts. In the Rossano manuscript, as well as in the other manuscripts mentioned above, this

structure is designed to enclose a figure. Similarly, in the manuscript of Apollonius of Citium, several figures are placed inside an arch resting on two small columns.

On fol. 5 of the Rossano Gospel we find a miniature that serves as the frontispiece to the concordance (Fig. 61). Once more, this reminds us of Dioscorides' manuscript. Here we see a circular frame containing the inscription, ΥΠΟΘΕCΙC ΚΑΝΟΝΟC ΤΗC ΤΩΝ ΕΥΑΓΓΕΛΙCΤΩΝ CΥΜΦΩΝΙΑC. This circle reproduces a similar one from the Dioscorides manuscript that is placed immediately before the text. Here it is decorated, not with a laurel wreath, but, as is more fitting, with four medallions enclosing the busts of the Evangelists who are shown holding closed Gospels. The braided border is gold. The lunate shields between the medallions are ornamented with pink, black, red, and blue stripes diverging from their centers. The rim of each shield has a row of white dots, or pearls, such as we have already observed in the manuscripts of Cosmas Indicopleustes and of Apollonius of Citium.

The Epistle of Eusebius (fol. 6ᵛ) is edged with a gold band 2 cm. wide. A pink flower, with two little birds on either side, is placed at the top and bottom. At the four corners are small baskets with red flowers.

Antique conventions, so well preserved in the manuscript of Dioscorides, have thus maintained themselves in the ornamentation of the Rossano Gospel. Some of its details bring to mind other manuscripts. Christ is always clad in a gold himation and a purple chiton with two wide gold bands. His nimbus is golden. The nimbi and books of the Evangelists are also golden. These traits correspond to the golden clothes and ornaments of the manuscripts of Dioscorides and Cosmas Indicopleustes, and of the Syrian Gospel of 586.

11. The Vienna Genesis [160] exhibits many traits in common with the Rossano Gospel. There is an extraordinary similarity in the execution of the figures and in a multitude of other details, beginning with the fact that both manuscripts are written in gold letters on purple-mauve parchment. The Vienna Genesis lacks beginning and end. The subjects of its illustrations are dif-

ferent, and yet one could hardly find two manuscripts that are so similar to one another.

Usov has already emphasized the features that exhibit a direct resemblance. These include: the repetition in both manuscripts of the same shape of cities, the similarity of the ciboria, the similarity between the ornament that decorates the interior of the ciborium in the Vienna Genesis and the one that decorates the gate of Paradise in the Rossano Gospel, the shapes of the armchairs and of animals (zebus and goats), and finally, the analogous representation of the caves of Lazarus and of Jacob, with trees growing above them.[161] The similarity of these two manuscripts goes even further and is especially noticeable in the execution, technical devices, and formation of figures. Haseloff has already pointed this out.[162] It suffices to compare these two manuscripts with the Syrian manuscripts described previously, or with that of Cosmas Indicopleustes, to realize that the Vienna Genesis and the Rossano Gospel belong to an entirely different school or atelier, with different artistic techniques. The antique figures of Cosmas' manuscript, with their classical drapery, sturdy bodies, wide shoulders, muscular arms and legs, differ greatly from the figures in the Syrian manuscripts, which have drooping shoulders, flatly drawn clothing, angular knees, and harsh Oriental features. Compared with these two types of figures, those of the Vienna Genesis and the Rossano Gospel prove to belong to a third variety. They have big heads, thin legs, and small feet, thus giving an appearance of instability. It is particularly important to note how close this type stands to the one we find in Byzantine manuscripts of the eleventh and twelfth centuries. The crown of the head and the forehead are disproportionately large and, in some cases, elongated upward.[163] The eyebrows and eyelids are indicated by slanting strokes. The pupil of the eye consists of a big round dot; next to it, a white dot stands for the white of the eye. Young men's faces, rounded and full-cheeked, call to mind the usual late Byzantine type; [164] likewise, the type of old man, with long gray hair and gray beard, resembles the late Byzantine type of prophet.[165] The cheeks, nose, and lips are set off by highlights. The antique manner of arranging figures is in many cases lost. When a figure is shown moving from right

to left, it often steps out with its left leg, thus hiding the right one. This is also encountered in late Byzantine mosaics, especially in representations of the Communion of the apostles, as it is already in the Rossano Gospel (Fig. 53).[166] Figures are deprived of their liberty of movement and appear tense.

Both manuscripts display the same inability to represent properly the turning of the head, whether it be to gaze up or sideways. Female types are repetitious, draped in garments with red and brown bands; male figures wear paenulae and chlamydes with semicircular golden *tablia*. The sky is uniformly represented by means of two colored stripes;[167] a mountainous or rocky landscape is often repeated.[168] The complete similarity of the figures, including their very imperfections, and of the types of faces thus differentiates the Vienna Genesis and the Rossano Gospel from the other manuscripts discussed previously and enables us to classify them together. Indeed, their similarity justifies the assumption that they originated in the same center and at the same time. Such an assumption is not invalidated by differences of iconography that are caused by the different contents of the two manuscripts. The reason, for example, why the angel in the Rossano Gospel does not hold a staff as do the angels in the Vienna Genesis, is because he holds a vessel which he offers to Christ to wash the wayfarer's wounds (fol. 7ᵛ). The white clothes, the wings, the head-band, and the very figure of the angel are exactly the same as in the Vienna Genesis.[169]

It is by this difference in the contents that one can explain the greater number of scenes in the Genesis, as well as their more antique character. There can be no doubt that various originals were copied in order to decorate the Vienna Genesis. Just as the Rossano Gospel reproduces monumental compositions, so the Vienna Genesis reproduces the miniature style of at least two manuscripts. This opinion has already been expressed by Usov.[170] The difference between the two manuscripts lies in the originals from which they were copied, not in their style.

All of the miniatures in the Vienna Genesis can be divided into two groups: those forming small rectangular pictures and having a colored sky and clouds, and those where the parchment provides the background.[171] The representation of the Deluge (p. 3), of the covenant of the Lord and Noah (p. 5), of the Pharaoh's

banquet (p. 34), and of the miniatures from pp. 37 to 48 are all independent tableaux with sky, colored backgrounds, and sometimes perspective. All the others present some curious peculiarities. Each miniature can be joined to the following one to form a continuous frieze after the manner of the Joshua Roll. Thus, Paradise, in the scene of the fall of man, continues on the left side of the next scene, which is the expulsion from Eden (pp. 1, 2). Furthermore, most miniatures of this type are divided into an upper and a lower scene by means of a narrow band. Even when this band is omitted, the upper portion of the miniature is filled with cities or trees, so that the height of the frieze would be maintained (pp. 6, 13, 16, 22). The mountains that are clipped on the sides also indicate the adaptation of scroll illuminations to the folios of a codex (Fig. 62). This characteristic of the miniatures has already attracted the attention of Lüdtke, who came to the conclusion that this type of miniature in the Vienna Genesis was copied from an earlier scroll, similar in type to the Joshua Roll.

Likewise, one can assume that the miniatures with colored background and sky entered the Vienna Genesis from some other manuscript, similar to those of Homer and Virgil, in which both the sky and distant landscape are represented. The mosaics of the nave of Sta. Maria Maggiore in Rome, representing biblical scenes, are a clear proof of the existence of such illustrated Bibles. The discovery at Quedlinburg of several parchment folios from a fourth-century Latin Bible having rectangular miniatures framed by a red band and executed in the style of the manuscripts of Virgil and of the *Iliad*, leaves no doubt in this respect.[172] The miniatures of this type in the Vienna Genesis differ from those discussed previously in that they are not divided into friezes and the figures in them are bigger and bulkier.

Wickhoff has ascribed the illuminations of the Vienna Genesis to five hands: a miniaturist in the full sense of that word, a colorist, and three illusionists.[173] That a single manuscript should have been illustrated by several hands need not seem peculiar, since the Vatican Menologium was also decorated by several artists. However, the differences observed by Wickhoff must be attributed exclusively to the fact that the Vienna Genesis was copied from different originals.

Wickhoff himself was inclined to assume that the illuminations of the Vienna Genesis were executed by two groups of painters (one working in the miniaturist and the other in the illusionist style), since the first two of his conjectural artists are as close to each other in style as the last three.[174] Kondakov, however, has pointed out the indisputable uniformity in the execution of all the drawings in the Bible, regardless of the differences in the structure and character of the compositions. This is indicated by the sameness of the human figures, by the uniform manner of representing the extremities of human beings and animals, and by the carelessness and rapidity of the brushwork that may be noticed in all the miniatures.[175] Indeed, in spite of the observable variations, such as the gradual change in the size of figures and in the character of landscapes and compositions, the manner and technique of painting remain constant. All the way through we encounter the same type of figure, with a big head, thin legs, and small feet; the same careless and rapid brushwork; and the same defects in execution that are common to the Rossano Gospel.

The distinction that exists between the two types of miniatures in the Vienna Genesis consequently results from the copying of two different prototypes. It is interesting to note that the two eleventh-century Octateuchs in the Vatican Library, as well as the one in Smyrna, also display a great variety in the character of their illustrations which must have been copied from several earlier manuscripts. These include copies of compositions that appear in the Joshua Roll, whereas other drawings are borrowed from the *Topography* of Cosmas. More important yet, these Octateuchs include compositions from that particular illustrated recension of the Bible that is known to us through the mosaics of Sta. Maria Maggiore in Rome. On the other hand, the miniatures depicting the Egyptian tribulations must have been copied from an original that is now lost.[176] This variety may be easily explained. The full text of the Bible was not as widespread in one volume as the Pentateuch, the Octateuch, the Prophets, and the Psalter. The illustrations of these books could thus originate quite independently and later be included in more complete editions of the Bible.

Miniatures of Alexandrian and Syrian Manuscripts

Kondakov has compared the illustrations of the Vienna Genesis to those of the *Iliad*, the *Odyssey*, and the *Aeneid*,[177] and has pointed out the historical connection between the illustrations of antique and Christian manuscripts. The drawings of the Vienna Genesis accompany the text in an interrupted sequence. The manuscript begins with the fall of Adam. Then come the Deluge and the story of Noah. The story of Abel and Cain is lacking because of the loss of several folios. There follow scenes from the lives of Abraham, Isaac, Jacob, and Joseph, all elaborately illustrated.

The idyllic character and the variety of bucolic scenes illustrating the story of Joseph, the genre pictures of everyday life (Rebecca at the well, her marriage, and family life), and, generally speaking, the wealth of true detail in the representation of houses and cities—all of this reproduces so faithfully the character of antique life, that the close relationship between the illustrations of the Vienna Genesis and those of the ancient epics becomes immediately apparent. Indeed, Schultze could compare the parchment folios of an illustrated Bible recently discovered in Quedlinburg only to the *Aeneid* of the Vatican Library.[178] One begins to understand the spirit in which painters approached the text of the Bible, or at least certain sections of it, including the story of the first men and of the Patriarchs. The illustrations of the Bible assumed an epic character. Wickhoff has also noticed this epic character in the illustrations of the Vienna Genesis, but did not sufficiently emphasize it in relation to other illuminated manuscripts of the Bible, such as the Joshua Roll.

This fact alone sheds light on the Hellenistic character of the illustrations of the Vienna Genesis. The purely Greek type of the faces and figures that was inherited by Byzantine art shows that the Vienna Genesis must have originated in a country having a Hellenistic art. This is also shown by other characteristics. Particularly interesting is the picturesque execution of some miniatures that display the traditions of Alexandrian painting. For example, we see the reflection of the sun's rays on rocks and on Jacob's clothes. Furthermore, the blue mountains, the sky which is light blue above and pink below, the golden yellow color of the earth with green shadows cast upon it by human legs and by

objects, and finally, the play of red and bronze lights on faces and bodies—all of these are traits known to us from Pompeian painting and later from the Rabula Codex.

Furthermore, the two miniatures representing the meeting with Rebecca at the well (Figs. 62 and 63) contain personifications

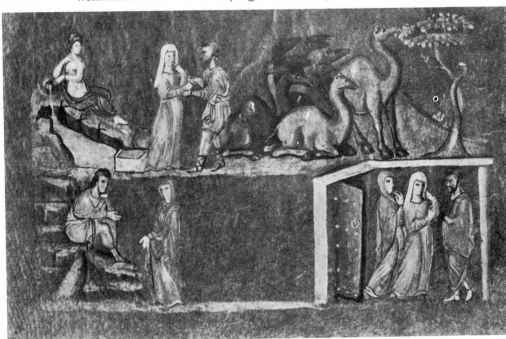

Fig. 62

of springs in the form of female figures leaning on urns out of which water pours into a river. The Deluge (Fig. 64), in its picturesque execution, reminds us of the birth of the giants in Nicander's manuscript. The waters occupy the greater portion of the miniature; men and animals are shown drowning in it. The listing ark is afloat on the raging waters. There is a white strip of clouds above, out of which there falls a solid wall of rain. In the right corner a few black snakes are swimming.

We may also draw attention to the polychromy of the buildings. The walls of the house in which the Pharaoh is feasting are painted blue and yellow; the column that stands on one side is red (p. 34). In another miniature (p. 46) the upper part of doors and walls is painted deep red, while the lower part is dark.

Shadows are therefore indicated in purple above and in blue below.

In the scene of the fall of Adam (p. 1) we see a luxurious garden with fruit trees, which reminds us of the magnificent gardens in Pompeian frescoes and at Prima Porta in Rome. These

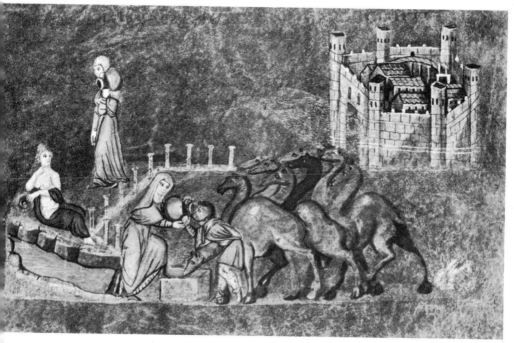

Fig. 63

gardens can be traced to the "paradises" of Alexandrian painting. Representations of gardens are also known to us from Christian mural paintings in Gaza and Constantinople.[179]

The Joshua Roll in the Vatican Library [180] stands in the same relationship to the illustrations of antique epic poetry. Wickhoff erroneously assumes that the uninterrupted sequence of scenes depicting Joshua's conquest of the Promised Land is indicative of the influence exerted by Roman triumphal art upon Greek art. "Among works of painting," he asserts, "none is as closely related in genre, though not in historical content, to the Roll as the reliefs of Trajan's column. The Greek inscriptions of the Roll indicate that we are witnessing here the reverse influence of Roman art on Greek art in late antiquity." The biblical hero

with his warriors fights battles and takes prisoners, as does the emperor on the triumphal column. Both the Roll and the column are decorated by the method of simultaneous representation.[181] Wickhoff's arguments have won approval from Graeven.[182]

However, the reliefs of the column cannot be considered as

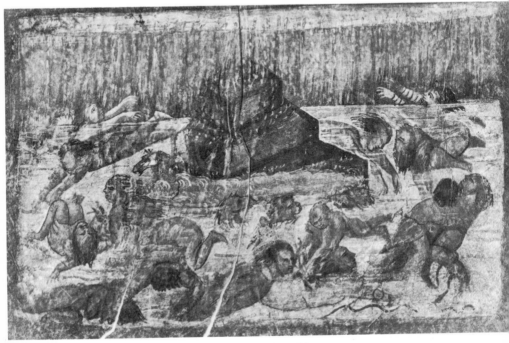

Fig. 64

the historical prototype of the parchment scroll. The resemblance indicated by Wickhoff is limited to the character of the martial scenes and to their arrangement in an uninterrupted frieze. This is not sufficient reason for the conclusion that Roman triumphal art has here influenced Greek art.

The Joshua Roll is not a triumphal monument like the column. It owes its origin to illustrated scrolls such as those of the *Iliad* and the *Odyssey*, and although such scrolls are no longer extant, we still have the *Iliad* of the Ambrosian Library and the *Aeneid* of the Vatican. These are codices and not scrolls, but to a certain degree they may be considered as substitutes of scrolls as regards their content and the general character of their illustrations. Kondakov has compared the Joshua Roll with these two illus-

trated heroic poems. The resemblance is indeed very close. In the Joshua Roll, as in the antique manuscripts, are represented the heroic deeds of ages past and not the historical exploits of emperors, which provide the subject matter for triumphal columns. In the Ambrosian *Iliad* there is an endless sequence of battles and sieges, followed by the story of the Trojan horse and of the fall of Troy. In the Joshua Roll we see the military exploits of Joshua and the conquest of the Promised Land with all the incidents of that war. It is important to point out the multitude of

Fig. 65

personifications of rivers and cities in this Roll (Fig. 65), the use of blue nimbi, and the fantastic character of some of the edifices: These traits emphasize the kinship between the Roll and monuments of painting such as the *Iliad* of the Ambrosian Library. Curiously enough, the figure of Joshua stopping the motion of the sun is repeated both on the mosaics of Sta. Maria Maggiore and in the Rabula Gospel. The personification of the city of Gabaon is also of considerable interest because it reproduces the famous statue of the Tyche of Antioch by Eutychides.[183] This observation is not by itself sufficient to ascribe the manuscript to the Antiochene orbit, although it does point to the Greek East as its place of origin.

We should remember that magnificent scrolls of the *Iliad* and the *Odyssey*, lettered in gold, belonged to the library of Constantine the Great.[184] It is highly probable that scrolls of this kind were illuminated, and this is, in fact, stated by the chronicler Cedrenus.[185]

The few extant folios of the Cotton Genesis may be linked with the Vienna Genesis.[186] Compositions present in the Cotton Genesis were faithfully reproduced in the mosaics of S. Marco in Venice, as has been demonstrated by Tikkanen.[187] One of the miniatures of this manuscript showed allegories of the four seasons in the guise of female figures. Kondakov has observed that the miniatures of this manuscript anticipate later Byzantine illumination even more than does the Vienna Genesis. We find here Christ in golden vestments, angels with blue wings, and robes embroidered with gold, as well as a particular fondness for light blue and pink which is characteristic of Byzantine painting.[188]

Concerning the Rossano Gospel, the Vienna Genesis, the Joshua Roll, and the Cotton Genesis, we can make only one judgment, which also applies to most of the Byzantine copies of Alexandrian manuscripts: They belong to Byzantine art. It is not known where and when they were written; on that point we have nothing but contradictory hypotheses.[189]

It is, however, necessary to point out that the Joshua Roll exhibits in a particularly pure form the characteristics that we have observed in the miniatures of the Nicander manuscript. This is apparent in the choice of colors, in the use of nimbi, and above

all, in the fondness for personifications of cities and rivers. In the Rossano Gospel, we find a circle containing the title and a representation of St. Mark that are reminiscent of similar representations in the Dioscorides manuscript. The Vienna Genesis preserves the general principles of Hellenistic art in the use of personifications, in the character of its landscapes, and in certain traits of picturesque composition. In the Cotton Genesis are shown personifications and sunrays that remind us of the rays and the personifications of springs in the Vienna Genesis.

These antique characteristics found in Byzantine manuscripts can be fully understood only through an examination of Alexandrian manuscripts such as has been carried out in this chapter. The existence of Byzantine copies of ancient originals not only proves that scientific Alexandrian treatises were copied in Byzantium, but also that the very art of Alexandria was transplanted into Byzantine soil. The wide diffusion of Alexandrian characteristics in the field of miniature painting proves that Alexandrian influence cannot be considered as having been limited to the mere copying of Alexandrian manuscripts: It must be understood on a larger scale. The Dioscorides manuscript demonstrates that certain aspects of Hellenistic art appeared in Constantinople in the guise of imports from Alexandria. Similarly, the appearance in the Rossano Gospel of the Oriental type of Christ and of compositions based upon Palestinian apocryphal writings, also found in the Rabula Gospel, proves that Syro-Palestinian art was also transplanted into Byzantine soil.

We shall now meet these two major influences, the Alexandrian-Hellenistic and Syro-Palestinian, in another domain, that of the plastic arts.

II. Pictorial Relief

1. In the study of the antique foundations of Byzantine art an important place is occupied by pictorial relief which was maintained in Byzantine sculpture. In many instances, works of late Byzantine carving not only display a type of composition peculiar to miniatures and to mosaics, but also preserve, from a technical standpoint, and however slightly in some cases, the peculiarities of pictorial relief. These characteristics of late Byzantine carving can be explained on the basis of monuments of the fourth to the sixth centuries.

In publishing certain works of ivory and wood carving of Egyptian origin, Strzygowski has formulated some interesting conclusions regarding the development of Egyptian sculpture prior to the thirteenth century. Having considered these works in conjunction with other ivories in European museums and in private collections, he has made the following deductions: (1) Egyptian sculpture originates in places where late Roman art was dominant; (2) its development parallels that of Syrian art to such an extent that Egyptian and Syrian works of the fourth century cannot always be distinguished; (3) after the period of Justinian, Egypt follows the lead of Byzantium until it falls under the influence of the Arabs; (4) arched frames were at all times favored by Egyptian art; (5) any consideration of the rôle of national Coptic elements in Egyptian sculpture is to be totally dismissed.[1]

The term "late Roman art" does not in this instance refer to the

art of Rome as such. Here we are concerned with the Hellenistic art of Egypt and Syria, since the autonomy of the schools of Monza and Ravenna is no longer admitted, whereas it is recognized that Egyptian works of art were imported into Europe and consequently influenced the beginnings of Western Christian art. After examining a wooden relief from al-Mu'allaka and two pyxides, one from the Nesbitt collection in London (now in the British Museum), and the other from the Figdor collection in Vienna, Strzygowski comes to the perfectly correct conclusion that the two latter works must be considered as imports from Egypt and that this sheds new light upon the art of Ravenna and its ties with the East. As he puts it, "To demonstrate this, compare the architecture of the background of Maximian's throne with the relief from al-Mu'allaka." Strzygowski does not offer an adequate explanation of the peculiarity he mentions, which can be observed in a whole group of minor works marked by Oriental stylistic traits, although he does promise to return to this topic at a later date.

This peculiarity, namely the architectural background, denotes in the first place the presence of a pictorial element in the plastic art of Egypt and Ravenna. Hence it is interesting to observe that this applies to a whole series of ivories that may be grouped around the most conspicuous of these works, Maximian's chair in Ravenna. This kind of architecture is to be found on such works as the Paris and Etschmiadzin diptychs and on numerous pyxides that show a kinship with Maximian's chair in the structure of the compostion, in the choice of subject matter, and even in the technique of carving.

The pictorial characteristics of Egyptian sculpture remind us of the traditions of the Alexandrian school of painting. Even if it were not generally acknowledged that the pictorial style of Roman marble reliefs originated in Alexandria, one would have had to note carefully the presence of this trait in Byzantine works, which indicates in a general manner the Hellenistic character of Byzantine plastic art. This becomes even more important once a point of reference has been established for the classification of the monuments. Pictorial relief, considered as a genre of plastic art, is historically connected with Alexandrian art. Among the monuments actually found in Constantinople, there is as yet

only one that embodies pictorial relief, but this fact cannot be used to prove that this genre did not flourish there either before or after the period of Justinian. Similarly, the dearth of outstanding works in this same plastic genre in Alexandria only points to the wholesale destruction of the monuments of the Christian

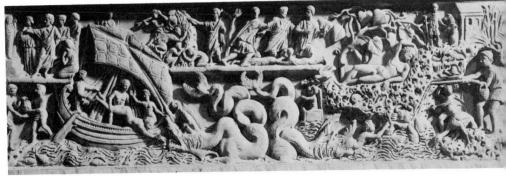

Fig. 66

East. It is not there, but in Rome and in Ravenna that the most remarkable monuments of pictorial relief have been preserved. We must take these as the basis for the history of early Byzantine plastic art.

The use of pictorial relief is found on Roman sarcophagi. The best instance is the sarcophagus in the Lateran Museum that represents the story of Jonah (Fig. 66).[2] The decoration of this sarcophagus is not, however, entirely in the pictorial manner. The upper portion of the slab represents the raising of Lazarus and Moses drawing water in the desert. These scenes form a narrow frieze, separated from the lower portion of the slab by a protruding strip of ground which extends over the tails of the sea monsters and is interrupted by the sails of Jonah's ship. The heads of the figures in the frieze touch the upper frame, while their feet rest upon the protruding strip below. The background is filled with figures of disciples and other persons, a symbolic representation of the wind, and a small tree as high as a man. This frieze is executed according to the rules of high, or classical, relief.

By contrast, the lower part of the slab displays all the characteristics of pictorial relief. Here are represented the ground, a rocky shore, and a billowing sea, shown not as a narrow band

but as an expanse of water extending upward in perspective. A crab, a lizard, and two snails crawl on the shore, and a stork walks upon it. Two monsters are twisting their reptilian bodies among the waves on which sails the ship from whose deck sailors are casting Jonah into the jaws of one of the monsters. On the right, we see Noah sailing in a square ark. On a cliff above the coast stands a shepherd's hut with two lambs peering out of its door. The hut is in perspective, showing two of its walls and its gable roof. The rocky shore and cavern that occupy the entire right-hand side of the slab have the uneven, chunky surface that was a favorite motif of pictorial relief. The human figures are shown stepping on the hilly ground, not on the lower frame; their height is not elongated to fit the height of the frieze. Moreover the sea, the shore, the mountains, the hut, and the ship are executed in low relief, occasionally turning to high relief; the fishermen, the boys, and the stork are in rounded relief. Their legs, arms, heads, and torsos are detached from the background landscape.

This combination, in a Christian work of art, of compositions executed according to the rules of both types of relief—classical and pictorial—is of great interest. To account for this fact we must suppose that ready-made models of these compositions were reproduced and combined here on the same slab. The upper scenes represent the type of high relief constructed according to the principle of isocephaly that is commonly found on sarcophagi. On the other hand, the Jonah scenes offer an example of pictorial composition, known to us from catacomb paintings. This pictorial mode of execution is combined with such motifs of Alexandrian sculpture as the bare-legged fisherman wearing a cap and a sleeveless exomis, with a plaited basket over his left arm. This figure reminds us of similar fishermen's statues of Hellenistic type, particularly of the statuette in the British Museum.[3] The whale resembles Andromeda's monster, and Jonah himself, as well as his companions, are shown like the naked *putti* of Hellenistic painting and sculpture. The stork places the scene in an Egyptian setting.

An equally interesting example of pictorial relief is afforded by another sarcophagus in the Lateran Museum, on the sides of which are represented Peter's denial and the healing of the woman with an issue of blood (Fig. 67). In both instances the

background depicts a complex set of buildings whose roofs and pediments are executed in perspective in low or flat relief. One can see not only the façades of the buildings, but also their sides. The buildings in front partly obscure those behind them. The ground is represented as a series of hillocks on which the buildings are placed. This is the normal manner of representing the ground on Hellenistic reliefs. The figures are executed in higher relief, but no part of them is fully rounded. Even so, not all the conventions of pictorial relief are observed here. The human figures do not always step on the hilly ground; on the second slab in particular, they stand on the lower frame, and their heads are shown at the same level, although this disposition is not called for. The cause of this phenomenon is the same as in the previous example. The pictorial setting was adapted to ready-made compositions belonging to the genre of high relief. This fact is particularly noticeable in the adaptation of the Paneas group to its pictorial setting. The manner in which the group is disposed among the buildings of a city points to a pictorial redaction of this composition. This is also indicated by the flat relief. The portrayal of Christ's figure in strict profile, its "historical" type, with long wavy hair and a short beard, as well as the reproduction of the famous group that stood at Paneas (minutely described by Eusebius and other historians) [4] prove the Oriental origin of the composition. It is interesting to note that this scene is represented in a similar form in both Syrian Gospels, as well as on an Egyptian textile now in the ethnographic collection of the Trocadéro in Paris. The two Syrian compositions display very close kinship to each other. The Egyptian textile is no less interesting. It depicts a woman, clothed in red, who has fallen on one knee before Christ; the latter extends His hand towards her in the same manner as on the Lateran sarcophagus. Four persons are shown behind the woman, and behind Christ is an apostle clad in blue. Christ is clothed in purple and has a yellow halo. The letter *T* stands next to the apostle's head; above is placed the inscription ΛΗ ΟΡΜΟΚΗΧ. The background of the textile is bright red; the ground, strewn with a few pebbles, is green. The symmetrical structure of the other scene, depicting Peter's denial, points to a type of composition pertaining to high relief: Christ and Peter are disposed on either side of the small column

Fig. 67

with the cock, and their heads reach up to the same level; the base of the column is placed on the lower frame. Early pilgrims to the Holy Land make no mention of the cock's column, although they often describe the house of Caiaphas and the church of Peter's Repentance. However it is known that such a column did stand in front of the Lateran basilica in Rome,[5] and this particular monument may have been included in representations that originated in Rome. The column with a cross, marking the place of Christ's baptism in the river Jordan, may serve, on the other hand, as an example of the practice of erecting votive columns in Palestine.[6]

Such instances of the introduction into pictorial relief of traits belonging to classical relief are not infrequently found on sarcophagi. They sometimes indicate to us from what milieu a given composition was borrowed and may thus help us to a certain degree to unravel the knotty problem of the gradual formation of the iconography of Roman sarcophagi.

On the sarcophagus of S. Celso in Milan (Fig. 68), for instance, part of the frieze develops according to the rules of classical relief, while the rest follows the pictorial type of composition.[7] In the scene portraying the women at the Sepulcher, the ground is depicted pictorially. The building of the Sepulcher does not stand on the lower line of the frame, but on an elevation depicted in the manner of the hillocks of pictorial relief. The feet of the women are placed on this ground. Next to this scene, and upon the same ground, the sculptor has fitted in the doubting of Thomas. To represent this ground, the artist even went beyond the *extrema linea,* i.e., the lower frame of the frieze, and placed it on the bottom edge of the sarcophagus. The presence of the rotunda of the Sepulcher and the introduction of the scene itself into the cycle of the Passion indicate that the artist was following a new model which he clumsily attempted to fit into a classical relief.

Another example of the combination of both types of relief is provided by a sarcophagus in the Vatican,[8] which unfortunately is known to us only through an old drawing of poor quality. The story of Jonah is here depicted pictorially, but on the left-hand side is represented the adoration of the Magi, with the heads of all the figures on the same level.

Generally speaking, pastoral scenes are distinguished by their pictorial character. We are often given a bird's-eye view of a grove or a vineyard; the strip of sky is absent. Shepherds and farmhands are toiling in the vineyard. We are shown a hut and a brook with sheep along its banks.[9] Similar scenes from pastoral

Fig. 68

life, drawn in bird's-eye perspective and lacking sky, are also found in the Vatican Virgil.[10] This manner of depicting the earth in perspective was, as we shall see later, taken over by Byzantine painting and was preserved in Byzantine cartography.

Thus we see that, on Roman sarcophagi, pictorial relief loses its autonomous meaning and its artistic value as a consequence of its being adapted to compositions in high relief. It appears in an abbreviated form, as though by chance, and only the pastoral scenes preserve a more or less complete, though conventional, landscape character. All these vacillations in the execution of pictorial relief suddenly disappear when we turn our attention from sarcophagi, with their complicated iconography taken from several sources, to works of more independent nature, produced in a higher artistic milieu; in other words, when we turn from copies to originals. We shall find such works among the minor arts, in ivory and wood carving.

2. One of the most important monuments of pictorial relief in ivory carving is the famous plaque from the Trivulzio collection in Milan, which has been published and described many times

(Fig. 69).[11] This unique work is a most typical specimen of the mature style of pictorial relief. Stuhlfauth dates it to the Carolingian period,[12] but this misconception is due to his poor knowledge of style. Schultze considers it a product of Greek sculpture, while Strzygowski sees in it an example of classical Byzantine sculpture of the best period and attributes it to Constantinople.[13] The figures, objects, and buildings on this plaque are executed in a most elegant low relief, which becomes a little higher only for the heads, hands, feet, and some parts of the garments. The plaque is divided into two rectangles, with an ornamental frame that is repeated, in a somewhat modified form, on the doors of Sta. Sabina in Rome and on the consular diptych of Probianus.[14] This ornament consists of a combination of lotus and acanthus forms. The composition is developed pictorially, and its component parts are symmetrically disposed. In the upper corners of the upper rectangle are two Evangelists' symbols—a bull and an angel. In the center is the Holy Sepulcher, on either side of which is a Judean warrior falling down in fear. The billowing mantle of the warrior on the left balances the tree shown behind the warrior on the right. The strip of ground at the bottom corresponds to a band of clouds at the top. The center of the lower square is taken up by a sumptuous door flanked by two narrow windows or slits. The figures of a seated man and a standing woman are placed symmetrically. The second woman, who is kneeling, balances the stone on which the man is seated. The latter is depicted as being considerably larger than the two women.

Both compositions have been given a rectangular shape similar to that of a painting. Their slight elongation is required for the representation of the sky and of the tall door. The traits of the pictorial manner are conspicuously expressed. In both compositions, the ground, even though it is not hilly, rises up in perspective. The stone on which the man is seated is shown as a natural boulder of the type found in Hellenistic reliefs and sculpture. The Sepulcher is depicted standing on the ground in correct perspective. The ground line of the building, the edge of the roof, the rows of tiles, and the windows form arcs of circles. A twisted branch of ivy climbs along the wall and roof of the Sepulcher. It is important to note the presence of an oblong cloud of

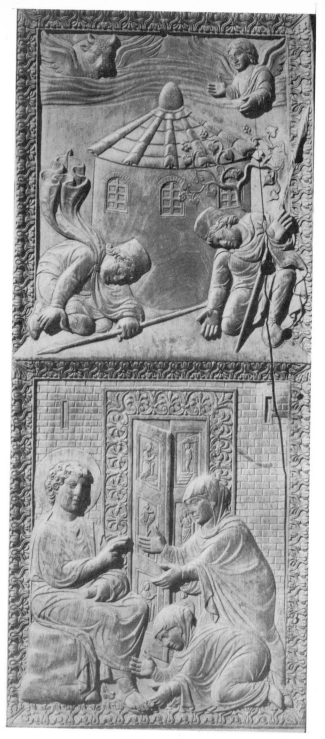

Fig. 69

the same kind as those in fourth- and fifth-century mosaics. Clouds are not depicted in Alexandrian pictorial reliefs.

In the lower scene the wall of the Holy Sepulcher, with its sumptuously decorated door, occupies the entire background. Its wall is built of oblong stones.[15] The leaf of the door that is partly opened is drawn in correct perspective, i.e., slanting downwards. The door is proportionate to the size of the human figures. The observance of proper proportion between figures and buildings is generally a characteristic of pictorial relief.[16] In high relief, in order to adhere to the rule of isocephaly, buildings and doors are of the same height as human figures, or even lower. Graeven believes that the two rectangles of the plaque depict the upper and the lower stories of the Holy Sepulcher,[17] but that would mean that the warriors are hiding on its roof. Besides, the band of ornament that separates the two compositions is intended to show that each one of them is a separate tableau in its own frame. The lower square represents only a small part of the building of the Anastasis with the well-known door of the Myrophoroi.

It is most important to observe the pictorial manner in which the figures themselves have been executed. The impression of substantiality and roundness is achieved by means of slightly higher relief and by foreshortenings and contractions which are pictorial in nature. Thus, one shoulder in fairly low relief is flattened against the background of the plaque while the other is rendered in higher relief. Behind one hand we see the other; the warrior's wind-blown cloak shows folds on its inside; the garments of the figures in the lower scene have folds carved in several planes. The figure of the warrior on the right is of particular interest for its pictorial foreshortening. The left shoulder is hidden by the palm of the hand; the thigh recedes behind the knee and the hanging folds of the tunic. The same technique may be observed in the execution of the other warrior. Only part of his left knee is visible, hidden behind his right leg.

The sensitive rendering of the drapery, hair, facial traits, and ornament, and the elegant classical shape of the foot of the male figure point to the existence of a remarkable school imbued with the tradition of pictorial sculpture. It should be noted that the contour of the faces, the regular noses and lips, and the softly

outlined eyes without pupils reproduce the graceful types of the Hellenistic period. These faces have one thing in common: They are beautiful but lifeless, inasmuch as they conform to a stock pattern. The same facial character and style may be seen on the silver vessels from the Boscoreale treasure. This is particularly true of the head of the personification of Alexandria.[18] The low relief on the Trivulzio plaque is also reminiscent of *repoussé* metalwork.

And yet the plaque cannot be dated earlier than the fourth century. The circular structure of the Holy Sepulcher with no plinth at the base represents the first stage in the development and elaboration of the Holy Sepulcher as it is depicted on Christian monuments. The ivy branch stands for the garden which was behind the Holy Sepulcher when Constantine's buildings were first erected. The sumptuous carving on the doors of the Sepulcher bring to mind the enthusiastic accounts of pilgrims concerning the magnificent decoration of the buildings commemorating the death and burial of Christ. These doors have inset plaques representing the raising of Lazarus, the story of Zacchæus, and another miracle. The door frame has an ornament of Greek style, consisting of palmettes in a wide border. Near the door is represented the stone that was taken away from the Sepulcher. This was displayed in the Holy Sepulcher, but is not found on Roman sarcophagi. The plaque cannot, therefore, be earlier than 326.

The appearance of themes from the Passion in a milieu showing the monumental structures of Constantine the Great is related to a new stage in the development of Christian art, a stage marked by increased reverence for the holy places of Jerusalem. It is here that the first "historical" compositions must have originated, and it is from here that they must have spread over all of Christendom. That they were widely copied is indicated by the constant repetition of the same iconographic traits on Eastern and Western monuments. This is why it is important to determine the place of origin of the Trivulzio plaque, i.e., both of its actual execution and of its iconography. Both of these point to the East and not to Rome. The similarity to Roman sarcophagi is most evident in the garments and weapons of the warriors, in their Oriental headgear, and in their spears. But this similarity

cannot be considered decisive, since these types can be held to have been borrowed from the East by the Roman school. In the manuscript of Cosmas Indicopleustes (Fig. 16) we see the same loose trousers, cloaks, and footgear. The execution of the bull's and angel's wings indicates a connection with a motif of the Neapolitan and Capuan mosaics, each wing being composed of three separate wings or feathers. However, this wing structure should also be related to the six-winged Victories on the relief from Khoja Kalessi in Asia Minor.[19] This fact points to a tie with Alexandria and Asia Minor, which is also attested by the Greek character of the ornamentation of a kind found on antique monuments of Rome and Asia Minor.[20]

Other iconographical traits give better clues as to the place of origin of the Trivulzio plaque. Of the scenes depicted on the door of the Holy Sepulcher, one—Lazarus rising from the dead— is well known from Roman sarcophagi, but the two other scenes are more unusual. The calling of Zacchæus (Luke 19:2-5) may be recognized by the figure of a man seated in a tree. Christ stands in front of the tree, stretching out His right hand towards Zacchæus. This scene is absent from catacomb paintings, although it does occur on a sarcophagus from Tarragona.[21] It is, therefore, especially interesting to find it represented on a sixth-century Egyptian gnostic amulet [22] and on Maximian's chair. The bottom scene depicts Christ stretching out His hand to a figure that is somewhat hunched and that holds out both hands towards Christ. An analogous scene may be found on an encolpion of the Ottoman Museum and in the Rabula Gospel. The inscription on the encolpion indicates that Christ is healing the leper; the latter, dressed in a tunic and a pallium, is stretching out his hands towards Christ (Fig. 70).[23] This scene differs from the one on the plaque in that the arrangement of the figures has been reversed. In the Syrian Gospel, Christ stands to the left and the leper to the right.[24] The leper holds his hands outstretched in the same manner, although his figure is less expressive and his clothing consists only of a knee-length tunic. The analogy with the encolpion is particularly interesting, since Strzygowski, who pointed out its Syro-Palestinian characteristics, did not ascribe it unequivocally to Palestine, but also mentioned the possibility of Egyptian origin on the basis of the name

ΕΓΥΠΤΟC that is inscribed in the scene of the flight into Egypt. But another significant trait, beside the ones already mentioned, does indeed point to Palestine. The representation of the Holy Sepulcher in the shape of a squat building with a sloping roof and no plinth is repeated on the Monza ampullae. In the latter

Fig. 70

the structure is shown flat, but has the same form as on the Trivulzio plaque. In two instances, a garden consisting of trees and branches is represented behind the building.

Thus the connections of the Trivulzio plaque with African and Palestinian art prove that it belongs to the East, most probably to Alexandria. The beauty and extraordinary freshness of the tradition of pictorial relief do indeed point to Alexandrian art of the fourth century.

3. Among the works that display, at least in part, the use of pictorial relief and that are marked by Palestinian characteristics, we must include the two pyxides from the Berlin and Bologna museums that have already been examined above (Figs. 48 and 49).[25] On the Berlin pyxis, two scenes are depicted: Christ among the twelve apostles and the sacrifice of Abraham. In both

compositions the use of pictorial relief is apparent not only in the arrangement of figures and the application of foreshortening, but also in the presence of a portico behind the figures and, in the sacrifice of Abraham, in the perspective representation of the flight of fourteen steps leading up to the altar. Isaac, in the form of an antique *putto,* stands on these steps which are partly hidden by the folds of Abraham's garments. Abraham and the steps are executed in low relief, Christ and the apostles in high relief. On the Bologna pyxis the miracles of Christ are executed according to the rules of classical relief with no architecture in the background, but the added scene of Abraham's sacrifice reproduces many details of the Berlin pyxis, namely, the steps, the altar, the figure of Isaac, the position of the lamb, and, in part, the figure of Abraham. Stuhlfauth insists upon the Roman origin of both works,[26] whereas Strzygowski[27] and Tikkanen[28] rightly suggest an Oriental origin. Indeed, the similarity of the composition of Abraham's sacrifice on both pyxides and in the Etschmiadzin Gospel is further corroborated by the Palestinian origin of this scene as shown by the representation of the flight of steps and Abraham's altar. Graeven, who did not take into consideration the nature of the relief used here, came to the conclusion that the altar was represented atop a pile of stone slabs, whereas it actually stands at the head of a flight of steps, rendered in perspective by means of an incision for each step. Steps are depicted in the same manner on the famous British Museum ivory representing an angel. As a result of this mistaken explanation, he assumed that the Etschmiadzin miniature incorrectly reproduced this feature of its model, namely, in substituting a flight of steps for the pile of stone slabs.[29] But the presence of this flight of steps in the *Biblia Pauperum,* where it is shown aslant, as in the Etschmiadzin miniature, proves that the Berlin and Bologna pyxides modify the original iconography by representing the steps head on, probably for reasons of symmetry. The shape of the altar, for which Graeven could find no precedent, is known in Alexandria itself. An altar of similar form was found in a Christian funerary chapel northwest of Gabbary, near Alexandria. It has a round pedestal and a narrow neck supporting the upper part which terminates in three angular projections.[30]

And yet it seems to us that Graeven was perfectly right in

pointing out the resemblance of the figure of Abraham, in the Berlin pyxis, to that of Calchas in the Pompeian painting of the sacrifice of Iphigenia copied from the original by Timanthes (Fig. 71). This resemblance provides explicit proof that early Christian art borrowed from Hellenistic painting. The scene of the judgment of Ananias and Sapphira on the Brescia casket provides another example of borrowing from the same painting by Timanthes.[31] The figures that are shown carrying Ananias are closely copied from that painting, and Ananias himself is represented with one arm raised (Fig. 72). Edmond Le Blant has published a fragment of a sarcophagus from Gaul on which the same subject is treated in a similar manner.[32]

Fig. 71

Fig. 72

4. The chair of Bishop Maximian, in Ravenna, is an even more important monument that preserves the style of pictorial relief in all its freshness.[33]

The chair consists of a frame inset with plaques decorated in relief. Even a cursory examination shows that the character of the reliefs is not the same throughout. The large tall plaques are executed in low and even flat relief, whereas the narrow plaques, set lengthwise, are executed in high, sometimes fully rounded, relief. This peculiarity indicates a deliberate use of both types of relief for different surfaces. All the large plaques are decorated with scenes from the Gospels, whereas the small plaques have scenes from the life of Joseph.

This observation on the technique of carving is by itself sufficient to show that there is a certain artistic value in the very mode of execution of the reliefs, and to prevent us from having recourse to strange theories regarding the existence in Ravenna of a "New Testament School" and an "Old Testament School," which, allegedly, pooled their efforts for the decoration of this one chair, as one German scholar believes.[34] Such a theory would not be worth mentioning if it did not provide a clear illustration of how far we still are from a scientific approach to the problem of style in Byzantine art.

Particular attention should be paid to the pictorial execution of the plaque representing the baptism of Christ (Fig. 73). It is executed in very low relief. At the bottom are seen the stormy waves of the river, flowing from the urn of the youthful figure of

the river Jordan. Christ's body shows through the water which rises to His waist. John the Baptist stands on a rocky ledge of the shore, executed in perspective. Behind John can be seen part of a building with a tiled roof and one spirally fluted column. The pediment is presented in correct perspective, but the tiles are in reverse perspective. Two angels stand behind Christ. Thus the composition forms several planes: The first is occupied by the figures of Christ and John; behind is the figure of Jordan; further back are the angels; and in the very background stands

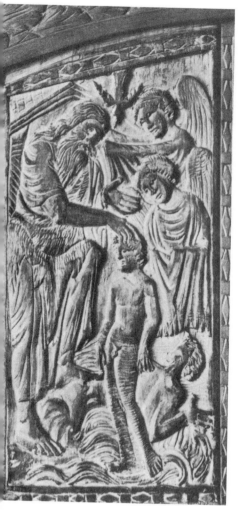

Fig. 73

Fig. 74

the building. The forms are foreshortened as in a painting. Note the left hand of John, the heads of the angels seen in three-quarter profile, the feet of Christ, and the back of Jordan, in addition to the building which is drawn in perspective.

The same traits appear in the plaque which depicts the Virgin and Child, with Joseph standing behind the Virgin's throne and an angel introducing the Magi, who must have been represented on the following plaque, now lost (Fig. 74). Here also the relief is very low. The ground and the footstool slant upwards. The crossed legs of the Virgin and of the Child are seen in a three-quarter view. The angel's foot is shown in correct perspective, toe pointing forward. Here too we can distinguish several planes. The Mother and Child are shown in front; further back, next to the throne, stands the angel; behind the throne are seen the head and torso of Joseph; in the far background two small trees represent a garden.

The plaques representing the Nativity, the entrance into Jerusalem, the Samaritan woman, the wedding feast at Cana, the flight into Egypt, and the trial by water are of the same character. Some of these plaques have more pictorial detail, others less; but this does not affect their basically pictorial nature, expressed by the very low relief. The modeling is provided by deeply cut lines, by hatching, and by the rounding of certain forms.

Some of the compositions contained within upright rectangles are executed according to the rules of classical relief, but are filled with pictorial details. In most cases, arcades and columns, indicated by deep incisions, appear behind the figures. In such cases, the ground is either completely omitted or is indicated in the spaces between the figures by means of strokes and hatching. The figures are arranged side by side; their feet stand on the lower frame, while their heads touch the upper edge. These reliefs remind us of the pyxides in the Figdor and Nesbitt collections, of the Etschmiadzin and Paris diptychs, and of the al-Mu'allaka relief. The multiplication of the loaves and the healing of the blind man (Fig. 75) are of this type. In other cases, although the figures in the foreground do have their feet on the lower frame, the ground is nevertheless indicated by uneven projections, strokes, and hatching, and the back figures are shown standing naturally on this ground. Thus, in the Entrance into

Fig. 75

Jerusalem, the ass stands on the lower frame, but the female personification of the city of Jerusalem, or the "daughter of Zion," stands on a raised, hilly portion of ground. In the plaque depicting the journey to Bethlehem, Joseph, the angel, and the ass are shown walking on the frame, but the ground is indicated between their legs by means of grooves. The same disposition of figures is used in the feast of Cana and in the scene of Christ with the Samaritan woman. In the latter, a disciple, who is shown behind the two principal figures, stands on an elevation of the ground.

The plaques depicting the life of Joseph are executed in higher relief; figures and buildings project sharply from the background. The characteristics of pictorial style are less in evidence here, and in one case we find a pure instance of classical relief. It should be stressed that this kind of relief is called for by the long and narrow shape of the plaque itself, which does not permit a pictorial development of the composition. This plaque portrays Joseph being sold to the Ishmaelites (Fig. 76, bottom). The figures seem to be separate statuettes. Their legs, arms, heads, and sometimes shoulders are completely rounded out. No figure stands in front of another one: All are set out side by side. Their heads touch the upper frame and their feet are placed on the lower one. There is neither ground nor landscape. The figure of the first camel is the only one that is pictorially foreshortened; its body is shown in low relief behind the merchant's legs. The head of the other camel is subjected to the compositional structure of the relief and also touches the upper frame.

In the entire story of Joseph, the ground is represented only once, on a fairly large plaque depicting Joseph sold to Potiphar (Fig. 77). This interesting relief unites two moments of the action and presents two rows of figures. In the upper left corner one sees the arch of a gate or of some other building. A merchant holding a long bow leads a camel on the back of which is a tall saddle. The upper part of this saddle, the camel's head, and the merchant's head touch the upper cornice of the plaque. On the right is seen an entablature supported by two spirally fluted Corinthian columns. Under the entablature stand Potiphar's wife and a youth who raises his arm in astonishment. The ground is represented under the feet of these figures by means of incised

Fig. 76

strokes. The position of the feet is free and natural. The second row of figures portrays Joseph as a small boy sitting on a smooth plank affixed to a camel's hump, holding the reins in his left hand. To the right, the merchant is shown receiving a bag of money from Potiphar. The transaction takes place over the head of Joseph who stands between them. The heads of Potiphar, the merchant, and Joseph on the camel are shown on one level. The merchant occupies the exact center of the composition. The feet of the figures in the front row are placed on the lower frame. Here, as in some of the Gospel scenes, the pictorial element is limited to the arch, the portico, and the indication of the ground. In other cases there are only colonnades with or without arches, hangings stretched between columns (as, for instance, in the scene of Joseph's brothers bringing his bloodstained garment to Jacob [Fig. 76, top]), trees in the pastoral scenes, and two rows of figures, just as in the Gospel scenes. This shows that the method of execution remains the same throughout, except for the height of the relief and the presence of more or fewer pictorial elements, so that there is no reason whatever to assume the existence of two schools. High relief is used when it is required by the narrowness of the plaques; low relief, when the height of the plaques permits the pictorial development of a composition.

Decadent traits have already made their appearance in this art. On Maximian's chair, we may observe in a few instances an abnormal position of feet (with the toes of one foot touching the heel of the other), a disproportionate elongation of bodies, and reverse perspective. However, these signs of decadence are lost in the wealth of technical competence displayed by the school or atelier that was responsible for the chair. These signs appear so very seldom and under such special conditions, that it is possible to account for their existence. It is particularly important to explain these traits, since they become more and more pronounced as Byzantine art develops until finally they become the dominant characteristics of Byzantine style.

The stance in which the toes of one foot touch the heel of the other is found only once on the chair, in the figure of St. Mark on the left-hand side of the front panel (Fig. 78).

The figures of the Evangelists and of John the Baptist imitate statues placed in niches. The three wider plaques are done in

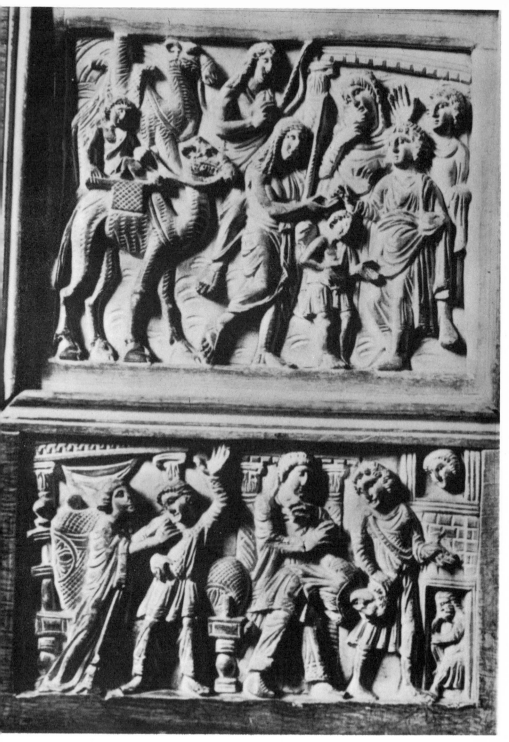

Fig. 77

low relief, while the two narrow plaques are done in somewhat higher relief, according to the principle that we have already observed. This variation in the height of the relief adds a particular beauty and elegance to the whole panel. The figure of St. Mark is one of those executed in low relief and reproduces a

Fig. 78

statue whose weight is supported not by one, but by both legs. The carver was able to foreshorten the feet correctly only for those figures whose weight falls on one leg, while the other is bent. In the case of St. Mark, his inability to foreshorten the right foot led to an ugly representation of the whole figure, as in Egyptian, Assyrian, and archaic Greek reliefs. The head of St. Mark is turned to the right, his chest and stomach are seen *en face,* and his toes point forward. In the Joshua Roll, the figure

of Joshua has a posture similar to that of St. Mark and remarkably close to archaic Greek reliefs, since his head is seen in profile, the torso *en face*, and the toes of both feet point forward. This analogy is all the more interesting since the figure of Joshua rests its weight on both legs. The figure of the archangel, on the other hand, is correctly portrayed (Fig. 65).

The elongation of the figures on Maximian's chair, just as in the Rabula Gospel, results from the narrowness of the spaces into which these figures have been fitted. This is quite clear with regard to the figures of St. Matthew and St. John as compared to those of John the Baptist and the other two Evangelists. In the Gospel scenes a few figures are also elongated, depending on the height of the plaque on which these figures are disposed according to the rules of classical relief (Fig. 75).

The use of reverse perspective is particularly clear in the books held by the four Evangelists. These are shown widening towards the top, presumably because the artist has tried to represent the thickness of the books, not on two sides only, but on all four, as if he was dealing with free-standing relief where the thickness of an object can be seen from all sides. The greatest amount of plasticity is found in the heads and also in the hands and legs of the Evangelists John and Matthew. The clothes and books are executed in a flat manner. Thus, the appearance of reverse perspective results from an incorrect transition from high to low relief. This is clearly indicated by the manner in which the sides of the books have been cut off at an angle. It is sufficient to compare the books held by the Evangelists on Maximian's chair with the marble bust of St. Mark in the Ottoman Museum in order to see that this fault derives from precisely this cause. In the latter work, the thickness of the Bible is shown from all sides, but correctly, in high relief. Elsewhere on Maximian's chair books are depicted correctly, their thickness being shown from two sides only (Fig. 75).

All these various characteristics of Maximian's chair, namely the preservation of the traditions of both pictorial and classical relief on the one hand, and, on the other, the appearance of defects due to the neglect of certain fundamental principles of carving, were combined in one school and one atelier. That school was as yet in possession of a rich inheritance of Hellenistic art.

At the same time the iconography of Maximian's chair shows a close connection with Palestine. For example, in the scene of the trial by water (Fig. 79) we see a well shaped like a cistern; on

Fig. 79

either side stand Joseph and the Virgin who holds a patera with the water. A building is represented behind Joseph. The well containing the water of the ordeal was located in or near the Temple of Jerusalem. In the Middle Ages and even later, it was shown near 'Ain Karim, as it is now called, and also in the house of Zacharias. The building in the relief must therefore be the Temple of Jerusalem, which suggests that the earliest illustrations of this subject, taken from the apocryphal Gospels, must have appeared in Palestine.[35]

The building behind John the Baptist in the scene of the Baptism (Fig. 73) occurs only once in the whole iconography of that subject; that is why this detail, incomprehensible at first glance, is so interesting and instructive. The building represents the church or monastery of John the Baptist, erected at the very spot where Christ laid down His clothes when He was baptized.[36] This rare detail gives us therefore another proof of the influence of Palestine on Maximian's chair. The hilly shore, although conventionally represented in the style of pictorial relief, also conveys the true characteristics of the locality where the baptism took place.[37] Another interesting point is that John the Baptist places his left foot on a stone, a feature that later disappears from the iconography of the baptism. This stone was regarded as a relic and was preserved in the apse of the church that had been built over the place of the baptism, as stated by the monk Epiphanius in the eleventh century.[38]

To these traits of Palestinian origin we must add the rectangular shape of the manger in the scene of the Nativity. This shape of the manger is described by pilgrims to the Holy Land, and it is retained in later Byzantine iconography.[39] The use of Palestinian apocrypha is also indicated by the spindle in the Annunciation, the flight to Bethlehem with an angel leading the ass by the halter, Salome with a withered arm in the Nativity, and the flight of Elizabeth which was represented on a plaque that has now been lost, but which was described by Trombelli.[40]

The story of Joseph was a favorite subject in Egyptian art, as shown by the textiles that have been found in Coptic tombs.[41] The naturalistic traits of the Joseph scenes on Maximian's chair are, however, without parallel. It is true that the Coptic textiles, too, show Joseph and the merchant riding a camel, the well with

half of Joseph's figure protruding out of it, and the dark gray body of the Ishmaelite merchant, but these textiles are too coarse and fragmentary. The examples that are known to me have oval medallions representing Joseph asleep in the center, the sun and moon with human faces, and the stars above them.

Fig. 80

Other subjects are arranged in a continuous band around the central medallion. These textiles, which can be dated to the sixth or seventh centuries, give but an incomplete understanding of the character of late Alexandrian art. But on Maximian's chair all the characteristics of that art can be observed in their most developed form. The types of the Egyptian merchants and their coiffure closely resemble the heads of Alexandrian sculpture. The hair is arranged in long curls falling down on the shoulders, which was the Egyptian fashion.[42] Riegl has indicated a similar hair style on an Egyptian textile which he considers to be a specimen of the Hellenistic art of the fourth century.[43]

Joseph's guard, represented on one of the plaques of the chair, consists of barbarians (Fig. 80). We should note especially the two bearded guards with long hair cut in a fringe over the fore-

head. They wear baggy trousers and belted tunics with embroidered patterns, and hold wide sheathed swords. The two other guards, who are beardless, are just as characteristic. The relief apparently reproduces very accurately not only the ethnographic type of the barbarians but also their individual facial features, which suggests that the ivory plaque was copied from a model of very high quality.

We should also point out another characteristic feature of the reliefs of Maximian's chair, one that we have repeatedly noted in the previous chapter: a great fondness for personifications. In the Baptism, the river Jordan, in the guise of a youth, lifts up the palm of his right hand in astonishment. In the scene of the entrance into Jerusalem, Christ is met by a tall female figure who lays down garments under the ass's feet. She personifies the city of Jerusalem or the "daughter of Zion," i.e., the Church.[44] In the scene of the Pharaoh's dream, the bearded, winged figure of Sleep leans over the Pharaoh who lies on a couch. This figure carries a flaming torch in its hand, is crowned with a wreath, and wears a tunic and a himation (Fig. 81).

The late Alexandrine character of the reliefs on Maximian's throne becomes even more striking when we compare them to other Alexandrian works of art, especially to the manuscript of Cosmas Indicopleustes. It is true that these two works are in a different medium, have a different cycle of subjects, and are not contemporary, since the Cosmas manuscript is later than the chair by at least two centuries and possibly more. And yet, the fundamental artistic traits are the same in both works. This applies even to several minor features of the kind that constitute the transient mannerisms of a school and are therefore the most instructive.

This kinship is especially noticeable in the representation of human figures which are wide-shouldered and powerful, with full, round faces, sharply delineated muscles, big hands and feet. Both works show the same distinctive weaknesses in the movement and the posture of figures. Striding figures place one leg sideways; this leg tends to be angular, noticeably elongated, and out of proportion to the torso. Note the similarity between Abraham in the sacrifice scene of the Cosmas manuscript (Fig. 15) and Jacob meeting his son on Maximian's chair (Fig. 81,

top); or between the shepherds on the chair and Merodach with his courtiers in the manuscript (Fig. 16). The motion of these figures, their stooped posture, the type of head with long hair and beard, the leg thrust to one side, the wide folds of the garments—all these are strikingly similar.

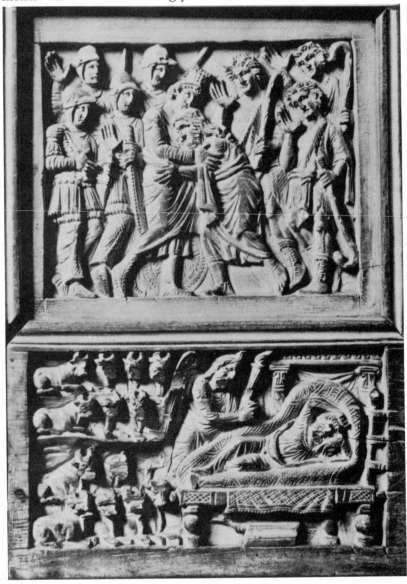

Fig. 81

Pictorial Relief

The figure of the Apostle Paul in the Cosmas manuscript (Fig. 25) bears a close resemblance to the Evangelists on the front panel of the throne (Fig. 78). Note the monumental posture of these figures, the classical drapery, and the large square Bible held in the left hand that is covered by the himation. We find the same resemblance in the heads. The youthful type of Moses, with short hair and full cheeks (Fig. 14), may be compared to the young disciple of Christ on the plaque depicting the multiplication of the loaves and fishes on Maximian's chair. The bearded apostle in the healing of the blind man (Fig. 75) is remarkably close to St. Paul in the manuscript. This type has a long smooth beard, a high bald forehead, a sparse growth of hair on the crown, full cheeks, angular eyebrows, a straight wide nose, jutting ears, a drooping moustache, and a pronounced Oriental appearance. The same position of the Bible near the shoulder and the same gesture with an open hand further accentuate the similarity. A striking example of this type of head is that of the second Evangelist from the left on the front panel of the chair. In both monuments we also encounter the same tall female figures, entirely covered with voluminous garments.

The shepherds—Joseph's brothers—are dressed in sheepskins thrown over the left shoulder, so that the right part of the chest is left bare. Abel in the Cosmas manuscript and the shepherds in the Nicander manuscript are dressed in the same manner. The resemblance is further accentuated by the fact that Joseph's brothers have short crooks which they rest on their shoulders, or on which they lean, placing the hooked end on the ground like Abel and the shepherd of the Nicander manuscript. The youthful type with curly hair remains the same, although the figures on Maximian's throne are executed with greater realism. The staffs of the latter are gnarled and thick, differing from the thin staffs represented in the manuscripts under consideration. Joseph's brothers wear high boots which Abel and the shepherd of the Nicander manuscript do not have, but these very boots are placed on the ground next to Moses in the manuscript of Cosmas (Fig. 14). Such boots are also found in the Vienna Genesis and in the Rossano Gospel. They are distinguished by a row of clasps extending from the top to the toes as can be seen both in the Cosmas manuscript and on Maximian's chair.

The repetition of the same type of couch also points to the same artistic milieu (Figs. 16 and 81). This couch has wide cross-beams, thick carved legs, a hanging covering its lower part, a footstool, and a thick mattress. Such a couch is represented on a Coptic textile in the collection of V. S. Golenishchev, but, for lack of space, the footstool and the hanging are omitted.[45] Another common feature is a backless throne with a bolster, the ends of which are decorated with a rosette. These traits of resemblance between the manuscript of Cosmas Indicopleustes and Maximian's chair gain in importance when we compare the figures, composition, and style of these two monuments with the Ravenna diptych (Fig. 120), the style of which points to an entirely different school.

The character of the reliefs on Maximian's chair, which is distinguished by the preservation of the traditions of pictorial relief and other features of Hellenistic art, shows that this monument cannot be considered the product of an autonomous Ravenna school, but must be related to Alexandrian and Palestinian art. Only this assumption can adequately explain the Palestinian traits in the compositions of the throne and the similarity of its figures with those of the Alexandrian manuscript of Cosmas Indicopleustes.

The monogram of the Bishop Maximian that is carved on the front of the throne (Fig. 78) proves that this object was commissioned by him and made for Ravenna during his episcopate, i.e., between 542 and 552. The Greek inscription, ΠΑΤΗΡ, placed near the dove on the Baptism plaque, suggests that the work was executed by Greek craftsmen. All the characteristics of the chair that we have pointed out above support this conclusion. The revival of art in Ravenna in the sixth century was in many ways indebted to Maximian's enlightened influence: The mosaics decorating the sixth-century churches of Ravenna bear witness to this. Maximian's dealings with Constantinople and with Alexandria may explain the appearance in Ravenna of a work such as this chair. We must certainly assume the establishment in Ravenna of a school of carving artistically related to the East. The brilliance of this artistic production may give us an indirect indication regarding the Alexandrian character of Constantino-

politan art in the sixth century, an art of which, for lack of monuments, we know almost nothing.

The style of Maximian's chair is so distinctive that it is possible to relate it to a group of other contemporary monuments. The pyxides of the Nesbitt and Figdor collections, as well as the Etschmiadzin,[46] Paris, and Berlin diptychs, show by virtue of their style and iconography that they belong to the same school, perhaps to the same workshop. To these we ought to add the Barberini diptych in the Louvre which, as Diehl has pointed out,[47] displays a remarkable stylistic resemblance to Maximian's chair. On the other hand, the Ravenna diptych, the comb from Antinoë, and the Uvarov ivory (a fragment of a diptych, the central part of which is in the Khanenko collection) represent another group, in which the antique tradition is much less in evidence.[48]

However, the diptychs and pyxides that can be classed with Maximian's throne do not display the latter's freedom in the use of plastic effects. Neither the long, narrow panels of the diptychs nor the circular friezes of the pyxides can permit the full use of pictorial relief. Moreover these works are small when compared with the throne, and the figures depicted on them are minute. That is why they resemble those plaques of Maximian's throne that show a relief of the mixed type. Figures are executed in low relief, but follow the rules of high relief, whereas the background is filled with architectural forms.

In the background of the Nesbitt pyxis there is a brick wall as well as buildings adorned with hangings that are also found on Maximian's chair.[49] The pyxis of the Figdor collection has arcades.[50] On the Etschmiadzin diptych (Fig. 82), we see a twisted column supporting an arch and a long colonnade such as are found on the reliefs from al-Mu'allaka.[51] Only two of its scenes, the Nativity and the healing of the demoniac, poorly executed as they are, display some features of the pictorial style. The Nativity repeats in an abridged form the composition of Maximian's chair. The Virgin is reclining on a cushion. The Infant in the manger is above her, and at the very top can be seen the heads of an ox and an ass. Salome is absent. In the healing of the demoniac, we see a lake framed by a hilly shoreline. The de-

moniac and a fish are swimming in the water. The heads of two apostles protrude above the rocky shore. Jesus stands on the left, His left foot resting on an elevation of the ground, in the same position as John the Baptist on Maximian's chair. Part of a disciple's body is visible behind Christ. The Paris diptych also displays columns, arches, and porticoes. The kinship of these monuments to Maximian's chair is indicated by their thickset figures

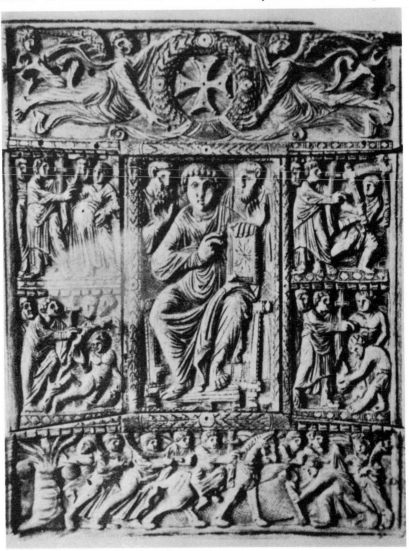

Fig. 82A

and by the repetition of several compositions that occur on the chair, such as the Annunciation, the Nativity, the trial by water, the adoration of the Magi, etc. Moreover, we also find in the Etschmiadzin diptych the personification of the "daughter of Zion" that we have already met on Maximian's chair.

5. The carved doors of Sta. Sabina in Rome offer an even more

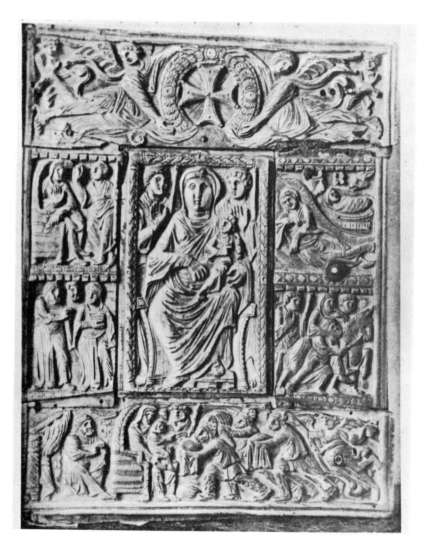

Fig. 82B

outstanding example of the use of pictorial relief. In spite of the extensive literature that has been devoted to these doors since the publication of Kondakov's description of them, we must nevertheless take the latter study as our point of departure, since it alone defines the chief stylistic aspects of this monument.[52]

Kondakov has drawn attention to the pictorial execution of the panel depicting Elijah's ascension which, after the Trivulzio diptych, is indeed the finest example of fifth-century pictorial relief. The big format of this plaque allows the composition to be arranged in perspective (Fig. 83). At the left edge is depicted part of a rocky mountain, at the foot of which grows a gnarled tree. A lizard and snail are crawling over the rocks. At the top, a flying angel touches the prophet Elijah's elbow with his staff. The prophet stands in a chariot pulled upward by two horses; he looks up in amazement, holding his open right hand near his shoulder. His cloak falls down, and Elisha grasps it by the end. On the left, a young laborer turns away in fright, looking over his shoulder; another one falls down, his hoe by his side. Between the angel and the chariot is a strip of cloud. The mountainous landscape is executed in low, smooth relief with a few transitions to slightly higher relief. The rocky ledges, the lizard, the snail, the small tree, and the steps cut into the rock are typically antique and remind us of the Farnese Bull. As one looks at the composition, one sees first a spring and the steps of a mountain path, then the prophet Elisha standing on a kind of platform, and the small tree further away. The figure of Elisha is shown from the back, one knee bent, the other leg straight. Of his feet, only the heels are visible. A cap covers his bald head.

The landscape serves for background; it extends on either side of the figures and can be seen between their legs. We may note certain conventions of antique sculpture: The horses are disproportionately small compared to the human figures; so is the chariot.

Another scene, showing the Israelites crossing the Red Sea, is no less pictorial in execution (Fig. 84). The raging sea in which a quadriga is sinking is shown in the foreground. The waves are piled one over the other, becoming gradually smaller as they recede. Above, the Israelites are coming out of the water. Their figures look small compared to that of the young and powerful

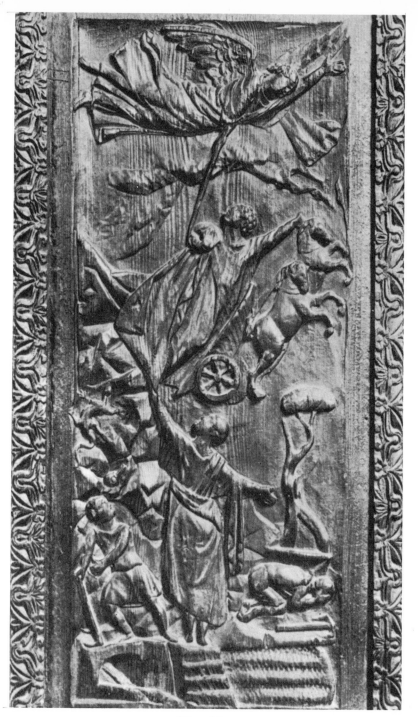

Fig. 83

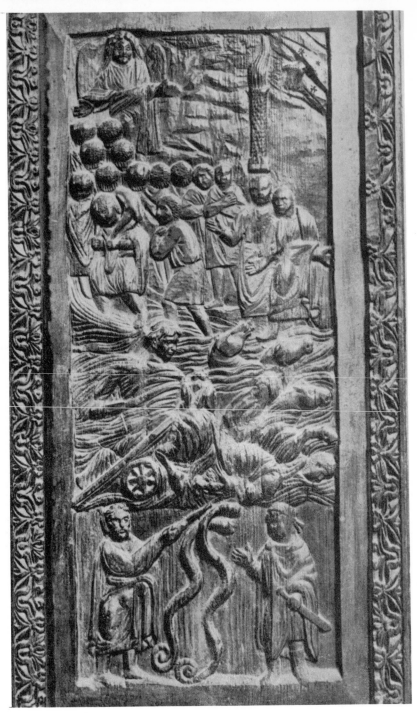

Fig. 84

Pharaoh. The last two Israelites are seen in profile. The two on
the right, obviously Moses and Aaron, face forward as they
watch the Pharaoh's destruction. The heads of the other Israelites
are seen from the back. An angel greets the people. At the very
top are striped clouds and the column of fire, and in the right

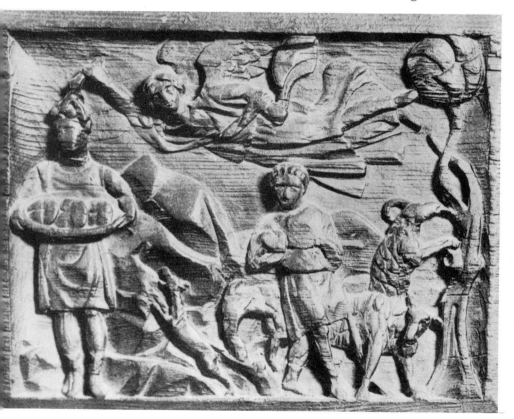

Fig. 85

corner one sees the hand of God. The upper portion of the relief
bears the marks of clumsy restoration.

A third relief, depicting the calling of Habakkuk (Fig. 85), is
of a mixed type. The figures stand on the bottom molding; the
top of a little tree extends to the upper molding. Behind the fig-
ures is a mountainous landscape with sheep and a goat. The
flying angel is similar to the one in Elijah's ascension except that
he is reversed. The panel is oblong and of small dimensions.

The big plaque representing the Agony in the Garden[53] also

exhibits characteristics of the pictorial style (Fig. 86). The figures are arranged in tiers on the declivity of a mountain. This relief has been damaged by restoration, and its antique style has almost disappeared. The ground is streaked with lines resembling a spider's web; the garments of the figures are covered with incisions; even the contours of the figures have been altered.

The representation in some of the other panels of a solid brick wall (e.g., in Peter's denial and the adoration of the Magi), or of buildings (in the Crucifixion) indicates a pictorial execution. We have pointed out a similar wall on the Trivulzio plague (Fig. 69).

The large relief depicting Moses and the burning bush has also suffered some damage (Fig. 87). The figures of the sheep at the bottom retain all their original freshness, but the upper portion of the relief has been chiseled over by restorers. Here we see a mountain forming several ledges, somewhat like the famous relief of the apotheosis of Homer by Archelaus of Priene.[54] At the bottom, sheep are resting or grazing in various positions while Moses is seated on a rock, looking upward. Higher up, he is removing his shoes in front of an angel and the burning bush. At the very summit of the mountain Moses is depicted twice: once in a posture of astonishment upon hearing the voice and again as he receives the Commandments from the hand of God, which emerges from a cloud. The rounded outlines of the mountain and the step-like projections of the ground are the same as in the relief of the apotheosis of Homer. In spite of the great difference in date between these two works, their comparison is nevertheless warranted owing to the absence of other such monuments. The characteristics of the pictorial relief of the fifth and sixth centuries can thus be traced back to their origins, in the context of which they assume their proper significance.

The reliefs on the doors of Sta. Sabina also reproduce numerous traits of Palestinian art. In the scene depicting the angel's appearance to Zacharias,[55] we can see, over the roof of the Temple, a tall cross of Calvary, studded with jewels (Fig. 88). A similar cross, standing on the rock of Golgotha, appears in the mosaics of Sta. Pudenziana in Rome and on the Monza ampullae. In the Crucifixion, behind the figures of Christ and the thieves, are brick buildings with three pediments. They represent, ap-

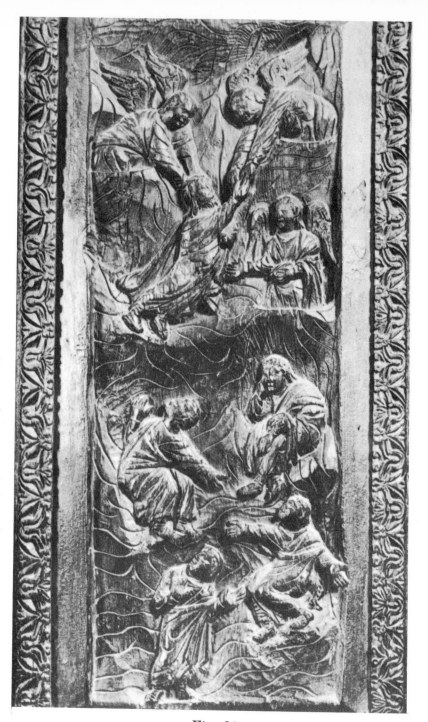

Fig. 86

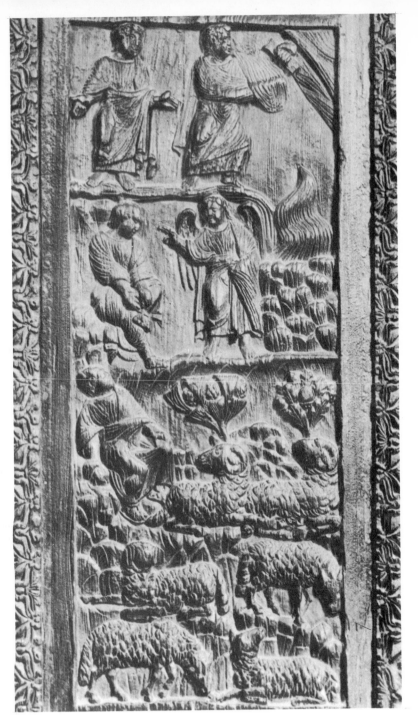

Fig. 87

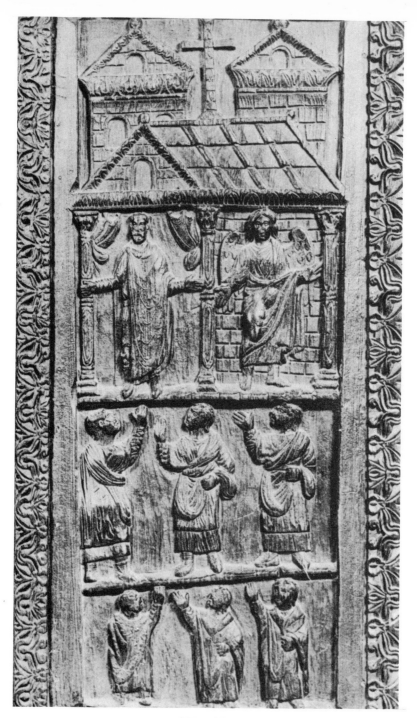

Fig. 88

proximately, the buildings that stood on the site of Christ's passion, death, and resurrection. The figures of Christ and the thieves are like the same figures on the ampullae from the Holy Land. The relief depicting Elijah's ascension is of particular interest in this respect in that its composition differs from the normal type that is found on sarcophagi. On the sarcophagi, as well as in the miniature of Cosmas Indicopleustes (Fig. 11), the river Jordan is depicted recumbent, below the chariot. The absence of the figure of Jordan on the doors of Sta. Sabina represents a new treatment of this subject. The scene of the action is different: It is a cultivated mountainside with a tree, steps, and a spring. Two workers—the prophet's sons—are depicted with their hoes. They see Elijah lifted up to heaven, although, according to the Bible, Elisha was the only witness (II Kings 2:7-11). From the fourth to the seventh century, Elijah's ascension was believed to have taken place on a specific mountain not far from the river Jordan and the place where Christ was baptized. Antoninus of Piacenza reports a Palestinian legend according to which the prophet's sons lost the blades of their tools in that place.[56] The relief of Sta. Sabina represents, therefore, the very locality that was shown to pilgrims. All that remains here of the old iconography is the movement of the chariot to the right;[57] in all other respects this is a new composition.

The representation of Mount Sinai as a big rocky mountain (Fig. 87) also indicates a transition to a historical rendering of the story of Moses. Mount Sinai is not represented on any other monument of this period.

Our examination of works executed in the pictorial style leads us therefore to a general conclusion of some significance. The presence of the pictorial style is combined with "historical" data, such as the basilica and rotunda of the Holy Sepulcher, the well containing the water of the ordeal, Golgotha, the cross of Calvary, etc. This indicates a dependence of these compositions upon Palestinian art.

In order to complete our survey of works in the pictorial style, we may examine two reliefs, published by Graeven and Strzygowski, respectively. Both of them depict the baptism of Christ.

The first of these is a fragment of an ivory plaque, acquired by Forrer in Strasbourg (Fig. 89).[58] The relief is higher than that

of the same composition in Maximian's chair. The bottom molding has indentations representing an uneven ground. The figure of Jordan has one leg propped against one of these indentations,

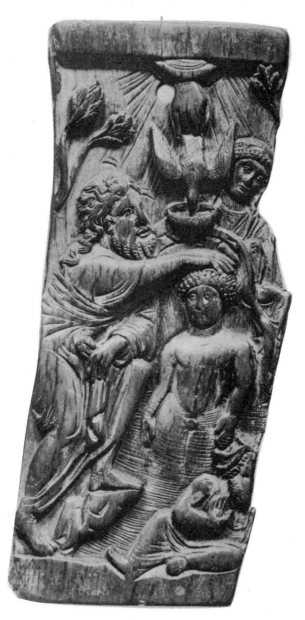

Fig. 89

while the other lies flat on the ground. The river bank rises diagonally under the feet of John the Baptist. The water, represented by fine lines, covers Christ's body up to the waist; the modeling of the body shows through the stream. The opposite bank is indicated by a narrow strip that curves around the head and shoulders of Christ. Behind this strip is seen half of the figure of an angel, with his head inclined to the right, his hands covered with a cloth. Next to him is part of another angel's hand, covered in the same manner. There was a tree on either side, but only their tops have remained. Above, the hand of God emerges from a semicircle. Under the hand is a descending dove, holding a crown in its bill. In its general outlines this composition is similar to the one on Maximian's chair, but the representation of the opposite shoreline, the half-figures of angels, and the river in the form of a gulf repeat the composition of the healing of the demoniac in the Etschmiadzin diptych (Fig. 82), a composition that follows the iconography of the Baptism.[59]

The other monument is the drum of a column found in Constantinople, now in the Ottoman Museum (Fig. 90).[60] The Baptism is represented here, together with other scenes and figures, surrounded by the coils of a grapevine, executed in such high relief that in places it stands completely free from the body of the column. The most statuesque figure, that of John, originally had a free-standing arm and right leg, but the arm is broken off. The faces of Christ, the Jordan, and the angels are also broken off, which indicates that they were executed in high relief. The relief becomes lower in the bodies of Christ and the angels. Furthermore, the waters of the Jordan are shown in perspective, and the ground under St. John's feet rises in steps. The composition is represented in reversed order: St. John stands to the right while Christ and the angels are to the left. The figure of the Jordan is consequently also placed to the left.

This Constantinopolitan column, so far the only known example of pictorial relief that has come from the Byzantine capital, has certain traits in common with the ivories of Ravenna. The ornament decorating the framework of Maximian's chair is almost identical to that of the column. In both cases the basic motif is a grapevine, which is developed in same manner. On Maximian's chair, birds and other animals are placed within the

coils of the vine; on the column there remains the figure of a bull that recurs, though in a more feeble form, on Maximian's chair. In both instances high relief and carving *à jour* are used for the leaves and stem of the vine and for the animal figures. The five-lobed grape leaves have exactly the same shape on both monuments and in many cases stand free of the background. The kinship in technique and in the choice of motifs is thus beyond doubt. Strzygowski has pointed out other examples of the

Fig. 90

use of the grapevine in Constantinople, but only this column displays such an obvious kinship to the style of Maximian's chair. This resemblance, however, applies only to the ornamentation and not to the figures, which are quite different. The figures of the column, female as well as male, are strong and wiry, in complete contrast to the heavy, broad figures of Maximian's chair. The facial types are also different. The two figures on the column that have suffered no damage have slightly elongated oval faces and somewhat slanted eyes with a dot for the pupil. The thin hands and bodies of these two figures can only be compared to those of another work from Ravenna, the so-called Ravenna diptych, which will be discussed in our last chapter (Fig. 120). The figure of the Virgin on the Crawford plaque, which is the second panel of the diptych, shows great similarity to the female figure on the column. The other figure on the column resembles in facial type the angel on the right side of the Crawford plaque. This kind of figure is related to a number of monuments that may be grouped around the Ravenna diptych. It is of interest that these wiry figures with thin hands occur on a stone relief from Lower Egypt in the Boulaq Museum of Cairo.[61] This relief represents a man and a woman, seated facing each other. The man holds the woman's chin, a motif well known from consular diptychs. These figures have lean legs and knees, narrow torsoes, and angular elbows. The character of their heads is very close to that of the heads on the Ravenna diptych and on the column at Constantinople. The same kind of figure is also found on a number of pyxides. In the al-Mu'allaka relief, most of the figures are of this type, but there are also broad figures similar to those of Maximian's chair.

III. The Hellenistic Character
of Byzantine Wall Painting

1. A broad Hellenistic current is apparent in the monumental painting of the fourth to the eighth centuries, during the formative period of Byzantine art. The character of this monumental painting is known to us rather imperfectly from church decorations. Heretofore these decorations have been studied independently, i.e., without reference to the character or style of monumental painting in general, whether of the same period or earlier (such as the wall paintings of houses and palaces), and have consequently remained unexplained. By broadening the frame of our investigation and making it our goal to study the decorative painting of the fourth, fifth, and later centuries as a whole, we can discover the basic principles that underlie this new decorative art and establish its sources.

Judging by some indications, Christian houses in the East as well as in the West continued for a long time to be embellished in a manner that had become traditional since the Hellenistic period. Our information about the general characteristics of such decorations comes from the writings of Christian authors and from the Fathers of the Church. This decoration included polychrome walls, i.e., walls covered with paintings of different colors, as well as revetments of different kinds of marble. It is obvious that the force of tradition should have made itself felt here, as it always has in the history of art. If the houses of pagan antiquity had sumptuous decoration for their walls, ceilings, and floors, is it conceivable that this should have been absent from

Christian houses? The well-known Roman house discovered on the Caelian Hill (Casa Celimontana) bears witness to the contrary. Besides, the sumptuous decoration of Christian churches indirectly indicates that its basic traits were derived from a specific, highly complex, and fully established tradition of monumental painting. It is enough to remember that the system of church decoration of the fourth to the sixth centuries includes such separate genres as the portrait, the independent tableau with sky, landscape and complex composition, a whole series of decorative compositions on an even blue or gold background, intricate ornament, marble revetments and incrustations. It can be clearly shown that the development of church decoration into a specific system took place in the context of decorative painting in general. Here again the role of the East, which had preserved both the Hellenistic and the Asiatic artistic traditions, is vividly apparent.

In his description of the church of St. Sergius at Gaza, the rhetor Choricius begins by taking his reader on an imagined tour of the town: He mentions its broad streets, the brilliance of multicolored painting, and the variety of the buildings. The expression χρωμάτων ποικίλων [1] shows that in the sixth century the houses and temples of Gaza had façades of different colors. The same Choricius describes the splendor of the buildings on the public square and mentions the costly textiles that were stretched from one house to another.[2]

In his sermon on the rich man and Lazarus, Asterius of Amasia gives us some most important information concerning the adornment of houses. Asterius criticizes the rich for using the art of painting to embellish their clothes. Not only their garments, but also those of their wives and children were adorned with a multitude of figures, "so that garbed in this manner, they appear to passers-by like painted walls." [3] Urchins stopped and pointed their fingers at the figures depicted on their clothes: lions, panthers, bears, bulls, and dogs; forests, cliffs, and hunters; and everything else that could be pictured by an art that imitated nature. Rich people felt that it was not enough to decorate their outer garments in this manner; they even adorned their undergarments (i.e., their chitons). Some of them, men as well as women, who appeared to be more pious, had biblical pictures

on their clothes. One could see representations of the feast at Cana, the paralytic carrying his bed, the healing of the blind man, the woman with the issue of blood, the woman taken in adultery falling at Christ's feet, and the raising of Lazarus. In doing this, the rich assumed that they were acting piously. Although he argues against representing Christ on garments, Asterius does not speak against images on the walls of houses, presumably because he considers such a custom to have been widespread and appropriate. Further on in the same work, Asterius describes a rich man's house and says that it was adorned like a bride, with mosaics, marble, and gold.[4] He also mentions gilded ceilings, walls faced with marble and porphyry, and numerous other details of domestic art reflecting the general character of this luxurious, half-Asiatic and half-Hellenistic style.[5]

St. John Chrysostom also inveighs against the luxury of the Christian house and compares it to a theater. He mentions rugs, couches decorated with silver, ivory chairs and footstools, walls faced with marble, and floors covered with mosaics.[6] Cyril of Alexandria uses almost identical terms to describe the dazzling house of a wealthy Alexandrian.[7] Theodoret of Cyrrhus paints a vivid picture of the interior of a house with its furnishings and adornments. He speaks of textiles, of Euboean and Thessalian marble, and mentions paintings embellishing men's chambers.[8]

It is known that the houses of wealthy Christians were sometimes transformed into churches. This custom is known to have existed in Palestine, Antioch, Alexandria, and Rome. St. John Chrysostom recalls the time when the home and the church were one.[9] The story of the transformation of a house into a church at Amasia is quite enlightening because it bears witness to the ease with which such a change took place and to the fact that the original decoration of a house was not considered an obstacle to consecration, except for images pertaining to pagan cults. A person named Chrysaphius who owned a house in Amasia wished to transform its lower story into a chapel of the Virgin and its upper story into an oratory of St. Michael. He called in a mosaicist to scrape off the mosaics then in place, depicting the story of Aphrodite, and to replace them with new ones.[10]

The Casa Celimontana presents an interesting example of a Christian home decorated with paintings. In one room [11] the

lower portion of the wall was faced with white marble to a height of two meters. Above the facing, a figured frieze extended around the entire room. The lower portion of this frieze shows young genii standing like caryatids upon a green ground; some of them are winged. Garlands of flowers are stretched between the shoulders of these figures. Birds, such as peacocks, ducks, and partridges, sit on the ground on either side of the figures. Little birds flutter above each garland. A narrow red strip divides this frieze from the barrel-vaulted ceiling on which are painted grapevines growing out of acanthus bushes. The vines are coiled over a white background in exactly the same manner as in the catacombs of SS. Domitilla, Callixtus, and Praetextata, and as in the later mosaics of Sta. Costanza in Rome.[12] In the chapel of S. Prisco at Capua and in the floor mosaics of Ancona [13] and Uthina (in Africa),[14] the vine is arranged symmetrically; among its coils are depicted wingless *putti* picking grapes. It is important to note that the frieze of genii in the Casa Celimontana serves, so to speak, as a foundation for the over-all ornamentation of the vault. This method of constructing a ceiling decoration appeared also in the lost mosaics of Sta. Costanza and in many later monuments, to which we shall return later.

The decoration of the domed dining room (*tablinum*) is even more remarkable (Fig. 91). The walls and the ceiling are covered with frescoes of the usual kind, such as are known in other antique houses. The wall decoration is in the form of *opus isodomum*, i.e., separated into rectangles with a pediment painted above each one. The interior of each rectangle is filled with an even color; a niche is depicted in the central rectangle. The pediments rest on a molding, and the rectangles themselves are framed by a wide band. The remaining space between the pediments is covered with a design imitating stonework in the so-called first Pompeian style. Above this is a wide band filled with an acanthus rinceau, which emerges from a bush placed in the center of the band. The transition to the ceiling is effected by means of four corners that have been cut off, somewhat in the manner of the later pendentives. Here are depicted antique masks, whereas in Christian decorations this place is often occupied by the symbols of the Evangelists. The ceiling was divided into twelve parts by bands of three colors, disposed as the radii of a circle and con-

verging upon a medallion in the center. Only a quarter of this circle has been preserved. In one of the twelve compartments are a sheep and a goat facing in opposite directions on either side of what may be an acanthus bush or a tree stump. In two other compartments are male figures holding unfolded scrolls. Both

Fig. 91

figures resemble the apostles and Evangelists of Christian mosaics and the prophets of the Rabula Gospel. One figure is shown walking to the right; the other is standing with one foot placed on a stone.

On one of the lateral walls, in a separate rectangle, is a female orant after the manner of catacomb paintings. Next to this are hippocampi, also in separate frames. On another wall are represented two sheep on either side of a milking jug. Elsewhere are the usual rectangles with yellow, pink, or light blue backgrounds, sometimes with geometrical ornament.[15]

In spite of the uniqueness of this decoration and its fragmentary character, it provides nevertheless an excellent illustration of the meager literary data we have quoted. The murals of this

house preserve the polychrome style of earlier times; the walls are faced with marble or are painted to imitate incrustations; there are the usual genii, garlands, hippocampi, and masks. At the same time we find here forms that are particularly dear to Christian art: the grapevine with *putti* picking grapes, lambs standing by a milking vase, an orant, and other figures which, although their significance is unclear, are closely related to the figures of later periods. These Christian subjects are placed in the midst of an antique decoration and are governed by its structure, being contained within separate subdivisions of the walls and the ceiling of the house.

The presence of portraits among these murals shows the high standing of portrait painting in the early centuries of the Christian era, a fact that is, of course, attested by the earlier portraits from Faiyum, Hawara, and Arsinoë, and by the references to individual portraits in the writings of Eusebius.[16] Portraits on the walls of houses presuppose mural polychromy. We also know that the iconoclasts painted their own portraits on walls, a practice that caused the Patriarch Nicephorus to accuse them of vainglory.[17] The real issue in this case was the iconoclasts' well-known hatred of icons and of holy images in general. Thus the Patriarch's words can be better understood on the assumption that the iconoclasts were replacing icons by their own portraits. This is presumably what Nicephorus means when he accuses the iconoclasts of having lost a true understanding of the meaning of art. This is confirmed by the proscription of icons which were as numerous on walls as on boards. Houses were searched for icons and their owners were punished.[18] It is also known that it was customary to display icons in city streets and squares. The pagan figures that had been used to decorate the prows of ships were replaced by images of the Virgin and of martyrs.[19] These practices were widespread throughout the East. At the Seventh Oecumenical Synod, John, the representative of the Eastern patriarchs, in explaining the origin of the iconoclastic heresy, attributed to a Jewish magician the intention "to destroy the images, not only in churches, but also those, of whatever kind they might be, that added beauty and adornment to city squares." [20]

The over-all system of wall decoration must have also included the various symbols, such as the crosses that were represented

on the walls and over the doors of Christian houses.[21] St. John Chrysostom tells us that images of St. Meletius could be seen on rings and cups and that they were also "painted on the walls of rooms" (καὶ ἐν θαλάμων τοίχοις).[22] The same was true of the sacrifice of Isaac, which met pious eyes at every turn,[23] and which must have been a part not only of an over-all system of wall painting but also of a definite iconographic cycle. At the end of the fifth and at the beginning of the sixth century an entire cycle of Passion subjects makes its appearance on the walls of both churches and houses. Our evidence for this is a passage from Leontius, bishop of Neapolis, which was read at the Seventh Oecumenical Synod: "For the sake of Christ we represent His sufferings in churches, in homes, in market places, in chambers, on veils and on garments, and in every other place that we may constantly see them." [24] A woman of Laodicea ordered the Anargyroi to be represented on every wall of her house.[25] These and other Christian subjects must have entered into the system of polychrome wall decoration. We are told, for example, that Constantine the Great placed a representation of the cross on an enormous panel in the center of the gilded ceiling of the most important hall of the palace in Constantinople.[26] Also in the palace, among other pictures placed over the propylaea, Eusebius saw a representation of the Emperor himself with arms upraised and eyes lifted to the sky.[27] There was yet a third picture showing the Emperor and his sons trampling a dragon underfoot. This was also placed high above the entrance and could be seen by all who went by.[28]

According to Evagrius Scholasticus, there was, on the ceiling of the palace at Apamea, an image of the miracle of the exaltation of the Cross, which had occurred in that city.[29]

From these data we may conclude that the Christian world, both in the East and in the West, kept alive that system of polychromy which is barely known to us from the fragments of church paintings that have survived. An examination of the composition of the earliest Christian decorations will confirm this conclusion.

2. An important fact that immediately attracts our attention when we examine the remaining wall paintings of the fifth and sixth centuries is the uniform application of certain basic prin-

ciples in both the East and the West, as well as the uniformity in the adaptation of certain subjects and decorative compositions to different parts of buildings. For example, the decoration of an apse with a complex picture of the Transfiguration is found on Sinai and in S. Apollinare in Classe at Ravenna. Portrait medallions are used to adorn arches in the mosaics of Ravenna, Sinai, and Cyprus. Continuous friezes over colonnades occur in S. Apollinare Nuovo and in the Bethlehem basilica; circular friezes in domes are found in the mosaics of Milan, in the two baptisteries of Ravenna, and in the church of St. George in Salonica. We can discover the same resemblance in the choice of decoration. The architectural motifs of the circular frieze of the Orthodox Baptistery are also found in the earlier frieze of St. George at Salonica and in the later, flat frieze of the Bethlehem basilica. This points to a number of remarkable coincidences between Eastern and Western church decorations. We should also note certain peculiarities of church decorations of the pre-iconoclastic period which further corroborate our point of view concerning their Eastern Hellenistic character: the architectural motifs, so intimately connected with the decorative painting of antiquity, and the preservation of Egyptianized genre scenes depicting cupids, gardens, and hunting.

Woermann was probably the first to notice that Christian painting had preserved certain motifs of Egyptian landscape representing the flora and fauna of the Nile. One of the examples of this type of landscape to which he draws attention is the semicircular frieze in the apse of Sta. Maria Maggiore (Fig. 92) which represents cupids engaged in fishing. He compares this to the frieze which framed the famous mosaic of Alexander's battle in the Naples museum.[30] Elsewhere I have pointed out the Hellenistic character of these scenes, their kinship to the scenes of the life of Jonah and others in the catacombs and mosaics of Rome, and their wide distribution in the art of Africa and the East in general.[31] At the same time Wickhoff indicated the close resemblance of a similar frieze in the Lateran basilica depicting cupids engaged in fishing, to the picture called "A Marsh" described by Philostratus.[32] Philostratus saw it in the picture gallery of a wealthy Neapolitan home. The subject of the frieze and that of the painting described by Philostratus coincide in every par-

ticular, such as the various activities of the little fishermen and the setting in which their life is depicted. Philostratus had seen the busy life of these cupids represented in other paintings as well and even gives us the name of this pygmy tribe: They were called πήχεις (cubit-dwarfs). Philostratus saw them busying themselves in various ways near the Nile.[33]

Fig. 92

The device of representing a river as a frieze is known from many monuments. This is true of Egyptianized landscapes in general, especially those collected in the Naples Museum, and similar mosaics that have been found in Africa. The well-known floor mosaic of Palestrina offers the most complicated example of this kind of landscape, but it differs from the others in that it is a square picture, not a frieze, and has ordinary human figures in the place of cupids.

The mosaics of Sta. Costanza, Sta. Maria Maggiore (Figs. 92 and 93), and other Christian churches [34] reproduce, more or less clearly the characteristics of the so-called Egyptianized land-

scape representing the river Nile. Over and over again the river is shown as a long band with banks covered by sparse bushes. There are birds, fish, and mollusks, but no crocodiles or hippopotami, although the latter are typical of this kind of landscape, the origin of which is considered to be Egyptian, and more specifically Alexandrian. Indeed, this water frieze is a favorite decorative theme in monuments of African origin. A silver patera found at Tipasa bears a representation of Neptune surrounded by a marine frieze similar to that of a Christian patera, which bears in its center a head (Neptune or the Nile) surrounded by various fishes and fishing scenes.[35] The African patera was published by Villefosse who rightly compares its ornamentation to the mosaics discovered in various Roman villas in Africa.[36] The activities of the little fishermen in the Naples picture described by Philostratus are repeated in the mosaics of the Roman churches of Sta. Costanza, the Lateran, and Sta. Maria Maggiore. One should particularly note the *putto* riding a swan in the mosaics of Sta. Costanza, a subject known from Pompeian painting[37] and described by Philostratus.[38] The same picture at Naples showed a *putto* stretched out on the shore attempting to catch an octopus, and several boating scenes. The beautiful floor mosaic that has been discovered at Uthina contains scenes of the same genre. It represents a river without banks, shaped like a ribbon. On it are two boats with rowers, while in the water are fish, shellfish, crayfish, octopi, and polyps.[39] The mosaic in the National Museum in Lyon is no less interesting. It shows, once more, a river without banks. In the middle is the head of the river god of the Nile, adorned with crab's claws; shellfish and dolphins swim around it. Another part of this mosaic shows the head of a river god with crayfish claws and seaweed instead of hair:[40] This is the prototype of the river Jordan in Christian mosaics and of the sea goddess in the Dioscorides manuscript (Fig. 32).

A Coptic textile discovered in a tomb at Saqqara (now in the Vienna Museum of Industrial Art) represents two boats, each containing two nude cupids holding oars. Around them are fish and mollusks.[41] A similar textile fragment from Achmim-Panopolis shows two Erotes clad in exomides, standing in boats; one of them steers with an oar. A polyp, part of a fish, and an octopus can be seen under the boat.[42] Another Coptic textile, in the

Hermitage (No. 41), has fishing *putti* inside a medallion, but they are not in boats. In discussing another textile in the Vienna museum, Riegl has pointed out the Egyptian style of a female figure and the Hellenistic character of the fishing motif. The combination of these two elements is typical of Alexandrian art.

Fig. 93

The friezes in the Lateran basilica and in Sta. Maria Maggiore represent the Jordan, judging by the inscriptions. It is not known whether there was a similar inscription in the church of Sta. Costanza. Ugonio, who saw the mosaic in its original condition, calls it simply *flumen argenteus*.[43] The *Iordanes* inscriptions in the two former churches cannot be considered trustworthy, since both mosaics were restored by Jacopo Torriti who could have added the inscriptions on his own, being unable to interpret correctly this river inhabited by a world of genii. He might have been inspired to do so by the fact that in other Roman mosaics

such rivers are indeed named Jordan, but these are shown as narrow bands of water bordered by low banks with clusters of grass.

This very simple type of river should be distinguished from the more complex representations designated as the Nile by Philostratus. Choricius of Gaza describes such a Nile in the church of St. Stephen at Gaza. This rhetorician, who lived under Justinian and had been trained in the school of Philostratus, has left us descriptions not only of two churches in Gaza, but also of a number of pictures with pagan subjects. As a professional art critic, he must have been fully acquainted with the terminology that was current at that time.[44] After dwelling on the ceiling, the columns decorated with animal figures, the marble and gold, Choricius continues as follows: "I almost left out the Nile. This river is not represented here as rivers are usually depicted by painters, but it appears with its own streams and symbols, and with meadows along its banks. Various kinds of birds, such as often bathe in its stream, live in these meadows. All this beauty is displayed on the wall above the colonnade." [45]

The location of this image above a colonnade indicates that the river was represented in the form of a frieze. Although he mentions birds, Choricius says nothing of cupids, so that the Nile that is described here must be regarded as merely a more elaborate version of the Jordan that is often represented in Roman mosaics. Nilus of Sinai, too, who was well acquainted with the use of the aquatic and fishing genres in wall painting, does not call such a river the Jordan, but refers to it as the sea ($\vartheta\acute{\alpha}\lambda\alpha\tau\tau\alpha$). He saw the representation of this "sea" on the walls of a church and considered it to be of a purely decorative type, intended for the pleasure of the eye ($\pi\varrho\grave{o}\varsigma$ $\dot{\eta}\delta$ov$\grave{\eta}\nu$ $\dot{o}\varphi\vartheta\alpha\lambda\mu\tilde{\omega}\nu$). He describes "the casting of nets into the sea, and all sorts of fish being caught by the fishermen's hands." [46]

One can hardly ascribe a deep symbolic meaning to such decorative friezes that came to be included in the mural program of churches. The very history of this genre, native to the banks of the Nile, does not admit such an interpretation. Its presence on the walls of Christian churches is quite analogous to its use in antique houses and villas. Of course it cannot be denied that a relationship exists between the fishing theme and the biblical

parable of the fishermen. A few details of Christian content could thus have been included in the aquatic genre. The Christian patera from Tipasa that we have already mentioned bears a figure that places its hand in the mouth of a fish: This brings to mind the biblical story of the coin that St. Peter found in a fish. In Sta. Costanza, Ugonio saw the representation of a boat with three figures that appeared to be clad in priestly garments. The contrast between the clothed figures in the boat and the naked cupids around them attracted Ugonio's attention. He made a sketch of this boat and assumed that the figures belonged to some incident from the Gospels.[47]

In addition to the aquatic genre, various hunting scenes were introduced in church decorations. Nilus of Sinai writes as follows in this connection: "You wish . . . to cover the walls both upon the right hand and upon the left with all manner of hunting scenes, depicting snares spreading out upon the ground, and likewise hares, deer, and other beasts in flight, and hunters pursuing them breathlessly with their hounds, desiring to slay them."[48] One cannot fail to see that this description applies to the very same subjects which Asterius of Amasia and Theodoret of Cyrrhus had seen on the walls of houses and on the garments of rich Christians. Not a single example of this kind of painting in a Christian church is now in existence. The basilica of Junius Bassus in Rome, rebuilt as the church of S. Andrea in Catabarbara, displayed on its walls a few vignettes of this type along with subjects taken from the hippodrome. Each image was contained in a square. Among the scenes related to the animal genre we may mention lions and panthers attacking deer.[49]

A curious example of a hunting frieze is found on a Christian sarcophagus of the Lateran Museum.[50] On the left side of the lid are shown nets. Six trees represent a grove in which hares are being hunted. Three hares, driven by hounds and hunters, are running towards the nets. One hare has been caught by a hound. Two young hunters, armed with sticks, are running in pursuit. This is the very subject that has been described by Nilus. We know from sources of the iconoclastic period that such subjects formed part of early church decorations. In the Life of St. Stephen the Younger it is stated that the iconoclasts preserved only those paintings in churches that represented trees, birds, animals, and

especially pictures of "satanic horse races," hunts, and theater scenes.[51] During the iconoclastic period such decorations came to the fore and were forcibly substituted for sacred images,[52] but they were subsequently outlawed by the Seventh Oecumenical Council.

These data are corroborated by the description of the church of St. Sergius at Gaza by Choricius, who writes as follows: "The four internal arches, of which I have already spoken, are supported on either side by walls reaching to the same height as the arches. . . . Here are 'pears and pomegranates, and apple trees with their bright fruit.'[53] They blossom in all seasons, do not wilt in the winter, and have no need of rain. Thus can we contend with the king of the Phaeacians who, as the poet says, always had fruit in abundance, both in the winter and in the summer. . . . The artist did not forget the poet who spoke of the 'soaring' eagle: See the birds that fly in the air on outstretched wings, pecking at the fruit that grows on trees."[54]

The specific information that may be extracted from this rhetorical description indicates that a luxuriant garden was depicted here, probably in the form of a frieze. There were fruit trees, and birds flying and pecking at the fruit, but no human figures, animals, or buildings. We have very few data that give us a fuller understanding of this kind of wall decoration. The frescoes discovered at Prima Porta near Rome (Fig. 94) and part of a mural depicting a garden, excavated in Pompeii, are the most perfect examples, to which we can compare only the miniature of the Vienna Bible which depicts Paradise. In these monuments the garden is shown in the likeness of an ancient *peripatos*, i.e., all the trees are in a row, forming a solid wall of greenery. The trees, heavily laden with red fruit, do not extend over a given level. In the Rabula Gospel, a garden of this kind, but much less elaborate, extends as a solid band behind the Holy Sepulcher (Fig. 39). The trees are without fruit. However, the fantastic form of the Holy Sepulcher and the strip of yellow-green ground are reminiscent of the type of garden painting with curious bowers that we encounter in Pompeian frescoes. The blue sky that is painted over the garden places this miniature into a definite class of garden landscapes, well known in Alexandrian painting.

Nevertheless, it is only the magnificent frescoes at Prima Porta [55] that can fully explain the garden described by Choricius and the presence in it of birds and fruit. In this fresco the trees are set out in a row, along a road or alley, so that the garden is shown in cross section along the *peripatos*. The composition of

Fig. 94

the frieze as a whole is broken up into groups of trees; the great size and splendor of the garden are achieved by the repetition of these groups. In the center of each group is an evergreen tree flanked on either side by fruit trees. Flowering shrubs are depicted near the base of the trees. All the treetops are on the same level. The trees in the foreground are rendered with meticulous detail; those behind appear in faint outline, fading into an over-all bluish fog. Above is an even blue sky. There are no human figures. Birds are symmetrically disposed on the trees, the boughs of which are weighed down with ripe red fruit. Other birds, with fluttering wings, perch on twigs. Some sit on the ground and look up at the fruit. This is a motif that was preserved in Christian mosaics. A lattice-like fence stretches along

the alley, forming recesses in which are placed the evergreen trees. The flowering bushes near the trees' roots and the green lawn are also traits maintained by Byzantine art.

A portion of a frieze discovered at Pompeii must have represented a similar garden.[56] In the Casa Celimontana, along the

Fig. 95

stairway leading to the main entrance, is painted an oblique lattice with badly preserved green bushes behind it.

This kind of garden painting was developed in the Hellenistic period, simultaneously with the appearance of planned gardens at Antioch, Seleucia, and Alexandria, whence they spread to Greece and Italy. The painter Demetrius, who, in the second century B.C., was in the service of King Ptolemy Philometor and later went to Rome, is known as a leading exponent of this type of painting.[57] Choricius' description makes it clear that this genre, so widespread in Hellenistic decorative art, was preserved in a Byzantine church in Phoenicia.[58]

The rows of palm trees in the Ravenna mosaics are but pale copies of such gardens, but they do preserve certain traits of the kind of painting we are describing. The trees are set in a row and fruits hang down from their branches. A green lawn is spread out below; white lilies grow by the trees' roots. The friezes in St. Sophia in Salonica and in the Lateran basilica also belong to the same type. The lost mosaic of the arch of the church of St. John the Evangelist in Ravenna also depicted palms and other trees.[59] In these monuments the garden loses its independent character. Saints stand between the trees, as if to express

the thought: ἀνθεμόεις παράδεισσος ὁ τῶν ἁγίων χορός ἐστιν ("The choir of the saints is a flowery garden.").[60]

3. Of particular interest are the architectural friezes, a typical motif of ancient monumental painting, that were maintained in church decorations. Such friezes have been preserved in the mosaics of Milan, Ravenna, Salonica, and Bethlehem.

The architectural frieze in its simplest form may be seen in the chapel of S. Vittore in Ciel d'oro in Milan (Fig. 95). It extends around the base of the dome, which is completely covered with gold mosaic and has a medallion of St. Victor in the center. The frieze consists of a series of conches resting on pilasters. The latter are decorated with medallions and small figures akin to ancient statuettes. The coloring conveys the full brilliance of antique polychromy: The background, in the corners between the conches, is red; the interior of the shells is blue; the figurines and busts are gray. Within each conch is a medallion with a bust, flanked by volutes and birds.[61] We have here in an embryonic form the basic traits of this type of architectural frieze. The conches follow each other without interruption and are presented in cross section, so as to show their inner fluting as well as the volutes and birds which are placed inside. The magnificent frieze in the church of St. George in Salonica is constructed on the same principles.

The first editors of the Salonica mosaics have noted their fantastic character and their similarity to the architectural paintings of Pompeii.[62] The frieze consists of eight structures separated from each other by a wide band containing an acanthus "candelabrum" (Fig. 96). The structures differ from one another in the form of their details, but are essentially of the same type. Each structure consists of three or sometimes five parts, i.e., a central and two or four lateral ones, and stands out as an independent edifice against a golden background. In spite of considerable deterioration, the main parts of the frieze are sufficiently well preserved. The restoration in stucco does not prevent one from distinguishing either the details or the general aspect of each edifice, and it is possible to reconstruct the missing parts on the analogy of those that are extant.

Each edifice presents a whole complex of different structures.

An important feature of these structures is that some of their arched elements are freely suspended in the air, whereas others are shown in cross section.[63] The apses on columns, which would not be unusual on façades or above outside entrances, are here represented in such a manner that they seem to pertain to the interior. This is indicated by the presence of ciboria, chancel screens, and lamps.[64] The lateral structures, on the other hand, appear to represent façades. They have pediments, columns, and hangings. In some instances a coffered ceiling is partially visible inside. Birds are perched on the upper portions of the structures. Vases are placed either inside or on top of various architectural elements. The ground on which the structures stand is paved with square slabs. Saints, facing the viewer, are represented standing on this ground, in front of the edifices.

The so-called second and third Pompeian styles include many of the individual elements found in the Salonica frieze, but these are not combined so as to form the kind of structure we have been describing. The elegant arch rising freely into the air, the barrel vaults on four little columns seen in cross section, the pediments, the pavilions with domed canopies somewhat like Byzantine ciboria, the apses, the entablature with moldings decorated with an egg-and-dart design, even the birds such as peacocks, partridges, pigeons, and ibises that are shown perching on the buildings, and finally the candelabra of acanthus—all of these may be seen at Pompeii. Even the tripartite form of buildings is common in Pompeian frescoes of the third and "candelabrum" styles. In the latter, the structures are placed on a ground painted yellow or some other color, on which there often stands a kind of ambo or raised platform with steps, that resembles similar elements in the Salonica frieze. There are also pavilions with a circular band at the top, and even full-length human figures placed on pedestals inside the pavilions, on the ground, or in the midst of the buildings. Yet nowhere do we find a combination of these elements which forms an independent structure unrelated to the rest of the painted decoration, having full-length figures standing in front of this architectural background. It is obvious that we are dealing with structures that were put together from the above elements, but that these were modified to meet a new artistic purpose.

In this connection, the frescoes discovered in 1893 on the Palatine Hill are of some importance [65] in that they have certain traits common to the Salonica frieze. We have here a wall with a complex articulation consisting of a row of columns, pilasters, and niches. What is of interest to us is that this wall is shown

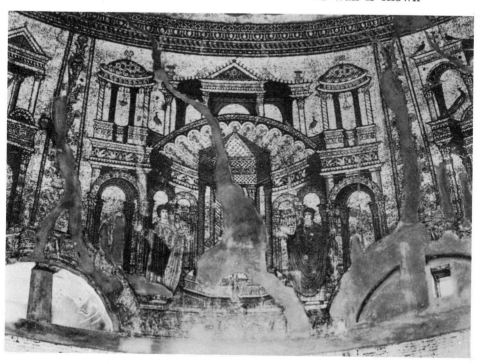

Fig. 96

as if it were a section through a building. It rises over a floor on which life-sized figures in civilian dress (tunic and toga)—hence not mythological figures—are standing or walking like the saints in the Salonica mosaic. The Palatine fresco has been dated in the second century A.D. and shows evidence of Alexandrian influence. Unfortunately the upper portion of the fresco has flaked off, so that the top of the architectural background cannot be reconstructed. Considering the scarcity of monuments illustrating the development of this genre of painting, we ought to mention the description by Choricius of a palace represented in a painting at Gaza, the subject of which was the story of Phaedra and Hippolytus. This palace was shown in such a way that one could

see its interior: There were columns with golden capitals, porticoes, niches, and pictures on the walls. Choricius also speaks of the roof of the palace, with a peacock and two pigeons symmetrically perched on the top. Inside the palace Theseus was represented asleep on a couch. A garden extended along the sides of the palace.[66]

The formation of these fantastic structures could thus be dated to the period between the second and the fourth centuries A.D. Many peculiarities of the Salonica mosaics, such as the form of the arches, the scallops, and the wide pilasters decorated with gems, rhombi, and small circles, are conspicuous in the Calendar of 354, although in the latter work the architecture is simpler and rendered only in outline. Moreover, it is designed so as to contain a text as well as figures. Some of the structures in the Calendar consist of three parts: The central part is covered with an arch under which stands a figure, whereas the two lateral parts contain the text (Fig. 97).[67] It is evident that these architectural forms were borrowed from mural painting; witness the caryatids in the form of slaves, their hands tied behind their backs, supporting a frieze with a scallop of the type already described and ornamental acroteria on either side as in the Salonica mosaics. The fantastic character of this architecture has already been commented upon by Kondakov and Strzygowski. It consists in the absence of ground and in the fanciful combination of various forms. On the other hand, this architecture lacks the sumptuousness and typical furnishings characteristic of Christian decorative painting. One can only note the absence of the elegant Pompeian column, for which is substituted a heavy, gem-studded pilaster, and the general lack of finesse in the structural forms. The hangings that are used so much in the mosaic frieze are also found here.[68]

Another feature of the Salonica mosaics is the spirally fluted column, so typical of Christian art in general, but unknown in antique wall paintings. It has replaced the antique colonnette, but has grown thicker and acquired a less elegant appearance. The traditional form of pediment has been maintained, but an apse has appeared above it and a ciborium in front of it. Another important change concerns the use of hangings, which acquire great decorative significance. New forms are introduced, such

Fig. 97

as the ciborium and the pulpit that leads to the altar. Lamps hang in the sanctuary. On the pulpit is a lattice of openwork that is common in church architecture.[69] Indeed, the whole fantastic structure is an imitation of a church interior, and more specifically of the bema. A new kind of ornamentation consisting of round and square precious stones makes its appearance. These features result in an architecture that is heavy and ostentatious. The imitation of church interiors has also led to the isolation of each structure. In the frescoes of Pompeii the architectural elements are related to the whole painted surface, whereas in the mosaic frieze each structure is independent, separated from the next one by a wide band. The use of bright red and blue friezes and pediments, of pink and green hangings, and the profusion of gold, point to that particular taste that developed quite early in Alexandria and that firmly established itself in Byzantium.

These observations show that the development of the architectural frieze followed the same process as that of the Pompeian styles of painting. In other words, this process was based on the imitation of real architectural forms. That this architecture fully belongs to the Christian period is demonstrated by the introduction of the furnishing of a Christian sanctuary, of apses, lamps, lattices, and hangings.

The Christian element of the Salonica mosaics is, however, limited to these features. There is not a single cross or monogram. Moreover, as Texier has pointed out,[70] all the saints depicted there belong to the era before Constantine the Great. Next to each saint's name is indicated the month in which his feast was celebrated, as in a calendar. Starting from the right of the apse, the saints depicted have their feast days in June, March, August, September, December, January, April, October, and July. The name and month of one of the saints have been obliterated.

The use of this type of architectural representation in the Calendar of 354 explains its appearance in the dome of St. George's, all the more so since the saints, represented as orants, correspond to the figures in the Calendar, such as Saturn, Mars, Mercury, and so forth. It is quite possible, therefore, that the dome reproduces the architectural decoration with saints of a de luxe Christian calendar antedating Constantine the Great. This would account for the absence of crosses, and particularly

of the Cross of Calvary, which became a dominant feature in the architecture of canon tables after Constantine. Hence we may agree with the prevalent opinion that the dome mosaics are contemporary with Constantine the Great.[71] It is also important to note that the indication of months corresponds in all cases to the Greek menology (compiled later under Basil II), but differs from the Latin menology. This suggests in our opinion the Eastern origin of the calendar on which the Salonica mosaic was based. Bayet has rightly pointed out the resemblance between the saints of the mosaic and those of the Menology of Basil II.[72] An even more striking example of saints represented against a magnificent architectural background is provided by the manuscript of Gregory Nazianzen, Par. gr. 510. The use of such architectural forms in these manuscripts can be explained only in the context of a much older tradition.

The foregoing observations show the wide use of architectural motifs in the Christian painting of the East. This genre, so brilliantly developed in Alexandrian painting, left a noticeable imprint on Byzantine art. Its use in the monumental painting of the Syro-Palestinian school is indicated by the miniatures of the Etschmiadzin manuscript.[73]

The sixth-century mosaics of Ravenna often display the same architectural forms, though disconnected and dispersed through various compositions. In the earlier mosaics of the mausoleum of Galla Placidia the conch shell is the only element of this kind that is represented. The mosaics of S. Vitale and S. Apollinare Nuovo frequently show pilasters decorated with rows of precious stones, conch shells and hangings. In the Orthodox Baptistery, on the other hand, the architectural frieze appears in a new brilliance, showing a number of innovations introduced by Byzantine art.

As in Salonica, this mosaic is an annular frieze placed in the lower portion of the dome (Fig. 98). The architectural forms are less elaborate, but they imitate more clearly the arrangement of a Christian church, more specifically that of a basilica. As in the Salonica frieze, there are eight structures, separated from each other by candelabra of acanthus, but those of the Baptistery are broader and heavier in design.

Whereas in Salonica each structure differs considerably from

the others, in Ravenna there are only two variations, each repeated four times. The structures have no roofs or hangings, but preserve the appearance of an interior seen in cross section. The roofs of these structures have been cut away, leaving only part of the coffered ceiling (λακωνάρια) and the entablature. The

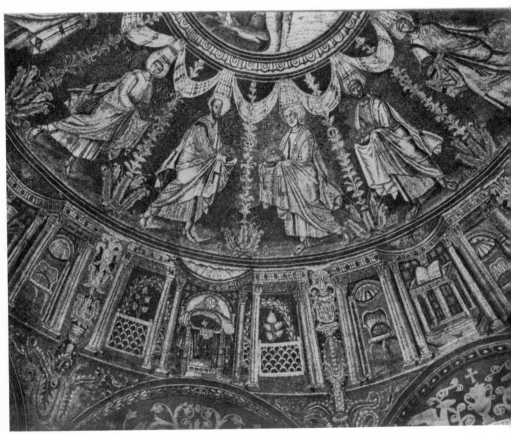

Fig. 98

buildings are in three parts representing the three aisles of a basilica. The columns are those of the lateral naves, but they are placed under the semicircular entablature of the apse. Four of the edifices have within the apse an altar, upon which the Gospels are laid, whereas in the lateral compartments are armchairs similar to bishops' thrones, with crowns placed upon them. The other four edifices have in the center a throne like that of the *Etimasia,* with a cushion, a cloth, and a cross; on either side,

Fig. 99

behind a balustrade that is either of openwork as in Salonica or carved in relief, are garlands of palm and oak leaves. Golden capitals, green columns, gilded apses with blue coffers, precious stones, and revetments of green marble and porphyry are used throughout this frieze.

In the Bethlehem basilica (Fig. 99), the architectural frieze is not as rich.[74] Here, too, the structures are separated from one another by an acanthus ornament of complex shape. In one instance, however, this ornament is replaced by a cross between two trees. The ornament consists of acanthus branches that emerge from a cantharus or some other vessel and curl fancifully about the main stem; at the top the branches assume the shape of a lyre and are tied with a ribbon. On either side of the main ornament is a tall candelabra-shaped branch.

The structures have lost the character of antique architecture. True, they preserve the tripartite division, as well as the gathered-up hangings with even folds. They, too, are shown in cross section, but being designed to frame the texts of conciliar decisions, like canon tables, they have no interior perspective, apses, colonnades, floors, or figures. The most curious feature of these structures is that their roofs, which consist of pediments and domes, are executed in perspective. The central part is usually covered by an arch with a lunette decorated with a cross or some other ornament. In the first structure to the left, the execution of the wall with windows recalls the *opus isodomum* of

antique painting. Above the lunette there rises either a pointed gable or a dome. The lateral elements, basilical in form, have roofs in perspective; they have façades and sides, windows, doors, porticoes, and domed towers. In one instance the roof is replaced by volutes shaped like an S lying on its side—a feature certainly derived from an antique prototype. Inside the structures are altars with books laid upon them, as in the Ravenna Baptistery. The altars are flanked by candlesticks.

In addition to the impoverishment of architectural forms, one may note the resemblance of these structures to those fantastic church buildings that are often found in Byzantine art, especially in manuscripts. The latter are given in cross section and enclose entire biblical scenes. Their upper parts consist of marble revetments, lunettes, domes surmounted by crosses, and little towers, painted either in perspective or in flat linear design.[75]

The meaning of these structures can be understood only in the context of their development from the architectural genre of antique wall painting. Representations of councils, to which this genre was applied, existed in the Imperial Palace of Constantinople before the iconoclastic period. These were probably compositions with figures like the ones in the manuscript of Gregory Nazianzen (Par. gr. 510) (Fig. 100).[76]

4. In addition to the kinds of painting that we have discussed, portraiture occupied an important place in church decorations. The use of portrait painting for the images of Christ, the Virgin, the apostles, the Evangelists, and the martyrs imparts a special character and style to these decorations. In this respect, the medallion images that were placed in the soffits of arches or along the nave deserve particular attention. It is in these that we see most clearly the characteristics of portraits, i.e., the "historical" appearance of the persons portrayed and certain distinctive techniques used to express their individual traits.[77]

In spite of the fact that the portraits of Faiyum and Hawara are considerably earlier than those of the churches of Ravenna, Cyprus, and Mount Sinai, there is an obvious affinity between the two groups. The four encaustic icons brought from Mount Sinai by Bishop Porphirii Uspenskii, which are now at Kiev (Fig. 101), are likewise directly related to Egyptian portraiture.[78]

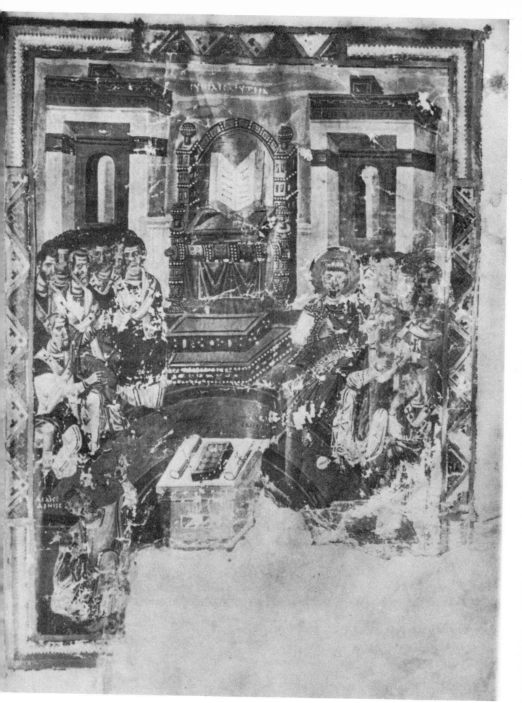

Fig. 100

Mosaic portraits in medallions preserve all the features of encaustic portraits. The figure is portrayed as a bust, either full-face or in three-quarter view, with its gaze fixed on the beholder. The bust is draped. Another important trait of Egyptian portraiture is that the arms are not shown, since the portrait fitted over the upper part of the mummy and represented the head, neck, and often the shoulders.[79]

Egyptian portraits are distinguished by their sharp individuality, immobile faces, and fixed gaze directed straight at the onlooker. Their most striking feature is the enlargement of both the eyeball and the pupil. Ebers has pointed out that this is particularly true of women and suggested that it was due to the custom of painting the eyelids.[80] This, however, is not an adequate explanation, since men's portraits have eyes that are just as wide-open and heavily emphasized. Perhaps this phenomenon is simply a convention of decorative painting: The eyes, lips, and nose were made prominent so that the expression of the face would not lose its vividness when viewed from a distance.

The mosaic portraits of Ravenna offer a clear proof of the application of this technique. The features of the face are sharply delineated: The eyes are wide-open, the pupil is round and entirely visible, deep lines mark the nose and the corners of the mouth. The portraits are shown full-face or in three-quarter profile, always looking directly at the viewer.

Elsewhere I have presented evidence to show that portrait painting was widely used in the iconography of saints, especially in the East. This is confirmed by the medallion portraits of Christ and of the apostles on the rim of ampullae from the Holy Land (Fig. 109). Furthermore, we know that on a wall of the church of St. Sophia in Nicaea were portrayed all the Fathers who condemned the Arian heresy. Theophanes calls these portraits χαρακτῆρες, but does not say who was responsible for them; Willibald calls them *imagines*.[81]

It is important to note that the medallion portrait with a blue background and the full-length portrait are both found in a fully developed form in the manuscript of Cosmas Indicopleustes.[82] Medallion portraits of the Evangelists, with a light-blue, pink, black, and red brick background, appear in the Rossano Gospel (Fig. 61).[83] In the Ravenna mosaics and those of Panagia An-

geloktistos in Cyprus [84] blue backgrounds are used. In the mosaics of Mount Sinai the background of the medallions is silver.[85]

The effect produced by the use of colored backgrounds (dark or light blue, gold, silver, and occasionally purple) is related to the Oriental taste for polychromy that was inherited by Hellen-

Fig. 101

istic art. Two medallions, enclosing personifications of the Earth and of the Nile, on Coptic textiles, have blue backgrounds shading into light blue near the heads. We have already indicated the diversity of colored backgrounds, in addition to blue and gold, in the manuscripts of Cosmas Indicopleustes, Dioscorides, and in the Rossano Gospel. Hence the appearance of gold, silver, and blue backgrounds in Byzantine art cannot be considered as a new departure. The luxurious, semi-Asiatic style of Alexandrian art found expression in the widespread use of gold, silver, and copper for wall revetments, as, for example, in the Serapeum of Alexandria, described by Callixenus. All this splendor and brilliance became the inheritance of decadent Rome and passed into

Byzantine art at the very time of its inception. In the same way the blue backgrounds that are so prominent in Assyrian ceramics, in Egyptian, archaic Greek, and Etruscan painting, retained their importance in Alexandrian art and were taken over by Byzantine monumental painting. Helbig, Semper, and Kondakov ascribe the origin of these colored backgrounds to the East, Asia Minor, and Mesopotamia, the birthplace of all decoration.[86]

We may assume that the preference for blue and gold was due to the striking effect produced by the combination of these colors. In his description of a carved ceiling, Gregory of Nyssa speaks of polygonal blue coffers which enhanced the glitter of the gold. In his own words, the blue served the purpose of making the gold shine more brightly.[87] Choricius mentions the same color combination in the church of St. Sergius at Gaza: "Some arches are entirely adorned with blooming gold, others are decorated with gold mixed with blue, so that each color may contribute equally to beautify them." [88] The chapel which Constantine the Great built at Antioch was, according to Eusebius, filled with an abundance of gold and copper.[89]

Whereas gold was used very lavishly in the churches of Constantinople and Jerusalem,[90] silver backgrounds appear rather seldom. We may mention, however, the medallions of the apostles on Mount Sinai, which have silver backgrounds, and the use of silver in St. Sergius at Gaza.[91] Silver appears in the mosaic of the enthroned Christ in St. Sophia at Constantinople,[92] and in the recently discovered mosaics of St. Demetrius at Salonica.[93]

IV. Constantinople and the East

1. In surveying the character of Byzantine manuscript illumination, monumental painting, and pictorial relief, we have noted a number of features pertaining to Hellenistic art. The luxurious half-Asiatic, half-Greek way of life that prevailed in the provinces bordering on Persia and particularly in cities such as Antioch, Damascus, Gaza, and, above all, Alexandria, which was open to every Eastern influence, must be taken into account when we attempt to define both the Hellenistic character and the Oriental style of Byzantine art. Indeed, it was the summoning of scholars from Alexandria to Constantinople, the foundation of a library, the decoration of the new capital with antique masterpieces collected from all the eastern provinces of the Empire [1] that marked the beginning of Byzantine artistic life and determined its future course.

We possess descriptions of the artistic treasures of Constantinople, of its monuments, statues, palaces, churches, and picture galleries. Of these, however, practically nothing remains. The Dioscorides manuscript and a few fragments of sculpture discovered within the city itself are perhaps the only remnants of the figurative art of Constantinople in the fifth and sixth centuries. The style and form of these sculptures do, however, confirm the close ties of the Christian art of Constantinople with the Orient. A fragment of a marble column decorated with a representation of the Baptism,[2] a marble bust in a medallion of St. Mark, a slab with a cross from the base of the column of Arcadius, a slab rep-

resenting Moses receiving the Ten Commandments (now in the Berlin Museum), and a similar slab in the Çinili-Köşk Museum in Constantinople—these are practically the only remaining specimens of sixth-century Constantinopolitan art. Strzygowski has correctly pointed out the connection of these works with the art of Syria and Palestine and noted the importance of some of them —namely, the column fragment and the slabs in Berlin and Constantinople—for the study of Maximian's chair in Ravenna.[3] The statuette of the Good Shepherd, published by Kondakov, should be dated to the fifth century on the basis of its style.[4] To this short list we may add a few unpublished monuments.

The most interesting of these is part of a marble sarcophagus discovered in Constantinople in the *hagiasma* of the Armenian church of St. George at Psamatia (Fig. 102). The credit for the discovery of this remarkable work is due to the director of the Russian Archaeological Institute in Constantinople, F. I. Uspenskii.[5] The slab was set into a wall along with two late Byzantine reliefs depicting the Virgin orant and the Archangel Michael respectively. The slab is 145 cm. high and 147 cm. wide, but was originally wider—a part of it, on the left side, has been sawed off, with the result that a small column and part of a figure are missing. The surface is divided into three compartments by means of small columns. Within each compartment stands a full-length figure: Christ in the middle and an apostle on either side. The entablature that extends above the heads of the figures is interrupted in the middle by a low pediment with an acroterium on each side. The spirally fluted columns have elegant Ionic bases and tall Corinthian capitals consisting of two acanthus leaves. Above the abacus is an impost with convex sides, and above this a row of dentils. The pediment is decorated with a leafless rinceau, and the acroteria with acanthus leaves.

The marble has been polished, but not over its entire surface: Only the figures, columns, and bases, i.e., the most important parts of the relief, are polished. These are executed in high relief, occasionally going into rounded relief. The columns are detached from the background. The necks of the two lateral figures are also fully rounded, as were their arms which are now missing; the very fact that the latter have been broken off proves that they projected from the torso. After the marble had been polished, small folds were indicated by means of deep incisions.

Fig. 102

These figures are reminiscent of statues standing in niches. Their disposition is completely symmetrical. The two apostles are almost similar except for the drapery over the chest and waist and the slight inclination of the head of the figure on the left. One apostle rests his weight on his right leg, the other on his left. The symmetry is further accentuated by the fluting of the colonnettes, which runs in opposite directions.

The head of Christ is particularly remarkable. The full oval face, inclined slightly to the left and framed by wavy locks of hair, reproduces the classical type of the so-called Eubuleus of the Athens National Museum. The resemblance between the two heads is particularly noticeable in the execution of the long hair which falls in separate heavy locks and is tied with a headband. The forehead, framed by locks of this kind, the very full cheeks, the wide chin, the soft transitions in the modeling of the cheeks, the shallow eyesockets, the faintly marked frontal ridge indicate that this type is descended from the same classical original as the head of Eubuleus. The nose, the lips, and part of the eyes have been damaged, probably as a result of a long sojourn in a pile of debris before the relief was set in the wall of the *hagiasma*.

One may observe in this figure of Christ a slight elongation of the waist and a shortening of the arms and legs. These peculiarities are traditional traits of the Byzantine style that have been noted by Strzygowski in connection with Constantinopolitan sculpture of the time of Justinian.[6] They also appear in works of the mature style of the ninth and tenth centuries.[7] The two other figures are more normal. They do not present the same distortions as the figure of Christ, except that in both of them the right humerus is conspicuously short. Nevertheless, these figures have an undeniable finesse and elegance. They are fairly wide at the shoulders, but become narrower further down. The feet are placed close together, instead of being set apart for greater stability.

Christ's head is surrounded by a crossed nimbus executed in low relief. The cross, without a *rho*, has flaring ends. This shape of the cross became prevalent after the year 326, i.e., after the Invention of the Holy Cross by St. Helena, as I have attempted to show elsewhere.[8] Christ holds His left hand beside His hip, while the right hand rests in front of His chest, within a fold

of the himation. The very same stance and type of Christ occur on a sixth-century sarcophagus in S. Marco, Venice, in which Doge Marino Morosini was buried.[9] This sarcophagus in its ornamentation and style resembles a fragment of another sarcophagus found in Asia Minor and now in the Berlin Museum.[10]

The apostles have long narrow books, executed in free relief, i.e., not attached to their chests. They hold them with both hands, leaning the lower edge on the palm of the left hand and grasping the upper edge with the right hand. This manner of holding a book is common on Roman sarcophagi, except that on the latter the book is usually replaced by a scroll that is tied in the middle and therefore flares out at the ends.[11] The book held by the apostle on the right, which also has a band across the middle, may be compared to the long narrow book held by the bearded figure on the pyxis from the Ozerukov tumulus in the Caucasus (Fig. 123).

The architectural décor of the Psamatia sarcophagus is distinguished by one unusual detail, namely the shape of the impost block which is unknown in Western monuments. The few specimens of this structural element that have been noted by De Rossi on a Roman sarcophagus of A.D. 353,[12] by Strzygowski on various Eastern monuments, and by Kraus in Naples and Rome,[13] have a different appearance. Imposts of a related but not identical shape are found in Constantinople and Ravenna. There are pillow-shaped impost capitals decorated with a flat ornament in St. Sophia and in Tekfur Saray at Constantinople, but these correspond only to the lower half of the impost on the Psamatia sarcophagus, and the character of their ornament is quite different.[14]

Imposts of the very same shape as on the Psamatia slab are, however, found on sarcophagi from Asia Minor, also discovered by the Russian Archaeological Institute. The fragmentary specimen illustrated here (Fig. 103) was found by P. D. Pogodin at Iconium (Konya). It depicts the Skyros episode of the Achilles legend.[15] The figures are placed in conches and are separated from one another by little fluted columns. The impost blocks have not only the same shape but also the same ornaments as on the Constantinople sarcophagus. They are divided into two halves, are covered with a flat ornament, and have convex sides. Here we see once more the egg-and-dart flanked by acanthus

leaves and surmounted by a band of dentils that runs under the
curve of an arch, in the same manner as it runs under the gable
of the Constantinople sarcophagus.

The heads of the apostles, like the head of Christ, are ideal
sculptural types. They are beardless; the apostles' hair is short

Fig. 103

and is cut in a fringe over the forehead. The fact that their hair
has not been fully elaborated may indicate that the sarcophagus
was originally painted. Compared to other Constantinopolitan
sculptures published by Strzygowski and dated by him in the
sixth century, the Psamatia sarcophagus is distinguished by its
antique character. The repetition of the Eubuleus type, the ele-
gant stance of the figures, the correct drapery, and the use of
foreshortening for the arms and legs provide a sufficient distinc-
tion between this monument and the sculpture of the sixth
century.

Constantinople and the East

In view of the close resemblance of the impost block on the Constantinople and Konya sarcophagi, one may suppose that the former is related to the sculpture of nearby Asia Minor. It cannot be doubted that it is a work of the fifth century.

Another monument, later in date but of no less importance, is closely related to the art of Constantinople, although it was not found in that city. It is a statuette of the Good Shepherd, now in the Archaeological Museum of Constantinople, but discovered at Broussa, as I have been informed by O. Wulff (Fig. 104). The style of this statuette shows a close kinship to the marble column in the same museum (see above, p. 182). In the catalogue of the museum (No. 165) it is described not altogether accurately and dated in the fourth century. The catalogue states that the Good Shepherd holds two of the lamb's legs in each hand, whereas in fact this statuette belongs to the type of which the distinguishing feature is that he holds all four legs in his right hand, while his left hand leans on a tall staff. This type is well illustrated by the splendid statuette of the Good Shepherd in the Lateran Museum.[16]

Furthermore the catalogue does not indicate that the statuette was part of a group: To the shepherd's right one can still see traces of the four legs and tail of another sheep. The right-hand part of the pedestal is broken off, but its projection shows that originally there was a sheep on either side of the Good Shepherd. This is corroborated by the fact that the right arm was stretched out far to the side and forward, as can be deduced from the angle of the elbow. The staff held in the right hand also required adequate space on the pedestal. On the left hip of the statuette is a projection which was probably part of a marble peg that connected the staff to the figure. Behind the shepherd's back is a tree trunk, the cracked bark of which is visible between the legs. The back of the statuette is unfinished. We can therefore assume that it was intended to be placed against a wall and not in the open.

The most interesting feature of this statuette is that it presents a part of a group that is well known in catacomb painting, namely, the Good Shepherd flanked by two sheep. Except for the monument under discussion, this composition is not encountered in early Christian sculpture.

The statuette of the Good Shepherd from Constantinople that has been published by Kondakov closely resembles the one from Broussa: [17] Both belong to the same type and are clad in the same garments. The left arm of the Constantinople statuette is broken off at the same place, so that it, too, must have held a tall staff. The difference between the two statuettes consists in the fact that in the first the lamb's head is turned towards the shepherd, while in the second it looks to the right. The legs of the Constantinople statuette are broken off.

De Rossi has already suggested that statuettes of this type were free copies of the famous statue of the Good Shepherd erected by Constantine the Great to adorn a public square at Constantinople.[18] Eusebius mentions this statue, together with another one representing Daniel in the lions' den: "You may see by the fountains in the market place images of the Good Shepherd, well known to readers of the Holy Writ, and also Daniel with the lions, wrought in brass and glittering with plates of gold." [19] These statues therefore were placed near fountains and, in view of the well-known iconographic type of Daniel standing between two lions, we may assume that the statue of the Good Shepherd was set between two sheep so as to form a pendant to the Daniel group. The Broussa statuette is clearly related to this group in Constantinople. Its rough execution and faulty bodily structure point to a period close to the sixth century. The figure of the Good Shepherd has a close resemblance to that of a shepherd with a dog on the column in the Museum of Constantinople.[20] Both figures have an unstable stance and are awkward in appearance. Their legs and arms are short while the torso is elongated. Their clothes and hair are treated in the same manner, the latter rising in curls above the forehead, as it also does in the figures of shepherds on Maximian's throne. The hair style and crude facial type relate this kind of shepherd to antique satyrs. The Broussa statuette stands in the same tradition as the Hellenistic statuettes and small groups representing in a realistic manner shepherds, fishermen, old men and women. The groups of Orpheus [21] and Bellerophon, of the same size as the statuettes of the Good Shepherd, maintained in Byzantine art the tradition of this kind of decorative sculpture.

The style of the Broussa figure shows a close connection with

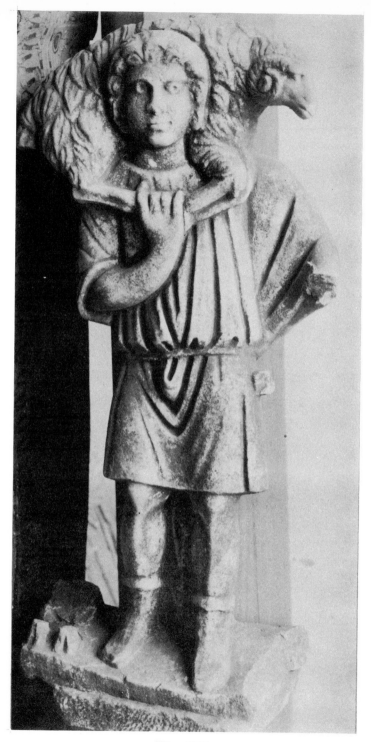

Fig. 104

sixth-century Syrian art, especially to the so-called Ravenna diptych (Fig. 120). The facial type differs from the antique by its Oriental cast; the folds of the flattened garments are indicated by deep, almost straight incisions.

An even cruder specimen of Oriental style is provided by a piece of a tufa slab, discovered in the same *hagiasma* of St. George's church at Psamatia as the relief of Christ and the two apostles (Fig. 105). It represents Isaac kneeling down. Over his head can be distinguished Abraham's hand and part of his himation. Isaac's head is seen in profile, his torso *en face;* the knees are also in profile. His hands are tied behind his back. This composition, appropriate for high relief, is here executed in crude low relief. The head is very large and out of proportion to the body. The hair is indicated by curved lines; it is trimmed on the forehead and falls in curls on the shoulders. The ear is placed too far from the eye. One can discern, however, in Abraham's elongated hand and in Isaac's sharply outlined eyelids and straight nose something of the technique of antique sculpture. The folds of the clothing are rendered by means of rough incisions. The character of this relief is reminiscent of carved tufa slabs of Coptic origin which present the same traits: large heads, flat folds, the inability to dispose a figure correctly on a plane, and, especially, the same low, flat relief.

These characteristics of Constantinopolitan sculpture correspond to the data we have gathered from our study of Byzantine manuscripts, ivories, and wall paintings. They indicate the close ties that connected the art of Constantinople to the art of the East.

2. These ties are even more evident when we consider the relations between Palestine and the Eastern capital. The building activity of Constantine and Helena in the Holy Land accounts for the appearance in Byzantine art of a whole group of compositions to which we must ascribe a Palestinian origin. In discussing some of these compositions we have already had occasion to mention the Palestinian legends which determined their content and to note their kinship to Eastern works, especially the ampullae from the Holy Land. Indeed these ampullae shed light on an entire period of the history of Byzantine art. They belong

to the time when Palestinian art was at its height, as a result of the initiative of the court of Constantinople, a period that lasted until A.D. 614, i.e., until the first invasion of Chosroes.

The ampullae from the Holy Land, now preserved in the sacristy of the cathedral of Monza, were a gift to Queen Theo-

Fig. 105

delinda and were brought to her from Rome by the subdeacon John in about A.D. 600. Barbier de Montault who has collected all the inventories relating to the ampullae and the treasure of the cathedral of Monza, has shown that there is no evidence for the conclusion that the ampullae were a gift from Pope Gregory (590–604). The papyrus merely indicates that they were brought from Rome during Gregory's pontificate.[22]

Each ampulla is a round silver flask, flattened on both sides, with a round neck soldered onto the body. On either side of the neck was a ring so that the ampulla could be worn on a chain. The shape of the Monza ampullae is similar to that of the clay ampullae of St. Menas in Alexandria.

The two convex sides are decorated with representations in relief, which were not chased, but embossed with a die. This is shown not only by the low relief, which is not equally sharp in all parts of the ampullae as a result of uneven impression, but also by the repetition of the same die on different ampullae. On two of the small ampullae the Crucifixion, the inscription, and all the other details of the die are exactly duplicated. Two medium-sized ampullae repeat the same cross set inside an arch, the same number of stars, and the same medallions containing busts of the Evangelists. Likewise, the same mold was used for the Ascension on two of the large ampullae. The remaining ampullae were stamped with different dies.

Generally speaking, all the ampullae display such unity of execution, style, form, and composition that they can all be ascribed to the same time and place of origin; all the more so since in certain cases we can even indicate the reason which prompted compositional changes.

The change of dies, and therefore of the composition, was due primarily to the size of the ampullae. The compositions are more complex on the larger ampullae, simpler on the smaller ones. In most cases the compositions simply copy each other. As new dies were made, they were modified only in details: The composition became more or less complex depending on the space available. Thus the thieves in the Crucifixion have their arms either extended or bent at the elbows or tied behind their backs. The same is true of Christ, whose arms are not stretched out, but bent at the elbows due to lack of space.

The shepherds and the Magi are depicted either standing or walking, in which case the first of the Magi is shown kneeling down and is balanced by a seated shepherd on the right (Fig. 106). Such variety in the representation of the Magi and the shepherds results from their disposition within the circle of each ampulla. In one case, the adoration of the Magi is placed in a

Fig. 106

narrow frieze so that the figures are set out according to the principle of isocephaly; in the other cases, the absence of an upper cornice makes it possible to arrange a pyramidal group around the Virgin and to diversify the attitudes and gestures of the figures.

The circular surface of the ampulla does not allow a free development of complex compositions. This is why, in the scene of the Adoration, the flock is represented not next to the shepherds, but beneath them, in the exergue; sometimes there are many sheep and at times only four. For the same reason angels are occasionally represented at the top, separated from the central part of the composition by the narrow strip of the inscription, sometimes flying on either side of the inscription; or else one angel is shown behind the Magi, leading them to the Virgin, while another stands among the shepherds and points up to the star.

Furthermore, one may note a number of abbreviations in the figures, scenery, and other details. The busts of the Evangelists are often replaced by heads. The size of figures is reduced to fit into the inadequate space left for them. The end figures in the Ascension are squeezed against the rim. The Holy Sepulcher is depicted either as a splendid rotunda in a garden or as a hut with a sloping roof. The latter form results from the fact that the die does not convey the roundness of the building, but flattens it out and simplifies it.

These considerations prove that each die is the work of a craftsman who resorted to various abridgments and modifications of compositions according to the size of the ampullae and the space available for his subject. Consequently, the scenes represented on the ampullae cannot be considered as direct copies of their originals, but are distant copies, adapted to the round surface of the ampullae and related to the dominant iconographic types.

The cycle of subjects is distinguished by its lack of variety. All the subjects are taken from the Gospels. They include neither scenes from the Old Testament nor the miracles of Christ—subjects that are widely used in other contemporary monuments. A peculiarity of the ampullae is that they depict two or more scenes. One of the large ampullae displays as many as seven scenes in medallions on one side, and two more on the other side

(Fig. 107). Such an abundance of subjects must have presented serious difficulties in the preparation of the dies and was called for by the destination of the ampullae—to contain oil or some other *eulogia* not from one sanctuary but from several. This use of the ampullae has already been pointed out by Garrucci [23] and is proved by the subject matter of the scenes and by the inscrip-

Fig. 107

tions. Some of the latter indicate that the *eulogia* was taken from "the holy places of Christ" (ΕΥΛΟΓΙΑ ΚΥΡΙΟΥ ΤΩΝ ΑΓΙΩΝ ΧΡΙCΤΟΥ ΤΟΠΩΝ); others speak more specifically of oil taken from the True Cross and from elsewhere: (ΕΛΑΙΟΝ ΞΥΛΟΥ ΖΩΗC ΤΩΝ ΑΓΙΩΝ ΧΡΙCΤΟΥ ΤΟΠΩΝ). The inscription on a clay ampulla, also in the cathedral of Monza, names only one place whence the *eulogia* derived and displays only one subject: ΕΥΛΟΓΙΑ ΤΗC ΘΕΟΤΟΚΟΥ ΤΗC ΠΕΤΡΑC ΒΥΔΑΜΟ . . . or BVΔΑΧΙΟ.[24] This last inscription corresponds exactly to those on the clay seals of St. Phocas, St. Euthymia, and St. George (?) and on the clay ampullae of St. Menas.[25]

The subjects represented on the Monza ampullae, like those of the clay seals and the ampullae of St. Menas, indicate exactly the sanctuaries from which the *eulogiae* were taken. Thus their cycle of subjects has a definite significance. The Nativity, adoration of the Magi, and Visitation indicate Bethlehem; the Annunciation (with a spindle or next to the spring) indicates Nazareth; the Baptism refers to a specific location on the banks of the Jordan; the Crucifixion, the women at the Sepulcher, and the True Cross, depicted separately, refer to Jerusalem; the Ascension and the doubting of Thomas refer respectively to the Mount of Olives and to Mount Zion; the Madonna and Child, with an angel on either side, apparently also refers to Bethlehem.

Thus the iconography of the ampullae affords a clear understanding of which "holy places of Our Lord" are meant by the inscriptions. The complex iconography of the large ampulla bearing the inscription ΕΥΛΟΓΙΑ ΚΥΡΙΟΥ ΤΩΝ ΑΓΙΩΝ ΧΡΙCΤΟΥ ΤΟΠΩΝ (Fig. 107) may be explained by the supposition that its *eulogiae* were taken from several shrines, probably those indicated by the subjects represented. In the same way we can explain why another ampulla bears the Adoration on one side and the Ascension on the other, whereas the inscription as well as the cross on its neck refer to a *eulogia* from the True Cross. Evidently this ampulla too was meant to contain *eulogiae* from several shrines. Such a use of ampullae is indicated by Theodoret of Cyrrhus, who speaks of a lecythus containing *eulogiae* taken from the relics of many martyrs.[26]

Except for the mosaic map of Palestine found at Madaba and the mosaic in the apse of the Sinai Monastery, there is no other

pictorial document of Palestinian origin with which one may compare the compositions of the ampullae. The peculiarities of these compositions, however, prompt us to assume the existence of splendid prototypes in the churches that were built by Constantine and Helena at Jerusalem, Bethlehem, and Nazareth, beginning in A.D. 326. Contemporary historians and pilgrims to the Holy Land describe the magnificent shrines that were built at various times in these towns. The paintings and mosaics that decorated these shrines are sometimes mentioned. The church of the Resurrection and the Martyrion, erected by Constantine and Helena in Jerusalem, were adorned not only with precious marbles, but also with gold and mosaics.[27] The fullest information on this subject is provided by Aetheria, a pilgrim of the fourth century, and by Eusebius, and is corroborated by a text ascribed to Petronius, bishop of Bologna (A.D. 420). A short excerpt from the latter text, published by Molinier and Kohler, is of prime importance because it contains data derived from some unknown source. Later interpolations and the impossibility of proving that this text is really by Petronius have led the editors to regard it as dubious. And yet this is the only text that refers specifically to the columns, marble, and paintings with which Constantine adorned the church of the Ascension on the Mount of Olives: "He decorated the walls of the entire building, all around, as well as its vestibule and atrium, with beautiful paintings." [28] Eusebius speaks of the ornamentation of this church in general terms, dictated by the structure of his panegyric of Constantine.[29]

It is also known that the church of the Nativity at Bethlehem was built and magnificently decorated by Constantine.[30] This decoration, too, is mentioned by Aetheria.[31] The mosaics in the grotto of the Nativity are attested by a number of documents, some of which are later than the ampullae but are nevertheless important for the interpretation of the compositions depicted thereon.

Aetheria also mentions the church on Mount Zion, erected on the spot of the descent of the Holy Ghost and the doubting of Thomas.[32] The Armenian description of the holy places, which Vasil'evskii ascribes to the seventh century, mentions the representation of the Last Supper in the dome of the chamber where it took place. The monk Epiphanius (eighth–ninth century) mentions an image of the publican and the Pharisee in the same

chamber,[33] and the Russian pilgrim Daniel speaks of mosaics that adorned this room, which he terms a "cell" in the house of John the Divine.[34]

The Bordeaux pilgrim mentions the church at Nazareth built over the location of the synagogue in which Jesus had studied; and if we are to believe Gamurrini, Aetheria too saw this church.[35] The church of the Annunciation in Nazareth, built on the spot where Joseph's house had stood, is of later date. It had a cave or room in which the Virgin had dwelt and where the angel of the Annunciation had appeared to her. Aetheria, as quoted by Petrus Diaconus, mentions only the cave and an altar on the spot where the Virgin used to draw water.[36] Arculf (A.D. 670) is the first to mention the church of the Annunciation in addition to the other church.[37] None of the early pilgrims mentions any mosaics decorating these churches. The statement of Phocas, a twelfth-century writer, concerning two mosaic pictures in the church of the Annunciation (the one built over Joseph's house) cannot be used as evidence in connection with the ampullae until such time as the existence of these mosaics is confirmed by earlier sources.

We also know nothing concerning the decoration of the church erected on the banks of the Jordan near the place of the baptism of Christ. This was known as the church of St. John, according to the pilgrim Theodosius (*ca.* 530), who ascribes its construction to the Emperor Anastasius (491–518).[38] Both Arculf and Epiphanius mention another church or monastery of St. John in the same place. The first church was erected on the spot where the garments of Christ were laid when He was being baptized.[39] Seeing that this church is mentioned in the fourth-century Life of Mary the Egyptian, one may conclude that it had existed before the reign of Anastasius. In the fifth century it housed a convent.[40] But even if there is no positive evidence concerning the pictorial decoration of the churches of Nazareth and those on the bank of the Jordan, it cannot be doubted, in view of the practice of that time, that such decorations existed.

Thus the iconography of the ampullae must be considered in connection with the wall decoration of these churches and, in general, with the originals that had been created in the periphery of the holy places.

Constantinople and the East

In some cases it is possible to establish a close connection between this iconography and the splendid mosaics that adorned the churches of Palestine. The adoration of the Magi and of the shepherds (Fig. 106) is encountered three times on the ampullae published by Garrucci.[41] On the whole, these compositions stand very close to each other, differing only in details. On all three ampullae the Virgin and Child are represented in the center; the Virgin is seated frontally on a throne, while the Magi and the shepherds are on either side of her. The flocks are shown grazing underneath. An eight-pointed star enclosed in a circle is always depicted at the top, above the Virgin. The Virgin and the angels are nimbed. The Child has a cross-nimbus. The form of the throne and of its back which terminates in two sharp points, the dots representing the decoration of the throne, and the carvings of the legs are nearly the same on all three ampullae. In one case the cushion of the throne has been replaced by two big globes attached to the top of the legs.[42] On all three ampullae the pose of the Virgin and Child, His extended right hand, and even the folds of the garments are alike. This proves that the dies were made from the same prototype. The position of the Magi and the shepherds, as we have already explained, is altered in accordance with the space available.

Smirnov was among the first to point out that these compositions probably reproduce the mosaics that adorned the Bethlehem basilica. For, even if the pilgrims Eucherius (A.D. 440) and Antoninus of Piacenza (A.D. 570) speak only of the gold and silver decoration of the manger in the grotto of the Nativity and say nothing about the mosaics of the church,[43] this still does not prove that they did not exist. The Arabic chronicle of the Patriarch Eutychius states that during their first invasion of Palestine the Arabs saw the church of the Virgin at Bethlehem decorated with "fsefysa" (ψηφῖσι).[44] Consequently there were mosaics there before 614. It is true that the basilica of the Nativity was restored by artists whom Justinian sent to Palestine under the supervision of the architect Theodore,[45] but there is no reason to suppose that the mosaics were made by these artists. The words, such as "glittering," which Eucherius uses to describe the grotto indicate some kind of wall ornamentation, perhaps the marble facing that is mentioned by later pilgrims, or mosaic. In the

seventh century the Patriarch Sophronius mentions beautiful mosaics in his description of the Bethlehem basilica (μούσης καλλίτευκτον ἔργον).[46] In the conciliar epistle of the year 836, the mosaic on the façade of the Bethlehem basilica is ascribed to St. Helena: "Having erected a majestic church of the Mother of God, [the Empress] caused an image of the holy birth of Christ with Our Lady holding the life-giving Child and the adoration of the gift-bearing Magi to be represented, by means of mosaic tesserae, on the outside of the western wall of the church." [47] In this text the mosaics are mentioned in connection with a miracle that occurred during the Persian invasion of 614: Upon seeing the representation of the Magi on the façade, the Persians spared the church. It would have been sufficient for an understanding of the miracle to mention the adoration of the Magi, but the author goes on to stress the antiquity of the mosaics and to enumerate their subjects, namely, the Nativity, the Virgin and Child, and the adoration of the Magi. Because of the brevity of the text we cannot establish the relation between the last two representations. One could imagine that the mosaic of the façade had a full-length image of the Virgin and Child, as in the Rabula Gospel and the Kiti mosaic in Cyprus.[48] On the other hand, since the Magi are mentioned immediately after the image of the Virgin, one could suppose that the latter was part of the composition of the adoration of the Magi. The terms used by the author of the epistle cannot serve to determine the type of this image. The expression ἐγκόλπιον φέρουσαν τὸ ζωοφόρον βρέφος could refer to the position of the Child in the lap of the Virgin.[49] The words προσκύνησις τῶν μάγων appear to mean the adoration in general rather than a genuflection. The conjunction of the three representations by means of the particle καί may indicate that each one of them had an independent position on the wall of the basilica.

On the three ampullae we are discussing, the image of the Virgin occupies a central position. The adoration of the Magi is connected not with the Nativity, but with the adoration of the shepherds. In seeking an analogy to the Syrian miniature in the Etschmiadzin Gospel, Strzygowski has noted the resemblance of its composition to the Palestinian ampullae. This consists in the fact that in both instances the Virgin is placed in the center, with

figures on either side of her.[50] In spite of this resemblance, however, there is also a considerable difference: The ampullae consistently depict the shepherds with their flock, whereas the shepherds are excluded by the very conception of the miniature and of the second plaque of the Ravenna diptych now in the collection of the Earl of Crawford (Fig. 122), which has a similar composition. In the two latter instances only the Magi are represented on either side of the Virgin. This circumstance lends a special interest to the conciliar epistle of 836, which does not mention any shepherds, as well as to the Crawford ivory, which shows the Nativity and the adoration of the Magi with the Virgin and Child in the center. The consistent representation on the ampullae of the shepherds and their flock in conjunction with the adoration of the Magi should therefore be related to the mosaics of the Bethlehem grotto rather than to those of the façade of the basilica. The grotto or cave of the Nativity had been associated with the Nativity, the adoration of the Magi, and the adoration of the shepherds from the earliest times.[51] The pilgrim Epiphanius describes in the following words the decoration of this grotto, which consisted of two cavities: τὰ δύο σπήλαια ὁμοῦ. εἰσὶ δὲ περιχρυσωμένα καί εἰκονισμένα καθὼς ἐγένετο.[52] We may suppose, therefore, that he saw there the representation under discussion. A twelfth-century writer, Phocas, describes a mosaic of this grotto, representing the Nativity, the adoration of the Magi, and the adoration of the shepherds. He ascribes its execution to the Emperor Manuel Comnenus (1143-1180).[53] But mosaics had been seen there earlier by the Russian pilgrim Daniel: "both of these places are in one single cave; and this cave is decorated with mosaic and is beautifully paved." [54] Phocas' description of the mosaics is only partly by his pen—his eloquence is borrowed almost word for word from the sixth-century rhetorician Choricius of Gaza. For his account of the mosaics of the grotto, Phocas simply chooses suitable passages from the panegyric in which Choricius describes the mosaics of St. Sergius at Gaza. However, the description of the apse that contained the mosaics of the grotto is not taken from Choricius and is therefore of particular interest.[55] Phocas mentions the Magi who had alighted from their horses and, kneeling down, were presenting their gifts to the Virgin.[56] The monumental character of the com-

position on the three ampullae under discussion, the full-face po-
sition of the Virgin, the symmetrical grouping of Magi and
shepherds on either side of her—all these suggest that the com-
positions on the dies were adapted from wall painting. Not with-
out reason, Smirnov has assumed that the scene on the ampullae
was copied from the façade of the Bethlehem basilica.[57] But
such a composition could just as well have been placed in an apse.
Phocas' account is of some significance in this connection, if only
because a kneeling Magus is depicted on one of the ampullae
(Fig. 106), as specified by this author. We can assume that on
another ampulla [58] the first Magus was also shown kneeling, since
the dies of both these ampullae are very similar, and furthermore
the seated shepherd on the right must have balanced a kneeling
Magus as he does on the first ampulla.

A few details in the representation of the shepherds and their
flock on the ampullae also correspond to Phocas' description,
whose text at this point is borrowed word for word from Chori-
cius.[59] In the mosaic was represented a peacefully grazing flock,
as it is also on the ampullae. The center on two of the ampullae
is occupied by two goats butting each other. To the left are two
sheep with lowered heads, either grazing or drinking. Next to
these are other sheep, running towards the first two. These sheep
are mentioned by Phocas who also describes the shepherds with
their heads lifted up and their arms raised, their crooks, their
various positions, and the angel appearing to them.

The coincidence of these details in the ampullae, in Phocas'
description, and in the mosaic of the Nativity in the church of
St. Sergius at Gaza bears witness to the kinship between Syrian
and Palestinian compositions, a fact that we have already indi-
cated on several occasions. If Phocas was able to use Choricius'
text almost to the letter in describing the mosaic of the Bethle-
hem grotto mosaic, it was probably because Choricius' descrip-
tion fitted the mosaic so well.

Later pilgrims frequently mention the mosaics of the Beth-
lehem grotto, but only rarely do they indicate the subjects.
Johannes Poloner informs us that to the right of the entrance
was a mosaic representing the "Genealogy of Christ" (*geneal-
ogiam Christi per lapides musivos sursum in latere dextro, cum
ingreditur, habens conpictam*),[60] which presumably refers to the

scenes mentioned above, since the later representation of the tree of Jesse was in the upper church.[61] The Russian pilgrim Varsonofii mentions a mosaic in the grotto, representing the Nativity: "The Birth of Christ," he says, "is pictured with the story of it"; [62] i.e., as on many Byzantine icons, the Nativity was combined with the adoration of the Magi and of the shepherds.

The star on the ampullae is unusual in that it is too big and is surrounded by a circle.[63] Such a star can be seen on the mosaics of the triumphal arch of Sta. Maria Maggiore in Rome, on the Ravenna diptych, and on some monuments of unknown origin.[64] Similar stars are used to decorate the empty spaces between the medallions of the large ampulla (Fig. 107). It obviously depicts the miraculous star of the Magi.

On the same ampulla, in the scene of the Nativity, which bears a close resemblance to the compositions of Maximian's throne and of the Paris and Etschmiadzin diptychs, is represented a squat structure with a semicircular top and grilled doors. This structure is not found anywhere else, except in a miniature of the Rabula Gospel. It apparently represents the entrance to the grotto of the Nativity.[65] The semicircular lunette over the door has some sort of ornament which is not rendered clearly enough by the die.

The Annunciation and the Visitation are represented in two medallions next to the Nativity (Fig. 107). In the twelfth century, Phocas alone saw in the church built over Joseph's house at Nazareth, a cave whose entrance was decorated with marble and mosaics. Above the cave were two mosaic scenes: the Visitation and the Annunciation with a spindle and purple yarn.[66] As before, Phocas has borrowed the description of these mosaics from Choricius. It is not known, however, whether these mosaics were contemporary with the erection of the church. The chair depicted in the Annunciation may be connected with the Virgin's chair which Antoninus of Piacenza saw at Diocaesarea together with the pitcher which she had used to draw water.[67]

Two small columns surmounted by crosses stand beside Mary and Elizabeth in the scene of the Visitation. They apparently represent votive columns of a type common in Palestine, like the column with a cross in the Jordan, Peter's column in the basilica of Zion, and the two columns of the Flagellation. One of the latter was also in the basilica of Zion and was surmounted by the horn

of Solomon; the other stood on the road from Jerusalem to Dios-
polis and had an iron cross affixed to its top.[68] It is interesting to
note that a silver column is represented on either side of Mary
and Elizabeth on a gold ring from Palermo; each is surmounted
by a cross.[69]

The scenes of the Crucifixion and the Resurrection, often rep-

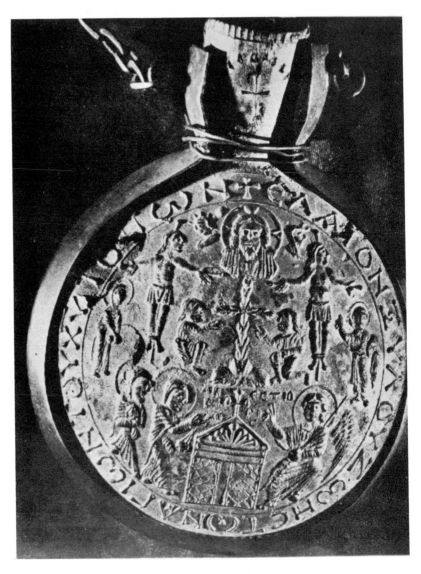

Fig. 108

resented on the ampullae, are of particular interest because of the numerous local traits they contain. In the Crucifixion we see the big votive cross which stood between the Holy Sepulcher and Constantine's basilica, in an opening of the rock of Golgotha (Figs. 107 and 108). Only once is this cross replaced by the crucified Christ.[70] Ordinarily only the bust of Christ, in a medal-

Fig. 109

lion or without one, is displayed above the cross. The Cross of
Calvary is already pictured in the fourth-century mosaic of the
church of Sta. Pudenziana in Rome.[71] On the ampullae it is some-
times made of laurel leaves or is perhaps decorated with laurel
leaves (Fig. 108).[72] More often it is a plain cross with flaring
arms, of the kind known in monuments of the fourth to the sixth
centuries. On the neck of all the ampullae, as well as on the re-
verse of some of them (Fig. 109), this cross is shown inside a
small arch consisting of a garland that rests on two colonnettes.
The ends of the crossarms are sometimes adorned with almond-
shaped drops, and there is a raised dot in the center. The sunken
dots at the ends of the crossarms apparently mark the place of
the nails. The rock of Golgotha is not represented under this type
of cross. When it does appear, it is in the form of a pile of stones
so as to convey its natural and unfinished aspect (*genus silicis*).
Sometimes the four rivers of Paradise are shown flowing out of
its base (Fig. 108). On one of Garrucci's drawings [73] a small tree
appears on either side of the thieves. In reality, however, these
are poorly impressed figures of the Virgin and St. John which the
draftsman mistook for trees.

The Holy Sepulcher, one of the most famous structures of
Jerusalem, is also frequently represented. The ampullae usually
feature an edifice without a plinth, shaped like a rotunda. The
details of these representations are most instructive. Sometimes
two edifices are shown, one inside the other.[74] The first one rep-
resents the church of the Resurrection, while the second is the
interior rotunda (*tugurrium*) that stood above the Holy Sepul-
cher. A latticed door consisting of two valves stands in front of
the inside rotunda. This lattice is mentioned several times by
Aetheria.[75] Atop the conical roof of the rotunda is the cross that
is mentioned by Arculf; it was large and made of gold.[76] In other
cases it seems that only the inside rotunda is depicted with its
latticed doors and the cross on its roof (Figs. 107, 108).[77]

The more complex representations of the rotunda of the Holy
Sepulcher show trees growing beside and behind it. This calls to
mind the garden in the Resurrection scene of the Rabula Gospel
(Fig. 39). These trees stand for the garden mentioned in the
New Testament but they might also refer to the garden that
was near the Constantinian Holy Sepulcher.[78] The rotunda is cov-

ered with a cupola, with a cross above it. High latticed doors are shown ajar. Inside the rotunda three lamps hang from a rectangular object, which may be the *transvolatile argenteum* mentioned in the Anonymous Breviary,[79] or the *lucerna erea* which was seen by Antoninus of Piacenza.[80] A fourth lamp is placed inside this object. Arculf states that there were four lamps beside

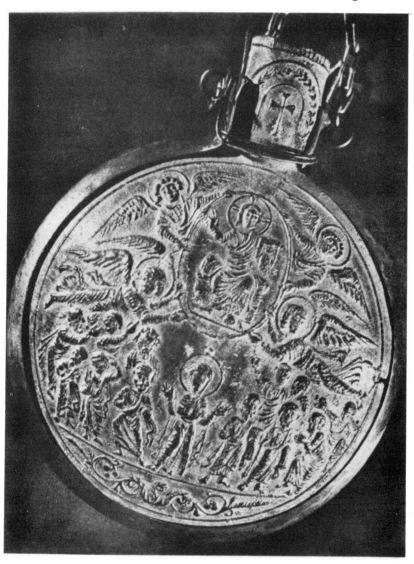

Fig. 110

the place of Our Lord's burial and eight above it.[81] The rotunda is surrounded by columns, with arches and lunettes. On two of the ampullae is shown an arched entrance, near which is a square object resembling the stone that was rolled away from the tomb in the mosaic of S. Apollinare Nuovo in Ravenna. Some pilgrims state that this stone was inside the rotunda, others that it was outside.[82]

The Ascension is also represented with greater or less complexity (Figs. 107, 110). There is no doubt that the dies are copied from each other, as shown by the repetition of postures, figures, and minor details; yet they are distinct from each other. The most striking difference is that whereas in some cases all the twelve apostles stand motionless in a row, six on each side of the Virgin, in others the same compositional technique is used as for the adoration of the Magi and shepherds, i.e., the apostles are arranged in superimposed rows of three, thus forming groups. In the latter case, the figures are distinguished by livelier poses: They converse, lift up their arms, or point upward. The aureole in which Christ is ascending is carried either by two or by four angels. In one case the Virgin is shown in profile, her face and arms lifted up. This is the prototype of the medieval composition of the Ascension. Christ, seated on a throne inside the aureole, makes a gesture of blessing with His right hand and holds the Gospel in His left. His face is sometimes youthful, sometimes "historical." On one interesting ampulla [83] the *mandorla* is carried by four angels, two of whom are shown in half figure. In the group to the left the Apostles Paul and Andrew can be recognized, the latter by his unruly hair. Under the aureole is the open hand of God, with rays of light emanating from it, and a descending dove. The beams of light and the dove apparently refer to the descent of the Holy Ghost, here combined with the Ascension. Both events are associated with the Mount of Olives and Mount Zion.

The baptism of Christ is represented only once (Fig. 107). The waters of the Jordan cover the body of the youthful Christ. John the Baptist and an angel are disposed symmetrically, each placing one foot on a rocky projection of the river bank. There is a little tree behind St. John, who is clad in a chiton and a himation that comes down below his knees. The angel holds a cloth

in both hands. All the figures are haloed. The Jordan is not personified.

The doubting of Thomas is also represented only once.[84] Christ is in the center, the apostles are grouped on either side of Him. The youthful Thomas approaches Christ from the left. Taking Thomas' hand, Christ pulls it towards His chest, while holding

Fig. 111

the Gospel in His right hand. The composition is distinguished by its complexity. On the sarcophagus of S. Celso in Milan, which we have already mentioned, Christ is shown raising His left hand, thus baring His side (Fig. 68).

The last composition encountered on the extant silver ampullae represents the Virgin and Child, seated on a throne, with an angel on each side (Fig. 111). The workmanship is very crude by comparison with the other ampullae. This is probably a reproduction of a revered image of the Virgin, many of which are known to have existed in Palestine, and especially in Bethlehem.[85] That the composition of this ampulla reproduces a specific type is indicated by its repetition on the Berlin diptych and in the mosaic of Kanakaria in Cyprus, published by Smirnov.

The crude die of the ampulla reproduces only the main lines of the composition. The Virgin holds the Child on her lap. We can see only the head of Christ with a cross-nimbus. His legs and torso, clearly visible on other ampullae, have here disappeared in the folds of the Virgin's garments. Although the Virgin is meant to be holding the Child, her hands are not visible. But for the position of the Child and the slanting struts of the throne, we might not have guessed that the Virgin was seated. The heads of the two angels are shown in profile, whereas their bodies are *en face*. The two round balls above the legs of the throne could be taken for globes held by the angels, were it not for the angel on the left, whose right hand is seen in front of his chest, among the folds of his garments. The dots over the angels' shoulders probably represent the tips of their staffs which do not show because of the poor impression of the die. In the Kanakaria mosaic the Virgin is shown in the same pose, and two angels holding staffs stand motionless beside her. In the mosaic of Panagia Angeloktistos at Kiti the movement of the angels towards the Virgin is portrayed in a manner very similar to that of the ampulla. The different shape of the throne and of the aureole in the Kanakaria mosaic does not substantially alter the basic type of this composition. The Berlin diptych shows the two angels behind the Virgin's throne, one of whom holds a globe.

The roughness of the die of this ampulla is matched by the illiteracy of the inscription: EMMANANOVHΛ MEΘ IMON Ω ΘΕΩC. The obverse shows a cross inside an arch supported by

two columns. This is encircled by a laurel garland and a band of stars.

We should note a few important traits in the execution of the ampullae. Their compositions are arranged according to the rules of symmetry and contrast. The flat relief maintains the traditions of two types of antique sculpture. On some of the ampullae, the compositions are executed pictorially. Thus, the Virgin's chair in the Annunciation and the more complex representations of the rotunda of the Holy Sepulcher are in perspective. In the scene of the Baptism, the river bank forms an uneven ledge. The body of Christ is seen through the waters of the Jordan. Figures are often composed in groups. On other ampullae, however, the compositions follow the rule of isocephaly, as in high relief. All the figures stand in a row, forming a frieze. The ground is occasionally represented by a thin strip.

The ampullae display representations of pastures and shepherds that call to mind Choricius' descriptions of pastoral scenes in an antique painting and in the mosaics of the church of St. Sergius at Gaza.[86] Such pastures with youthful and old shepherds and peacefully grazing flocks belong to the pastoral genre that was so popular in Byzantine art. Furthermore, the ampullae have medallion portraits of the apostles, an antique decoration consisting of volutes, and personifications of the sun and the moon with torches, which call to mind the personification of Night on Maximian's chair. In addition to these, we find laurel wreaths and bands of starry sky—motifs that were so popular in Christian wall paintings of the fourth and fifth centuries.[87] It is particularly interesting that both types of Christ are found on the ampullae, the youthful and the "historical." This, as we have seen, is also the case in the Rabula manuscript. Both these types are also found in the mosaics of S. Apollinare Nuovo in Ravenna.

The figures of the ampullae have lost their antique character and have become Oriental, although the nature of this change is rather difficult to evaluate, given the small size of the dies. The character of the faces is close to that of Sassanian coins. Particularly typical is the fixed gaze of the eyes marked by a large raised dot, as in the Ravenna diptych and in Syrian manuscripts. The small parallel folds of the garments on the sleeves and knees call to mind the tufa relief from Psamatia; such folds are also found

in later sculpture from Asia Minor and on the Salonica ambo.[88] This rendering of drapery is particularly marked on a sarcophagus at Konya representing a funeral banquet, kindly communicated to me by P. D. Pogodin (Fig. 112).[89] The motion and stance of the figures on the ampullae betray the weakness of their drawing. Figures moving to the right are often shown putting forward the right instead of the left foot (Figs. 107 and 108), a weakness we have already noted in the Rossano Gospel and in the Vienna Genesis, but not in the manuscript of Cosmas Indicopleustes or on Maximian's throne. The most curious trait is the representation of figures with faces in profile and torsoes in frontal view.

One can entertain no doubt as to the influence of Palestine and

Fig. 112

Asia Minor on the compositions and style of the ampullae. Their subjects must be connected with the dominant types of Palestinian iconography. Local details encountered on the ampullae— such as the cross, the rock of Golgotha, the rotunda of the Holy Sepulcher—indicate the historical character of Palestinian icon-

Fig. 113

ography. These traits became a permanent part of Byzantine iconography.

The ampullae from the Holy Land were disseminated all through the Christian world, carrying *eulogiae* from the holy places and representations of the most venerated shrines. Antoninus of Piacenza mentions the custom of distributing oil in such ampullae near Our Lord's Cross.[90] This is directly confirmed by the inscriptions on the ampullae, which mention the wood of the Holy Cross. The Patriarch Eutychius also received oil from

the True Cross.[91] The oil was consecrated by touching the wood of the Cross with the ampulla. Oil was also taken from the lamps that hung above the Holy Sepulcher.[92] Antoninus of Piacenza tells us that on Mount Sinai pilgrims received ampullae containing dew that was called "manna,"[93] but none of the Monza ampullae has any connection with Mount Sinai. During the blessing of the waters of the Jordan on the spot where Christ was baptized, Alexandrian sailors immersed in the river vessels filled with balsam and spices and used this holy water to sprinkle their ships.[94]

The clay ampulla of the cathedral of Monza (Fig. 113) suggests that in or near Nazareth pilgrims received the *eulogia* not in the form of oil, but of earth taken from the spring from which the Virgin was drawing water when the angel of the Annunciation appeared to her. Barbier de Montault and De Rossi both date this ampulla in the eighth century on the basis of the lettering.[95] The ampulla is filled with earth and dust which are called in the inscription *"eulogia* of the Virgin of the Rock." On the obverse is represented the Annunciation at the spring. To the right is the rock covered with vegetation, with a strip of water at the foot of it. The Virgin is kneeling in front of the spring, about to dip her pitcher into the water. Her head is turned to the left in the direction of the angel who is flying toward her, holding a staff in his hand. The words of the angel's greeting are inscribed under him. The figure of the angel is identical to the flying Victories of the Monza ampullae, and the figure of the Virgin is repeated in the same scene on the Adelfia sarcophagus at Syracuse, on the Milan diptych, and on the box in Count Saltykov's collection.[96] These works reproduce the Virgin's kneeling position and the shape of her pitcher. It is difficult to associate the ampulla with a specific place in the vicinity of Nazareth since the name of the rock cannot be distinctly read in the inscription.[97]

3. The round medallion published by G. Schlumberger may be regarded as a Palestinian work closely related to the ampullae (Fig. 114). It bears the inscription CTAVPE BOHΘI ABAMOVN.[98] On this medallion, as on several ampullae, two compositions are combined: The Crucifixion is shown above, the women at the Sepulcher below. The inscription beside the Crucifixion,

EMMANOVHΛ, gives the first word of the inscription widely used on ampullae: EMMANOVHΛ MEΘ HMΩN. Christ is clad in a chiton and a himation. His arms are bent at the elbows, and there is a nimbus around His head. This is an exact copy of the crucified Christ on the one ampulla that represents Him full-

Fig. 114

length in this scene.[99] On either side of Him are the two thieves. Their figures also duplicate the figures of the thieves on the ampullae. This is equally true of the two soldiers casting lots at the feet of Christ. The lower scene is also copied from the ampullae. The only difference is in the representation of the rotunda, which is higher than the one on the ampullae and has an arched roof instead of a cupola or a cone. However, like the structure on the ampullae, it has no plinth and preserves other characteristic details, such as the grillwork, the cross on the roof, and a circlet hanging from a cord inside the rotunda, i.e., the lamp of the Holy Sepulcher. The two women are on the left. The first carries a lamp suspended from a cord. Near the women is the inscription MAPIA (καὶ) MAPΘA. To the right an angel is seated on a rock (ΑΓΕΛΟC \overline{KV}).

On the basis of the Egyptian name "Abamoun," Schlumberger assumes that the medallion itself is Egyptian. However, the inscription directly refers to the True Cross, which was kept at Jerusalem in the basilica of Constantine. The close resemblance to the ampullae also prompts us to assign the medallion to Jerusalem. It must have been made before 614—before Chosroes invaded Palestine and carried away the Cross. The Egyptian name Abamoun, if it is indeed Egyptian, is obviously the name of the person who commissioned this medallion and can be easily accounted for by the relations between Egypt and Jerusalem. Egyptians annually took part in the festival of the Exaltation of the Holy Cross. In 505, Bishop John forbade them to participate in this festival, and as a result, disturbances took place in Alexandria.[100]

Nevertheless, we cannot doubt the kinship between Alexandrian and Syro-Palestinian iconography in the sixth century in view of the analogies that we have pointed out between the decoration of Syrian manuscripts and the so-called Coptic textiles, and the repetition of the same subjects on works of Syrian and Egyptian origin. Strzygowski does not even find it possible to differentiate between the style of ivories originating in Syria and in Egypt.[101] Indeed this close relationship between the art of Syria, Palestine, and Alexandria is corroborated by an amulet that was kindly communicated to me by E. M. Pridik (Fig. 115).[102] The place of origin of this amulet is unknown. It is carved as an intaglio, which shows that it was meant to be used as a seal. However, the inscriptions become reversed on the impression. It cannot be doubted that this amulet is of Gnostic Egyptian origin. It preserves the outline of a scarab seal, and both its representations and inscriptions are arranged in friezes as is customary on Egyptian scarabs, although most of the subjects are Christian. A nude genius with four wings, wearing a crown and a nimbus, is represented on one side. He appears to be bearded. He tramples underfoot two crocodiles which turn their heads in different directions, while in each hand he holds two scorpions by their tails. The movement of the figure and its outspread wings indicate a triumphal attitude. On either side are shown various magical signs, also found in Gnostic manuscripts. Below, under the inscription, stand two lions, jaws open, one

· 250 ·

paw raised, flanking a star consisting of two triangles. Above each lion is a crescent and a star. The figure of the genius may be compared to that of Horus on an Egyptian tablet published by Néroutsos-Bey.[103] This god is also represented nude, wearing a helmet-like crown similar to those of ancient Egyptians. He

Fig. 115

stands motionless on two crocodiles and in each of his lowered hands he holds two snakes, two scorpions, a lizard, a gazelle, and a lion. He does not have a nimbus nor any of the additional emblems depicted beside the head of the divinity on the amulet.

Two confronted lions are also found on the Byzantine amulets published by A. Sorlin-Dorigny and Schlumberger. They are shown on either side of an eye, a symbol very frequently represented on ancient Egyptian amulets and later on Coptic textiles. But the lions on these amulets stand on their hind legs, whereas their front legs are placed on the corners of the eye.[104] The star is also found on one of these amulets; it stands for the Seal of Solomon (CФPAΓIC COΛOMONOC), mentioned in the inscription of our amulet before the names of the archangels and of Sisinius. On the same Byzantine amulets we find the crescent with a star, a Gnostic sign, a scorpion, and a crocodile, but in other combinations than on the amulet published here.

The other side of the amulet shows various scenes from the

New Testament, most of which are familiar in the iconography of the fifth and sixth centuries. At the top is an aureole containing a bust of Christ. The ends of the cross project behind Christ's head, which is of the "historical" type and might have been copied from one of the ampullae of the Holy Land. The medallion is carried by four angels looking like Victories. These are an exact replica of the angels on some of the ampullae depicting the Ascension.[105] Above the aureole are eight-pointed stars not enclosed in a circle. They probably represent the heavens to which Christ is ascending. In the Rabula Gospel, on either side of the angels who are bearing the aureole, in the upper corners of the miniature are represented the personifications of the sun and the moon in the form of crowned human heads (Fig. 40). The amulet appears therefore to represent in an abridged manner the composition of the Ascension that is found on ampullae, but the latter do not display stars on either side of the aureole. A starry sky with a crescent is found on the Syrian plate discovered in the district of Perm.[106]

In the next register of the amulet we find the adoration of the Magi and the star appearing to the shepherds. The Virgin is represented in profile. The Magi are kneeling and are wearing cloaks as they do on one ampulla (Fig. 106) and on many other monuments, some of which are of unknown origin. There is an eight-pointed star over the Magi. This composition calls to mind the adoration of the Magi on two medals in the Vatican.[107] Two shepherds with straight staffs stand next to each other. Between them and the Magi are two ewes, one of which is lying down while the other is leaping. The figure of one of the shepherds, whose legs are crossed and who is leaning on his staff, also occurs on an encolpion from Adana in the Ottoman Museum,[108] in a mosaic of Sta. Maria Maggiore representing Moses in the pasture, and in a lost mosaic of the Lateran basilica.[109]

In the third register are represented the miracles of Christ. Some of the compositions are not yet known in Christian iconography, such as the first scene on the left, which appears to represent the blind man bathing his eyes in the spring of Siloam. The spring is represented as a brook flowing out of a little hill. A youth stretches out his hands towards it. In the Rossano Gospel quite a different composition is used to represent this miracle.

Next is a demoniac, clad in a tunic with his hands tied behind his back. His hair stands up on end. A small flying demon is seen on each side of his head. A similar figure of a demoniac occurs on the Ravenna diptych which is published below (Fig. 120) and in the Rabula Gospel.[110] Beside the demoniac is the woman with an issue of blood kneeling before Christ and grasping the end of His himation as she looks up at Him.[111] Christ has a cross-nimbus and holds a tall staff in His hand—a detail that does not occur elsewhere. Usually He is represented with either a scepter or a cross. Christ lifts up His right hand as He does on the encolpion from Adana. Another woman, shown to the right, is also kneeling and stretching out both hands towards the feet of Christ. She might be either one of the Myrophoroi, or Martha, the sister of Lazarus, or the woman taken in adultery. It is difficult to decide which one of these is represented here. Among the subjects he describes, Asterius of Amasia mentions the adulterous woman throwing herself at the feet of Christ.[112] Next comes Zacchaeus sitting on a tree, a scene found only on the Trivulzio diptych.[113] Then comes the paralytic carrying his own bed. The last figure in the register seems to represent the demoniac after he has been healed. He is depicted in a similar fashion on the Adana encolpion (Fig. 70), where this scene also follows that of the woman with an issue of blood and the paralytic, just as on the amulet. The demoniac stands with legs akimbo and arms hanging down. Thus, the figures of the various afflicted persons are grouped on either side of Christ, who stands in the middle.

In the lowest portion of the amulet, Christ is shown betrothing a bridegroom to his bride within a structure supported by two spirally fluted columns. This subject occurs on Roman reliefs and on coins with the inscription *concordia;*[114] the amulet represents it in a modified manner. Christ occupies the place of "Juno Pronuba" or of the "Pontifex." In Christian Roman reliefs this place is taken by a young man; on a mosaic of Sta. Maria Maggiore, Jethro, clad in a tunic, unites Moses and Zipporah in wedlock. But it is only in a few Eastern works that one can find a complete analogy to the composition on the amulet. On a ring from Tarsus, Christ is represented between the bride and the bridegroom laying His hands upon their shoulders. A be-

trothal is also represented on a plaque from a gold necklace found in Beirut. The inscriptions VΓIENOVCA ΦΩPI ("wear it in good health") and ΘEOV XAPIC show that the necklace was meant to be a wedding gift. Kondakov dates this object in the sixth or seventh century and considers it to be of Syrian workmanship.[115] A Byzantine ring from Palermo presents an analogous nuptial subject.[116] On the amulet under discussion the bride and groom hold out their hands to each other. On one side of the structure are five amphoras, on the other several loaves and two fishes—a reference to the feast of Cana and to the feeding of the people in the wilderness. The presence of the betrothal scene amid the miracles of the New Testament indicates that this amulet, like the Beirut necklace, was meant to be used in connection with a marriage.

The inscription on the amulet is a prayer to ward off every kind of evil, which explains the abundance of miraculous healings represented. It is not clear how the adoration of the Magi and the star of the shepherds are related to the purpose of the amulet. However, one of the Byzantine amulets mentioned above depicts the adoration of the Magi.[117] This scene is also found on two medals in the Vatican, one of which has a little hole and the other a loop so they could be worn round the neck. These medals[118] do not present the distinctive features of amulets. They were apparently used as little icons to be worn on one's person. The medals and the amulet date from about the same period. There are other similar medallions from Reggio, Achmim, and Rome.[119]

These analogies make it clear that the amulet is akin to certain works of Syro-Palestinian origin. Thus we may conclude that a fully developed Eastern iconography was taken over by Egyptian art. What is of particular importance in this amulet is the resemblance of Christ's face to that of the ampullae and of the Rabula Gospel. In all three cases we find abundant hair rising over a narrow forehead and a wide beard. The ugly character of the execution is similar to that of carved ivories of African and Syrian origin: Note the hunched, unnaturally shortened figures, the feet placed in such a way that the toe of one foot points to the heel of the other, the angular arms and legs. The eyes are indicated by means of raised dots. The ugly profiles of

the faces resemble those of Coptic textiles. The only detail that indicates some measure of skill on the part of the craftsman is the figure of the genius which is executed in delicate low relief. The outline of this figure blends softly with the background, and the relief is raised slightly to mark the knees, the abdomen,

Fig. 116

and the muscles of the chest and arms. The figure is well-proportioned, but somewhat heavy. We can hardly be mistaken in dating the amulet in the sixth century.

4. Several other monuments indicate the wide dissemination of the original compositions first created in Palestine. Such is a stone mausoleum decorated with frescoes discovered in Sofia, Bulgaria. It is a chamber of moderate size, covered with a barrel vault.[120] In the vault is painted a large cross, ornamented with precious stones, within a light blue circle intersected by four

rays. Under the vault, on the lunette of the western wall, which is bordered by a wide brown stripe, are three crosses (Fig. 116). The central one is taller and wider than the other two. It is inscribed in a circle consisting of three concentric bands of light blue, becoming gradually lighter as they approach the center. Four rays extend from the center to the rim of the circle. The background is white. All three crosses have flaring arms and are decorated with teardrops. The central cross is ornamented with rows of rectangular and oval precious stones alternating with pearls. The cross in the center is brown, the other two are red.

This interesting composition is encountered on a great number of Eastern and Western monuments. Groups of three crosses are often found on the sarcophagi of Ravenna and Milan,[121] but with the difference that they have no halo. They represent the three crosses discovered by St. Helena in Jerusalem. Arculf's drawings show them standing side by side on the spot where they were found in the basilica of Constantine.[122] These same crosses are also depicted on the ampullae, but only the middle one stands free on the rock of Golgotha; on the others are the two crucified thieves. The Sofia fresco does not show the rock of Golgotha. The three crosses stand over a straight line. The halo surrounding the central cross may be explained by a legend relating the invention of the Holy Cross. After the discovery of the three crosses, Bishop Cyriacus [sic] stood on Golgotha and, lifting up his arms, prayed for a sign that would tell him which was the True Cross. The sign was vouchsafed to him and was witnessed by all those present who saw "the brilliance of a lightning flash and the nails glistening like gold." [123] Later sources allege that the crosses of the two thieves were in the Forum of Constantine in Constantinople.[124] Two small crosses on either side of a big one are depicted in the paintings of a catacomb discovered by J. M. Vansleb in the Thebaid.[125] This catacomb has been dated in the sixth century. Smirnov describes a carved stone with a Pehlevi inscription in the British Museum, which depicts in a conventional manner Golgotha with the three crosses.[126] On an unpublished marble slab of the Ravenna National Museum (No. 421) are three crosses very similar to the ones in Sofia, but without the halo and rays. Three crosses stand behind the altar of the Temple in the scene of the Presentation

in a miniature in the Latin MS No. 9448 of the Bibliothèque Nationale.[127]

The central cross of the Sofia fresco is particularly close to the haloed cross in the apse of S. Apollinare in Classe, which leads us to think that these two representations were made under the influence of Constantinopolitan art, in which similar crosses, reproducing the shape of the Golgotha cross, are frequently found.

On the other hand, the Syrian plate found in the district of Perm (Fig. 117) testifies to the dissemination of Palestinian com-

Fig. 117

positions in those parts of Syria that were under the influence of Sassanian art. The compositions on this plate bear a close relation to the subjects represented on the ampullae from the Holy Land. N. V. Pokrovskii believes that it was precisely from this kind of source that the compositions on the plate were copied.[128] This is quite probable, all the more so since both the plate and the ampullae are made of silver. The plate is decorated with three medallions, which brings to mind the arrangement of seven medallions on the large ampulla (Fig. 107). In the medallions are represented the Crucifixion, the Resurrection, and the Ascension, i.e., the scenes most frequently found on the ampullae.

In the Ascension we see once more the apostles standing in a row—six on the right and six on the left—and four angels. Christ is of the youthful type, without a moustache, but with dots on His chin indicating a slight growth of hair. He holds the Gospel on His chest with both hands: This detail is not found on the ampullae. In the Resurrection the two women are once more represented to the left of the rotunda of the Holy Sepulcher and the angel to the right of it. Inside the rotunda a cross stands above a lattice.[129] A cross inside the Holy Sepulcher is also represented on the ampullae, but it is on the roof of the inner rotunda. This roof is omitted on the plate, and the lattice is represented by oblique intersecting lines. The semicircular lunette which on the ampullae appears above the arches [130] is also maintained on the plate. The angel, however, is standing instead of being seated, whereas the two women seem to be sitting.

The Crucifixion bears a close resemblance to the composition on the only ampulla showing Christ on the cross, which we have described above, but it is more complex. We see here the same uneven outline of the rock of Golgotha and the same disparity between the small figures of the thieves and the large figure of Christ. Christ is once more represented as a youth, with dots on His chin. A soldier stands on either side of Christ, and one of them extends to Him a vessel on the tip of his lance. The other appears to be Longinus, as indicated by his sword and by the open palm of his right hand, a gesture characteristic of Longinus. The thieves are bearded. The soldiers casting lots at the foot of the cross reproduce very closely the figures on the

ampullae. The shape of the crosses, with transverse bars for the feet, indicates a later type of Crucifixion than the one found on the ampullae and in the Rabula Gospel. This footboard occurs on an Egyptian textile published by Forrer. This textile shows evident traces of Arab influence and must be dated in the seventh century, if not later. Neither Longinus nor the soldier offering a drink to Christ is found on the ampullae.

In the corners between the medallions are represented Daniel in the lions' den, two squatting soldiers, and St. Peter with the cock. The two soldiers are next to the medallion with the Resurrection. They stand for the guard of the Sepulcher. It is interesting to note that the rooster represented with St. Peter is placed not on a column, but on the ground. This detail may be compared to the representation of the rooster among the branches of a bush on a Caucasian slab from the Voronov estate, a slab that is stylistically close to the Syrian plate.

This plate offers an instructive example of the modification of Greek models under the influence of the Persian style. In the decoration of our plate this style has become crude and has lost its sharpness and expressiveness, but it has preserved its most characteristic traits. The relief, impressed by a die, is very low and flat. Beards and hair are expressed by means of little circles which distantly reproduce the curly hair of Sassanian reliefs and silver plates. Dots and circles also enliven the garments and adorn the edifice of the Holy Sepulcher. The wide pointed beards are sharply set off from the cheeks. The hair on the back of the angels' and soldiers' heads is reminiscent of the Assyrian coiffure. The rows of figures in the Ascension bring to mind Assyrian reliefs: The body is seen *en face,* the head in profile, but the long slanted eye is also *en face.* The soldiers have maces and squat in the Eastern manner. All the figures are clad in wide-skirted, tight-sleeved caftans similar to those worn by kings and hunters on Sassanian plates.[131] The type of beardless head is closely reproduced in that of a Persian hunter on a silver plate in the Hermitage.[132] The lions on either side of Daniel remind us of the lioness on a relief of Ashurbanipal's palace, whereas the angels resemble the harpies on the monument of the harpies at Xanthus in Lycia, as has been pointed out by Smirnov.

Caucasian stone reliefs present similar traits of a debased

Sassanian style (Fig. 118).¹³³ Like the plate, they copy Byzantine compositions, but their iconography is of a later date, approximately of the sixth to the eighth centuries. The Crucifixion, as represented on them, is similar in some respects to the compositions on the ampullae. The arms of the thieves are looped over the transverse bars of the crosses and tied over their chests. The thieves, who are smaller than Christ, are dressed in the same manner as on the ampullae. The Resurrection differs from early prototypes. Instead of the rotunda of the Holy Sepulcher, the tomb itself is represented. Two soldiers lie prostrate on the ground; a third is standing. Two Myrophoroi, holding vases, approach the angel who is seated on a stone. The denial of Peter is represented in an unusual way: Peter covers his face with his hands and weeps, a composition that is seldom found in Byzantine iconography. The sacrifice of Isaac includes a boy who is holding a mule by its bridle. The Baptism has two angels, and John stands next to a big rock. In the lower frieze is the vision St. Eustace saw while hunting. The general disposition of these subjects is the same as on Syrian and Alexandrian diptychs of the fifth and sixth centuries. In the center is a large rectangle, divided into two parts as on the Ravenna diptych. It is bordered by a wide frame of leaves. The sides are occupied by smaller rectangles, while an oblong frieze fills the lower section. On another carved slab a similar frieze representing SS. George and Demetrius on horseback fills the upper section, too. The decoration is also copied from diptychs. The style, however, is debased Sassanian. The faces seen in profile, while the eyes are *en face,* and the wide beards recall Sassanian reliefs and the Syrian plates we have just examined. Here, too, human bodies have the appearance of flattened chunks. The little circles enclosing a dot that we have pointed out on the Syrian plate are seen here on the garments of the angel and of the youth with uplifted hands (in the lower frieze of the first relief). The two soldiers who are crucifying the Apostle Peter (?) wear the same kind of wide-skirted, belted caftan as the soldiers on the Syrian plate. In both cases they are bareheaded. St. Eustace is depicted in the guise of a Sassanian king, with a bow and a headgear with streamers. In spite of the later date of the two stone reliefs, their style is so close to that of the Syrian plate that all three works must have

originated in neighboring localities where the tradition of Sassanian art had been preserved. The Syrian inscriptions of the plate suggest that this object might have been made in the region of Syria bordering on Armenia or Persarmenia, which is close to the Caucasus. We may suppose that this plate found its way

Fig. 118

across the Caucasus to the banks of the Volga, since it does not bear Byzantine customs stamps. The Caucasian reliefs cannot, in any case, be much later than the Syrian plate.

Another plate, in the collection of Count G. S. Stroganov in Rome, may be said to be the most elegant specimen of Syrian Christian art. It portrays two angels standing on either side of a cross (Fig. 119). This plate is distinguished by a more artistic execution, a stricter adherence to Sassanian style, and a more faithful reproduction of the Greek model. The heads of the two angels with their abundant hair, while they reproduce the antique type of angel, nevertheless present certain Sassanian traits, such as the big, sharply delineated eyes with a dot in the middle and the line of the nose and cheeks. The fluttering hems of the garments can also be seen on numerous silver vessels of Sassanian or Indo-Persian workmanship. The ground on which the angels and the cross stand has an uneven surface, executed in a pictorial manner. The four rivers of paradise flow out of the ground. The same kind of ground with the four rivers of paradise is repeated on a Carthaginian pyxis, on which, however, a youthful Christ is represented instead of angels.[134]

The cross stands on a sphere. The shape of this cross is reproduced in a relief above the entrance of the church of the Assumption of the Virgin at Gemlik, near Broussa. The latter cross is also set on a sphere, on which is carved the word *nikos* in a monogram. This epithet was often applied to crosses in general and in particular to the crosses erected by Constantine the Great in certain public squares of Constantinople, as has been rightly pointed out by O. Wulff.[135] One of these crosses was flanked by statues of Constantine, Helena, and two angels.[136] On Count Stroganov's plate the sphere is decorated with stars. The representation of a sacred monument of Constantinople on an object of Sassanian style should not surprise us, since the capital exerted a considerable influence on Syria and Palestine. Dishes of this kind give us a glimpse of the style used by those silversmiths who are occasionally mentioned in the East. For example, the silversmith Mocianus (Μωκιανὸς ἀργυροτέχνης) is commemorated on a funeral stele at Heraclea (Perinthus); the monogram of Christ, in a wreath, shows that he was a Christian. The inscription also mentions the name of his father (Προβολίου),

who was presumably also a silversmith.[137] St. Athanasius, by
birth a Persian called Magundat, was a silversmith at Hierapolis.
He worked for a Christian silversmith at Antioch, received from
him his first instruction in the Christian faith, and was baptized
by Modestus, the restorer of the holy places.[138]

The debased Sassanian style is also found in ivories. The frag-
ment of a pyxis, in A. S. Novikov's collection at Kerch, belongs
to the same group of works as the Syrian plate. Once again we
find here the same type of figure, the abundance of hair on the

Fig. 119

back of the head, and a wide beard on the priest who offers the water of ordeal to the Virgin. Hair and beard are represented by dots. The sharp noses and round eyes are a legacy from the same style. We may compare the fluttering hems of the Virgin's garments to the angels' garments on Count Stroganov's plate. Only two scenes are preserved on the pyxis, the Annunciation with an angel flying down and the trial by water.[139]

5. In addition to the Syrian manuscripts examined above, the Ravenna diptych, previously kept at Murano, is of extreme importance for defining the characteristics of Syrian art (Fig. 120). Different parts of the missing second leaf of this diptych have been found in the collections of Count Stroganov in Rome (Fig. 121), of the Earl of Crawford near London (Fig. 122), and of M. P. Botkin in St. Petersburg.[140] The distinctive style of these widely scattered fragments have made it possible to piece them together and to reconstitute sufficiently well the aspect and subject matter of the entire monument. The style of this diptych stands in sharp contrast to that of Maximian's chair. This difference is important because of the numerous similarities among details of both works, which indicate common iconographic sources and even certain fundamental stylistic features that are shared by both monuments. On the Ravenna diptych the human figure is lean and has angular knees and elbows. When placed in a narrow frieze it has normal proportions, but in most cases it is considerably elongated, and its torso and legs are narrowed. Given this elongation, the head appears small. The heads are round and have almost square chins. The special quality of these faces consists in the fact that their eyes almost always gaze upward, and sometimes squint, as do those of the figures on either side of Christ (Fig. 120). This harsh, squinting gaze reminds us of Syrian manuscripts in which the pupil of the eye is indicated by a black dot. The same detail is also found on a number of pyxides of unknown origin. Curiously enough, the same facial characteristics can also be seen on the fragment of a pyxis discovered in 1893 in the Ozerukov tumulus, together with a coin of Chosroes I Anushirvan (543). The elegant carving of this pyxis is executed in rather high relief. Only part of a composition depicting Christ's entrance into Jerusalem has been preserved

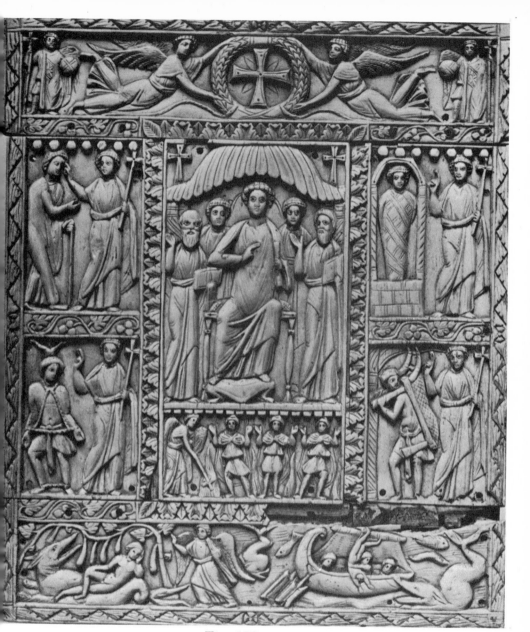

Fig. 120

(Fig. 123). To the right we can see the tail and a hoof of the ass stepping onto a rug decorated with transverse lines. Next to the ass a bald middle-aged man walks towards the right, clad in a chiton and a himation, holding a long narrow book. His figure bears a strong resemblance to that of Joseph as an old

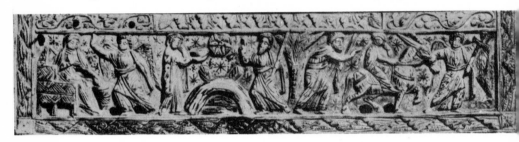

Fig. 121

man on the Ravenna diptych, and is also reminiscent of the type of bald head found on Maximian's throne (Fig. 75). Two youths walk beside him, holding branches. The head of the first of these is almost identical to that of the angel leading a mule in the lower frieze of the second leaf of the Ravenna diptych (Fig. 121): It has the same gaze, directed upward, the same thickened lower eyelid, the same incised dot to indicate the pupil, and the same kind of hair, made to look like a net by means of crosshatching.[141] On the plaque belonging to the Earl of Crawford (Fig. 122),[142] we should note the figures of the Magi and the enthroned Virgin who is considerably larger than the other figures. The wide oval shape of her face, the sharply outlined eyes, the broad line of the nose and eyebrows are reminiscent of those heads on the Syrian plate which are represented *en face.* The Magi's faces, with their eyes shown *en face* and their pronounced Oriental expression, remind us of the figures of the apostles on the same plate and of Persian reliefs in general, especially in the stance of the feet. It is only by comparing such monuments that we can become fully convinced that this characteristic which became an attribute of Byzantine art was borrowed from the Orient, i.e., from Persia and Syria. The Magi are depicted in profile. They take short steps, exactly as do the figures on Assyrian and Persian reliefs which are shown advancing against each other. Their unstable—one might say timid—stride results

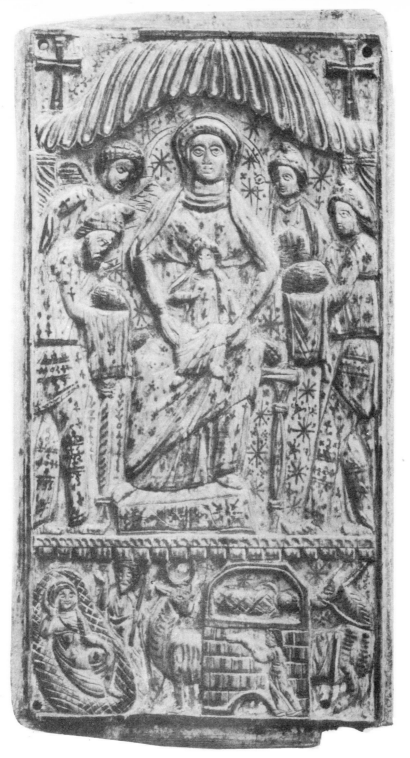

Fig. 122

from the fact that the arch of the foot is pressed flat against the ground and the foot is depicted in full side view, hence the toe of one foot points directly at the heel of the other. As in the reliefs of Persepolis and Pasargadae, the figures of the Magi display an inability to foreshorten the shoulders, the torso being shown in a three-quarter view, whereas the legs are in full profile.[143] The flat relief of the Ravenna diptych is also in keeping with Assyrian and Persian reliefs. It is interesting to compare the head of the ox in the Nativity scene to an Assyrian or Chaldean bronze in the British Museum: In both cases the outlines of the forehead, the horns, and the entire head are identical.[144]

The admixture of Persian style in the Ravenna diptych is, however, less pronounced than in the Syrian plate. This style is superimposed on the antique form of the ornament, the garments, and the figures which are derived from the plastic art of ancient Greece.

The cycle of subjects depicted on the Ravenna diptych is connected with Eastern iconography. We have here representations of miracles known to us partly from the amulet we have examined, partly from other works of Egyptian or Palestinian origin. Jonah lying on the whale's back occurs on a small Carthaginian lamp and on a pyxis from the Basilevskii collection in the Hermitage.[145] The raising of Lazarus is identical to the representation of this scene on a comb from Antinoë.[146] The adoration of the Magi is taken from the same model as the Syrian miniature in the Etschmiadzin Gospel. The Virgin and Child is very close to the type found on the Monza ampullae. The Nativity includes details found on the leaf of a sixth-century triptych, brought from Egypt by V. S. Golenishchev, as well as in the mosaics of the church of St. Sergius at Gaza, as described by Choricius. The Annunciation, the Nativity, the trial by water, and the journey to Bethlehem are all based on the Apocrypha. The small crosses on either side of ciboria are exact duplicates of the crosses of the Crucifixion on the ampullae.[147]

Maximian's chair and the Ravenna diptych, in spite of the many differences in the execution of figures that we have just indicated, nonetheless display a kinship in that they both contain certain traits of Persian or Sassanian style. As Count I. I. Tolstoi and N. P. Kondakov put it, "one is instinctively driven to estab-

lish a close but undemonstrated relationship between, on one hand, the overloaded style, heavy figures, and massive arms and legs found on the diptychs and the reliefs of Maximian's throne, and, on the other hand, Sassanian plates and antiquities dating from Parthian times." [148] This relationship is indeed con-

Fig. 123

firmed by certain peculiarities of the sculptures on Maximian's throne. In addition to the characteristics enumerated above, it is important to note the conspicuous muscles, the often shortened arms and legs, and the Oriental features. The figures of barbarians are typical in this respect (Fig. 80). As regards their costume and physical type, one may compare them to the Magi of the Ravenna diptych (Fig. 122) and the Assyrians in the manuscript of Cosmas Indicopleustes (Fig. 16), but in execution they greatly surpass the latter. The barbarians' features are so lifelike that one cannot help but think that their types were so portrayed intentionally, as was pointed out by Molinier, who took them for Ethiopians. It is, however, difficult to say who

· 269 ·

these barbarians are. Similar physical types are represented on saddlery of the Völkerwanderung era.[149] We can therefore assume that they were as well known in Byzantium as in Alexandria. Long straight hair and wide beards are found among Scythian and Sarmatian tribes; furthermore, the same facial types, though crudely represented, occur in almost all of the male figures on the Caucasian stone reliefs that we have described above.

Joseph, surrounded by his guard (Fig. 80), wears a tiara or crown of a kind also found on the Persepolis reliefs. A similar crown, though not as high, can be seen on the head of a statuette of a Persian king from the Oxus treasure.[150] The statuette has very short arms and the same long caftan that we have noted on the Syrian plate found in the region of Perm (Fig. 117).

Moreover, certain figures of Maximian's throne display the same awkwardly bent forearm and thick hand as the Broussa statuette of the Good Shepherd (Fig. 104). This defect is particularly noticeable in the figure of the angel leading a mule, in the scene of the journey to Bethlehem. The twisted arms of some figures in the Rabula Gospel and the arm of the angel with a staff on the Syrian plate (Fig. 117) present an analogy to this feature of Maximian's chair. The figure of St. Mark (Fig. 78) with his head in a three-quarters view, his torso *en face,* his knees in profile, and the toe of one foot pointing towards the heel of the other, is as close to figures on Assyrian, Persian,[151] or archaic Greek reliefs as the figures of the Magi on the Ravenna diptych or Isaac's figure on the tufa slab from Psamatia.

The decoration of the front of the chair, which has so much in common with the marble column in Constantinople, is reproduced exactly in the lower portion of a triangle or pediment on the wall of a palace erected by Chosroes II at M'shatta,[152] near the mouth of the Jordan. In both instances, we find lions placed on either side of a wide, squat cantharus from which there emerges a grapevine which spreads on both sides and curls around the lions' tails. The vine has clusters of grapes, and there are birds perching within it. The general character of this ornamentation, which fills the entire space available with openwork carving, is the same in both monuments. The same type of ornament is also found on Coptic reliefs in the Gizeh Museum.[153]

The peacocks in the coils of the grapevine are compared by Molinier to a similar motif on the reliefs of Dana, in Syria, and on Coptic textiles.[154]

Comparing all the works we have examined, we discern in them a general stylistic kinship. The angularity of the figures, their gait, which is similar to that of archaic Greek figures, and their physical type, which is far removed from that of classical antiquity, bespeak an artistic decline resulting from the modification of Greek models under the influence of Oriental styles and techniques that clung to their Assyrian and Persian inheritance. The admixture of Persian and Sassanian styles in Byzantine works of art may be explained on the assumption that some of them were made by Persian artists copying Greek models, artists such as Magundat whom we have mentioned. The reproduction on the Syrian plate of compositions taken from the Palestinian ampullae may be compared to the copying of a miraculous icon of the Virgin and Child by an artist whom King Phraates IV of Parthia sent for this purpose to Bethlehem. The story is told by Nicephorus Callistus and by Georgius Hamartolus.[155] The Oriental characteristics of the monuments of Constantinople may be likewise explained by the presence of Persian and Syrian artists in the Eastern capital.[156]

The relative freshness of the antique tradition in the reliefs on Maximian's chair allows us to assume that they were done by Alexandrian or Constantinopolitan craftsmen. It is known that Bishop Maximian visited both of these cities.[157] The Ravenna diptych, on the other hand, points to Syria or Palestine and to a close contact with the art of Persia. The Oriental features of the figures in the manuscript of Cosmas Indicopleustes, which are so closely related to those on Maximian's chair, can also be explained by Syrian artistic influence.

Historical documents confirm the developed state of wood and ivory carving in the East. In his description of the basilica of Tyre, erected by Bishop Paulinus in the reign of Constantine the Great, Eusebius mentions carving of cedarwood for the decoration of the windows and of the whole church. He also speaks of a carved wooden grille that aroused the admiration of all who saw it.[158] Gregory of Nyssa cites "the likeness of animals" made by a carver for a church of St. Theodore.[159] At Cyrrhus in Syria, the

wood carver Gerontius was famous for his representations of animals and trees.[160] We also know from Choricius' descriptions, that wood carvings were widely used in the churches of SS. Stephen and Sergius at Gaza, not only to decorate the cupola, but also to form baskets (καλαθίσκοι) on the ceiling.[161] Three cathedrae are mentioned in Constantine's basilica in Jerusalem; two of these were magnificently decorated with different metals, while the third was of plain cedar wood.[162] According to Joannes Biclarensis, tusks of elephants were brought around A.D. 573 to Constantinople as a gift to Justin II.[163]

6. The extensive building program undertaken in Syria and Palestine by Constantine the Great led to a flowering of Christian art, a flowering that continued in the subsequent period.[164] We may quote here the mosaics of the Sinai monastery and the floor mosaic of Madaba, both of which presumably belong to the time of Justinian.

The Sinai mosaics are especially important in that they display the same features of monumental painting that we find in contemporary churches in Ravenna, Rome, and Cyprus.[165] The interior of the apse is occupied by a monumental Transfiguration (Fig. 124). The soffit of the arch is decorated with portrait medallions of the apostles. Under the Transfiguration is a series of medallions with representations of the prophets. On the wall above the apse are mosaics that are either new or perhaps restored, representing Moses on Horeb and Sinai. Over the center of the triumphal arch are two flying angels, also restored, each holding a globe with a cross.

Gold and silver as well as light and dark blue predominate in this mosaic. Christ's halo is silver; the cross of the halo is gold; silver rays emanate from a *mandorla* consisting of three bands— dark blue, medium blue, and light blue respectively. The stripes on Christ's white chiton are gold. The medallions have silver backgrounds.

Christ's abundant auburn hair is piled high over his narrow forehead, a feature we have noted in Syrian manuscripts, on the ampullae, and on the Egyptian amulet. The image of Christ in the Rossano Gospel presents at times an extraordinary resemblance to that of the Sinai mosaic, a resemblance that is height-

ened by the long, unforked beard. The same type was also used in the mosaic of the arch of S. Apollinare in Classe in Ravenna [166] and in the apse of SS. Cosma e Damiano in Rome. Kondakov has pointed out the similarity of this type to the Syrian one found in the Rabula Gospel and to the Byzantine one in the ninth-century Chludov Psalter.[167]

Fig. 124

The composition of the Transfiguration is symmetrically constructed. An aureole surrounds the figure of Christ in the center, and Moses and Elijah stand on either side of him. Underneath, on a strip of ground, are three apostles: in the center, Peter prostrated on the ground; on either side, James and John on their knees, facing away from each other.

In the sixteenth century, Paisios Hagiopolites (1577-1592) saw the Sinai mosaics and described them quite thoroughly. He mentions the representations of the prophets over the conch, but says nothing of Moses on Horeb and Sinai. He also describes

the Transfiguration in the apse, the apostles inside the arch, and the marble facing of the lower portion of the apse.[168]

The floor mosaic discovered at Madaba, in the ruins of a church of the Virgin, depicts a map of Palestine (Fig. 125). Its technique is the same as that of the fifth- and sixth-century wall mosaics. The tesserae are set in regular rows to provide even backgrounds that easily shade into half tones, as has already been noted by M.-J. Lagrange, the first investigator of this mosaic.[169] The cubes are tiny, as in wall mosaics, but oblong tesserae are used in some places, e.g., for the columns of the different buildings that are represented. This may be compared to the use of large, round or oblong tesserae in the gem-studded garments of Justinian and Theodora in the famous panels of S. Vitale in Ravenna and in other ornamental motifs of the fifth and sixth-century mosaics.

The most important feature of the Madaba mosaic is its landscape quality. The Dead Sea is shown in light blue, with ripples: A ship sails over it, its sails furled on top of the mast; another boat sails alongside. Sailors are represented in both vessels. Fish are shown swimming in the rivers. Palm trees and cactus shrubs grow in the desert. There is a panther pursuing a doe, just as in Pompeian hunting scenes. Mountains extend in uneven rocky ridges. Cities and small towns are shown with their walls, gates, towers, and most famous buildings. Bethlehem is shown with the basilica of the Nativity but without walls; Jerusalem with its long porticoes, a public square, a high tower, and gates, whose names are indicated in the inscriptions. On the other hand, rivers, seas, and trees are represented on a flat surface without perspective. There is no strip of sky above; hence all the representations on the map are given, as it were, in a bird's-eye view.

Cities and buildings are placed in horizontal lines as in landscape painting. Thus they are oriented not with respect to the cardinal points, but with respect to the viewer: This is the most striking feature of the mosaic map. The viewer sees the different towns with their buildings, usually shown in front view, as in a landscape painting and not in ground plan, as would be the case on a map.

Because of its landscape character, Peutinger's map greatly resembles the Madaba mosaic. Neither of them has lines for longi-

Fig. 125

tude and latitude, although such lines were used in the maps of Ptolemy's *Geography* which we have already discussed. Peutinger's map, which is supposed to be a copy of the *orbis pictus* of Augustus, nevertheless consists of a series of oblong maps, whereas we may assume that the *orbis pictus* was circular; the latter must also have included landscape features. The existence of such maps in ancient times is confirmed by the statement that a map of Ethiopia, which was presented to Nero, depicted various kinds of palm and ebony trees. The map of the universe commissioned by Theodosius II (408-450) abounded in representations of mountains, bodies of water, harbors, bays, and cities.[170]

Medieval maps inherited the landscape character of ancient Greek and Roman maps. Miller has pointed out the important fact that the Madaba map is distinguished by a striking wealth of varied representations, which is as typical of ancient maps as it is of medieval ones.[171]

Landscape painting, as a genre, developed most fully in Alexandria. The Alexandrian painter Demetrius, called *topographos*, worked in Rome; Brunn considers him to have been a mapmaker, while Helbig takes him for a landscape painter.[172]

The Madaba mosaic attests to the landscape character of Byzantine cartography. The well-known map of the earth of Cosmas Indicopleustes only partly preserves this characteristic of ancient maps (Fig. 22). On this map the earth is yellow, the ocean that surrounds it is bright blue. Neither cities nor animals are represented, on account of the small scale. Paradise, however, is represented by a row of blossoming trees. The rectangular shape of this map is due to the fact that it represents the base of the Tabernacle, which Cosmas takes to be the model of the universe. The four winds, depicted as human busts in medallions, are placed next to the earth on the band representing the ocean. The small maps of the earth found in Psalters, although derived from the map of Cosmas Indicopleustes, are more clearly marked by the features of landscape painting.

In the Barberini Psalter, No. 372, of the eleventh century (Fig. 126), a similar map is decorated by two rows of trees. The earth is green, the ocean light blue. The four winds, in the corners of the map, are blowing into horns, as they do in Cosmas' manuscript. In the Vatican Octateuch, No. 746, the earth is portrayed

as a semicircular island, with the ocean flowing around it (Fig. 127). The waters of the ocean are blue and white; the earth is green and is covered with trees, flowers, and bushes. The winds are absent. In the same Octateuch there is a curious representation of Paradise (Fig. 128) in the shape of a square edged with red,

Fig. 126

with a lily blossom at each corner. Here, too, the earth is bright green; the waters of the lake are blue, with white highlights that denote currents. The four rivers of Paradise flow out of the lake across the entire square. The Tree of Life is in the middle surrounded by green bushes, trees, and flowers. The character of a map is preserved in the square shape, the absence of sky, and the bird's-eye view representation of rivers and trees.

The map of the land of Pharan, in the Latin Pentateuch, No. 2334, of the Bibliothèque Nationale, fol. 50, is also represented in the shape of an elongated rectangle. The earth is green; flowers and trees with wide branches grow on it. The rectangle is en-

closed within a wide frame. In the miniature representing the creation of the earth there is an elongated rectangle, evenly colored, with the inscription *terra*.[173]

On the basis of an inscription discovered in a cistern near the Madaba church, one is led to believe that the mosaic, as well

Fig. 127

as the cistern itself, date from the reign of Justinian. Héron de Villefosse is of the same opinion.[174] We may recall in this connection that between 530 and 565 Justinian sent the architect Theodore with a number of assistants to Palestine in order to erect new buildings and restore many old ones. Theodore seems to have been very active and to have covered a large territory. He began by undertaking various major enterprises in Jerusalem, then moved to the vicinity of Jerusalem and of the Jordan, then to Diospolis, Mount Garizim, Neapolis, and Mount Sinai.[175] The list of his works does not include either the church or the cistern at Madaba.[176] It does, however, mention the fortress and the

monastery on Mount Sinai. One of the inscriptions on the Sinai mosaics, at the right-hand end of the frieze of prophets, names the presbyter Theodore who, according to Bishop Porphirii Uspenskii, completed the mosaic in the twenty-fourth year of Justinian's reign, i.e., in 551. But there is no evidence that would allow us to identify Theodore the architect with the presbyter of the inscription. In Kondakov's opinion the mosaic dates not from the middle of the sixth century, but, at the earliest, from the beginning of the seventh.[177]

The inscription discovered in the cistern near the church of the Virgin at Madaba alludes indirectly to Justinian's masters.

Fig. 128

Conclusion

When we speak of the antique foundations of Byzantine art, we have in mind the art of Alexandria, Palestine, Syria, and Asia Minor—places which from early times had assimilated the culture and art of Greece. The general character of Byzantine art is reflected clearly enough in the copies of Alexandrian manuscripts, in the antique features displayed by Syrian manuscripts, in the traditions of pictorial relief, and in both the general composition and the specific traits of monumental painting, which hark back to antiquity. Each of these domains retained numerous distinctive characteristics of the art that flourished during the Hellenistic era and later under the Roman Empire.

At the same time the style and technique of ancient art may be seen to undergo a series of changes. The most important of these concerns the racial type and appearance of the human figure, whose proportions lose their classical harmony. Figures become shortened or elongated; arms and legs are disproportionate with respect to the torso. In the movement, stance, and general appearance of figures there develop certain peculiarities that are akin to Assyrian and Persian art. In the representation of figures, buildings, and other architectural forms, reverse perspective makes its appearance, correct foreshortening is forgotten, and relief becomes flat. Furthermore, a new system of ornamentation begins to show itself in painting, while the decoration of books loses its miniature style. Large figures are now disposed in the margins of manuscripts, and compositions belonging to monu-

Conclusion

mental settings are placed over the entire page, without background or frame. A close resemblance may be observed in the marginal decoration of Syrian and Coptic manuscripts consisting of animals, birds, and plants, outlined on plain parchment without indication of ground.

These changes led to the formation of certain stylistic traits that are inherent in later Byzantine art of the so-called mature period. Their appearance should be ascribed to Syrian and Persian art. Reverse perspective, archaic figures, and flat relief indicate the infiltration of Oriental technique into the artistic domain of antiquity. Foreshortening, correct perspective, and high relief were unknown in the East.

The historical importance of Constantinople lies in the fact that it united all the characteristics of Hellenistic art that we have endeavored to define with the arts and styles of the Orient. The relations of Constantinople with the East imply an interchange of styles, and while the architect Theodore was sent on a mission to Palestine, St. Sophia in Constantinople was being built by such masters as Anthemius of Tralles and Isidore of Miletus.

Notes

NOTES TO EDITOR'S PREFACE

1. *Zapiski Imper. Russkogo Arkheol. Obshchestva*, N.S. XII; *Trudy Otdeleniia arkheol. drevne-klassicheskoi, vizantiiskoi i zapadno-evropeiskoi*, V.
2. O. Wulff, *Repertorium für Kunstwissenschaft*, XXVI (1903), 35-55.
3. *Origin of Christian Church Art*, trans. by O. M. Dalton and H. J. Braunholtz (Oxford, 1923), p. 3.
4. E.g., E. H. Swift, *Roman Sources of Christian Art* (New York, 1951).
5. For an interesting critique of Kondakov's method see V. Lazarev, *Nikodim Pavlovich Kondakov* (Moscow, 1925). Cf. also Ainalov's own appreciation of his master, "Akademik N. P. Kondakov, kak istorik iskusstva i metodolog," *Seminarium Kondakovianum*, II (1928), 311-21.
6. *Vizantiiskia tserkvi i pamiatniki Konstantinopolia* (Odessa, 1886), preface.
7. "Kievskii Sofiiskii Sobor, *Zapiski Imper. Russk. Arkheol. Obshchestva*, N.S. IV (1890), 231-381.
8. "Mozaiki IV i V vekov," *Zhurnal Minist. Narodnogo Prosveshcheniia*, April 1895, pp. 241-309; May 1895, pp. 94-155; July 1895, pp. 21-71; also published as a separate book.
9. "Sinaiskiia ikony voskovoi zhivopisi," *Vizantiiskii Vremennik*, IX (1902), 343 ff.
10. *Pamiatniki khristianskogo Khersonesa. I. Razvaliny khramov* (Moscow, 1905).
11. *Vizantiiskaia zhivopis' XIV stoletiia* (Petrograd, 1917).
12. *Ibid.*, p. 150.
13. *Geschichte der russischen Monumentalkunst der vormoskovitischen Zeit* (Berlin and Leipzig, 1932); *Gesch. d. russ. Monumentalkunst zur Zeit des Grossfürstentums Moskau* (Berlin and Leipzig, 1933).
14. "Etiudy po istorii iskusstva Vozrozhdeniia," *Zapiski klass. Otdeleniia Imper. Russk. Arkheol. Obshchestva*, V (1908), 214-52.

Notes

15. "Vinciana," Ross. Akad. Istorii Mater. Kul'tury, *Izvestiia*, V (1927), 1-64.
16. *Vizantiiskii Vremennik*, IX (1902), 139.
17. A. Grabar, *Ampoules de Terre Sainte* (Paris, 1958).
18. "Iskusstvo Palestiny v srednie veka," *Vizant. Vremennik*, XXV (1927), 77-86.
19. See A. Grabar, *Les peintures de l'évangéliaire de Sinope* (Paris, 1948). Curiously enough, one folio of this manuscript, without any illustrations, was acquired by Ainalov himself at Mariupol.

NOTES TO INTRODUCTION

1. *Vizantiiskiia emali sobraniia A. Zvenigorodskogo* (St. Petersburg, 1894), pp. 293-4.
2. *Ibid.*, p. 78.
3. *Byzantinische Zeitschrift*, I (1892), 65-6.
4. *Ibid.*
5. *Stilfragen. Grundlegungen zu einer Geschichte der Ornamentik* (Berlin, 1893), p. 273.
6. *O nauchnykh zadachakh istorii drevne-russkogo iskusstva* (St. Petersburg, 1899), p. 6.
7. This is the view of Ch. Bayet who considers Byzantine art to be Hellenistic art modified under the influence of Syria and Persia: *Recherches pour servir à l'histoire de la peinture et de la sculpture chrétiennes en Orient* (Paris, 1879), pp. 132-3.
8. *Geschichte der christlichen Kunst* (Freiburg im B., 1896), pp. 85-7, 534-7.
9. *Römische und byzantinische Seiden-Textilien aus dem Gräberfelde von Achmim-Panopolis* (Strasbourg, 1891), p. 23.
10. Kraus, *op. cit.*, pp. 547-8, 551.
11. *Ibid.*, pp. 549, 551.
12. Cf. the review of Kraus' book by E. K. Redin in *Vizantiiskii Vremennik*, VI (1899), 185-203.
13. Delivered at the session of March 13, 1892, of the Imper. Pravoslavnoe Palestinskoe Obshchestvo.

NOTES TO CHAPTER I

1. [The miniatures of the Paris Nicander are described and reproduced by H. Omont, *Miniatures des plus anciens manuscrits grecs de la Bibliothèque Nationale* (Paris, 1929), pp. 34-40, pls. LXV-LXXII. See also K. Weitzmann, *Die byzantinische Buchmalerei des 9. und 10. Jahrhunderts* (Berlin, 1935), pp. 33-34, who dates the manuscript in the middle of the tenth century. The text of Nicander is edited, with an English translation, by A. S. F. Gow and A. F. Scholfield (Cambridge, 1953).]
2. *Gazette archéologique*, I (1875), 69-72, 125-127, pls. 18, 32; II (1876), 34-36, 87-89, pls. 11, 24; N. P. Kondakov, *Histoire de l'art byzantin*, I (Paris and London, 1886), 76-78.
3. H. von Christ, *Geschichte der griechischen Literatur*, 3rd ed. (Munich, 1898), p. 536.

4. K. Krumbacher, *Geschichte der byzantinischen Literatur,* 2nd ed. (Munich, 1897), pp. 527, 567.

5. *Adv. Gnosticos Scorpiace,* cap. 1, Migne, *Patrol. lat.,* II, col. 143.

6. [This miniature is discussed by Weitzmann in *Dumbarton Oaks Papers,* XIV (1960), 49 ff.]

7. [The Apollonius manuscript is discussed by Weitzmann, *Byzantinische Buchmalerei,* p. 33, who dates it in the first half of the tenth century.]

8. Hermann Schöne, *Apollonius von Kitium* (Leipzig, 1896), pp. XXV-XXVI; E. Dobbert in *Repertorium für Kunstwissenschaft,* XX (1897), 66.

9. Schöne, *op. cit.,* pl. XXX.

10. *Ibid.,* pl. IX.

11. *Ibid.,* pl. XVI.

12. *Ibid.,* p. 2, line 23.

13. See the description of the process of painting by John Chrysostom, *Patrol. gr.,* LI, col. 247; cf. Cyril of Alexandria, *Patrol. gr.,* LXVIII, col. 140; Athenagoras, *Legatio pro Christianis, Patrol. gr.,* VI, col. 924.

14. *Patrol. gr.,* VIII, cols. 561C, 697B.

15. *Vita Constantini,* I, 3.

16. *Ibid.,* III, 3.

17. F. Boll, "Beiträge zur Überlieferungsgeschichte der griechischen Astrologie und Astronomie," *Sitzungsberichte der philos.-philol. Klasse der Bayer. Akad. d. Wissenschaften,* 1899, pp. 110-138. [Weitzmann, *Byzantinische Buchmalerei,* pp. 1-2, figs. 1-5.]

18. *Syntaxis,* VIII, 3.

19. *Zhurnal Ministerstva Narodnogo Prosveshcheniia,* LV (1847), 33-35.

20. V. Langlois, *Géographie de Ptolemée* (Paris, 1867), pls. LXVII-CVIII. [See also *Cl. Ptolemaei Geographiae Cod. Urb. gr. 82 (Codices e Vaticanis selecti,* XIX), 3 vols. (Leyden and Leipzig, 1932).]

21. H. Omont, *Fac-similés des plus anciens manuscrits grecs* (Paris, 1892), pl. XXXIX.

22. *Heronis Alexandrini opera,* ed. W. Schmidt, I (Leipzig, 1899); *idem, Hieron von Alexandria* (Leipzig, 1899).

23. G. Codinus, *De aedificiis,* ed. Bonn, p. 74.

24. Agathias, V, 8. The later manuscripts of Athenaeus (15th/16th centuries) in the Bibliothèque Nationale are indicated by H. Bordier, *Description des peintures et autres ornements contenus dans les mss grecs de la Bibl. Nat.* (Paris, 1883), p. 47, Nos. 2435-2438 ancien fonds.

25. [*Le miniature della Topografia Cristiana di Cosma Indicopleuste,* ed. C. Stornajolo (*Codices e Vaticanis selecti,* X, Milan, 1908). The best ed. of the Greek text is by E. O. Winstedt, *The Christian Topography of Cosmas Indicopleustes* (Cambridge, 1909). English trans. by J. W. McCrindle, *The Christian Topography of Cosmas, an Egyptian Monk* (London, The Hakluyt Society, 1897). The most thorough investigation of the illustrations is by E. K. Redin, *Khristianskaia Topografiia Koz'my Indikoplova po grecheskim i russkim spiskam,* I (Moscow, 1916; no more published).]

Notes

26. [This manuscript is now regarded as a work of the late ninth century.]
27. [*Ca.* 550, to be more exact. See M. V. Anastos, "The Alexandrian Origin of the *Christian Topography* of Cosmas Indicopleustes," *Dumbarton Oaks Papers*, III (1946), 75-80, esp. note 10.]
28. V. S. Golenishchev, *Arkheologicheskie rezul'taty puteshestviia po Egiptu zimoi 1888-89 g.* (St. Petersburg, 1890), pl. V, 4.
29. *Hawara, Biamhu and Arsinoë* (London, 1889), XX, 7.
30. *Römische Quartalschrift*, XII (1898), pl. I. R. Forrer (*Die frühchristliche Alterthümer aus dem Gräberfelde von Achmim-Panopolis* [Strasbourg, 1893], p. 16, pl. 13, fig. 19) has published a statuette in the form of a mummy, allegedly found in a Christian grave. Its arms are folded over the chest, the body and legs are swathed. Forrer considers this to be a statuette of Lazarus, but without any proof.
31. G. Ebers, *Antike Portraits* (Leipzig, 1893), p. 42.
32. G. Stuhlfauth in *Röm. Mittheilungen*, XIII (1898), 289, 302, fig. 3. There are similar reliefs in the St. Louis Museum and in the basilica of Hadscheb-el-Aiun (*ibid.*, pp. 289-90).
33. *Histoire de l'art byzantin*, I, 150.
34. Here are some of the expressions he uses: τὸ χρήσιμον τῶν σχημάτων τοῦ κόσμου (*Patrol. gr.*, LXXXVIII, col. 56B); ὄψει παραλαβεῖν σχήματα (*ibid.*, col. 56C); κατεγράψαμεν καὶ τὰ σχήματα τοῦ παντὸς κόσμου (*ibid.*, col. 57A), etc. Cf. the expression ἐν ὀκταέδρου μὲν συνεστῶτα σχήματι, applied to the plan of the church of Antioch built by Constantine the Great, and τὸ τοῦ σταυροῦ σχῆμα used by Procopius with reference to the plan of the church of the Holy Apostles (H. Holtzinger, *Die altchristliche Architektur* [Stuttgart, 1889], pp. 102, 111); the opuscule Τοῦ Ὀλοβόλου εἰς τὰ τρία σχήματα, inc. γράμματα ἔγραψε γραφίδι τεχνικός (*Byzant. Zeitschrift*, V [1896], 552). The Patriarch Photius uses the term σχήματα for the ornaments of the mosaic floor of the Nea Ekklesia [in reality the church of the Virgin of the Pharos in the Imperial Palace of Constantinople] (Bonn ed., along with Georgius Codinus, p. 198). The clearest use of this geometrical term is found in Asterius of Amasia (*Hom. IX in S. Phocam, Patrol. gr.*, XL, col. 301B): Καὶ πολλὰ μὲν ὁ γεωμέτρης περὶ τὴν βίβλον καμὼν, καὶ πληρωθεὶς παρὰ τοῦ διδασκάλου τὴν ἀκοὴν, οὐκ ἄλλως καταλήψεται τῶν ποικίλων σχημάτων τὴν δύναμιν, ἂν μὴ καταμάθῃ τὰ κέντρα, καὶ τὰς γραμμὰς, καὶ τοὺς κύκλους ἐπὶ τοῦ πίνακος.
35. I. von Müller, *Handbuch der klassischen Altertums-Wissenschaft*, Vol. VI: Karl Sittl, *Archäologie d. Kunst*, p. 306.
36. *Patrol. gr.*, LXXXVIII, col. 192.
37. *Ibid.*, col. 384.
38. *Histoire de l'art byzantin*, I, 150; J. J. Tikkanen, *Die Psalterillustration im Mittelalter* (Helsingfors, 1895), p. 22.
39. Cf. Tikkanen, *op. cit.*, p. 220, note 1.
40. N. V. Pokrovskii, "Strashnyi Sud v pamiatnikakh vizantiiskogo i russkogo iskusstva," *Trudy VI Arkheol. S'ezda v Odesse*, III, 300-01.
41. W. Salzenberg, *Altchristliche Baudenkmale von Constantinopel* (Berlin, 1854), pl. XXV, 1. [Ainalov has been misled here by Salzenberg's reconstruction of this mosaic made on the basis of small fragments uncovered in 1848. In reality, the apostles were not standing, but

The Hellenistic Origins of Byzantine Art

seated on a bench; the central medallion was probably occupied by an *Etimasia*, and not a seated Christ; there were no angels in the pendentives; and, finally, this mosaic could hardly have been earlier than the ninth century.]

42. Charles Diehl, *Le couvent de Saint Luc en Phocide* (Paris, 1889), pp. 70-71.
43. *La basilica di San Marco a Venezia*, ed. F. Ongania, *Cromolitografie* (Venice, 1881), pl. VI.
44. See above, p. 276 ff.
45. Cf. Tikkanen, *op. cit.*, p. 22.
46. See Strzygowski, *Der Bilderkreis des griechischen Physiologus*, Byzantinisches Archiv, II (Leipzig, 1899), 54-64.
47. *Die Wiener Genesis*, ed. Wilhelm Ritter von Hartel and Franz Wickhoff (Vienna, 1895), p. 8.
48. E. Bertrand, *Etudes sur la peinture et la critique de l'art dans l'antiquité* (Paris, 1893), pp. 44-45.
49. C. Robert, *Die Marathonschlacht in der Poikile und weiteres über Polygnot*, XVIII hallisches Winkelmansprogr. (Halle, 1895), pl.; cf. R. Schöne, "Zu Polygnots delphischen Bildern," *Jahrbuch d. K. D. Archäol. Instituts*, VIII (1893), 191.
50. *Patrol. gr.*, XLVI, col. 572.
51. *Bulletino di archeologia cristiana*, ser. 4, II (1883), 87.
52. R. Garrucci, *Storia dell'arte cristiana*, 6 vols. (Prato, 1872-1880), VI, pl. 463, 2.
53. *Archivo Español*, IV, fig. 5.
54. *Archäologische Studien über altchristliche Monumente* (Vienna, 1880), p. 94. The Sacrifice of Isaac is discussed in detail by G. Stuhlfauth, *Die Engel in der altchristlichen Kunst* (Freiburg i. B., 1897), p. 95 ff.
55. Labbe, *Concilia*, VII, 204. [Mansi, *Sacrorum Cinciliorum nova et amplissima collectio*, XIII, cols. 12-13.]
56. *Materialy po arkheologii Kavkaza* (Moscow, 1894), pl. VIII; *Arkheol. Izvestiia i Zametki*, 1895, no. 3, pl. III and p. 238.
57. Kondakov, *Puteshestvie na Sinai* (Odessa, 1882), p. 139.
58. *Patrol. gr.*, LXXXVIII, cols. 441-44.
59. *Ibid.*, col. 141.
60. Theophanes, *Chronographia*, ed. Bonn, I, 170: Τῷ δ' αὐτῷ ἔτει . . . ἦλθεν δὲ ἐν Ἀλεξανδρείᾳ καμηλοπάρδαλις καὶ ταυρέλαφοι καὶ ἄλλα θηρία.
61. T. Tobler, *Itinera et descriptiones Terrae Sanctae*, I (Geneva, 1877), 116: "Ibi [i.e., at Memphis] vidimus pallium lineum, in quo est effigies Salvatoris, quem dicunt tersisse faciem suam in eo et remansisse ibi eius imaginem."
62. J. A. Cramer, *Anecdota graeca e codd. mss. Bibl. Reg. Paris.*, II (Oxford, 1839), 333: Ὁ δὲ αὐτὸς Ἡράκλειος ἐξ Ἀφρικῆς πλοῖα πολλὰ ἐξοπλίσας καὶ στρατὸν, τὴν Κωνσταντινούπολιν κατέλαβεν, ἐπιφερόμενος καὶ τὴν ἀχειροποίητον εἰκόνα τοῦ Κυρίου καὶ Θεοῦ ἡμῶν.
63. Salzenberg, *op. cit.*, pls. IX, XXXI.
64. *Cherubim, Throne und Seraphim* (Altenburg, 1894), pp. 60 ff., 77 ff. Cf. Strzygowski in *Byzant. Zeitschrift*, VIII (1899), 207.
65. Ed. Bonn, pp. 260-61.

Notes

66. [See above, note 26.]
67. Kondakov, *Histoire de l'art byzantin*, I, 107 ff. This manuscript was acquired at Constantinople by Busbecq in the reign of Maximilian II. E. Q. Visconti, *Iconographie grecque* (Paris, 1811), I, 289. Another manuscript of Dioscorides of the 9th or 10th century, which was formerly at Naples (B. de Montfaucon, *Palaeographia graeca* [Paris, 1708], p. 212), now belongs to the Bibliothèque Nationale; specimen in Omont, *Facsimilés*, pl. VIII; cf. Bordier, *Description*, p. 92 ff. The latter also describes yet another manuscript of the year 1481 (p. 263). [Facsimile ed. of the Vienna Dioscorides: *Dioscurides, Codex Aniciae Julianae*, etc., ed. A. von Premerstein, C. Wessely, J. Mantuani, 2 vols. (Leyden, 1906). See also *Beschreibendes Verzeichnis der illuminierten Handschriften in Österreich*, N.F. IV, 1 (Leipzig, 1937), 1-62; P. Buberl, "Die antiken Grundlagen der Miniaturen des Wiener Dioskurideskodex," *Jahrb. d. D. Archäol. Inst.*, LI (1936), 114-36; V. Gardthausen, *Griechische Palaeographie*, 2nd ed., II (Leipzig, 1913), 134 ff.]
68. Such herbals must have been first created by the Greek scientists mentioned by Pliny, *Hist. natur.*, XXV, iv.
69. Christ, *op. cit.*, p. 861.
70. *Iconographie grecque*, I, 302, note 1.
71. *Palaeographia graeca*, pp. 196-97.
72. Seroux d'Agincourt, *Sammlung von Denkmälern, Malerei* (Berlin, 1840), pl. XXVI, 4; text, p. 28.
73. E. Bethe, "Aratusillustrationen," *Rheinisches Museum für Philologie*, XLVIII (1893), 98-101.
74. Color reproduction in J. Labarte, *Histoire des arts industriels*, Album, II (Paris, 1864), pl. LXXVIII; cf. text, vol. III, p. 20 ff.
75. [The correct reading is πόθος τῆς φιλοκτίστου.]
76. *Griechische Palaeographie*, 2nd ed., II, 135. Lambecius was already unable to read this word: Montfaucon, *op. cit.*, p. 204. Cf. the bottom of a glass vessel showing a woman bowing before a seated female figure in the manner of the kneeling figures of provinces on coins (Garrucci, III, pl. 201, 4).
77. E. K. Redin, *Mozaiki Ravennskikh Tserkvei* (St. Petersburg, 1896), p. 29, notes 4, 5.
78. E. Molinier, *Histoire générale des arts appliqués à l'industrie*, I, *Ivoires* (Paris, 1896), 47.
79. Except for the fragment of a porphyry sarcophagus in the Ottoman Museum representing *putti* gathering grapes: Strzygowski, *Orient oder Rom* (Leipzig, 1901), p. 79.
80. See above, p. 192 ff.
81. See above, note 41.
82. G. Parthey, *Das alexandrinische Museum* (Berlin, 1838), p. 100. On the destruction of the Octagon by Leo III, see Georgius Codinus, ed. Bonn, p. 83.
83. Kondakov, *Histoire de l'art byzantin*, I, 151-52. [Ainalov's suggestion that this miniature represents a specific Byzantine emperor has been accepted by several scholars, notably by R. Delbrueck (*Die Consulardiptychen* [1929], pp. 270-74) who identified him with Heraclius.

Unfortunately, this is not so: The miniature does in fact represent Job (as Jobab, king of Edom) and his three daughters. See O. Kurz, "An Alleged Portrait of Heraclius," *Byzantion*, XVI (1942-43), 162-64.]

84. *Patrol. gr.*, LI, col. 71. [This passage refers to imperial portraits in general, not to miniatures. See Kurz, *op. cit.*, p. 163, note 5.]

85. No illuminated Coptic manuscript of the Old or New Testament of the period that concerns us, i.e., from the 4th to the 8th century, has yet been published. The Coptic Gospel of the Bibl. Nationale, No. 13, is of the year 1173, and falls therefore outside the limits of our enquiry. The manuscripts preserved in the School of the Propaganda in Rome have remained unknown to me. Specimens of their ornamentation have been published by V. V. Stasov, *Slavianskii i vostochnyi ornament* (St. Petersburg, 1887), pls. CXXX-CXXXIV.

86. E. Amélineau, *Les moines égyptiens. Vie de Schnoudi* (Paris, 1889), p. 306.

87. Cf. O. Wulff, "Sem' chudes Vizantii," *Izvestiia Russkogo Arkheol. Inst. v Konstantinopole*, I (1896), 77. [See also above, p. 262.]

88. *Römische Quartalschrift*, I (1887), 330 ff. and pl. XI.

89. *Op. cit.*, pl. CXXXII, 7.

90. The illuminations have been published by Garrucci, III, pls. 128-140, and by S. A. Usov, *Sochineniia* (Moscow, 1888-1892), II, 145-94. [Facsimile ed. in color by C. Cecchelli, G. Furlani, and M. Salmi, *The Rabbula Gospels* (Olten and Lausanne, 1959).]

91. Strzygowski, *Das Etschmiadzin-Evangeliar*, Byzantinische Denkmäler, I (Vienna, 1891), 78, note 3.

92. Strzygowski, *Die Calenderbilder des Chronographen vom Jahre 354*, Jahrbuch d. K. D. Archaeol. Inst., Ergänzungsheft I (Berlin, 1888), plates.

93. *Epist.* II, 2: "Nihil illis paginis impressum reperietur quod non vidisse esse sanctius. Pauci tamen versiculi lectorem adventicium remorabuntur."

94. Ch. Texier and R. Popplewell Pullan, *Byzantine Architecture* (London, 1864), pls. XXX-XXXIII.

95. Cf. the Corinthian capitals with human heads in a church at Madaba in Palestine: *Nuovo bull. di archeol. crist.*, V (1899), 163.

96. Cf. V. G. Bok, *O koptskom iskusstve. Koptskiia uzorchatyia tkani* (Moscow, 1897), IV, 25; E. Gerspach, *Les tapisseries coptes* (Paris, 1890), Figs. 42, 53.

97. Cf. Bok, *op. cit.*, II, 10; Gerspach, *op. cit.*, Figs. 30, 37, 127.

98. Cf. Bok, *op. cit.*, II, 11; Gerspach, *op. cit.*, Figs. 5, 31, 78.

99. Cf. Gerspach, *op. cit.*, Fig. 125.

100. Usov (*Sochineniia*, II, 190) gives a different explanation of these figures. On the basis of the colophon he believes that these are the two presbyters of the monastery, John and Martyrius, and behind them the deacon Isaac and the monk Lugentius. [These names are incorrect. See text of colophon in Cecchelli *et al.*, *op. cit.*, p. 19 ff.]

101. *Die Wiener Genesis*, p. 91.

102. J. A. Crowe and G. B. Cavalcaselle, *Storia di pittura in Italia*, I, 85. A. Morini considers the Crucifixion miniature to be an eleventh-

century copy from an ancient original: see *Bull. di archeol. crist.*, Ser. 5, IV (1894), 60. Stuhlfauth goes even further: He believes this miniature to be an original of the tenth or eleventh century, and holds the same view concerning the other large miniatures of the Rabula manuscript, but without any proof (*Die Engel*, pp. 144, 218).

103. Garrucci, VI, pl. 434, 3.
104. Cf. Redin, *Mozaiki ravennskikh tserkvei*, p. 87.
105. D. V. Ainalov, *Mozaiki IV i V vekov* (St. Petersburg, 1895), pp. 27-28 and note 1.
106. Kondakov, *Histoire de l'art byzantin*, I, 134. Reproductions of ornaments in V. V. Stasov, *op. cit.*, pls. CXXVI-VII. Short description of the manuscript by Redin, "Siriiskiia rukopisi s miniatiurami Parizhskoi Nats. Bibl. i Britanskogo Muzeia," offprint from *Arkheol. Izvestiia i Zametki*, 1895, No. 11, pp. 5-6. [The fullest publication of the miniatures is by C. Nordenfalk, *Die spätantiken Kanontafeln* (Göteborg, 1938), pls. 114-28.]
107. *Die frühchristliche Alterthümer aus dem Gräberfelde von Achmim-Panopolis*, p. 16, Fig. 1; pls. IX, 10; X, 10, 2.
108. Garrucci, VI, pl. 433, 8.
109. Stasov, *op. cit.*, pl. CXXVI, reproduces the sheep, rooster and ibis.
110. Garrucci, VI, pl. 434, 1, 2, 5, 6, 7.
111. Strzygowski, *Das Etschmiadzin-Evangeliar*, p. 21 ff. [Complete reproduction of the Etschmiadzin Gospel by F. Macler, *L'Evangile arménien; éd. phototypique du ms n° 229 de la Bibl. d'Etchmiadzin* (Paris, 1920).]
112. Garrucci, VI, pl. 440, 1.
113. Redin, "Drevne-khristianskaia piksida Bolonskogo muzeia," *Arkheol. Izvest. i Zametki*, 1893, Nos. 7-8, offprint, pp. 5-7.
114. *Patrol. lat.*, XXX, col. 661C: "Et perducunt eum in Golgotha, quod interpretatur Calvaria. Tradunt Judaei, quando in hoc montis loco immolatus est aries pro Isaac, ut ibi decolletur, id est, Christus," etc. According to another tradition, Abraham's sacrifice took place on Mount Garizim: "Ibi est mons Garizim. Ibi dicunt Samaritani Abraham sacrificium obtulisse, et ascenditur usque ad summum montem gradibus numero CCC" (Tobler, *Itinera*, I, 16).
115. A. A. Olesnitskii, *Vetkhozavetnyi khram v Ierusalime* (St. Petersburg, 1881), p. 231. This localization of the sacrifice occurs in Maimonides, Kimhi and Flavius Josephus (*Antiquit. jud.*, VII, 13, 4); so also the pilgrim Theodosius (Tobler, *Itinera*, I, 64). In the Bible (*Gen.* 22) the place is not identified.
116. Theodosius in *Pravoslavnyi Palestinskii Sbornik*, 1881, No. 7, p. 94; Tobler, *Itinera*, I, 63: "ubi est sepulcrum Domini nostri Iesu Christi. Est ibi mons Calvarie, ubi Abraham obtulit filium suum in holocaustum (illic decalvabantur homines). Mons petrosus est et per gradus ascenditur. Ibi Dominus crucifixus est. Ad pedem ipsius montis fecit Abraham altare, et super altare eminet mons."
117. Tobler, *Itinera*, I, 58.
118. *Ibid.*, pp. 101-2: "ab una parte ascenditur per gradus, ubi Dominus noster ascendit ad crucifigendum. In loco, ubi crucifixus fuit, paret

cruor sanguinis in ipsa petra. In latere petre est altare Abrahe, ubi ibat offerre Isaac."

119. For the number of steps indicated by different pilgrims see *Pravosl. Palest. Sbornik*, X, No. 1, p. 62, note 40.

120. Tobler, *Itinera*, I, 152, 149 (plan).

121. M. A. Venevitinov, *Zhit'e i khozen'e Danila Rus'skyia zemli igumena*, Pravosl. Palest. Sbornik, III, 9 (St. Petersburg, 1883), 22.

122. F. Laib and F. J. Schwarz, *Biblia Pauperum*, 2nd ed. (Würzburg, 1892), pl. 12.

123. *Patrol. lat.*, XCIV, col. 720C; *Bull. di archeol. crist.*, Ser. 4, V (1887), p. 58.

124. R. Forrer, *Römische und byzantinische Seiden-Textilien aus dem Gräberfelde von Achmim-Panopolis* (Strasbourg, 1891), pl. XVII, 9.

125. Ainalov, *op. cit.*, pp. 77-78.

126. Texier and Pullan, *op. cit.*, pl. XXXIII.

127. *Ibid.*, pl. XXXI.

128. Franz Bock, *Die byzantinischen Zellenschmelze der Sammlung Dr. Alex. von Swenigorodskoï* (Aachen, 1896), p. 309. The complex structures depicted in the Salonica mosaics suggest that the two buildings in the miniatures of the Annunciation to Zacharias and the Annunciation to the Virgin may have been united in the original along the section line of the roof and walls, or may have formed the lateral appendages of a central architectural element. This would explain why the roof and walls are cut off in a straight line.

129. For further details see my article, "Chast' Ravennskogo diptikha v sobranii grafa Krauforda," *Vizant. Vremennik*, V (1898), 169-70.

130. *Vita Constantini*, IV, 7.

131. *Script. hist. Aug.*, *Tyranni triginta*, XXV, 4: "Aurelianus pictus est utrique [*sc.* to the two Tetrici] praetextam tribuens et senatoriam dignitatem, accipiens ab his sceptrum, coronam, cycladem. Pictura est de museo."

132. Ch. Bayet, *Recherches pour servir à l'histoire de la peinture et de la sculpture chrétiennes en Orient* (Paris, 1879), p. 66.

133. See my article quoted in note 129.

134. *Zeitschr. für christliche Kunst*, XII (1899), col. 6.

135. Garrucci, VI, pl. 427, 6.

136. H. Graeven, *Frühchristliche und mittelalterliche Elfenbeinwerke*, Serie I (Rome, 1898), No. 30.

137. *Codex purpureus Rossanensis* (Berlin-Leipzig, 1898); [now superseded by A. Muñoz, *Il codice purpureo di Rossano ed il frammento Sinopense* (Rome, 1907)].

138. [Later marginal note by Ainalov: "Only now, after the publication of the Sinope Gospel book by Omont, it has become possible to ascribe a Constantinopolitan origin to this group of manuscripts, namely, the Vienna Genesis, the Rossanensis, and the Sinopensis."]

139. Haseloff, *op. cit.*, p. 77, Figs. 11-13.

140. Cf. D. V. Ainalov and E. K. Redin, *Kievo-Sofiiskii sobor* (St. Petersburg, 1889), p. 140.

141. See Haseloff, *op. cit.*, p. 113.

Notes

142. Tobler, *Itinera*, I, 104. Cf. Giovanni Zuallardo, *Il devotissimo viaggio di Gerusalemme* (Rome, 1587), p. 165: "Il qual detto luoco di Licostratos e quelli dove Pilato interrogò e parlò col Signore, il prefato P. Bonifatio, il P. Guardiano ed altri moderni, che vanno là, piu spesso (che non desiderano, per parlare al detto Sangiacco) dicono essere ancora nel suo intero pavimentato di pietre larghe e quadre, ben politamente, che dimostrano à essere di struttura antichissima ed anco (per volonta divina) le figure ed imagini dipinte sopra le mura, rappresentanti cio che ci è stato fatto."
143. See E. K. Redin in *Zapiski Imp. Russk. Arkheol. Obshchestva*, N.S., VII (1895), 55 ff.
144. A. di Erbach Fuerstenau, "L'Evangelo di Nicodemo," *Archivio storico dell'arte*, Ser. 2, II (1896), 225 ff.
145. Haseloff, *op. cit.*, pp. 103-4.
146. See A. A. Pavlovskii, *Zhivopis' Palatinskoi kapelly* (St. Petersburg, 1890), pp. 110-11; D. V. Ainalov in *Arkheol. Izvest. i Zametki*, II, 6 and note 13.
147. Usov, *op. cit.*, II, 38. Haseloff, *op. cit.*, p. 20, is mistaken in ascribing this detail to the artist's imagination.
148. *Histoire de l'art byzantin*, I, 120.
149. Garrucci, V, pls. 332, 2; 341, 1; 345, 1; 346, 2.
150. Cf. Ainalov, *Mozaiki IV i V vekov*, pp. 116-17.
151. Garrucci, VI, pl. 451, 3. [Now in the Bargello, Florence.]
152. E. Dobbert, "Zur byzantinischen Frage," *Jahrb. d. Königl. Preuss. Kunstsammlungen*, XV (1894), 130-31.
153. Hartel and Wickhoff, *Die Wiener Genesis*, pl. III.
154. Dobbert, "Zur byzantinischen Frage," *op. cit.*, p. 132 ff.; Haseloff, *op. cit.*, pp. 109-10.
155. Ainalov and Redin, *Kievo-Sofiiskii sobor*, p. 98.
156. *Histoire de l'art byzantin*, I, 116.
157. *Op. cit.*, pp. 98-101.
158. *Histoire de l'art byzantin*, I, 119.
159. Daremberg and Saglio, *Dict. des antiquités grecques et romaines*, s.v. imago, p. 407, Fig. 3973.
160. [Facsimile ed. in color by H. Gerstinger, *Die Wiener Genesis* (Vienna, 1931). See also *Beschreibendes Verzeichnis der illuminierten Handschriften in Österreich*, VIII, 4: P. Buberl, *Die byzantinischen Handschriften*, I (Leipzig, 1937), 63 ff.; *id.*, "Das Problem der Wiener Genesis," *Jahrb. d. kunsthistorischen Sammlungen in Wien*, N.F. X (1936), 9 ff.]
161. *Op. cit.*, II, 61 ff.
162. *Op. cit.*, p. 62.
163. *Ibid.*, p. 60.
164. *Ibid.*, pl. IX; Hartel and Wickhoff, *Wiener Genesis*, pls. VI, XXI.
165. Haseloff, *op. cit.*, p. 52.
166. *Ibid.*, pl. VI; cf. Hartel and Wickhoff, *op. cit.*, pls. XV and esp. XII and XXIV.
167. Haseloff, *op. cit.*, pl. VIII; Hartel and Wickhoff, *op. cit.*, pl. III.
168. Haseloff, *op. cit.*, pl. VIII; Hartel and Wickhoff, *op. cit.*, pls. II, VI.
169. Haseloff, *op. cit.*, pp. 62, 130.

170. *Op. cit.*, II, 76 ff.

171. Kondakov, *Histoire de l'art byzantin*, I, 79-80.

172. V. Schultze, *Die Quedlinburger Italaminiaturen der königlichen Bibliothek in Berlin* (Munich, 1898), pls. I-VI.

173. Hartel and Wickhoff, *op. cit.*, p. 162 ff.

174. *Ibid.*, pp. 144-45.

175. *Histoire de l'art byzantin*, I, 79, 89.

176. Ainalov, *Mozaiki IV i V vekov*, pp. 122-24.

177. *Histoire de l'art byzantin*, I, 79-80.

178. *Die Quedlinburger Italaminiaturen der königlichen Bibliothek in Berlin*, pp. 36-37.

179. See below, p. 197 ff.

180. [Facsimile reproduction: *Il Rotulo di Giosuè. Codices e Vaticanis selecti* V (Milan, 1905). See also C. R. Morey, "Notes on East Christian Miniatures," *Art Bulletin*, XI (1929), 46 ff.; K. Weitzmann, *The Joshua Roll: A Work of the Macedonian Renaissance* (Princeton, 1948); M. Schapiro, "The Place of the Joshua Roll in Byzantine History," *Gazette des beaux-arts*, Ser. 6, XXXV (1949), 161 ff.; C. R. Morey, "Castelseprio and the Byzantine 'Renaissance,'" *Art Bulletin*, XXXIV (1952), 173 ff.; D. Tselos, "The Joshua Roll: Original or Copy?," *Art Bulletin*, XXXII (1950), 275 ff.]

181. Hartel and Wickhoff, *op. cit.*, p. 93.

182. *Jahrb. d. Kön. Preuss. Kunstsammlungen*, XVIII (1897), 6, note 6.

183. M. Collignon, *Histoire de la sculpture grecque* (Paris, 1897), II, 486, Fig. 253.

184. Kondakov, *Histoire de l'art byzantin*, I, 35.

185. Ed. Bonn, I, 616: μεθ' ὧν βιβλίων καὶ τὸ τοῦ δράκοντος ἕτερον [i.e. ἔντερον] ποδῶν ἑκατὸν εἴκοσιν, ἐν ᾧ ἦν γεγραμμένα τὰ τοῦ Ὁμήρου ποιήματα ἥ τε Ἰλιὰς καὶ ἡ Ὀδύσσεια χρυσέοις γράμμασι μετὰ καὶ τῆς ἱστορίας τῆς τῶν ἡρώων πράξεως.

186. [See K. Weitzmann, "Observations on the Cotton Genesis Fragments," *Late Classical and Mediaeval Studies in Honor of Albert Mathias Friend, Jr.* (Princeton, 1955), pp. 112-31.]

187. "Die Genesismosaiken von S. Marco in Venedig und ihr Verhältnis zu den Miniaturen der Cottonbibel," *Acta Soc. Scient. Fennicae*, XVII (Helsingfors, 1889), 113.

188. Kondakov, *Histoire de l'art byzantin*, I, 92.

189. The Rossano Gospel and the Vienna Genesis have been described by some scholars to Alexandria, by others to Syria: see Haseloff, *op. cit.*, pp. 131-32. Wickhoff, basing himself on the representation of a volcano in the Vienna Genesis, has attributed this manuscript to southern Italy.

NOTES TO CHAPTER II

1. *Römische Quartalschrift*, XII (1898), 41.

2. [See F. Gerke, *Die christlichen Sarkophage der vorkonstantinischen Zeit* (Berlin, 1940), p. 38 ff., pl. I.]

3. M. Collignon, *Histoire de la sculpture grecque* (Paris, 1897), II, Fig. 289.

Notes

4. The Paneas group was destroyed by Julian: Theophanes, *Chronographia*, ed. Bonn, I, 75-76; Th. Preger, *Anonymi byzantini* Παραστάσεις σύντομοι χρονικαί (Munich, 1898), p. 23, § 48; cf. A. Pératé, "Note sur le groupe de Panéas," *Mélanges d'archéol. et d'histoire* (Ecole française de Rome), V (1885), 303-12. The group was reconstructed after its destruction; according to the anonymous *Itinerarium S. Willibaldi*, it was inside the church of Paneas (T. Tobler and A. Molinier, *Itinera Hierosolymitana et descriptiones Terrae Sanctae*, I, 2 (Geneva, 1880), p. 290; A. Molinier and C. Kohler, *Itinera Hierosolymitana et descriptiones Terrae Sanctae*, II (Geneva, 1885), 247). It is difficult to say whether this statue, which, according to Gregory of Tours, was made of electrum, had any connection with the bronze statue of Christ at the Chalke of Constantinople. According to G. Codinus (*De aedificiis*, ed. Bonn, p. 77), the latter statue was erected by Constantine the Great, healed a woman with an issue of blood, and was destroyed by Leo III. [The story concerning the statue of Christ at the Chalke is apocryphal: see C. Mango, *The Brazen House* (Copenhagen, 1959), p. 108 f.] Pératé (*op. cit.*, p. 312) also points to the existence of a column with a cock at the church *ad galli cantum* in Jerusalem, but such a column is not mentioned in early sources. A drawing of this church with part of the column may be seen in Giovanni Zuallardo, *Il devotissimo viaggio* (quoted above, p. 291, note 142), p. 134. On a bronze medal of the Patriarch Macarius of Antioch (who was deposed in 681), St. Peter is shown seated on a throne, one of the posts of which is surmounted by a cock (R. Garrucci, *Storia dell'arte cristiana*, VI (Prato, 1880), pl. 479, 16).

5. E. K. Redin, *Mozaiki Ravennskikh tserkvei* (St. Petersburg, 1896), p. 115; D. V. Ainalov, "Ravenna i eia iskusstvo," *Zhurnal Ministerstva Narodnogo Prosveshcneniia*, 1897, No. 6, p. 455.

6. See N. P. Kondakov's report read at the session of March 13, 1892, of the Pravoslavnoe Palestinskoe Obshchestvo (offprint, pp. 3-5).

7. Garrucci, V, pl. 315, 5.

8. Garrucci, V, pl. 377, 1.

9. Garrucci, V, pl. 298, 3.

10. W. R. von Hartel and F. Wickhoff, *Die Wiener Genesis* (Vienna, 1895), pl. D.

11. Cf. Ainalov, *Mozaiki IV i V vekov* (St. Petersburg, 1895), p. 55; *Soobshcheniia Pravosl. Palest. Obshchestva*, Feb. 17, 1894. [W. F. Volbach, *Elfenbeinarbeiten der Spätantike und des frühen Mittelalters* (Mainz, 1952), p. 58, No. 111, with bibliography. This ivory is now in the Castello Sforzesco, Milan.]

12. *Die altchristliche Elfenbeinplastik* (Freiburg I. B. and Leipzig, 1896), pp. 159-60.

13. V. Schultze, *Archäologie der altchristlichen Kunst* (Munich, 1895), p. 271; J. Strzygowski, "Das Berliner Moses-Relief," *Jahrb. d. K. Preuss, Kunstsamml.*, XIV (1893), 80.

14. W. Meyer, *Zwei antike Elfenbeintafeln der K. Staats-Bibliothek in München* (Munich, 1879), pl. II.

15. Cf. Theodor Schreiber, *Die hellenistischen Reliefbilder* (Leipzig, 1894), pls. II, XI, etc.

16. *Ibid.*, pls. I, VII, VIII, etc.
17. *Götting. gelehrte Anzeigen*, 1897, pp. 72-73.
18. *Monuments et mémoires Piot*, V (1899), pls. I and esp. XIX.
19. See above, p. 54. Cf. also the six-winged Evangelists' symbols on the Cattedra di S. Marco (Garrucci, VI, pl. 413).
20. W. M. Ramsay, *The Cities and Bishoprics of Phrygia*, II (Oxford, 1897), 684. Cf. the Alexandrian patera from Bizerta: *Mon. et mém. Piot*, II (1895), pl. IX.
21. J. Ficker, *Die altchristlichen Bildwerke im Christlichen Museum des Laterans* (Leipzig, 1890), p. 71, pl. II.
22. See above, p. 253.
23. Strzygowski, *Das Etschmiadzin-Evangeliar*, Byzantinische Denkmäler, I (Vienna, 1891), pp. 100, 106, pl. VII.
24. [Fol. 7ᵛ.]
25. See above, p. 94 ff.
26. *Die altchristliche Elfenbeinplastik*, pp. 18 ff., 29 ff.
27. *Das Etschmiadzin-Evangeliar*, p. 66.
28. *Archivio storico dell'arte*, IV (1891), 380.
29. *Götting. gelehrte Anzeigen*, 1897, p. 64.
30. Néroutsos-Bey, *L'ancienne Alexandrie* (Paris, 1888), p. 76.
31. [On the Brescia casket see J. Kollwitz, *Die Lipsanothek von Brescia*, Studien zur spätantiken Kunstgeschichte, VII (Berlin-Leipzig, 1933); R. Delbrueck, *Probleme der Lipsanothek in Brescia*, Theophaneia, VII (Bonn, 1952).]
32. *Les sarcophages chrétiens de la Gaule* (Paris, 1886), pl. VIII, 4.
33. [See esp. C. Cecchelli, *La cattedra di Massimiano ed altri avorii romano-orientali*, 7 fasc. (Rome, 1936-1944).]
34. Stuhlfauth, *op. cit.*, p. 90.
35. See Ainalov, "Tri drevne-khristianskikh sosuda iz Kerchi," *Zapiski Imper. Russk. Arkheol. Obshchestva*, N.S., V (1892), 204 ff.; *id.*, "Chast' Ravennskogo diptikha v sobranii grafa G. S. Stroganova," *Vizantiiskii Vremennik*, IV (1897), 135, 140.
36. Ainalov, "Ravenna i eia iskusstvo," *Zhurnal Minist. Narodn. Prosveshcheniia*, 1897, No. 6, p. 450. T. Tobler, *Itinera et descriptiones Terrae Sanctae*, I (Geneva, 1877), 177-78 (Arculf): "In extremitate vero fluminis quedam habetur parva quadrata ecclesia in eo, sicut traditur, fundata loco, ubi Dominica vestimenta hora illa custodita sunt, qua baptizatus est Dominus."
37. Tobler, *Itinera*, I, 68 (Theodosius): "Circum Iordanem monticelli sunt multi, et quando Dominus ad baptismum descendit, ipsi montes ante ipsum ambulabant gestiendo, et hodie velut saltantes videntur."
38. Εἰς τὴν κόγχην τῆς ἐκκλησίας ἵσταται ὁ λίθος ἐν ᾧ ἔστη ὁ Πρόδρομος ἔνθα ἐβάπτισεν τὸν Χριστόν. (Garrucci, I, 369).
39. Cf. Ainalov, "Vizantiiskie pamiatniki Afona," *Vizantiiskii Vremennik*, VI (1899), 83; Johannes Phocas in Pravosl. Palest. Sbornik, No. 23, p. 23.
40. Redin, *Plastina ot kresla episkopa Maksimiana v Ravenne* (Kharkov, 1893), p. 2, note 4.
41. V. S. Golenishchev, *Arkheologicheskie rezul'taty puteshestviia po Egiptu zimoi 1888-89 g.* (St. Petersburg, 1890), pl. V, 4. Another textile with this subject is in the Hermitage.

Notes

42. Cf., for example, the bronze head from Herculaneum: Collignon, *op. cit.*, II, 563.
43. "Zur frage d. Nachlebens d. altägyptischen Kunst in d. späten Antike," *Versamml. deutsch. Philolog. und Schulmänner in Wien*, 1893, pp. 191-97; *id., Stilfragen* (Berlin, 1893), p. 38, Fig. 2.
44. Redin, "Diptikh Echmiadzinskoi Biblioteki," *Zapiski Imper. Russk. Arkheol. Obshchestva*, N.S., V (1892), 228.
45. Golenishchev, *op. cit.*, pl. V, 4.
46. First described by J. Mourier, *La bibliothèque d'Edchmiadzine et les manuscrits arméniens* (Tiflis, 1885); cf. V. Stasov in *Zhurnal Minist. Narodn. Prosv.*, July 1886, p. 133 ff.
47. *Justinien et la civilisation byzantine au VI^e siècle* (Paris, 1901), p. 655 and frontispiece.
48. See above, p. 264 ff.
49. Graeven, *Frühchristliche und mittelalterliche Elfenbeinwerke*, Serie I (Rome, 1898), Nos. 14-17.
50. *Römische Quartalschrift*, XII (1898), 37, Fig. 6.
51. Strzygowski, *Das Etschmiadzin-Evangeliar*, pl. I; E. K. Redin, "Diptikh Echmiadzinskoi Biblioteki," Figs. 1, 2.
52. "Les sculptures de la porte de Sainte-Sabine à Rome," *Revue archéologique*, N.S., XXXIII (1877), 361 ff. To the bibliography given by Kraus, *Geschichte der christlichen Kunst* (Freiburg im B., 1896), I, 495-96, add Stuhlfauth, *Die altchristliche Elfenbeinplastik*, pp. 203-09. [See esp. J. Wiegand, *Das altchristliche Hauptportal an der Kirche der hl. Sabina* (Trier, 1900); A. C. Soper, "The Italo-Gallic School of Early Christian Art," *Art Bulletin*, XX (1938), 168 ff.]
53. Stuhlfauth, *Die Engel in der altchristliche Kunst* (Freiburg i. B., 1897), pp. 167-68, believes that this plaque represents the Ascension.
54. H. Brunn and F. Bruckmann, *Denkmäler griechischer und römischer Sculptur* (Munich, 1888-1900), pl. 50.
55. [On the meaning of this plaque see E. H. Kantorowicz, "The 'King's Advent' and the Enigmatic Panels in the Doors of Santa Sabina," *Art Bulletin*, XXVI (1944), 221 ff., who convincingly explains it as the advent of the Messiah, based on Malachi 3:1-2.]
56. The Bordeaux pilgrim says: "Ibi [i.e., by the river Jordan] est locus super flumen, monticulus in illa ripa, ubi raptus est Helias in celum" (Tobler, *Itinera*, I, 19). Theodosius places this event on Mount Tabor (*ibid.*, p. 68), and Antoninus of Piacenza near the place of the Baptism and the crossing of the Jordan by the Israelites: "ubi baptizatus est Dominus . . . et filii prophetarum perdiderunt securim, et ex ipso loco Helias assumtus est in celum" (*ibid.*, p. 96).
57. Cf. Garrucci, V, pls. 324, 2; 327, 3 (both with architectural background); 372, 5.
58. Graeven, *Elfenbeinwerke*, I, No. 28. [Now in the British Museum: O. M. Dalton, *Catalogue of the Ivory Carvings of the Christian Era* (London, 1909), p. 8, No. 10, pl. V.]
59. Strzygowski, *Das Etschmiadzin-Evangeliar*, pl. I; E. K. Redin, "Diptikh Echmiadzinskoi Biblioteki," pp. 8, 11.
60. Strzygowski in *Byzant. Zeitschr.*, I (1892), 576 ff., pl. II.

61. A. Gayet, *Les monuments coptes du Musée de Boulaq*, Mémoires publiés par les membres de la Mission archéol. française au Caire, III, 3 (Paris, 1889), pl. VI, fig. 7.

NOTES TO CHAPTER III

1. *Laudatio Marciani*, II, 21: εὐρυχωρίας, φωτός, χρωμάτων ποικίλων, σχημάτων οἰκοδομίας παντοδαπῶν.

2. *Ibid.*, II, 62: ἀλλὰ καὶ λεπτοῖς καὶ ποικίλοις παραπετάσμασιν ἄλλους ἄλλως ἠρέψαντο τόπους. Cf. *Or. fun. in Proc.*, 26. Alexandrian carpets (*Alexandrina belluata conchyliata tapetia*) were famous in antiquity. See L. Ronchaud, *La tapisserie dans l'antiquité* (Paris, 1884), p. 41; G. Semper, *Der Stil in den technischen und tektonischen Künsten oder praktische Aesthetik*. I. *Textile Kunst*, 2nd ed. (Munich, 1878), p. 258 ff.

3. *Patrol. gr.*, XL, col. 165D: ὅταν οὖν ἐνδυσάμενοι φανῶσιν, ὡς τοῖχοι γεγραμμένοι παρὰ τῶν συντυγχανόντων ὁρῶνται.

4. *Ibid.*, col. 169A: οἰκίας πολυτελοῦς, ψήφῳ καὶ λίθοις καὶ χρυσῷ κατὰ τὰς νύμφας κεκοσμημένης.

5. *Ibid.*, col. 209C: καὶ ὁ ἄλλος . . . πορφυραῖς πλαξὶν τοὺς τοίχους ἐνδύει. Porphyry was often used in later times, e.g., in Nea Moni on the island of Chios: πορφυρόχροα μάρμαρα, *Byzant. Zeitschr.*, V (1896), 152. An inscription found at Caesarea in Palestine mentions πλάκωσις and ψήφωσις (*ibid.*, p. 161).

6. *Patrol. gr.*, LVIII, cols. 750-51; LI, col. 195. Lazarus, who was poor, οὐκ εἶχε τοίχους μαρμαρίοις περιβεβλημένους, οὐδὲ ἔδαφος ψηφῖσι διηνθισμένον.

7. *Patrol. gr.*, LXXVII, col. 648.

8. *Patrol. gr.*, LXXXIII, cols. 617, 720.

9. *Patrol. gr.*, LVII, col. 385; LXII, col. 78.

10. *Vita S. Eutychii*, Acta Sanctorum, Apr. I, p. lxi, § 53.

11. Germano di S. Stanislao, *La casa Celimontana dei SS. martiri Giovanni e Paolo* (Rome, 1894), p. 83 ff. and plan at the end of the book.

12. *Bullet. di archeol. crist.*, I (1863), 3; F. X. Kraus, *Real-Encyklopädie der christlichen Alterthümer*, II (Freiburg i. B., 1886), 961.

13. D. V. Ainalov, *Mozaiki IV i V vekov* (St. Petersburg, 1895), pp. 151-52.

14. *Monuments et mém. Piot*, III (1896), pl. XXI.

15. Germano di S. Stanislao, *op. cit.*, pp. 81-135.

16. *Vita Constantini*, I, 3.

17. J. B. Pitra, *Spicilegium Solesmense*, IV (Paris, 1876), 276.

18. Script. post Theophanem, ed. Bonn, p. 609: κἀντεῦθεν τοὺς εὑρισκομένους ἔχοντας εἰκόνα Χριστοῦ ἢ τῶν ἁγίων δειναῖς τιμωρίαις καὶ θανάτῳ κατεδίκασεν [Leo V].

19. Procopius of Gaza, *Comment. in Isaiam*, Patrol. gr., LXXXVII, col. 2053D: ταῖς γὰρ πρώραις ἀεὶ θεῶν εἰκόνας ἐνέγραφον, ὡς καὶ νῦν ἁγίων μαρτύρων. Cf. Theophanes, ed. Bonn, I, 459: πλοῖα καστελλωμένα, ἔχοντα ἐν τοῖς καταρτίοις κιβώτια καὶ εἰκόνας τῆς θεομήτορος.

20. Mansi, *Sacrorum Cinciliorum nova et amplissima collectio*, XIII, col. 197D: καὶ ὅσα ἐν ταῖς ἀγοραῖς πόλεων κατὰ κόσμον εἰσὶ καὶ εὐπρέπειαν οἱαδήποτε ὁμοιώματα.

21. Tertullian, *De corona*, Patrol. lat., II, col. 99. Cf. a homily falsely attributed to John Chrysostom, *Patrol. gr.*, LII, cols. 838-40.

Notes

22. Mansi, XIII, col. 8D.
23. "Tot locis pictum": Augustine, Contra Faustum, Patrol. lat., XLII, col. 446.
24. Mansi, XIII, col. 46B: καὶ διὰ τὸν Χριστὸν καὶ τὰ Χριστοῦ πάθη ἐν ἐκκλησίαις, ἐν οἴκοις, καὶ ἀγοραῖς, καὶ ἐν σινδόσι, καὶ ἐν ταμιείοις, καὶ ἱματίοις, καὶ ἐν παντὶ τόπῳ ἐκτυποῦμεν.
25. R. Garrucci, Storia dell'arte cristiana, I (Prato, 1872), 594: εἰς πάντα τοῖχον τοῦ οἴκου αὐτῆς τούτους ἀνέγραψεν.
26. Vita Constantini, III, 49: ἐν αὐτοῖς τοῖς ἀνακτόροις τῶν βασιλείων, κατὰ τὸν πάντων ἐξοχώτατον οἶκον τῆς πρὸς τῷ ὀρόφῳ κεχρυσωμένης φατνώσεως κατὰ τὸ μεσαίτατον, μεγίστου πίνακος ἀνηπλωμένου μέσον ἐμπεπῆχθαι τὸ τοῦ σωτηρίου πάθους σύμβολον.
27. Ibid., IV, 15: ἐν αὐτοῖς δὲ βασιλείοις κατά τινας πόλεις ἐν ταῖς εἰς τὸ μετέωρον τῶν προπύλων ἀνακειμέναις εἰκόσιν ἑστὼς ὄρθιος ἐγράφετο.
28. Ibid., III, 3: πίνακι πρὸ τῶν βασιλικῶν προθύρων ἀνακειμένῳ. J. P. Richter, Quellen der byzant. Kunstgeschichte (Vienna, 1897), p. 257, connects this text with the Chalke of the Imperial Palace.
29. Patrol. gr., LXXXVI, col. 2745B: ἀνετέθη τοίνυν καὶ εἰκὼν ἀνὰ τὸν ὄροφον τῶν ἀνακτόρων.
30. C. Woermann, Die Landschaft in der Kunst der alten Völker (Munich, 1876), p. 303.
31. Mozaiki IV i V vekov, pp. 6, 13, 14.
32. W. R. von Hartel and F. Wickhoff, Die Wiener Genesis (Vienna, 1895), pp. 86-87.
33. Imagines, I, 5: περὶ τὸν Νεῖλον οἱ πήχεις ἀθύρουσι, παιδία ξύμμετρα τῷ ὀνόματι.
34. Ainalov, Mozaiki IV i V vekov, pp. 13-14. [On Sta. Costanza see H. Stern, "Les mosaïques de l'église de Sainte-Constance à Rome," Dumbarton Oaks Papers, XII (1958), 157 ff.]
35. Garrucci, VI, pl. 461, 2.
36. Héron de Villefosse, Mélanges d'archéologie et d'art (Paris, 1893), p. 181.
37. F. Niccolini, Le case ed i monumenti di Pompei (Naples, 1854-1896), III. Nuovi scavi, pls. XI, XII; M. I. Rostovtsev, O noveishikh raskopkakh v Pompeiakh (St. Petersburg, 1894), p. 17.
38. Imagines, I, 9: ἡνιοχεῖσθαι δὲ τοὺς κύκνους ὑπὸ τῶν Ἐρώτων θαῦμα οὐδέν.
39. Monuments et mém. Piot, III (1896), p. 198, Fig. 5. The floor mosaic of a synagogue discovered at Hammam-Lif, 15 kilometers from Tunis, also represents fish, ducks, and flowers in the water: Rev. archéol., Sér. 3, III (1884), pl. VII-VIII.
40. Museo Español de antigüedades, I, 168, color plate.
41. Riegl, "Zur Frage des Nachlebens der altägyptischen Kunst in der späten Antike," Versamml. deutsch. Phil. und Schulmänner in Wien, 1893, pp. 191-97; id., Stilfragen (Berlin, 1893), p. 38, Fig. 2.
42. Portfolio of Egyptian Art, part 4; Riegl, "Nachleb. d. altägypt. Kunst," p. 192 ff.
43. Ainalov, Mozaiki IV i V vekov, p. 13.
44. E. Bertrand, Un critique d'art dans l'antiqué. Philostrate et son école (Paris, 1881), p. 273 ff.
45. Laud. Marc. II, 50-51.

46. *Patrol. gr.*, LXXIX, col. 577C: κατὰ δὲ τὴν θάλατταν χαλώμενα δίκτυα, καὶ πᾶν γένος ἰχθύων ἁλιευόμενα . . . χεϱσὶν ἁλιευτικαῖς.
47. Ainalov, *Mozaiki IV i V vekov*, p. 14 and p. 15, Fig. 2.
48. *Loc. cit.*
49. G. G. Ciampini, *Vetera monimenta*, I (Rome, 1690), 242, pl. XXII ff.
50. Garrucci, V, pl. 298, 3.
51. *Patrol. gr.* C, cols. 1113, 1120. Cf. V. G. Vasil'evskii, "Zhitie Stefana Novogo," *Zhurnal Minist. Narodn. Prosv.*, June 1877, pp. 306-7; N. P. Kondakov, *Vizantiiskie tserkvi i pamiatniki Konstantinopolia* (Odessa, 1886), p. 50, note 1.
52. Theophanes Continuatus, ed. Bonn, pp. 99-100: ἐντεῦθεν οὖν καθῃϱοῦντο μὲν κατὰ πᾶσαν ἐκκλησίαν αἱ θεῖαι μοϱφαί, θηϱία δὲ καὶ ὄϱνιθες ἀντὶ τούτων ἀνεστηλοῦντο καὶ ἐνεγϱάφοντο. The Life of St. Stephen the Younger says the same concerning the church of the Blachernae in which sacred images were replaced by pictures of trees and birds, so that the church came to look like an aviary (*Patrol. gr.*, C, col. 1120).
53. *Odyssey*, VII, 115.
54. *Laud. Marc.* I, 34-37.
55. [See Mabel M. Gabriel, *Livia's Garden Room at Prima Porta* (New York, 1955).]
56. A. Mau, "Scavi di Pompei, 1892-93," *Röm. Mittheilungen*, IX (1894), 51. Woermann (*Die Landschaft in d. Kunst d. alten Völker*, p. 304) mentions a mosaic at Baiae representing a garden, a lattice, and birds.
57. W. Helbig, *Untersuchungen über die campanische Wandmalerei* (Leipzig, 1873), pp. 281, 288-9.
58. *Antike Denkmäler*, V, 11, 24; Daremberg and Saglio, *Dict. des antiquités grecques et romaines*, III, 1, *s.v.* "hortus," p. 286.
59. E. K. Redin, *Mozaiki Ravennskikh tserkvei* (St. Petersburg, 1896), p. 207, note 6.
60. *Byzant. Zeitschr.*, V (1896), 482.
61. Ainalov, *Mozaiki IV i V vekov*, p. 163. [F. Reggiori, *La Basilica Ambrosiana* (Milan, 1941), p. 216 ff.]
62. Ch. Texier and R. P. Pullan, *Byzantine Architecture* (London, 1864), p. 136 ff.; L. Duchesne and Ch. Bayet, *Mémoires sur une mission au Mont Athos* (Paris, 1876), p. 319 ff.
63. Note, for example, the central arch and lateral barrel vaults in Texier and Pullan, *op. cit.*, pl. XXX.
64. *Ibid.*, pls. XXX, XXXII (= our Fig. 96).
65. *Röm. Mittheilungen*, VIII (1893), 291-2.
66. Ed. J. F. Boissonade (Paris, 1846), p. 158.
67. J. Strzygowski, *Die Calenderbilder des Chronographen vom Jahre 354* (Berlin, 1888), pls. IX, X, XI. [See now H. Stern, *Le Calendrier de 354* (Paris, 1953).]
68. Strzygowski, *op. cit.*, pls. XXXIV, XXXV.
69. H. Holtzinger, *Die altchristliche Architektur* (Stuttgart, 1889), p. 123, Fig. 96.
70. *Byzantine Architecture*, p. 138.
71. [According to the latest investigations, these mosaics are said to date from the reign of Theodosius I (379-395). See H. Torp, "Quelques remarques sur les mosaïques de l'église Saint-Georges à Thessalonique,"

Notes

Πεπραγμένα τοῦ Θ'Διεθνοῦς Βυζαντινολογιχοῦ Συνεδρίου, I (Athens, 1954), 489 ff.]

72. Ch. Bayet, *L'art byzantin*, 2nd ed. (Paris, 1883), p. 168.
73. Strzygowski, *Das Etschmiadzin-Evangeliar*, Byzantinische Denkmäler, I (Vienna, 1891), pl. VI (= our Fig. 46); Ainalov, "Chast' Ravennskogo diptikha v sobranii grafa Krauforda," *Vizant. Vremennik*, V (1898), 163 ff.
74. Melchior de Vogüé, *Les églises de la Terre Sainte* (Paris, 1860), p. 87 ff., believes that all the mosaics of the Bethlehem basilica, both with Greek and Latin inscriptions, were made by Byzantine artists in the twelfth century. [This is also the view of O. M. Dalton in W. Harvey *et al.*, *The Church of the Nativity at Bethlehem* (London, 1910), p. 49 ff. H. Stern, on the other hand, dates the mosaics of the north wall to *ca.* A.D. 700 and those of the south wall to the twelfth century: *Byzantion*, XI (1936), 151 ff.; XIII (1938), 415 ff.; *Cahiers archéologiques*, III (1948), 82 ff. Stern is followed by A. Grabar, *L'iconoclasme byzantin* (Paris, 1957), p. 50 ff.]
75. Cf. the representation of such a building in the manuscript of the monk James, Par. gr. 1208: V. V. Stasov, *Slavianskii i vostochnyi ornament* (St. Petersburg, 1887), pl. CXXV, 4. [J. Ebersolt, *La miniature byzantine* (Paris, 1926), pl. XXXV, 1.]
76. A. S. Uvarov, *Vizantiiskii al'bom* (Moscow, 1890), pl. XX. [H. Omont, *Miniatures des plus anciens manuscrits grecs de la Bibl. Nationale* (Paris, 1929), pl. L.]
77. Cf. Strzygowski, *Das Etschmiadzin-Evangeliar*, pp. 115-6.
78. [See Ainalov, "Sinaiskiia ikony voskovoi zhivopisi," *Vizant. Vremennik*, IX (1902), 343 ff.]
79. W. M. Flinders Petrie, *Hawara, Biamhu and Arsinoe* (London, 1889), frontispiece and pl. X.
80. *Antike Porträts. Die hellenistischen Bildnisse aus dem Fajjum* (Leipzig, 1893), pp. 60-61.
81. Theophanes, ed. Bonn, I, 624: ἔνθα καὶ σεβάσμιοι αὐτῶν [*sc.* πατέρων] χαρακτῆρες ἀνεστήλωντο μέχρι τοῦ νῦν ὑπὸ τῶν ὁμοφρόνων αὐτοῖς τιμώμενοι. *Hodoeporicon S. Willibaldi* (T. Tobler and A. Molinier, *Itinera Hierosolymitana et descriptiones Terrae Sanctae*, I, 2 (Geneva, 1880), p. 272: "Et inde venit ad urbem Niceam, ubi olim habebat cesar Constantinus synodum. Et ibi fuerunt ad synodum trecenti decem et octo episcopi . . . Et in illa ecclesia erant imagines episcoporum, qui erant ibi in synodo."
82. Medallion portraits of Symeon and Anna, full-length portraits of Zacharias, Elizabeth, etc. (= our Fig. 26).
83. S. A. Usov, *Sochineniia* (Moscow, 1888-1892), II, 52.
84. Ia. I. Smirnov, "Khristianskie mozaiki Kipra," *Vizant. Vremennik*, IV (1897), 74.
85. N. P. Kondakov, *Puteshestvie na Sinai* (Odessa, 1882), p. 84.
86. W. Helbig, *Das homerische Epos aus den Denkmälern erläutert*, 2nd ed. (Leipzig, 1887), pp. 107, 433; G. Semper, *Der Stil in den technischen und tektonischen Künsten*, 2nd ed., I, 369, 376, 470, 478; N. P. Kondakov, *Vizantiiskie emali. Sobranie A. V. Zvenigorodskogo* (St. Petersburg, 1892), p. 12.

The Hellenistic Origins of Byzantine Art

87. Migne, *Dictionnaire des manuscrits* (Paris, 1853), I, 1191; Holtzinger, *Die altchristliche Architektur*, p. 53.

88. *Laud. Marc.* I, 40: χρυσὸς δὲ περιανθεῖ τὰς ἁψίδας, τὰς μὲν αὐτὸς ὡραΐζων, τὰς δὲ μίξει κυανοῦ χρώματος ἐναλλὰξ πεποιημένου φαιδρύνων, ὡς ἐν μέρει καλλωπίζεσθαι καὶ κοσμεῖν.

89. *Vita Constantini*, III, 50: ὃν [*sc.* εὐκτήριον] καὶ χρυσοῦ πλείονος ἀφθονίᾳ χαλκοῦ τε καὶ τῆς λοιπῆς πολυτελοῦς ὕλης ἐστεφάνου κάλλεσιν.

90. Kondakov, *Vizantiiskie tserkvi i pamiatniki Konstantinopolia*, pp. 44, 58; Ainalov, *Mozaiki IV i V vekov*, p. 170.

91. *Laud. Marc.* I, 29: ἡ μὲν ὑποχρύσῳ καὶ ἀργυρίτιδι ψηφίδι κεκοσμημένη.

92. Subsequently, silver is used for backgrounds in the mosaics of the nave of S. Marco and those of Fethiye Camii at Constantinople. In manuscripts, too, silver is seldom used. It is found, for example, in the frames of the miniatures of the Paris Psalter. The use of silver mosaic in the West is attested by a recipe for its manufacture, found in a manuscript of the 8th or 9th century, published by Muratori, *Antiquitates Italicae*, II (Milan, 1739), col. 365 ff.: *Compositiones ad tingenda musiva, pelles at alia.* A silver inscription occurs in the mosaic of Germigny-des-Prés: E. Gerspach, *La mosaïque* (Paris, n.d.), p. 80.

93. F. I. Uspenskii in *Izvest. Russk. Arkheol. Inst. v Konstant.*, XIV (1909), 1 ff.

NOTES TO CHAPTER IV

1. The cities that were robbed of statues by Constantine the Great are enumerated by G. Codinus, *De signis*, ed. Bonn, p. 53.

2. See above, p. 182 ff.

3. *Byzant. Zeitschr.* I (1892), 582 ff.; *id.*, "Das Berliner Moses-Relief," *Jahrb. d. Königl. Preuss. Kunstsammlungen*, XIV (1893), 75 ff.

4. N. P. Kondakov, *Vizantiiskie tserkvi i pamiatniki Konstantinopolia* (Odessa, 1886), pp. 221-29.

5. D. V. Ainalov, "Otchet o zagranichnoi komandirovke na Afon," *Zapiski Imp. Kazanskogo Univ.*, 1897, offprint, p. 2. [C. R. Morey, *The Sarcophagus of Claudia Antonia Sabina and the Asiatic Sarcophagi, Sardis*, V, part 1 (Princeton, 1924), p. 30 and Fig. 25; J. Kollwitz, *Oströmische Plastik der Theodosianischen Zeit* (Berlin, 1941), p. 166 ff. and pl. 50.]

6. *Byzant. Zeitschr.*, I (1892), 581-2.

7. Ainalov, "Vizantiiskie pamiatniki Afona," *Vizant. Vremennik*, VI (1899), 58-9.

8. *Mozaiki IV i V vekov* (St. Petersburg, 1895), p. 44 ff.

9. *La basilica di S. Marco in Venezia* (ed. F. Ongania), *Dettagli di altari, monumenti*, etc., V (Venice, 1881), pl. 204.

10. Strzygowski, "Das Petrus-Relief aus Kleinasien im Berliner Museum," *Jahrb. d. K. Preuss. Kunstsammlungen*, XXII (1901), 29 ff.

11. R. Garrucci, *Storia dell'arte cristiana*, V (Prato) 1879, pl. 330, 3.

12. Cf. H. Holtzinger, *Die altchristliche Architektur* (Stuttgart, 1889), pp. 46-7.

13. F. X. Kraus, *Geschichte der christlichen Kunst* (Freiburg im B., 1896), I, 548.

Notes

14. W. Salzenberg, *Altchristliche Baudenkmale von Constantinopel* (Berlin, 1854), pls. XX, 7; XXXVIII, 2.
15. [G. Mendel, "Le musée de Konia," *Bull. de corresp. hellénique*, XXVI (1902), 225; C. R. Morey, *The Sarcophagus of Claudia Antonia Sabina*, p. 33 and Fig. 36.]
16. *Bull. di archeol. crist.*, Ser. 4, V (1887), 145; Ser. 4, VI (1888-89), 93.
17. [*Vizantiiskie tserkvi i pamiatniki Konstantinopolia*, p. 229.]
18. *Bull. di archeol. crist.*, Ser. 4, V (1887), 136 ff. and pls. XI-XII.
19. *Vita Constantini*, III, 49; Εἶδες δ'ἂν ἐπὶ μέσον ἀγορῶν κειμέναις κρήναις τὰ τοῦ καλοῦ ποιμένος σύμβολα, τοῖς ἀπὸ τῶν θείων λογίων ὁρμωμένοις γνώριμα, τόν τε Δανιὴλ σὺν αὐτοῖς λέοσιν ἐν χαλκῷ πεπλασμένον χρυσοῖς τε πετάλοις ἐκλάμποντα. The same statue of Daniel appears to be mentioned in a poem by Theophanes (ed. Bonn, I, p. liii).
20. [*Byzant. Zeitschr.*, I (1892), pl. I.]
21. Cf. Strzygowski in *Römische Quartalschrift*, IV (1890), 104-6.
22. X. Barbier de Montault, *Inventaire de la basilique royale de Monza* (Tours, 1883), I, 11: "Quae olea sancta temporibus domini Gregorii papae adduxit Johannes indignus et peccator domnae Theodelindae reginae de Roma."
23. *Op. cit.*, I, 566.
24. [The correct reading appears to be ΕΥΛΟΓΙΑ ΤΗC ΘΕΟΤΟΚΟΥ ΤΗC ΠΕΤΡΑC ΒΟΥΔΙΑΜ: A. Grabar, *Ampoules de Terre Sainte* (Paris, 1958), p. 31.]
25. V. V. Latyshev, *Grecheskie i latinskie nadpisi naidennye v Iuzhnoi Rossii*, Materialy po arkheologii Rossii, No. 23 (1889), pp. 30-41.
26. Garrucci, I, 566: ληκύθιον τὸ παρὰ πολλῶν μαρτύρων συνελεγμένην ἔχον τὴν εὐλογίαν.
27. Ainalov, *Mozaiki IV i V vekov*, pp. 50-1, 66-7.
28. A. Molinier and C. Kohler, *Itinera Hierosolymitana et descriptiones Terrae Sanctae*, II (Geneva, 1885), 146: "In medio autem templi atrium cum columnis pretiosorum lapidum tereti circulo mire exornavit, et vestibulum, quod erat ante atrium, vestivit variis lapidibus lactei coloris cum coelaturis suis. Parietes autem totius aedificii, atrii et vestibuli circumquaque in circuitu per girum pulchris picturis decorare studuit."
29. *De laudibus Constantini*, IX, 17: τῷ δὲ τῆς ὑστάτης ἀναλήψεως τὴν ἐπὶ τῆς ἀκρωρείας μνήμην σεμνύνων . . . βασιλεὺς ἐκόσμει. Cf. V. G. Vasil'evskii, *Povest' Epifaniia*, Pravosl. Palest. Sbornik, XI, 207 ff.; I. V. Pomialovskii, *Peregrinatio ad loca sancta*, Pravosl. Palest. Sbornik, XX, 250.
30. Eusebius, *Vita Const.*, III, 41, 43.
31. Ed. Pomialovskii, *op. cit.*, XX, 145.
32. *Ibid.*, p. 253.
33. Vasil'evskii, *op. cit.*, XI, 94.
34. A. S. Norov, *Puteshestvie igumena Daniila* (St. Petersburg, 1864), p. 76; M. A. Venevitinov, *Zhit'e i khozen'e Danila Rus'skyia zemli igumena*, Pravosl. Palest. Sbornik, III, 9 (St. Petersburg, 1883), 58.
35. Ed. Pomialovskii, *op. cit.*, XX, 91. In the pilgrimage of Paula (T. Tobler, *Itinera et descriptiones Terrae Sanctae*, I [Geneva, 1877], 38), Nazareth is named *nutricula domini*, an expression which, consider-

ing the brevity of Jerome's indications, may refer to Joseph's house. A. S. Uvarov in *Drevnosti. Trudy Mosk. Arkheol. Obshchestva*, I (1865-67), 222, cites another text of Jerome concerning two churches at Nazareth; this indication is lacking in the excellent work of I. V. Pomialovskii, Pravosl. Palest. Sbornik, XIII, No. 732.

36. [P. Geyer, *Itinera Hierosolymitana* (*Corpus script. eccles. lat.*, XXXVIII) (Prague, Vienna, Leipzig, 1898), p. 112.]

37. Tobler, *Itinera*, I, 184; Pomialovskii, *Arkul'fa razskaz o sviatykh mestakh*, Pravosl. Palest. Sbornik, XLIX, 98.

38. Tobler, *Itinera*, I, 68.

39. Vasil'evskii, *op. cit.*, XI, 237-8.

40. Pomialovskii, *Feodosii o mestopolozhenii Sviatoi Zemli*, Pravosl. Palest. Sbornik, XXVIII, 79-80.

41. *Op. cit.*, VI, pls. 433, 7, 9; 434, 1.

42. Garrucci, VI, pl. 434, 1.

43. Tobler, *Itinera*, I, 53, 107. Eucherius says: ". . . presepe Domini, exornatum insuper argento atque auro, fulgenti cella ambitur."

44. A. N. Didron, *Manuel d'iconographie chrétienne* (Paris, 1845), p. 4, note.

45. Molinier and Kohler, *Itinera*, II, 209.

46. Vasil'evskii, *op. cit.*, XI, 3, 124.

47. Ἐπιστολὴ συνοδικὴ τῶν ἁγιωτάτων πατριαρχῶν πρὸς Θεόφιλον, ed. M. Sakkelion (Athens, 1864), p. 30: μέγιστον ναὸν τῆς Θεομήτορος ἀνεγείρασα καὶ τῷ πρὸς δύσιν ἔξωθεν μέρει μουσουργικοῖς ψηφώμασιν ἐξεικονίσασα τὴν ἁγίαν Χριστοῦ γέννησιν καὶ τὴν Θεομήτορα ἐγκόλπιον φέρουσαν τὸ ζωοφόρον βρέφος καὶ τὴν τῶν μάγων μετὰ δώρων προσκύνησιν.

48. Ia. I. Smirnov, "Khristianskie mozaiki Kipra," *Vizant. Vremennik*, IV (1897), pl. I.

49. E. A. Sophocles, *Greek Lexicon of the Roman and Byzantine Periods*, *s.v.* ἐγκόλπιος, ἐγκόλπιον = on the bosom, phylactery; ἐγκολπίζομαι = to embrace.

50. *Das Etschmiadzin-Evangeliar*, Byzantinische Denkmäler, I (Vienna, 1891), 72.

51. St. Jerome, who visited the grotto together with Paula, says: ". . . me audiente, iurabat cernere se oculis fidei infantem pannis involutum, vagientem in presepe Dominum, magos adorantes, stellam fulgentem desuper, matrem virginem, nutritium sedulum, pastores nocte venientes."

52. Vasil'evskii, *op. cit.*, XI, 3, 124.

53. Pravosl. Palest. Sbornik, XXIII, 57.

54. Venevitinov, *op. cit.*, III, 65.

55. Pravosl. Palest. Sbornik, XXIII, 25: γέγραπτο γὰρ περὶ τὴν ἀψίδα, ἐν ᾗ τὸ μέγα τοῦ κόσμου μυστήριον, etc.

56. *Ibid.*, p. 26: οἱ δὲ μάγοι τῶν ἵππων ἀποθρώξαντες, καὶ τὰ δῶρα λαβόμενοι ἐν χειροῖν, τὸ γόνυ κλίναντες, ἐν τρόμῳ ταῦτα τῇ Παρθένῳ προσφέρουσι.

57. "Khristianskie mozaiki Kipra," pp. 91-2.

58. Garrucci, VI, pl. 433, 7.

59. Ed. J. F. Boissonade, p. 91 ff.

60. Tobler, *Descriptiones Terrae Sanctae* (Leipzig, 1874), p. 248.

Notes

61. Tobler, *Bethlehem in Palästina* (St. Gallen and Bern, 1849), p. 115 ff.; G. G. Ciampini, *De sacris aedificiis a Constantino Magno constructis* (Rome, 1693), pp. 151-2.
62. Pravosl. Palest. Sbornik, XLV, 12.
63. This star is similar to the monogram of Christ without the *rho* that is so common in Byzantine art of the 11th-12th centuries. According to legend, the star of the Magi fell into a well that was either inside or outside the cave. Gregory of Tours, who heard this story from eye-witnesses, says that the star moved from one side of the well to the other: "videt stellam ab uno pariete putei super aquas transmigrare ad alium" (Molinier and Kohler, *Itinera*, II, 247). Willibald (A.D. 723-26) repeats the same story: "vidit in superficie aque ire a margine usque ad marginem figuram stelle, que magis nato Domino apparuit" (T. Tobler and A. Molinier, *Itinera Hierosolymitana et descriptiones Terrae Sanctae*, I, 2 [Geneva, 1880], p. 292). Epiphanius saw the star in a well to the north of the cave: Vasil'evskii, *op. cit.*, XI, 124-5. Saewulf (early 12th century) saw it in a cistern. The legend is probably due to a patterned pavement at the bottom of the well.
64. Garrucci, VI, pl. 437, 5.
65. An entrance pavilion on columns is described by Daniel, metropolitan of Ephesus: Pravosl. Palest. Sbornik, VIII, 52.
66. Pravosl. Palest. Sbornik, XXIII, 7, 36.
67. Pomialovskii, *Putnik Antonina iz Platsentsii*, Pravosl. Palest. Sbornik, XXXIX, 55.
68. Tobler, *Itinera*, I, 103, 106. Concerning the columns near Golgotha, see Vasil'evskii, *op. cit.*, XI, pp. 93-5.
69. Kondakov, *Vizantiiskie emali. Sobranie A. V. Zvenigorodskogo* (St. Petersburg, 1892), pp. 148-9.
70. Garrucci, VI, pl. 434, 4.
71. Ainalov, *Mozaiki IV i V vekov*, pp. 44-53.
72. According to legend, St. Helena preserved the various flowers that were used to decorate the Holy Cross and planted them in pots: Codinus, *De aedificiis*, ed. Bonn, p. 73.
73. VI, pl. 434, 4.
74. *Ibid.*, pls. 434, 4; 435, 1.
75. Pravosl. Palest. Sbornik, XX, 242-3, note 39: "cancello interiore, qui est in spelunca Anastasis."
76. Pravosl. Palest. Sbornik, XLIX, 6: "Hujus tugurioli . . . exterius summum culmen auro ornatum, auream non parvam sustentat crucem."
77. C. Mommert has drawn attention to the representation of the rotunda of the Holy Sepulcher on the Madaba map: *Mittheilungen und Nachrichten d. deutsch. Palästina-Vereins*, 1898, pp. 10-11 and Fig. 1. I have not had access to this author's *Die heilige Grabeskirche zu Jerusalem* (Leipzig, 1898).
78. Ainalov, "Detali palestinskoi arkhitektury i topografii na pamiatnikakh khristianskogo iskusstva," *Soobshcheniia Prav. Palest. Obshch.*, Feb. 1894, offprint, p. 12 ff.; Vasil'evskii, *op. cit.*, XI, 37-8.
79. Tobler, *Itinera*, I, 58; Pravosl. Palest. Sbornik, XXXIX, 71.
80. Tobler, *Itinera*, I, 101.
81. *Ibid.*, p. 148.

82. *Ibid.*, pp. 32, 58; Pravosl. Palest. Sbornik, XXXIX, 70.
83. [Garrucci, VI, pl. 434, 3.]
84. *Ibid.*, VI, pl. 434, 6.
85. *Ibid.*, I, pp. 403, 409, 466, 567-8.
86. E. Bertrand, *Un critique d'art dans l'antiquité. Philostrate et son école* (Paris, 1881), p. 359.
87. Ainalov, *Mozaiki IV i V vekov*, pp. 15, 20, 139, etc.
88. L. Duchesne and Ch. Bayet, *Mémoire sur une mission au Mont Athos* (Paris, 1876), pls. I-IV.
89. [See G. Mendel in *Bull. de corresp. hellénique*, XXVI (1902), 225-6 and Fig. 6.]
90. Tobler, *Itinera*, I, 102: "Et dum adoratur crux . . . offertur oleum ad benedicendum ampullis mediis; hora vero qua tetigerit lignum crucis has ampullas, mox ebullit oleum foras, et nisi citius claudantur, totum refunditur foras." Cf. Pravosl. Palest. Sbornik, XXXIX, p. 70, note.
91. *Patrol. gr.*, LXXXVI, col. 2328: ἔχρισεν ἀμφοτέρους τῷ ἁγίῳ ἐλαίῳ τοῦ τε τιμίου σταυροῦ, etc.
92. Tobler, *Itinera*, I, 101.
93. *Ibid.*, p. 113.
94. *Ibid.*, p. 98.
95. *Bull. di archeol. crist.*, Ser. 5, I (1890), 150. A photograph of this interesting ampulla has been published by Barbier de Montault in *Bull. monumental*, 1883, p. 114.
96. Ainalov, "Stseny iz zhizni Bogoroditsy na sarkofage Adelfia," Mosk. Arkheol. Obshchestvo, *Arkheol. Izvest. i Zametki*, 1895, offprint, p. 4.
97. [See above, note 24.]
98. *Byzant. Zeitschrift*, II (1893), 187-8. Republished by Ia. I. Smirnov, *Serebrianoe siriiskoe bliudo, naidennoe v Permskom krae*, Materialy po arkheol. Rossii, No. 22 (1899), Fig. 8.
99. Garrucci, VI, pl. 434, 4.
100. Theophanes, ed. Bonn, I, 244; J. A. Cramer, *Anecdota graeca e codd. mss. Bibl. Reg. Parisiensis*, II (Oxford, 1839), 108.
101. See above, p. 136. This has also been pointed out by G. Stuhlfauth, *Die altchristliche Elfenbeinplastik* (Freiburg i. B. and Leipzig, 1896), p. 146; id., *Die Engel in der altchristlichen Kunst* (Freiburg i. B., 1897), p. 145.
102. [See E. M. Pridik in *Zhurnal Minist. Narodn. Prosveshchenia*, Aug. 1901, pp. 91-96; Ainalov, *ibid.*, Dec. 1901, pp. 133-36.]
103. *L'ancienne Alexandrie* (Paris, 1888), p. 46.
104. *Revue des études grecques*, IV (1891), 287 ff.; V (1892), 73 ff., Nos. 1, 10; Nos. 7, 9 have one lion standing on all four legs. Garrucci, I, p. 566 mentions a seal "de cera sancta" at Monza representing two confronted lions.
105. Garrucci, VI, pl. 434, 2.
106. Materialy po arkheol. Rossii, No. 22 (St. Petersburg, 1899), plate (= our Fig. 117).
107. Garrucci, VI, pl. 480, 5, 6.
108. Strzygowski, *Das Etschmiadzin-Evangeliar*, pl. VII (= our Fig. 70); Ainalov, *Mozaiki IV i V vekov*, pp. 121, 160.

Notes

109. Garrucci, IV, pl. 239, 6, 7.
110. [Fol. 8ᵛ.]
111. κρασπέδου λαμβανομένη, to use the words of Asterius of Amasia, *Patrol. gr.*, XL, col. 168A-B.
112. *Ibid.*: τὴν ἁμαρτωλὸν τοῖς ποσὶν τοῦ 'Ιησοῦ προσπίπτουσαν.
113. See above, p. 148.
114. Ainalov, *Mozaiki IV i V vekov*, p. 120; H. Cohen, *Description historique des monnaies frappées sous l'Empire romain* (Paris, 1859), III, pl. XI, 523; XVI, 8.
115. Garrucci, VI, pl. 479, 3; Kondakov, *Russkie klady*, I (St. Petersburg, 1896), 190, 192-3.
116. Kondakov, *Vizantiiskie emali*, p. 247, Fig. 90.
117. *Rev. des études grecques*, V (1892), 77.
118. Garrucci, VI, pl. 480, 5, 6.
119. On the gold medallion from Reggio see *Mélanges d'archéol. et d'histoire* (Ecole française de Rome), X (1890), 302. Medallion from Achmim-Panopolis: R. Forrer, *Die frühchristliche Alterthümer aus dem Gräberfelde von Achmim-Panopolis* (Strasbourg, 1893), pl. XIII, 4. Medallion acquired in Rome: Garrucci, VI, pl. 435, 7. Stuhlfauth, *Die Engel*, p. 145, note 3, considers the first two to be Palestinian.
120. The description given here is based on data kindly communicated by P. D. Pogodin. The inside dimensions of the mausoleum are as follows: length, 2.80 m.; width, 2.77 m.; height, 1.97 m.
121. Garrucci, V, pls. 391, 3; 392, 1, 2, 3.
122. Tobler, *Itinera*, I, 149; I. V. Pomialovskii, *Arkul'fa razskaz o sviatykh mestakh*, Pravosl. Palest. Sbornik, XLIX, pls. I-IV, reproducing plans from manuscripts of the 9th and 10th centuries.
123. *Byzant. Zeitschr.*, IV (1895), 331: ὥσπερ γὰρ τὸ τῆς ἀστραπῆς φέγγος εἴδαμεν ἐπιλάμψαν τῷ τόπῳ· οἱ δὲ ἥλοι ἔλαμψαν ὥσπερ χρυσοῦ δίκην ἐξαστράπτοντες.
124. A. Banduri, *Imperium orientale* (Paris, 1711), II, 488-9: ἔνθα καὶ τῶν δύο λῃστῶν τῶν συσταυρωθέντων τῷ Χριστῷ αὐτῷ τῷ τόπῳ κεχωσμένοι εἰσὶν ἕως τῆς σήμερον. Cf. Codinus, *De signis*, ed. Bonn, p. 30; Th. Preger, *Anonymi byzantini* Παραστάσεις σύντομοι χρονικαί (Munich, 1898), p. 10, §23. This is also repeated by Suidas.
125. *Bull. di archeol. crist.*, Ser. 3, IV (1879), 30.
126. Materialy po arkheol. Rossii, No. 22, p. 38.
127. Rohault de Fleury, *La Sainte Vierge* (Paris, 1878), I, pl. XXXII.
128. Materialy po arkheol. Rossii, No. 22, p. 6.
129. Smirnov, *ibid.*, pp. 20-1 supposes that this is the True Cross exposed within the Holy Sepulcher. Such an exhibition of the Cross is mentioned only in the text of the pilgrim Theodosius (Tobler, *Itinera*, I, 64: "ad sanctum sepulcrum . . . ipsa crux ostenditur"), but the passage in question is rightly considered to be a later interpolation. Cf. Pomialovskii in Pravosl. Palest. Sbornik, XXVIII, p. iii.
130. Garrucci, VI, pl. 434, 5.
131. Tolstoi and Kondakov, *Russkiia drevnosti*, III (St. Petersburg, 1890), 76, 86.
132. *Ibid.*, p. 74.

133. P. S. Uvarova, *Khristianskie pamiatniki Kavkaza*, Materialy po arkheol. Kavkaza, IV (Moscow, 1894), pls. VII, VIII; Ainalov, "Nekotorye khristianskie pamiatniki Kavkaza," *Arkheol. Izvest. i Zametki*, 1898, No. 7-8.

134. G. B. de Rossi, *La capsella argentea africana offerta al sommo Pontefice Leone XIII dall' em-o Sig. Card. Lavigerie* (Rome, 1889), pl. I.

135. *Izvest. Russk. Arkheol. Inst. v Konstant.*, I (1896), 77-8.

136. Codinus, *De signis*, ed. Bonn, p. 28. More interesting is the text of the *Parastaseis*, where the cross and the statues of Constantine, Helena, and the two angels are combined into one group: ἔνθεν καὶ ταχυδρόμων δύο καὶ αὐτοῦ Κωνσταντίνου καὶ Ἑλένης ἐκ δεξιῶν καὶ εὐωνύμων σώζονται στῆλαι (Preger, *Anonymi byzantini Παραστάσεις*, p. 8, §16). It appears that these statues stood on the *kamara* of the Forum (*ibid.*, note based on Treu's text: ἐν τῇ ἁψίδι τῆς καμάρας τοῦ φόρου ἵστανται δύο στῆλαι Ἑλένης καὶ Κωνσταντίνου καὶ σταυρὸς ἐν μέσω αὐτῶν γράφων· εἷς ἅγιος, etc.). Lambecius, in his note to this passage (ed. Bonn, p. 232), suggests that the two angels were the ones that appeared to Constantine the Great and said to him, ἐν τούτῳ νίκα. He also refers to an offering made by Constantine in the form of four silver angels holding crosses, described by Anastasius Bibliothecarius. Such angels are represented on a necklace found at Mersin, near Tarsus, and on Byzantine coins: Kondakov, *Russkie klady*, I, pl. XVIII, 3 and p. 192. However, the cross with spheres attached to its ends, which was said to represent the one seen by Constantine in the sky, was in another—the northern—part of the Forum: Codinus, *De signis*, p. 29; Preger, *op. cit.*, p. 8, §16; Banduri, *Imperium orientale*, II, 501. Two sardonyx cameos, one in Russia, the other in the Cabinet des Médailles, Paris, represent two angels holding a cross between them (Garrucci, VI, pl. 479, 13, 14). The composition is close to that of the Stroganov plate. Two capitals from Moissac also represent a cross with an angel on either side; in the center of one of these crosses is a circular medallion with the chrism: Rohault de Fleury, *La messe*, V (Paris, 1887), pl. CDIV.

137. *Jahreshefte des Österreich. Archäol. Instit.*, I (1898), Beiblatt, p. 107.

138. *Patrol. gr.*, LXXXVI, col. 3271.

139. Ainalov, "Tri drevne-khristianskie sosuda iz Kerchi," *Zapiski Russk. Arkheol. Obshchestva*, N.S., V (1892), pl. I; Tolstoi and Kondakov, *Russkiia drevnosti*, IV, Fig. 26. Stuhlfauth, *Die altchristliche Elfenbeinplastik*, p. 93, ascribes this pyxis to the Ravenna school; see, in this connection, my remarks in *Vizant. Vremennik*, VI (1899), 464.

140. The two plaques in the Botkin collection have been published by Strzygowski in *Byz. Zeitschr.*, VIII (1899), 678 ff.

141. Ainalov, "Oblomok piksidy, nakhodiashchiisia v Istoricheskom Muzee," *Arkheol. Izv. i Zametki*, 1891, No. 1.

142. [Now in the John Rylands Library, Manchester. See W. F. Volbach, *Elfenbeinarbeiten der Spätanike und des frühen Mittelalters* (Mainz, 1952), p. 65, No. 127.]

143. F. Stolze, *Die achaem. u. sassan. Denkmäler u. Inschriften v. Persepolis* (Berlin, 1882), I, II, *passim;* G. Perrot and C. Chipiez, *Histoire de l'art dans l'antiquité*, II (Paris, 1884), Figs. 14, 352, etc.

Notes

144. Perrot and Chipiez, *ibid.*, II, Fig. 258. Cf. the representation of a bull on Persian reliefs, Stolze, *op. cit.*, II, 79.
145. Otto Mitius, *Jonas auf den Denkmälern des christlichen Altertums* (Freiburg i. B., 1897), pp. 74-5.
146. *Römische Quartalschrift*, XII (1898), pl. I, Fig. 2.
147. For further details see my articles in *Vizant. Vremennik*, IV (1897) and V (1898).
148. Tolstoi and Kondakov, *Russkiia drevnosti*, IV, 159.
149. *Ibid.*, III, 29, 62.
150. *Ibid.*, III, 16.
151. Cf. the genius on an Assyrian relief in the Louvre: Perrot and Chipiez, *op. cit.*, II, Fig. 226; Stolze, *op. cit.*, II, 85.
152. A. Gayet, *L'art persan* (Paris, 1895), p. 113. [M'shatta is now generally regarded as an Umayyad building of the 8th century. See esp. K. A. C. Creswell, *Early Muslim Architecture*, I (Oxford, 1932), 390 ff.]
153. Gayet, *Les monuments coptes du musée de Boulaq* (Paris, 1889), *passim.*
154. Molinier, *Histoire générale des arts appliqués à l'industrie*, I, *Ivoires* (Paris, 1896), 69-70.
155. Garrucci, I, p. 403.
156. K. Sittl, *Archäologie der Kunst*, p. 788, mentions the Persian architect Hormisdas who worked for the Emperor Constantius in 357. Theophanes, ed. Bonn, I, 230 speaks of a Syropersian painter who was brought from Cyzicus by Anastasius I and who executed paintings of Manichaean content in the palace of Hellenianae, which aroused a popular outbreak. Cf. Kondakov, *Vizantiiskie tserkvi i pamiatniki Konstantinopolia*, pp. 33-4.
157. *Patrol. lat.*, CVI, cols. 603, 607. His visit to Alexandria, *ibid.*, col. 608.
158. *Hist. eccles.*, X, iv, 42.
159. *Patrol. gr.*, XLVI, col. 737D.
160. Τοῦ μακαριωτάτου Θεοδωρήτου ἐπισκόπου Κύρρου ἐπιστολαί, ed. I. Sakkelion (Athens, 1885), p. 270.
161. Ed. Boissonade, pp. 116, 118 ff.
162. Molinier and Kohler, *Itinera*, II, 199, *sub anno* 518.
163. L. Duchesne, "Les missions chrétiennes au sud de l'Empire romain," *Mélanges d'archéol. et d'histoire*, XVI (1896), 87.
164. Little is known concerning the builders of the churches of Jerusalem. Theophanes, ed. Bonn, I, 50, states that the Martyrion was built by the architect Zenobius: Ζηνόβιος ὁ ἀρχιτέκτων, ὁ τὸ Μαρτύριον ἐν Ἱεροσολύμοις οἰκοδομήσας τῇ Κωνσταντίνου ἐπιταγῇ. Jerome ascribes the construction of the Martyrion to Eustathius, a presbyter of Constantinople (*Patrol. lat.*, XXVII, cols. 499-500: "Eustachius Constantinopolitanus presbyter agnoscitur: cuius industria in Hierosolymis martyrium constructum est"), but this is an evident corruption of the same text that is given by Theophanes, who, in the immediately preceding passage (I, 49) speaks of the presbyter Eustathius. It is known that the church of St. Helen in Jerusalem was built by the Patriarch Elias I: *Eutychii Patr. Alexandrini Annales*, trans. Pococke, II, 108.

Earlier, we hear of Alypius of Antioch who had been prefect of Britain and who, in 363, was sent to Jerusalem to restore the Jewish Temple: Molinier and Kohler, *Itinera*, II, 63.

165. [See G. Sotiriou, Τὸ μωσαϊκὸν τῆς Μεταμορφώσεως τοῦ καθολικοῦ τῆς μονῆς τοῦ Σινᾶ, *Atti dello VIII Congr. Internaz. di Studi Bizantini*, II (Rome, 1953), 246 ff.]

166. E. K. Redin, *Mozaiki ravennskikh tserkvei* (St. Petersburg, 1896), pp. 181-2.

167. Kondakov, *Puteshestvie na Sinai* (Odessa, 1882), pp. 75 ff., 88.

168. A. I. Papadopoulos-Kerameus, *Paisiia Agiopolita opisanie Sinaia*, Pravosl. Palest. Sbornik, XXXV, 21, verses 507 ff.

169. *Revue biblique*, VI (1897), 168.

170. Daremberg and Saglio, *Dict. des antiquités grecques et romaines*, II, 2, p. 1251, Fig. 3196, p. 1539 ff.

171. Konrad Miller, *Mappae mundi. Die ältesten Weltkarten* (Stuttgart, 1898), IV, 148, with a reproduction of the Madaba map and bibliography; J. Germer-Durand, *La carte mosaïque de Madaba* (Paris, 1897) with a discussion of the buildings of Jerusalem. On the names of the various towns see E. Stevenson in *Nuovo Bull. di archeol. crist.*, III (1897), 45 ff.; on the representation of Jerusalem see O. Marucchi, *ibid.*, V (1899), 43 ff. and pl. I. [A. Jacoby, *Das geographische Mosaik von Madaba* (Leipzig, 1905); M. Avi-Yonah, *The Madaba Mosaic Map* (Jerusalem, 1954).]

172. Cf. C. Woermann, *Die Landschaft in der Kunst der alten Völker* (Munich, 1876), p. 219; W. Helbig, *Untersuchungen über die campanische Wandmalerei* (Leipzig, 1873), p. 289.

173. Oskar von Gebhardt, *The Miniatures of the Ashburnham Pentateuch* (London, 1883), pls. II, XIII.

174. ἀνεκαινίσθη ὑπὸ 'Ιουστινιανοῦ αὐτοκράτορος τῶν 'Ρωμαίων: *Nuovo bull. di archeol. crist.*, III (1897), 101-2; Clermont-Ganneau, *Recueil d'archéologie orientale*, II (Paris, 1898), 52, 151 ff.

175. Molinier and Kohler, *Itinera*, II, 209; Procopius, *De aedificiis*, ed. Bonn, p. 321 ff.

176. The cisterns built by Justinian are enumerated by Procopius, *De aedificiis*, p. 328.

177. Kondakov, *Puteshestvie na Sinai*, p. 97.

Sources of Illustrations

Note: In the list below, an identifying name of the work is given first, preceded by folio or page number and followed by the code number in the case of manuscripts, then the present location of the actual object. In parentheses following this is the source of the photograph. After the first reference to a book, only the author will be cited.

Fig.

1. Fol. 3ʳ, Nicander manuscript, Ms. Suppl. gr. 247, Bibliothèque Nationale, Paris (Photo from H. Omont, *Miniatures des plus anciens manuscrits grecs de la Bibliothèque Nationale,* Paris, 1929).
2. *Ibid.,* fol. 18ᵛ.
3. *Ibid.,* fol. 47ʳ.
4. *Ibid.,* fol. 48ʳ.
5. Fol. 219ʳ, manuscript of Apollonius of Citium, Plut. LXXIV, 7, Biblioteca Laurenziana, Florence (Photo from H. Schöne, *Apollonius von Kitium,* Leipzig, 1896).
6. *Ibid.,* fol. 235ʳ.
7. Fol. 2ᵛ, manuscript of Ptolemy, Vatic. gr. 1291, Biblioteca Vaticana, Rome (Photo courtesy of the Department of Art and Archaeology, Princeton University).
8. *Ibid.,* fol. 9ʳ.
9. Fol. 272ʳ, *Christian Topography* of Cosmas Indicopleustes, Plut. IX, 28, Biblioteca Laurenziana, Florence (Photo courtesy of the Department of Art and Archaeology, Princeton University).
10. Marble group, Palazzo dei Conservatori, Rome (Photo from Ainalov's original collection).
11. Fol. 66ᵛ, *Christian Topography* of Cosmas Indicopleustes, Vatic. gr. 699, Biblioteca Vaticana, Rome (Photo from C. Stornajolo, *Le miniature della Topografia Cristiana di Cosma Indicopleuste,* Milan, 1908).
12. *Ibid.,* fol. 93ʳ.
13. *Ibid.,* fol. 56ʳ.
14. *Ibid.,* fol. 61ᵛ.

Fig.

15. *Ibid.*, fol. 59ʳ.
16. *Ibid.*, fol. 114ᵛ.
17. *Ibid.*, fol. 89ʳ.
18. *Ibid.*, fol. 43ʳ.
19. *Ibid.*, fol. 38ᵛ.
20. Fol. 67ᵛ, *Sacra Parallela*, Ms. gr. 923, Bibliothèque Nationale; Paris (Photo from K. Weitzmann, *Die byzantinische Buchmalerei des 9 und 10. Jahrhunderts*, Berlin, 1935).
21. Pentecost mosaic, San Marco, Venice (Alinari Photo, No. 13742).
22. Fol. 40ᵛ, *Christian Topography* of Cosmas Indicopleustes (Photo from Stornajolo).
23. Fol. 19ᵛ, Octateuch, Vatic. gr. 746, Biblioteca Vaticana, Rome (Photo courtesy of the Department of Art and Archaeology, Princeton University).
24. *Ibid.*, fol. 22ʳ.
25. Fol. 83ᵛ, *Christian Topography* of Cosmas Indicopleustes (Photo from Stornajolo).
26. *Ibid.*, fol. 76ʳ.
27. Fol. 3ʳ, manuscript of Dioscorides, Medic. gr. 1, Nationalbibliothek, Vienna (Photo from A. von Premerstein *et al.*, *Dioscorides, Codex Aniciae Julianae*, Leyden, 1906).
28. *Ibid.*, fol. 4ᵛ.
29. *Ibid.*, fol. 5ᵛ.
30. *Ibid.*, fol. 6ᵛ.
31. *Ibid.*, fol. 7ᵛ.
32. *Ibid.*, fol. 391ᵛ.
33. Fol. 4ᵛ, Book of Job, Ms. I, B, 18, Biblioteca Nazionale, Naples (Photo Giraudon, No. 31221).
34. Coptic manuscript of the Acts of the Apostles, formerly in the collection of V. S. Golenishchev (Photo from Ainalov's original collection).
35. *Ibid.*
36. *Ibid.*
37. Fol. 14ʳ, Rabula Gospels, Plut. I, 56, Biblioteca Laurenziana, Florence (Photo from C. Cecchelli *et al.*, *The Rabbula Gospels, Facsimile Edition of the Miniatures*, published by Urs Graf-Verlag, Olten and Lausanne [Switzerland], 1960).
38. *Ibid.*, fol. 9ᵛ.
39. *Ibid.*, fol. 13ʳ.
40. *Ibid.*, fol. 13ᵛ.
41. *Ibid.*, fol. 4ʳ.
42. *Ibid.*, fol. 1ᵛ.
43. Fol. 5ᵛ, Gospels, Ms. syr. 33, Bibliothèque Nationale, Paris (Photo from C. Nordenfalk, *Die spätantiken Kanontafeln*, Göteborg, 1938).
44. *Ibid.*, fol. 6ᵛ.
45. Fol. 10ʳ, Etschmiadzin Gospels, Ms. 229, Erevan, Matenadaran (Armenia) (Photo from F. Macler, *L'Evangile arménien. Ed. phototypique du ms. n° 229 de la Bibliothèque d'Etchmiadzin*, Paris, 1920).
46. *Ibid.*, fol. 229ʳ.
47. *Ibid.*, fol. 8ʳ.

Sources of Illustrations

Sources of Illustrations

112. Fragment of sarcophagus, Museum, Konya (Turkey) (Photo from Ainalov's original collection).
113. Clay ampulla, Cathedral Treasury, Monza (Photo from Ainalov's original collection).
114. Byzantine amulet (Photo from *Byzantinische Zeitschrift*, II, 1893).
115. Gnostic amulet (Photo from *Zhurnal Ministerstva Narodnogo Prosveshcheniia*, Aug. 1901).
116. Fresco, Christian mausoleum, Sofia (Photo from Ainalov's original collection).
117. Silver plate found in the region of Perm, Hermitage, Leningrad (Photo from *Materialy po arkheologii Rossii*, No. 22, 1899).
118. Georgian relief from Tsebel'da, Museum of Georgian Art, Tiflis (Photo from Ainalov's original collection).
119. Silver plate formerly in the Stroganov collection in Rome, Hermitage, Leningrad (Photo from Ainalov's original collection).
120. Leaf of ivory diptych, Museo Nazionale, Ravenna (Photo Giraudon, No. 30957).
121. Part of Ravenna diptych, formerly in the Stroganov collection, Rome (Photo from *Vizantiiskii Vremennik*, V, 1898).
122. Part of Ravenna diptych, John Rylands Library, Manchester (Photo from *Vizantiiskii Vremennik*, V, 1898).
123. Fragments of ivory pyxis, Museum of Fine Arts, Moscow (Photo copyright Museum of Fine Arts, Moscow).
124. Apse mosaic, Monastery of St. Catherine, Mount Sinai (Photo courtesy of the Sinai Expedition of the Universities of Alexandria, Michigan, and Princeton).
125. Mosaic map, Madaba (Photo from A. Jacoby, *Das geographische Mosaik von Madaba*, Leipzig, 1905).
126. Fol. 219r, Psalter, Cod. Barb. gr. 372, Biblioteca Vaticana, Rome (Photo courtesy of the Department of Art and Archaeology, Princeton University).
127. Fol. 23r, Octateuch, Cod. Vatic. gr. 746, Biblioteca Vaticana, Rome (Photo courtesy of the Department of Art and Archaeology, Princeton University).
128. *Ibid.*, fol. 35r.

Index

Index

Index

Index

Jerome, St., 97-8

Jerusalem, 84, 274, 278; church *ad galli cantum*, 293 n. 4; church of St. Helen, 307 n. 164; church of Holy Sepulcher, 98-9, 144, 146-7, 149, 228, 231, 239-42, 248-50, 256, 258, 260, 272, 307 n. 164; Golgotha, 98-9, 176, 239-40, 256, 258; house of Caiaphas, 142; house of St. John, 232; Mount Moriah, 98-9; Mount of Olives, 231, 242; Mount Zion, 231, 237, 242; Pilate's Praetorium, 114; Temple, 54, 98, 163

Johannes Biclarensis, 272

Johannes Poloner, 236

John the Baptist, St., iconography of, 54

John, Bishop of Jerusalem, 250

John Chrysostom, St., 20, 68, 187, 191

John, representative of Eastern Patriarchs at Seventh Council, 190

Jonah, 5, 32-3, 64-5, 138-9, 142, 268

Jordan, river, 248; personification of, 27-8, 33; church of St. John, 232; column with cross, 237; place of Baptism, 142, 163, 295 n. 56

Joseph, scenes from the life of, 26, 156-8, 163-5, 270

Judas, death of, 117

Juliana Anicia, 56, 58, 60, 64, 75

Juno Pronuba, 253

Justin II, Emperor, 272

Justinian I, Emperor, 25, 43, 48-9, 68, 233, 278-9

Kerch, Novikov collection, pyxis, 263-4

Khoja Kalessi, Isauria, 54, 148

Kiev, Museum, icons, 7, 210, Fig. 101; St. Sophia, 120

Kohler, C., 231

Kondakov, N. P., 3, 5-6, 25, 35, 42, 56, 63, 115, 120, 122, 128-9, 132, 134, 172, 204, 214, 216, 222, 254, 268, 273, 279

Konya, Museum, sarcophagi, 219-21, 246, Figs. 103, 112

Kraus, F. X., 5-6, 219

Lagrange, M.-J., 274

Lambecius, P., 58

Laodicea, 191

Last Judgment, 26, 33-35, 38, 40, 54

Last Supper, 119, 231

Lazarus, edicule of, 12, 27; *see also* Raising of Lazarus

Le Blant, E., 151

Leningrad, Botkin collection, ivory, 264; Hermitage, Coptic textiles, 195; plate from Perm, 252, 257-9, 266, 268, 270-1, Fig. 117; plate from Stroganov collection, 262, 264, Fig. 119; pyxis from Basilevskii collection, 268; Sassanian plate, 259; Public Library, Armenian ms., 72

Lenormant, F., 9

Leo VI, Emperor, 21

Leontius of Neapolis, 191

London, British Museum, Assyrian bronze, 268; Carolingian ivory, 107; ivory with Baptism, 180-2, Fig. 89; ivory with angel, 150; pyxis from Nesbitt collection, 137, 154, 169; statuette of fisherman, 139; stone with Pehlevi inscription, 256

Longinus, centurion, 258-9

Lüdtke, W. A. F., 127

Lyon, Museum, mosaic, 194

Madaba, mosaic map, 24, 230, 272, 274-6, 278-9, Fig. 125

Madrid, Gospel of Nicodemus, 114; sarcophagus, 52

Magundat, silversmith, 263, 271

Malalas, chronicler, 54

Manchester, John Rylands Library, Crawford ivory, 106-7, 235, 264, 266, Fig. 122

mandylia, 54; *see also* Veronica images

Manuel I Comnenus, Emperor, 235

Index

Mardin, monastery of Mar-Anania, 86

Mary the Egyptian, Life of, 232

Maximian, Bishop, 168, 271; *see also* Ravenna, Palazzo Arcivescovile

Meletius, St., 191

Memphis, 54

Menas, St., ampullae of, 226, 230

Merodach, 53

Mersin, necklace and ring from, 253, 306 n. 136

Michelangelo, 42, 48

Milan, Castello Sforzesco, Trivulzio plaque, 143-9, 176, 253, Fig. 69; diptych, 114, 117, 248; Biblioteca Ambrosiana, cod. F. 205 inf. (*Iliad*), 132-4; S. Celso, sarcophagus, 142, 244, Fig. 68; S. Nazaro, 106; S. Vittore in Ciel d'oro, 201, Fig. 95

Miller, K., 276

Mocianus, silversmith, 262

Modestus, Patriarch, 263

Moissac, capitals, 306 n. 136

Molinier, A., 231

Molinier, E., 269, 271

Montfaucon, B. de, 58

Monza, cathedral, ampullae, 82, 87, 90, 104, 149, 176, 225-50, 252, 256, 258-60, 268, 271-2, Figs. 106-11, 113

Moscow, Historical Museum, Chludov Psalter, 273; relief, 53; Museum of Fine Arts, pyxis from Ozerukov mound, 115, 219, 264-6, Fig. 123

Moses, 38; scenes from the life of, 29, 48-9, 51, 138, 176, 252, 272-3

Mount Athos, Vatopedi, cod. 655 (Ptolemy), 24

Mount Garizim, 278, 289 n. 114

Mount Sinai, 210, 248, 278-9; cod. gr. 1186 (Cosmas), 25, 53, 78; icons, 7; mosaics, 192, 213-4, 230, 272-4, Fig. 124

Mount Tabor, 295 n. 56

M'shatta, 270

al-Mu'allaka, *see* Cairo

Murano diptych, *see* Ravenna, Museo Nazionale

Naples, 48; Biblioteca Nazionale, cod. I, B, 18 (Job), 66-8, Fig. 33; Museum, Farnese globe, 22; mosaics, 192-3

Nativity, 82, 107, 163, 169, 230, 234-5, 237, 268

Nazareth, 248; churches, 232, 237

Neapolis, 278

Nero, Emperor, 276

Néroutsos-Bey, 251

Nesbitt collection, pyxis, *see* London, British Museum

Nicaea, St. Sophia, 212

Nicander, 9-10, 57; *see also* Paris, Bibliothèque Nationale

Nicephorus, Patriarch, 190

Nicephorus Callistus, 271

Nicetas, protospatharius, 16, 19

Nilotic landscape, 65, 192-4, 196

Nilus of Sinai, 196-7

Noah, 139

Oberzell, 42

Orion, 10

Orpheus, 222

Oxus treasure, 270

Ozerukov pyxis, *see* Moscow, Museum of Fine Arts

Paisios Hagiopolites, 273

Palermo, Palatine Chapel, 115, 120; ring from, 238, 254

Palestrina, mosaic, 193

Paneas, statue, 140, 292-3 n. 4

Paradise, four rivers of, 118-9, 240, 262, 277

Paris, Bibliothèque Nationale, diptych, 137, 154, 169-70, 237; ms. copte 13, 288 n. 85; ms. gr. 139 (Psalter), 300 n. 92; ms. gr. 510 (Gregory), 22, 207, 210, Fig. 100; ms. gr. 923 (*Sacra parallela*), 40, 42, Fig. 20; ms. gr. 1208 (James Kokkinobaphos), 299 n. 75; ms. gr. 2442 (Athenaeus), 24; ms. suppl. gr. 247 (Nicander), 9-16, 20, 25-6, 56, 64, 130, 167, Figs. 1-4; ms. lat. 2334, 277-8; ms. lat. 9448, 257; ms. syr. 33, 86-91, Figs. 43-4; Cabinet des

Index

Index

Torriti, Jacopo, 195
Transfiguration, 192, 272-4
Tree of Jesse, 237
Trial by water, 162-3, 264, 268
Trier, mosaic, 122; patera, 52
Trombelli, 163
Tyre, basilica, 271

Ugonio, 195, 197
Urania, 59, 122
Usener, H. K., 21
Usov, S. A., 115, 125-6
Uspenskii, F. I., 216
Uspenskii, P., 24, 210, 279
Uthina, mosaics, 188, 194
Uvarov collection, ivory, 169

Vansleb, J. M., 256
Varsonofii, pilgrim, 237
Vasil'evskii, V. G., 231
Venice, S. Marco, ciborium, 114; mosaics, 44, 134, 300 n. 92, Fig. 21; sarcophagus of Marino Morosini, 219
Veronica images, 115
Vespasian, Emperor, 54
Vienna, Figdor collection, pyxis, 137, 154, 169; Museum of Industrial Art, Coptic textiles, 194-5; Nationalbibliothek, cod. med. gr. 1 (Dioscorides), 53,

56-66, 75, 78, 122-4, 135, 194, 213, 215, Figs. 27-32; cod. theol. gr. 31 (Genesis), 48, 56, 66, 80, 117-9, 124-31, 134-5, 167, 198, 246, Figs. 62-4
Villefosse, Héron de, 194, 278
Virgin Mary, iconography, 84, 87, 108
Virgin and Child, 244, 268, 271
Visconti, E. Q., 57
Visitation, 230, 237

Washing of the Feet, 119
Wickhoff, F., 48-9, 80, 127-9, 131-2, 192
Willibald, 212
Wise and Foolish Virgins, 110, 118-9
Woermann, C., 192
Women at the Sepulcher, 78, 90, 142, 230, 238, 248-9, 258, 260
Wulff, O., 54, 221, 262

Xanthus, monument of Harpies, 259

Zacchaeus in the tree, 147-8, 253
Zacharias, Annunciation to, 100, 104
Zagba, city of Mesopotamia, 72
Zeno, orator, 24
Zenobius, architect, 307 n. 164
Zodiac, signs of, 21-2
Zopyrus, physician, 16